ON THE MAKE

THE HUSTLE OF URBAN NIGHTLIFE

DAVID GRAZIAN

THE UNIVERSITY OF CHICAGO PRESS CHICAGO AND LONDON

David Grazian is associate professor of sociology at
the University of Pennsylvania. He is the author of
*Blue Chicago: The Search for Authenticity in Urban Blues
Clubs,* also published by the University of Chicago Press.

The University of Chicago Press, Chicago 60637
The University of Chicago Press, Ltd., London
© 2008 by The University of Chicago
All rights reserved. Published 2008
Printed in the United States of America

16 15 14 13 12 11 10 09 08
1 2 3 4 5

Parts of chapters 1 and 2 originally appeared in David Grazian,
"I'd Rather Be in Philadelphia," *Contexts* 4, no. 2 (2005): 71–73.
A version of chapter 5 originally appeared in David Grazian, "The
Girl Hunt: Urban Nightlife and the Performance of Masculinity as
Collective Activity," *Symbolic Interaction* 30, no. 2 (2007): 221–43.

ISBN-13: 978-0-226-30567-7 (cloth)
ISBN-10: 0-226-30567-8 (cloth)

Library of Congress Cataloging-in-Publication Data

Grazian, David.
On the make: the hustle of urban nightlife / David Grazian.
p. cm.
Includes index.
ISBN-13: 978-0-226-30567-7 (cloth: alk. paper)
ISBN-10: 0-226-30567-8 (cloth: alk. paper) 1. Young
adults—Pennsylvania—Philadelphia—Social conditions.
2. City and town life—Pennsylvania—Philadelphia. 3. Bars
(Drinking establishments)—Pennsylvania—Philadelphia.
4. Nightclubs—Pennsylvania—Philadelphia. I. Title.
HQ799.73.P55G783 2008
307.76'408420974811—dc22 2007020855

For Meredith and Nathaniel

CONTENTS

1 Friday Night in Philadelphia: The Art of the Hustle, 1

2 Dynamic Imagineering: The Staging of Urban Nightlife, 29

3 Spin Control: Public Relations and Reality Marketing, 63

4 Winning Bar: Nightlife as a Sporting Ritual, 93

5 In the Company of Men: The Girl Hunt and the Myth
 of the Pickup, 134

6 Hustling the Hustlers: Challenging the Girl Hunt, 161

7 Where the Action Is: Storytelling and the Imagination of Risk, 198

8 Smoke and Mirrors: The Experience of Urban Nightlife, 224

 Acknowledgments, 235

 Appendix: Research Methods, 237

 Notes, 243

 Index, 277

FRIDAY NIGHT
IN PHILADELPHIA
THE ART OF
THE HUSTLE

At Tangerine, a fashionable French-Moroccan restaurant and cock-tail lounge in the Old City section of downtown Philadelphia, din-ers enter a candlelit Mediterranean dreamscape of rooms within rooms. Red fabrics and pillows adorn this mazelike Casbah, each chamber draped with velvet curtains, providing pleasure-seekers with their very own Arabian nights. Patrons rhapsodize over North African–inspired selections that include king salmon poached in olive oil and served with potato tortelloni and hazelnut-basil mousse, and chicken tagine, a Moroccan stew prepared with green olives and preserved lemons.

Many of the city's sharply dressed men and women flock to Tan-gerine to bask in its exotic glamour, but not Allison, a twenty-one-year-old hostess and cocktail waitress who endures every evening handling unruly customers. On any given night at Tangerine, the complaints remain the same: "Where is my table?" "I want the best table." "Why am I not seated?" "My reservation was for 6:30 p.m.! It's 6:35—where is my table?"

While entertaining their demands, Allison must remain composed and empathetic. "Well, they are just finishing their dessert." "It'll be

a few moments, if you would like to have a seat in the bar or lounge, or grab a cocktail?" she says.

"I don't want to grab a cocktail," they inevitably retort. "I want to sit down in my seat. I made a *reservation*."

According to Allison, "There was this one day, it was a Sunday and for whatever reason . . . there must have been three parties of twelve, all arriving at the same time. . . . It was a really busy day, it was really tight in terms of table seating, and we couldn't get one table sat right away because there wasn't a table for them yet—you know, people sit down for a dinner at Tangerine, and they don't get up. Sometimes they will be there for five hours, and you can't tell them to leave—you can try to hurry them along, crumb them a lot, water them, drop the check, but you can't make someone leave.

"They are all sitting there in the lounge, and this man just comes up and he screams, literally screams, 'GET ME MY FUCKING TABLE! I don't care what you have to do!' . . . I mean, he just came up and literally screamed at me, like, 'This is what you are supposed to do—if you tell me I am going to have a reservation, you are going to get me seated!' All this stuff, and I want to yell back so bad, 'Sir, take a look in the dining room. If you see a table that can accommodate your party, have a seat, by all means.' But you can't: you have to be nice. I remember as soon as that night was over, I just sat in the coatroom. I was crying. It was the worst."

Of course, from time to time Allison enjoys her revenge. As she confesses, "A lot of times people would say, 'I want a really good table—I want your best table.' And then you would kind of work it back with them in a way to make them think that that was a really difficult thing to do. . . . And then you would get side-tipped a lot. I have made $100 in a night sometimes, just letting people think that the tables they were getting were really difficult to get. . . . They'll either remember me on the way out, or they'll introduce themselves, shake hands, thank me, and there is money in their palm."

Across the Schuylkill River on the campus of the University of Pennsylvania, undergraduates Mackenzie, Nicole, and Mia juggle countless phone calls, instant messages, and consultations—"Are

jeans too casual to wear?" "Is it too cold outside to wear sandals?" "How heavy of a jacket do we need?" "Can I borrow your black belt?" before finally settling on matching outfits for their Friday evening of downtown barhopping. Casually clad in jeans and tank tops, the three young women hail a taxi to the bustling intersection of Second and Market streets a few doors down from Tangerine in Old City. Upon reaching their destination, the trio momentarily holds up traffic while disembarking from the cab; a pair of men in their mid-twenties admonishes them from their sleek silver sports car. Mackenzie, a nineteen-year-old sophomore, suspects that the men are just flirting with her and her friends while gratuitously calling attention to their flashy automobile.

Now where to go? Nicole knows a bouncer at Bleu Martini, a swanky cocktail lounge just around the corner, but he does not appear to be outside the bar as they pass by, so it is off to Saint Jack's so Mia can use the restroom. They flash their fake IDs and enter the darkened bar as the eyes of the all-male clientele follow them down the length of the room. Distressed by their stares, Mackenzie and her friends quickly escape back to Bleu Martini, where they fight their way through the well-heeled crowd to the backlit bar for their drinks. A gentleman attempts to converse with Mia, tapping her on the back several times even as she waves him away. She is eventually saved by Nicole's bouncer friend, who invites the trio into the VIP lounge and hands them over to another host.

The three friends are led downstairs into the lounge, an illuminated cavern bathed in red light and decorated with mirrored walls, tiger-skinned couches, and low cocktail tables. Two groups of guests are already seated: a young group of about eight men and women in the far corner and a group of four older gentlemen on a couch in the middle of the lounge. To the trio's surprise, the host instructs them to join the group of older men, promising that if they talk to them and "keep them happy," the gentlemen will likely ply them with drinks.

Mackenzie is disgusted. She had incorrectly assumed that the three of them were the lucky recipients of special privileges brokered by Nicole, rather than merely singled out as attractive young women

chosen to surround the nightclub's male high rollers. ("I feel as if they were trying to whore us out," she later admits.) Much to the host's dismay, they reject his offer, opting instead for a couch across the room. No matter—ten minutes later he returns with another set of three young women willing to do his bidding in the meantime. A man selects one and places his hand on her leg, rubbing it as he attempts to draw her into conversation. As another pretty young woman in a short skirt passes by the table, the men suddenly stop all conversation and stare, following her with a full 180-degree head turn before bursting out into laughter.

Meanwhile, the host continues to replenish the VIP lounge with different groups of females, each wearing progressively skimpier outfits. Two waitresses work the room dressed in tight black pants and tiny black shirts, flirting with the men to keep them entertained in between the arrivals of new groups of female companions.

At a certain point Mackenzie departs for the restroom and returns to find her friends talking to these big spenders. One of the men approaches Mackenzie and offers to buy her a cocktail, which she accepts. She guesses he is at least fifty years old. He asks her what she does for a living. Admitting she is a student, she returns the question: he mysteriously replies that he does "everything," has "been everywhere," and "no one fucks with him." As Mackenzie recalls, "Everything he says is calculated to impress me with his power and elusiveness, but instead I feel as if he oozes sliminess." He continues to converse with her as he begins kissing Nicole's back. This causes enough discomfort for the trio that they get up to leave, but not before the mysterious gentleman gives Nicole his telephone number and asks for hers. (She gives him a fake number.) The three friends hastily retreat from the VIP lounge and Bleu Martini, only to be harassed on the sidewalk by yet another male passerby in his mid-twenties who shouts to Nicole, "You're crazy!" in a drunken slur.

Finally, they seek refuge in a taxicab bound for campus, but the driver assumes that they are drunk and attempts to drive them home by way of a circuitous and unnecessarily expensive route. Catching on, Mia instructs him to make a turn to avoid going all the way around

campus—a turn the driver conveniently misses, and when the trio insists on getting out of his taxi, he tries to shortchange them $2, a ploy that Mia catches as well, demanding the correct amount back.

THE ANONYMITY OF THE CITY

In movies and television depictions of urban nightlife, fabulous dudes and divas sip cocktails in enchanting fantasy worlds where friends and lovers meet. But while evoking the glamour and allure of the city, downtown entertainment spots also function as aggressively competitive environments in which participants are forever on the make, challenging each other for social status, self-esteem, and sexual prestige in a series of contests, attacks, and deflections that fill the evening hours. On any given weekend, club bouncers match wits with queued-up thrill-seekers desiring admittance; dinner parties of six argue over available tables; cocktail drinkers vie for the attention of a bartender or server; hip-shakers attack the dance floor with their eyes directed toward all onlookers; taxi drivers and their customers argue over the fare. Single men and women take obsessive measures in their attempts to "score" with (or else avoid) their fellow revelers; and occasionally nighttime patrons confront one another in escalating moments of high-stakes interaction over the smallest of disputes. In many ways, the city at night is a playground for engaging in elaborate games of strategy and chance, especially for young affluent men and women who approach evenings out at upscale bars, restaurants, nightclubs, and lounges as if they were sporting events: combative games of negotiation, deception, and risk.

How do we account for the competitiveness of those who participate in scenes of urban nightlife? One line of research gaining increasing interest among evolutionary psychologists suggests that men and women are biologically hardwired to interact as rapacious creatures fighting in a Darwinian contest for survival of the fiercest by any means necessary, as extravagantly displayed on televised courtship competitions from ElimiDATE to The Bachelor.[1] Others argue that while all human animals may be capable of demonstrating competitiveness in the urban

jungle, some individuals are far cagier than others, driven by sexual lust, insatiable greed, deficiency of morals, or else an unquenchable desire to pull off a spectacular nocturnal stunt or caper, whether in a casino, billiard hall, nightclub, or singles bar. Our exemplars come from the world of popular American film—Tony Curtis's press agent Sidney Falco in *Sweet Smell of Success* (1957), the brat-pack thieves of *Ocean's Eleven* (1960), Paul Newman's pool shark "Fast" Eddie Felson in *The Hustler* (1961) and *The Color of Money* (1986), Will Smith's professional "date doctor" in *Hitch* (2005)—as well as from journalistic accounts of confidence artists who stalk the city's nightspots in search of susceptible victims. In Las Vegas and Atlantic City, a team of MIT students moonlight as blackjack card-counters by employing mathematical dexterity, false aliases, and elaborate hand signals to win big hands while living double lives. In Los Angeles, predatory men pay $500 for four nights of on-the-job training in the timeless art of seduction by self-proclaimed pickup artists with presumptuous names like Mystery, Juggler, and Style. In New York City, a website named Wingwomen.com offers men attractive female escorts for the night—not for the companionship, but for the purposes of luring *other* unsuspecting women into conversations at nightclubs and bars throughout the city. In Miami, Hollywood, Las Vegas, and New York, average Joes hire gorgeous accomplices from PartyBuddys to shepherd them past the crowded queues of hot nightclubs, guaranteeing them coveted access to their exclusive velvet-roped VIP lounges amid throngs of envious onlookers.[2]

While these exemplars may illustrate a credible Sleazy Man theory of history, a more sociological approach instead emphasizes how wider populations of more or less conventional individuals and groups are shaped by their social circumstances. In fact, perhaps it makes more sense to look beyond these unusual cases by refocusing our attention toward the larger landscape of urban nightlife in which more normal schemes are enacted. The last decades of the twentieth century mark a tremendous shift in the organization of urban life, particularly as cities formerly known for industrial manufacturing, like Philadelphia, have transformed into centers of entertainment,

leisure, tourism, and professional business travel. Downtown areas and their public spaces strongly reflect the urban renaissance experienced by many American cities during the 1990s, as illustrated by the rise of shopping malls, flagship stores, and cultural attractions. Amid this consumerist landscape lurks the spectacle of the new urban nightlife, a bonanza of gentrified entertainment zones, themed restaurants, velvet-roped nightclubs, spectator-sports bars, gaming arcades, and multiplex theaters. These places tend to be highly stylized, demonstrating a concern with aesthetic imagery, playful design, and trendy eclecticism. The new urban nightlife similarly evokes an overindulgence in branding, both among franchised outposts that celebrate trademarked popular culture (Hard Rock Cafe, ESPN Zone, Coyote Ugly), and more generic efforts at homogenizing nightlife through all too conventional tropes: the faux-Irish tavern, the swinging martini-tippling cocktail lounge, the beach party–themed dance club, and the beer-soaked and graffiti-stained hipster dive bar where nobody really knows your name.

In fact, through all the urban renewal efforts and branding campaigns characteristic of the rise of the postmodern city, one aspect of urban nightlife has remained constant throughout the last century: many downtown restaurants, bars, nightclubs, cocktail lounges, and popular music venues continue to represent anonymous worlds of strangers where patrons lack any strong sense of social solidarity with one another.[3] Sociologists have long observed the anonymity within cities as a primary motivator of competition and caution among dwellers interacting in the urban milieu. As the German social theorist Georg Simmel contemplates in his seminal 1903 essay "The Metropolis and Mental Life":

> The mental attitude of the people of the metropolis to one another may be designated formally as one of reserve. If the unceasing external contact of numbers of persons in the city should be met by the same number of inner reactions as in the small town, in which one knows almost every person he meets and to each of whom he has a positive relationship, one would be completely

atomized internally and would fall into an unthinkable mental condition. Partly this psychological circumstance and partly the privilege of suspicion which we have in the face of the elements of metropolitan life (which are constantly touching one another in fleeting contact) necessitates in us that reserve, in consequence of which we do not know by sight neighbors of years standing and which permits us to appear to small-town folk so often as cold and uncongenial. Indeed, if I am not mistaken, the inner side of this external reserve is not only indifference but more frequently than we believe, it is a slight aversion, a mutual strangeness and repulsion which, in a close contact which has arisen any way whatever, can break out into hatred and conflict. The entire inner organization of such a type of extended commercial life rests on an extremely varied structure of sympathies, indifferences and aversions of the briefest as well as of the most enduring sort.[4]

For Simmel, this cautious aversion to the city of strangers can only be adequately handled by deploying meticulous if crafty strategies of impression management. By incorporating what he refers to as "the strangest eccentricities" and "elaboration of personal peculiarities" into one's public persona, "the attention of the social world can, in some way, be *won* for oneself."[5] In doing so, the anonymity of the city emancipates the metropolitan individual by providing limitless opportunities for self-expression and reinvention, the art of everyday life.

In outlining the contours of the 1920s American city, University of Chicago urban sociologist Robert Park, a onetime student of Simmel, drew on his mentor's teachings by similarly identifying urban dwellers as living "much as people do in some great hotel, meeting but not knowing one another." For him, too, this anonymity inevitably encourages individuals to rely on deceptive tactics of self-presentation in their social interactions in the city, given that one's status is, according to Park, "determined to a considerable degree by conventional signs—by fashion and 'front'—and the art of life is largely reduced to skating on thin surfaces and a scrupulous study

of style and manners."[6] Under Park's direction, curious urban ethnographers at Chicago set out to catalog the countless ways that young adults pursue selfhood and the development of individuality through role-playing in Chicago's cafés, restaurants, art galleries, dance halls, movie palaces, tea shops, bookstalls, and other assorted downtown cultural spots.[7]

As a chronicler of his own historical moment, Park describes the anonymous industrial city of the early twentieth century as a Babel teeming with the diverse foreign languages, customs, and cultures of newly arrived immigrant groups, racial ghettos, and ethnic enclaves. Yet for a set of somewhat different reasons, the downtown districts of today's American cities and their nightlife scenes in particular continue to feature a high degree of anonymity. In contrast to neighborhood bars and corner taverns that cater to local residents, downtown nightspots attract an affluent, fast-paced crowd of transient, mobile, and notably anonymous go-getters. These leisure tourists, business travelers, conventioneers, elite college students, and high-income single (or otherwise childless) professionals are the city's primary consumers of fine dining, high-end liquor, and live entertainment. More than anyone else, their spending drives the twenty-four-hour downtown economy of the bustling contemporary American city.

In the last several decades, the ascendance of the global postindustrial age has given rise to an agglomeration of business-oriented service industries (including law, finance, architecture, advertising, consulting, design, accounting, insurance, publishing, and technology services) within downtown districts, thus increasing both the number of affluent professionals living in city centers and the frequency with which they can be expected to relocate, given the rising mobility and flexibility demanded of high-income workers. This economic restructuring has simultaneously increased the need for business air travel between cities—as best illustrated by the increasingly lonely lives of constantly commuting executives, management consultants, and sales representatives—and a hospitality infrastructure to accommodate these jet-setters and frequent fliers during their stays. This rise in business travel has occurred during an accompanying

plunge in urban crime across the country, encouraging the redevelopment of downtown spaces as safe havens for middle- and upper-class retail, entertainment, and nightlife consumption. Consequently, this has contributed to an exponential growth of tourism and convention trade in cities, as well as a collateral rise in the attractiveness of urban-based universities among out-of-town students.[8]

These changes have all helped revive once-dormant downtown nightlife landscapes across the country that today serve a growing class of prosperous yet nomadic consumers. Lacking traditional ties to one another, these urban movers and shakers represent an anonymous world of travelers, tourists, transplants, and transients.[9]

Philadelphia provides a fitting example of these transformations in the organization of city life. An urban renaissance jump-started during Mayor Edward G. Rendell's administration in the 1990s catapulted the city's downtown district (properly referred to by locals as Center City) from the brink of industrial collapse into a metropolitan world of affluence and nonstop entertainment that looks quite different from the rest of the city. Thanks to the passage of a ten-year real estate tax abatement, since 1997 developers and local residents have converted 110 buildings, factories, and warehouses to over 8,000 apartments and condominiums in Center City. Among downtown census tracts, the area with the highest median income tops out at $87,027, or a staggering 283 percent of the city's median income. Since 1991 serious crime in Center City has been slashed in half while so-called "quality-of-life" crimes have dropped by 75 percent. Perhaps as a result, in 2005 Philadelphia's Center City boasted a population of 88,000 residents, the third largest downtown population in the country, after New York and Chicago. College graduates make up two-thirds of Center City's population—the third largest proportion of downtown graduates in the nation (barely bested by Midtown Manhattan [71.5%] and Chicago [67.6%])—and the *highest* percentage of downtown residents with graduate and professional degrees (36%) in the country.[10]

To cater to this population of affluent, educated professionals, the city's dining and nightclub scene has undergone a dramatic

transformation in style and sophistication in the last decade. Given Philadelphia's proletarian heritage, this may seem a bit surprising, since when it comes to downtown culture, the rough-and-tumble city of Rocky Balboa is perhaps better known for its junk food—Pennsylvania Dutch soft pretzels, overstuffed Italian hoagies, and, of course, the Philly cheesesteak, smothered with fried onions and Cheez Whiz—than its fine dining. Yet in the last few years, the city's downtown restaurant and nightlife scene has developed into one of the most surprising success stories in the nation, with more than two hundred dinner restaurants (a figure that has more than tripled since 1993) and sixty-five bars and nightclubs spread out over a set of gentrified entertainment zones where affluent consumers seek out adventures in urban pleasure and excitement.[11]

For instance, Tangerine and Bleu Martini are both located in Old City, a recently revitalized industrial area adjacent to Philadelphia's Historic District, home to Independence Hall, the Betsy Ross House, and the Liberty Bell. Having experienced the predictable transition from manufacturing corridor to artist enclave to yuppie haven, today's Old City features a set of commercial blocks lined with hip restaurants and nightclubs with alluring names like Glam and Swanky Bubbles. At the intersection of Second and Market streets sits the neighborhood's crown jewel, Continental Restaurant and Martini Bar, its interior lit by halogen lamps shaped like giant Spanish olives. At Continental, attractive female servers present guests with fusion dishes splashed with curry, lime, coconut, and soy, and a limitless array of designer cocktails, including the White Chocolate Martini sprinkled with white crème de cacao and a Hershey's Kiss, and the Dean Martini served with a Lucky Strikes cigarette and matchbook. A few blocks away at Buddakan, an extravagantly ornamented Pan-Asian restaurant, a foreboding sixteen-foot gilded statue of the great Buddha himself overlooks all patrons, emphasizing the relationship between decadent gastronomy and theatrical style in the postmodern global city. Elsewhere in Old City, restaurateurs and other chefs prepare fashionable exemplars of hybrid cuisine and cosmopolitan chic, whether lobster empanadas and fried plantains at Cuba Libre Restaurant and Rum Bar, or

tobiko-crusted scallops with spinach risotto and lemongrass sauce at the appropriately named World Fusion.

And yet as Mackenzie, Nicole, and Mia (the students introduced in the book's opening vignettes) discover during their evening at Bleu Martini, Old City on a Friday night is also thick with the human traffic of anonymous strangers—the big spenders in the VIP lounge, the cruisers in their sports cars, and, of course, the herds of underage students like themselves. Deep in the heart of one of the largest college towns in the country, Philadelphia's Center City boasts a young and educated population with nearly a third (30.5%) of its residents between twenty-five and thirty-four years old. Of these Philadelphians, 79 percent are college graduates and 86 percent of them are childless. This is a population of energetic singles hungry for the nightlife of the city, and they share their zeal with over 100,000 college and university students: the 32,000 students who attend Center City's eleven postsecondary schools (including the Art Institute of Philadelphia, Moore College of Art and Design, and the Pennsylvania Academy of the Fine Arts); the 64,000 students who attend the main campuses of Temple, Drexel, and the University of Pennsylvania; and untold others from nearby schools (Swarthmore, Villanova, Haverford, Bryn Mawr, Saint Joseph's University) who commute into the city for their weekend kicks.[12]

These young affluent residents all add to the anonymity of the city, particularly given that they mostly represent a highly mobile population lacking in familial or neighborhood ties to the city's more traditional residential communities. As local journalist Sasha Issenberg reported in *Philadelphia Magazine* in 2003, "Center City looks all the more happening when juxtaposed with sweet, friendly neighborhoods where people do little but chat with neighbors. Where Center City used to be one unbounded zone among many, it has become, like Manhattan, a compact island in the heart of a sprawling city." In the city's downtown restaurants and lounges, young urban singles bump against countless Pennsylvania and New Jersey suburban commuters, as well as the anonymous 25.5 million visitors the Philadelphia region attracts each year, a figure that includes 18.8 million

leisure travelers and 6.7 million business travelers who stay in the city's 10,195 hotel rooms.[13]

This mobile and transitory mix of professionals, commuters, tourists, conventioneers, and university students characterizes a downtown culture of anonymity, an affluent world of strangers. Of course, consumers rarely experience the nightlife of the city truly on their own, lost in the lonely crowd—they socialize on romantic dates for two; in large packs of coworkers and clients; on outings with small groups of confidants; and during adventures with other assorted twenty- and thirty-something urban tribes. But even a casual observer of Center City can detect increasingly wider swaths of the downtown landscape where dining and barhopping clusters of friends and colleagues coexist alongside one another but never actually intermingle. It is as if the promise of the gated community as an urban fortress of solitude has been realized on an interpersonal level in the very spaces of public interaction once cherished for their ability to bring strangers together in moments of shared camaraderie, from colonial Philadelphia's City Tavern to McSorley's Old Ale House in New York. As the anonymity of urban life in Philadelphia grows alongside the intensified development of its landscape of downtown entertainment—its themed restaurants, elegant brasseries, swank nightclubs, cocktail lounges, sports bars, gentleman's clubs, and arthouse cinemas—it cannot help but impact how today's thrill-seekers experience the city at night.[14]

THE HUSTLE OF URBAN NIGHTLIFE

The anonymity of the city provides the driving force behind what I call the hustle of urban nightlife. A combination of hard-nosed aggression and stylistic finesse, the art of the hustle requires the smooth magician's skills of sleight of hand and deceptive trickery. The hustler relies on the seasoned politician's self-confidence and golden tongue, the hungry gambler's appetite for profit and risk, and the calculated, manipulative machinations of the con artist. In the world of Philadelphia's nightlife, the art of the hustle is perhaps best exemplified by

the city's culturally savvy hotshot restaurateurs and their indomitable ability to leverage the funds of deep-pocketed investors. Exhibit A could be Neil Stein, the creator of the high-end eateries Rouge, Bleu, Striped Bass, Avenue B, and Fishmarket, sentenced to federal prison in 2006 for tax evasion—a con man who skimmed $500,000 from his own businesses to support his expensive addictions to alcohol, cocaine, heroin, and Percocet.[15]

Of course, not all hustlers are crooks, and no Philadelphian has achieved greater success playing by the rules than *Bon Appetit* magazine's 2005 Restaurateur of the Year, Stephen Starr. A former nightclub owner and concert promoter, Starr specializes in branding high-concept dining as a theatrical event to be enjoyed as a total experience, a heady concoction of sight and sound, buzz and light. In this regard, he is as much a showman and entertainer as a businessperson. As he told *Philadelphia Magazine* in 2000, "I want people to feel like they're not in Philadelphia or near their home in Huntingdon Valley when they come to one of my places. Let's face it—life is pretty mundane, for you, for me, or Cindy Crawford. So I want their night out to feel like they're getting away. I'm selling the experience."[16]

Built as elaborate stage sets, each of Stephen Starr's stylized restaurants conjures up an imaginative fantasy world of exotic delight. In the process, Philadelphia's most famous nightlife impresario has created a cycle of success propelled by his own peculiar celebrity, and like many film directors, Starr is often only recognized in public through his creations. Through his Starr Restaurant Organization (SRO), since 1995 he has been responsible (as of this writing) for fifteen kaleidoscopic global fusion restaurants-cum–cocktail lounges in the city—including the aforementioned Buddakan, Continental, and Tangerine—each obsessively ruled with the most rigid of bureaucratic managerial styles, yet the illusion of glamour and decadence remains. As the SRO promotional website boasts, "With more than 20 years in the hospitality and entertainment industries, Starr likens the experience of dining out to that of attending a theater production, where the players, props, backdrops, lighting and rapport are integral components of an overall dramatic effect. When this atmo-

spheric drama is paired with edgy, delicious cuisine, dining out at an SRO restaurant becomes entertainment for all of the senses."[17]

Of course, the hustle of urban nightlife requires coordinating efforts among not just celebrities like Starr but entire armies of cultural engineers and enchantresses, including public relations consultants, professional performers, and their support personnel, each relying on tactics of deception and guile when crafting the allure of downtown nightspots for unassuming tourists, travelers, and other affluent cultural consumers. The promotional strategies of publicists and other nightlife marketers include event planning, media placement, and nontraditional buzz tactics, each concocted with the hope of stimulating public enthusiasm for the newest hotspots and their rapidly fading counterparts. In the parlance of the classic confidence game, PR consultants operate as *ropers* responsible for identifying easy marks and luring them to a previously agreed-upon site to be swindled, or at least overcharged. Media outlets similarly steer cultural consumers to downtown restaurants, bars, and nightclubs. Since a city's general economic growth often leads to increased profits and power for its hometown media organizations, newspapers, magazines, television stations, and Internet websites routinely assist in orchestrating public support for local arts and entertainment industries.[18]

If public relations consultants and media outlets act as ropers for the hustle of urban nightlife, then the lead stage performers of the hustle—bartenders, servers, cocktail waitresses—serve as *insiders*, responsible for receiving the mark once he or she has been directed to the nightclub or restaurant by the roper. As David W. Maurer argues in his classic 1940 exposé *The Big Con: The Story of the Confidence Man*, insiders are "highly specialized workers; they must have a superb knowledge of psychology to keep the mark under perfect control . . . while he is being fleeced." As exemplified by the deep acting abilities of smiling barmen and winking cocktail waitresses who flirt with customers for their tips, the highly theatrical yet deceptive routines required by an enormous range of lead performers from table servers and hostesses to musicians and exotic dancers

illustrates how nightlife productions resemble confidence games and other urban hustles.[19]

In *Art Worlds*, sociologist Howard S. Becker observes how *support personnel* operate as a network of secondary producers necessary for the creation and dissemination of artistic and cultural works and events, and include oft-forgotten yet essential contributors to this process, such as musical instrument manufacturers, film editors, and stage-set designers. Within scenes of downtown nightlife, a range of participants exists on the periphery as outsiders to the privileged interactions commonly recognized as such by the consumers of entertainment in the city. These support personnel include bouncers, coat checkers, food runners, bar backs, doormen, and others who fill working-class occupational roles necessary to the functioning of nightspots and their entertainment zones. As sociologist Peter Bearman reminds us in his study of Manhattan doormen, these service workers and the affluent consumers they encounter in the urban milieu must constantly "negotiate interpersonal closeness in the context of vast social distance" as a recurring strategy of everyday interaction.[20]

In the context of urban nightlife, such supporting characters often (but not always) operate as a set of *shills*, or accomplices, who assist the aforementioned lead performers in generating a credible aura of enveloping enthusiasm for patrons to consume. Sometimes these confederates participate by engaging in the most subtle of performances—a quick smile from a quiet hat-check girl, a slap on the back by a boisterous bouncer, a moment of lip-synching by a busboy collecting empty beer bottles. Just as overexcited shills add to the "atmosphere of synthetic excitement" during the climaxes of sidewalk shell games and other hustles, nightclub and restaurant managers encourage support personnel to help artificially heighten the overall mood experienced by their patrons. Bouncers additionally perform this role by operating as agents of social control able to systematically and unfairly deny access to working-class patrons, racial minorities, and other so-called "undesirable" customers seeking entry to exclusive downtown establishments.[21]

Support personnel also work behind the scenes of nightlife venues. Although typically invisible to the public, their laborious backstage efforts often rely on the art of the hustle to dupe consumers in small yet immeasurable ways. As sociologist Gary Alan Fine reveals in *Kitchens*, an ethnographic account of restaurant work, sous-chefs and line cooks mislead diners by hiding the shortcuts or mistakes made during food preparation, whether by adding grill marks to baked steaks, masking the blemishes on desserts with whipped cream, or even bathing well-done roasts in red light to give off the impression of rareness.[22]

THE CULTURAL CONSUMER AS A MARK

In commercial nightlife spots such as restaurants, nightclubs, and cocktail lounges, entrepreneurs provide entertainment for an audience of consumers seeking a certain kind of experience (be it romantic, glamorous, authentic, or otherwise) and recruit skilled workers to manufacture this experience as a seamless performance. According to Kate Andrews, a former exotic dancer from New York, customers of gentlemen's clubs frequently desire to learn the intimate details of the lives of the strippers they meet: "Hi, where are you from? No, where are you *really* from?" "What's your name? No, what's your *real* name?" "How old are you? No, how old are you *really*?" In order to generate a suitable level of feigned intimacy with their clients, exotic dancers are required to fabricate a credible biography that conforms to conventional stereotypes and male expectations of the stripper as either a "highly sexed, promiscuous drug user ... an empty-headed party girl," or else a single mother with "down-home values" forced into stripping "by necessity and self-sacrificing love for her children."[23]

The mob of hustlers that collectively engineers the experience of the nightlife consumer draws on traditional strategies of deception in order to separate the *mark*, or victim, from his money. In fact, successful confidence games have almost always relied on the distractions provided by the nightlife of the city. As one con man argues in sociologist Edwin H. Sutherland's 1937 profile *The Professional Thief*,

to swindle a sucker "it is necessary to hurrah him for some time. He is taken to dinner, to shows, to night clubs, and is shown a grand time for a while. His feet must not be permitted to touch the ground."[24]

Of all consumers, perhaps the tourist, conventioneer, and business traveler common to postindustrial cities are most easily beguiled by the hustle of urban nightlife. While downtown entertainment night-spots attract savvy neighborhood regulars as well as out-of-towners, the latter make the most suitable marks since their unfamiliarity with local surroundings makes them much more susceptible to being seduced by highly scripted repeat performances by service workers, whether pleasantries from a hunky table server or the flirtatious eye-lash flutters of a coquettish barmaid. As Maurer reminds us in *The Big Con*, for best results "the mark must not be a resident of the city where he is to be trimmed." In *The Professional Thief*, Sutherland quotes a hustler who argues as much: "No confidence game will work well in the sucker's own town. He is surrounded by too many regular conditions, and there are too many chances for him to get advice."[25]

For a number of reasons, undergraduate and graduate students also make particularly vulnerable marks. Many students enrolled in the city's universities are transplants from outside the Philadelphia metropolitan area, with a significant percentage hailing from abroad; like the aforementioned tourists and travelers, their familiarity with locally specific hustles will only emerge after repeated adventures and mishaps in the city at night. As a legacy of the unequal spatial distribution of socioeconomic classes within metropolitan regions across the country, elite colleges and universities like Villanova, Swarthmore, Haverford, and the University of Pennsylvania often admit a large percentage of applicants residing in wealthy suburban areas—young people lacking in experience negotiating the complicated urban terrain of a large cosmopolitan city like Philadelphia. Of course, given their youthful inexperience, many middle- and upper-class eighteen- to twenty-five-year-old college students—suburban, rural, urban, or otherwise—lack the maturity, self-confidence, and street smarts enjoyed by older service staff and support personnel employed by restaurants, nightclubs, and cocktail lounges. (Perhaps

for these reasons, college students also often find themselves the victims of *actual* confidence artists and their scams.) Exceptions include college students who moonlight in working-class occupations as nightlife service workers such as Allison, the aforementioned hostess and cocktail waitress from Tangerine, and Kate Andrews, the former exotic dancer from New York.[26]

Notably, the anonymity that exists among participants in downtown settings lightens the amount of strategically deployed emotion work required among producers and service staff (at least per customer) while heightening consumers' susceptibility to the hustle of urban nightlife. Neighborhood taverns catering to local regulars that enforce social norms of camaraderie between bartenders and patrons can entrap service workers in a small yet inescapable set of sham relationships that accumulate over time and thus require constant management, while the performances of intimacy expected of downtown nightlife employees are far less intensive. Anonymity among patrons reinforces their spatial and temporal isolation from one another—what the great sociologist Erving Goffman refers to in *The Presentation of Self in Everyday Life* as "audience segregation"— thus augmenting the ability of service staff to successfully "foster the impression that their current performance of their routine and their relationship to their current audience have something special and unique about them."[27]

Anonymity within nightspots also increases the desire among patrons to collectively rely on highly superficial and therefore misleading signals when evaluating their surroundings, as when diners seek out restaurants in Chinatown in which a majority of the customers visible from the street appear to be of Asian descent, even though cuisines across Asia and within China itself are extraordinarily diverse in texture and flavor, and ethnicity in and of itself is hardly a suitable marker of culinary expertise.[28] As a result, promotional efforts to portray urban nightclubs as super-cool succeed most effectively when anonymity among patrons can be employed to feign an aura of mystification out of thin air. For instance, at dance clubs along the Philadelphia riverfront, good-looking crowds of young yet

dapper drinkers can help elevate a club's hotness quotient for all participants, while their anonymity works to mask the extent to which large numbers of them are likely suburbanites from the notoriously un-cool towns of southern New Jersey long stigmatized by the city's hip and trendy for their presumed lack of urbane sophistication.[29]

NIGHTLIFE AS A SPORTING RITUAL

The art of the hustle is hardly limited to the production teams that create the city's cosmopolitan restaurants, opulent nightclubs, martini bars, and cocktail lounges. In fact, many of the city's denizens appropriate urban nightlife for their own kinds of hustles—games in which they cultivate competitive strategies of attack and subterfuge, engage in tactics of deception and risk, and defend themselves against oncoming advances of aggression. To facilitate their access to bars and nightclubs, some underage girls will strategically apply eye shadow and mascara designed to make them appear at least as old as the age listed on their fake IDs. Single heterosexual men rely on their friends to serve as confederate "wingmen" willing to confirm the veracity of their tall tales to female passersby. Some women resist these generally transparent efforts by giving out fictitious names and made-up phone numbers to solicitous men. Other women exploit their dominance in such situations by flirting their way to the bottom of as many free cosmopolitans as the poor saps will order before giving up and driving home alone. Meanwhile, many a confident young woman herself will aggressively hunt down her male prey by waiting patiently until her target unwittingly isolates himself from his buddies, at which time she will approach him to nonchalantly request a cigarette or ask for the time. In doing so, male and female thrill-seekers alike appropriate the strategies of international spies, impostors, confidence artists, and other hustlers, including the art of masquerade and role-playing; the creation of bogus aliases through falsifying legal documents; the reliance on accomplices and rehearsed tactics when approaching unassuming strangers; and the careful selection of a potential mark for any num-

ber of schemes, from starting an unfair fight to acquiring a desired (and hopefully authentic) phone number.

In some ways the changing context of urban entertainment itself generates the desirability for following game-oriented cultural scripts, or *sporting rituals*, as a requirement for nightlife participation, particularly among young people. Since the 1980s, states have raised the legal drinking age from eighteen to twenty-one, thus encouraging underage high school and college students to purchase counterfeit driver's licenses (at a cost of $50 to $150) for use in gaining illegal admittance to bars and nightclubs. The increased anonymity of urban life creates a context in which identity can only be proven through government-issued identification cards (as opposed to well-known familial relations within small towns), while decreasing the impact of locally based social sanctions on the behavior of youth. The anonymity of the city also fosters an aura of distrust among patrons whose sympathies are directed inward (toward themselves and their peer groups) rather than toward the public at large. Unlike more or less romanticized notions of urban nightlife that nostalgically evoke the old-time neighborhood corner tavern as a site of community solidarity, nightclubs and cocktail lounges represent sites of competitiveness and conflict that encourage the isolation of social friendship clusters from one another.

Some of this competitiveness and conflict emerges out of the sexualized atmosphere common to contemporary urban nightlife establishments. While most downtown bars and private social clubs in Philadelphia catered specifically to men throughout much of the twentieth century, the city's recent restaurant and nightclub revivals have increased the attractiveness of nightlife establishments for middle- and upper-class women, offering aesthetically playful, female-friendly spaces; designer drinks (e.g., cosmopolitans, champagne cocktails) pitched to a female consumer market; and increased safety for women, best exemplified by the rise in female bartenders, managers, and other employed service staff. (According to the U.S. Bureau of Labor Statistics, in 2004 women held a majority [58.2%] of all 360,000 bartending jobs in the United States, in addition to

73.1 percent of all restaurant waiter/waitress jobs, and over 90 percent of all restaurant, lounge, and coffee-shop hostess/hosting jobs.)[30] The increased presence of women in the city's liquor-serving establishments over the last several decades has consequently transformed male-dominated drinking havens into pickup spots where drunken strangers vie for the attentions of attractive female customers and scantily clad employees often hired on the basis of their sexual magnetism. As erotic encounters—desirable or otherwise—between anonymous men and women on the make multiply along with their social acceptance in downtown nightspots, men young and old develop ever-more competitive courtship strategies (that include harassing underage girls while bullying physically weaker males), forcing women to deploy an armory of defensive tactics designed to ward off their increasingly predatory advances.

This has the added effect of encouraging cohesion within friendship clusters of patrons (both male and female) who carouse together throughout the city at night. Participants collaborate with one another as a means of combining social resources to benefit their entire group. Young singles prepare for this collective effort by "pre-gaming"—the employment of alcoholic drinking rituals designed for engineering and intensifying group cohesion while simultaneously decreasing social anxiety prior to tackling the anonymous world of urban strangers. (The term comes from the pregame's similarity to parking-lot tailgate parties held prior to sporting events.) Subsequently, group members can better rely on one another when carrying out collective rituals of behavior in their public encounters.

URBAN NIGHTLIFE AND THE TRANSITION TO ADULTHOOD

The anonymity of city life not only requires that consumers develop a strategic orientation to nightlife participation, but also provides the opportunity for young people to publicly explore their own sense of themselves on the road to achieving adulthood. The overwhelming finding of the last decade in the sociology of youth and adolescence is the postponement of numerous life-course events marking the transi-

tion to adulthood as young people complete school later and take longer to achieve permanent employment, marry, and bear children.[31] This suggests a lengthening of the transition from late adolescence to early adulthood in recent years. Developmental psychologist Jeffrey Jensen Arnett characterizes this prolonged transition as a stage of "emerging adulthood," an elongated period of gradual development in which college-aged youth (eighteen to twenty-five years of age) spend their late teens and early twenties exploring life's possibilities through role experimentation and an increased exploration of their occupational aspirations, sexual preferences, and lifestyle possibilities. This is especially true of those who both reside in prosperous areas of the world (such as the United States and western Europe) and hail from affluent socio-economic backgrounds.[32] Unlike their younger counterparts, emerging adults often live independently (or at least semi-autonomously in college dormitories, fraternities and sororities, and similarly shared housing arrangements) and are therefore more empowered to venture into new cultural and sexual territories without fear of parental sanctions.[33] Since emerging adults continue to postpone the decision to marry and raise children, many of these twenty-somethings are far less constrained by familial responsibilities and thus more able to take advantage of their relative autonomy than those of earlier cohorts.

Active participation in downtown nightlife settings present youth with opportunities to experiment with various styles of public behavior and strategies of impression management. Adventures in cultural consumption have always provided an available context for adolescents and young adults to appropriate commercial culture for their own expressive ends by molding elements of style, including fashion, body adornment, music, dancing, and athletics into alternative modes of aesthetic display and identity formation—as illustrated by the subcultural affectations of American beats, hippies, surfers, bikers, Rastafarians, Deadheads, punks, headbangers, Goths, slackers, b-boys, candy-ravers, skateboarders, and snowboarders from the 1950s to the present.[34]

In doing so, young people experience nightlife as a rite of passage by crafting and inhabiting what I refer to in my first book, *Blue*

Chicago, as a *nocturnal self*—a set of public identities and personalities that consumers employ while negotiating the restaurants, bars, nightclubs, and sidewalk life of the city.[35] These public urban settings are especially conducive to the display of ritual behavior, the expectation of voyeurism, and, perhaps most importantly, the opportunity to perform an elaborated nocturnal self for an audience of anonymous strangers. For emerging adults, the city's entertainment zones resemble the interlocking worlds of an adolescent amusement park, a playground where nocturnal roles can be rehearsed, social skills practiced, self-confidence tested, and a wide variety of games can be initiated. Tangerine and Continental, Bleu Martini and Swanky Bubbles—these restaurants, nightclubs, and cocktail lounges are the stages upon which young people learn the dramatic art of the hustle.

Given the enthusiasm and playful spirit with which this cohort of emerging adults engages in the nightlife of the city, it is somewhat surprising that very little serious social research has been conducted on the question of what these experiences actually mean to them.[36] For certain, the nocturnal activities of young people represent the most frequently portrayed topic in our simulated "reality-based" popular culture. Entertainment news programs and tabloid magazines obsess over the naughty behavior of young Hollywood starlets drunk-driving their way to Los Angeles's hottest nightclubs—Paris Hilton at LAX, Lindsay Lohan at Element, Britney Spears at Les Deux. (By the time this book goes to press, these A-list celebrities may well be forgotten or at least seriously demoted, in which case the reader should feel free to substitute them with their latest replacements.) Steve Francis, founder of Mantra Films, makes an estimated $40 million a year off the success of his lurid *Girls Gone Wild* videos, which feature blitzed adolescent females pulling their tops off in and around nightclubs in Panama City and other spring break locales.[37] The longest-running television program in MTV's history, the reality show *The Real World*, chronicles the drunken debauchery and sexual abandon of seven great-looking young people stumbling their way through the nightlife scenes of a different city each season, includ-

ing New York, San Francisco, Boston, Las Vegas, Chicago, Miami, Austin, Key West, and Philadelphia—the last of which was mostly filmed around the cast's rehabbed luxury residence in the neighborhood of—where else?—Old City. Of course, with its casting calls, scene engineering, and vicious edit cuts, The Real World hardly illustrates life in the really real world, and while ethnographic research also relies on strategies of representation as its own kind of hustle, I hope that the following chapters accurately reveal more reasonable depictions of the urban environment than those dreamt up by the producers of Entertainment Tonight and Girls Gone Wild.[38]

In the interests of developing a sociological understanding of how emerging adults encounter the world of strangers in the context of urban nightlife in Philadelphia, I have made a conscious decision in this book to focus my attention on how the one group of young consumers that I know best—undergraduate students enrolled at the University of Pennsylvania—negotiate their way through the city at night. Of course, as social psychologist David O. Sears observes, there are substantial pitfalls associated with relying on undergraduate students to create generalized hypotheses about anything, especially given the age-specific parameters that typically define collegiate life in the United States.[39] This may be a particularly onerous problem for research conducted among University of Pennsylvania students, given that elite private universities like Penn exhibit much less diversity in terms of socioeconomic class, race, and ethnicity in comparison to the general population, or even when compared to the student populations at public institutions of higher learning in Philadelphia, such as Temple University.

The night lives of University of Pennsylvania students are nevertheless an important piece of the puzzle outlined in these introductory pages. Penn students make up a significant proportion of Philadelphia's collegiate population, and many are newcomers to the city and therefore contribute to the overall anonymity of its worlds of nightlife and downtown entertainment. A sizable number of Penn's students hail from affluent backgrounds and thus possess the requisite disposable income, leisure time, and cultural capital necessary

for participation in the city's dining and nightclub scenes. Moreover, as Nicole Ridgway illustrates in her portrait of Penn undergraduate business majors, *The Running of the Bulls: Inside the Cutthroat Race from Wharton to Wall Street*, upon graduation many of these students will take on the role of high-income business traveler and convention-eer themselves, if not also the well-heeled suburbanite and leisure tourist. As members of the preprofessional class, their tastes, habits, and, perhaps most of all, their treatment of one another as exhibited by the sporting rituals they employ represent the promise and peril of contemporary urban nightlife, and in the end they have much to teach us about ourselves.

Of course, no book can possibly do justice to the complex diversity of affluence, sexual proclivities, or social behavior representative of a large body of individuals, and in the pages that follow the usual caveats apply. No, not all Penn students engage in underage drinking or carouse at nightclubs and parties on the weekends. Some students cannot financially afford the Old City lifestyle, and many defiantly choose not to—they hit the books at the library; take on professional training in elite-level internships; participate in the often-sober regi-men demanded of intercollegiate athletes; or enjoy the pleasures and camaraderie offered by membership in an extracurricular student organization, be it a theater troupe, a cappella singing group, club sport, political campaign, school newspaper, or the campus chap-ter of Habitat for Humanity. While some students live in apartments or flats right in Center City, others almost never venture off campus at all. Moreover, the sexual attitudes and habits of Penn students emphasize diversity, rather than uniformity. Few students are mar-ried, but many are involved in monogamous heterosexual relation-ships; the university supports an active lesbian, gay, bisexual, and transgender community; and many religiously devout students opt out of the local sexual marketplace altogether. On the other hand, the repertoire of skills and smooth moves that comprise the hustle of urban nightlife are not dramatically different from the tactics of impression management, cultural scripts, and confidence games we all routinely initiate in our everyday interactions. Compared to

the machinations humans regularly employ as social beings, the presentation of a nocturnal personality may differ by degree, but not in kind. In the end, even Penn students who seem substantially different from one another may share more than even they would care to admit.

OUTLINE OF THE BOOK

In the chapters that follow, I rely on a variety of ethnographic and qualitative research methods borrowed from sociology—participant observation, interviews with industry professionals, focus groups, and a close analysis of hundreds of firsthand narrative accounts of nightlife participation, all written by undergraduate students —to tell a wide range of stories that illustrate how urban scenesters produce, market, consume, and experience downtown nightlife in the contemporary American city. (I have included a more detailed explanation of my research methods in the appendix.) In chapter 2 I explore the theatrical qualities of urban nightlife and the elaborate staging rituals involved in pulling off its seamless production as a confidence game, including the rehearsed performances of service staff in nightclubs and restaurants. Chapter 3 continues this discussion by emphasizing the growing role that public relations, brand marketing, and deceptive tactics of impression management play in the promotion of urban nightlife.

Chapter 4 turns toward the consumption of urban nightlife by focusing on the individual and collective sporting rituals in which young people engage as they negotiate the city's entertainment zones, and the strategies they deploy in competitive encounters with strangers. In chapter 5 I elaborate on this theme by highlighting one sporting ritual in particular—the *girl hunt*—as a collective activity in which men perform masculine roles for one another at the expense of the anonymous women they hassle along the way. Chapter 6 continues with a discussion of the routine harassment of women in public nightlife settings, explores how young females aggressively resist the girl hunt through their own strategies of deception, and concludes

with a discussion of the tactics of seduction that women themselves employ in public. In chapter 7 I examine how both men and women rely on their adventures in urban nightlife to craft appealing narratives as resources for identity construction and peer status, and how doing so inevitably involves not only seeking out predictably memorable experiences worthy of recollection, but also fabricating (or else exaggerating) the risks inherent in such adventures.

Finally, in chapter 8 I conclude with a reiteration and discussion of the book's key arguments. In taking the reader from the backstage areas of luxurious restaurants to the dance floors of upscale cocktail bars, my goal is to provide a sociological tour of the contemporary American metropolis and its nocturnal playground as a mise-en-scène for the performance of confidence games, competitive sporting rituals, and the hustle of urban nightlife as an integral feature of the anonymous city.

2

DYNAMIC
IMAGINEERING
THE STAGING OF
URBAN NIGHTLIFE

From the Spanish Prisoner to the Nigerian e-mail scam, confidence games represent staged performances and illusory sleights of hand deployed in order to defraud, swindle, or otherwise deceive an unwitting audience for monetary profit, and the entertainment infrastructure of downtown Philadelphia serves as a playground where these snares and other hustles surrounding the city's nightlife take place.[1] Sociological research on the confidence game, or "con," began at the University of Chicago during the 1920s and 1930s. Provocative Chicago school ethnographic studies of this exciting era in the history of the American city characterize a wide variety of hustlers and their schemes: street fakers and fortune-tellers who lull gullible customers into accepting their powers; hawkers who sell snake oil on the sidewalk to unwitting passersby; cult leaders who convince their followers to donate their entire savings in exchange for eternal salvation; and taxi dancers who lure and eventually exploit male immigrants for financial gain. In later work influenced by the Chicago school, sociologists would go on to explore how professional grifters, swindlers, racketeers, confidence mobs, and pool hustlers deceive their victims.[2]

Perhaps as a result, the confidence game has long served sociologists as a metaphor for impression management and other commonplace types of deceptive interaction rituals. In *The Presentation of Self in Everyday Life*, Erving Goffman uses the performances of double agents, shills, impostors, and charlatans in order to illuminate the more common acts of duplicity employed in everyday affairs. In his theatrical universe, married couples serve as each other's accomplices during gossipy dinner parties, hairdressers help us misrepresent our true age, and parents protect their children by telling them white lies and other well-intentioned falsehoods. Other research emphasizes how all sorts of professionals—doctors, lawyers, social workers, teachers, police detectives, politicians, flight attendants, croupiers, musicians, exotic dancers, doormen—regularly rely on a range of strategies commensurate with the art of the hustle by manipulating existing visions of reality (or what early twentieth-century sociologists W. I. Thomas and Dorothy Swaine Thomas referred to as "definitions of the situation") through exaggerations of fact, false displays of competence, friendliness and trust, tactics of misrepresentation and mystification, and sheer guile. As sociologist Ned Polsky observes in an essay on pool hustlers, "Of course, conning is only a matter of degree, in that all of us are concerned in many ways to manipulate others' impressions of us, and so one can, if one wishes, take the view that every man is at bottom a con man."[3]

Given the dramatic qualities of urban nightlife, what kinds of staging techniques are required to pull off its seamless production in the city? Like confidence artists and other seductive swindlers, shamans, and showmen, a host of cultural producers and support personnel (including interior decorators, publicists, managers, table servers, bartenders, and hostesses) rely on professional set design, elaborate costuming and role-playing, sleight of hand, and other strategies of manipulation and cunning to manufacture Philadelphia's entertainment landscape as an extravagant spectacle that camouflages as much as it reveals. From the city's enticing restaurants to its lavish cocktail lounges to even its grungiest dive bars, the urban terrain of nighttime fashion both dazzles and deceives as does a three-ring cir-

cus, replete with its clowns and connivers, acrobats and illusionists, ringleaders and showgirls—tricksters one and all.

THE STAGING OF URBAN NIGHTLIFE

In *The Presentation of Self in Everyday Life*, Goffman explains that we most successfully perform our social lives on "front stages" engineered for the purpose of impressing others. We tidy up our houses before important guests arrive; join exclusive social clubs that feature sitting rooms adorned with exquisite furnishings; and rent out pricey hotel ballrooms for weddings and anniversary parties. The physical settings of our daily theatrical performances operate like stage sets, and they work best when we have a degree of control over them.[4]

In his 1940 exposé *The Big Con*, David W. Maurer describes the most important stage set used by the successful confidence artist, "the big store." The big store is a room or set of interior spaces designed to look like a place of business, gambling casino, bank, or any other space required by the con. In a classic confidence game called "the wire" (memorialized in George Roy Hill's 1973 film *The Sting*), hustlers rent out a room and redesign its interior as an underground off-track betting parlor where victims are lured by ropers who convince them to wager large sums on sure things that inevitably go sour at the last minute. While suckers often discover that the roper is a con artist, they rarely catch on that the betting parlor *itself* is fake and that the con lies in the manipulation of their immediate surroundings as much as their greedy desires.[5]

Many of Philadelphia's most glamorous restaurants, particularly those that make up Stephen Starr's entertainment empire, have been designed as big stores—elaborate stage sets that hide the onerous backbreaking work performed nightly by his kitchen cooks, the psychological hazing experienced by his service teams, and the controlling managerial arms of his hyper-bureaucratic organization. Morimoto, the crown jewel of Starr's empire, features a cavernous dining room that beckons all comers like an ethereal banquet hall, a palace of dreams. Named for its executive chef and part-owner Masaharu

Morimoto—better known as one of the culinary stars of cable television's *Iron Chef*—the most renowned Japanese restaurant in Philadelphia is bathed in light, from its 3-D lenticular hologram that greets patrons at the door to the sprightly lit dining booths that turn various shades of Technicolor neon as the evening progresses. Conceived by industrial designer Karim Rashid, the interior decor features a rolling ceiling of compressed bamboo rods: a larger-than-life-size sushi mat built from seventy tons of wood.[6]

Like Morimoto, many of Stephen Starr's stylized restaurants are theatrical spectacles of global cosmopolitanism and myth. Across town at Pod, Starr's space-age, pan-Asian hideaway on the University of Pennsylvania campus, the cinematic interior evokes the futuristic chill of Stanley Kubrick's *2001: A Space Odyssey* and *A Clockwork Orange*. Mechanized conveyor belts transport maki and spring rolls around the bar while customers—or as Starr calls them, his "audiences"—fiddle with the florescent lights in their groovy booths that recall the Orgasmatron from Woody Allen's *Sleeper*.[7]

Other local restaurateurs have followed in Starr's footsteps. If Pod makes the diner feel enveloped by a Tokyo sci-fi dreamworld, then Cuba Libre simulates the sultry paradise of 1950s Havana and its beach resorts and sidewalk cafés—or at least the Havana longingly conjured up in nostalgic films such as *The Godfather: Part II* and *Before Night Falls*. The dining mezzanine is designed as a tiled rooftop garden overlooking a faux outdoor streetscape, replete with hanging flora, stained-glass windows, iron railings, and terra-cotta balconies. According to Danny Lake, a local publicist for various nightspots around Philadelphia, the cinematic metaphor is more than fitting to describe Cuba Libre. Its fabricated interior was constructed by a movie set designer and inspired by stock images of Cuba culled from the Internet. From the comfortable couches of the Rittenhouse Hotel's luxurious lobby, Lake explains:

> Cuba Libre decided to build their brand to look like buildings in Cuba, to look old. And, you know, we had really serious issues. . . . Do we want to disclose how we made this brand look

aged when it was brand-new? Because we used some interesting building materials: *Styrofoam*. The destination's built by a guy who owns a company called Dynamic Imagineering, and he builds movie sets. And it looks like a movie set (especially if you go back in, and now that I have told you that, you can see how it does), or like, I hate to use this word, but maybe like something you'd see in Disney—the street scene, the images, the crumbling planters, and the lush palms. . . . We went to salvage yards to find the wrought-iron gates that we had used for both the railings and the part of the decor. And we did it this way because our research primarily on the Internet showed us images that looked just like this.[8]

For decades the Disney Corporation has been both praised and vilified by media professionals and critics as a model for how successful entertainment firms conduct business in the new cultural economy: the synergy generated by merging diverse production companies and distribution outlets; the personalization of mass-marketed service and global retail industries through the emotional labor of fully costumed employees; an insistence on sanitized, orderly, and heavily policed "family-friendly" downtown and exurban spaces; and perhaps most apparent, an emphasis on simulated pleasures that rely on artificially produced entertainment landscapes that prioritize virtual realities over seemingly authentic experiences. While the Disneyfication of urban downtowns has characterized the development of themed restaurant chains such as the Rainforest Cafe, Planet Hollywood, and ESPN Zone (itself a Disney-owned franchise), the high-concept interior design of more exclusive restaurant and nightclub spaces like Morimoto and Cuba Libre are similarly shaped by the aesthetic values of theatrics and the cinema.[9]

While Cuba Libre attempts to pass itself off as the real thing, or at least a close facsimile, Stephen Starr's Barclay Prime provides a fitting example of how postmodern nightlife design can also work to creatively subvert popular expectations of authenticity—global, local, or otherwise. Created by Parisian designer India Mahdavi,

Barclay Prime's colorful interior pays homage to Old Philadelphia through its mahogany walls, marbled tabletops, and deep library bookshelves displaying worn but barely read volumes on art and theater, while simultaneously channeling the city's renewed hip aesthetic as inscribed in the dining room's lime-green leather couches and whimsical chrome and chartreuse fixtures. (*Philadelphia Inquirer* food critic Craig LaBan refers to the restaurant as a "sexy revamp of the staid chophouse genre.") The playful decor is reflected in the restaurant's menu, which features, in addition to its predictably dignified dishes (twenty-one-day aged rib eye, oysters Rockefeller), a $100 Philly cheesesteak prepared with Kobe beef, meaty lobster, shaved truffles, heirloom tomatoes, caramelized onions, melted taleggio cheese, and more than a pinch of irony.[10]

Even the restrooms in Philadelphia's restaurants serve as gimmicky set pieces designed to attract publicity as well as enliven the dining experience. According to Blake, a manager at Barclay Prime, the restaurant's unisex bathroom was created largely to provoke gossip: "People talk about it—whether it is positive or negative, they talk about it. . . . So you put in a unisex bathroom, and yeah, people say, 'You shouldn't have that,' but hey, they're talking about it. . . . They're like, 'Are you kidding me, they're unisex? We've gotta go check this out.'"[11] At Continental Mid-Town, the restrooms feature two-way mirrors that allow passersby to scrutinize unsuspecting patrons on display. "Damn, he must be on a hot date," remarks a young lady on a January evening as a gentleman preens in the mirror, inspecting his rear end. "I wonder if he realizes that we can see him. Are all men like this? . . . I sure hope not."

"Oh my god, look at her," her friend shrieks as she points to the women's room, where a blond woman adjusts her bra through her silk tank top in the mirror. "I feel like this isn't right; you shouldn't be able to watch people in the bathroom. But I'm not going to lie—I could stand here all day."[12] At Paradigm, a martini bar and restaurant, three unisex restrooms feature crystal-clear glass doors that fog over when locked, creating a "magically" opaque screen—a stunt that more than overshadows the schizophrenic menu offerings of

beef satay and duck spring rolls, fried calamari and pasta bolognese, Australian lamb chops and grilled ostrich fillet.

Barclay Prime, Continental Mid-Town, Paradigm, and many other downtown restaurants are specifically designed to look like sleek nightclub lounges with enough color-filtered fluorescent flash and retro swank to attract a young, sexually attractive clientele and encourage excessive spending on alcohol. According to Madison, a former server at Alma de Cuba, another Cuban fusion hot spot in Philadelphia:

> Dark and sexy, that was always kind of the draw of the place. . . . You felt like you were in a club, in a cool place, even though you were going out to eat. . . . Very dim lighting, which is really difficult if you have bad eyesight, so it really attracted people who were trying to be hip, people like, "Oh, we are in this hip great place," you know, it's the place to be if you are not going to a nightclub.

Among dominant design elements, complicated lighting schemes make up perhaps the most significant decor component of urban nightlife establishments. According to Jason, a photographer and filmmaker who has worked on lighting effects for a variety of reality TV programs in addition to bartending and waiting tables in Philadelphia nightspots since 1988, nightlife venues employ minimal lighting to create shadow and aura rather than bright illumination. In many local nightclubs, glowing light emits from underneath or within the bar fixtures themselves, rather than cast from directly overhead. Jason observes that at Tangerine, one of his former bartending posts, "the actual bar top glows."

> First off, the most important thing is the lighting. It is dark; it is intentionally dark and, again, it glows from the inside; it is as if there was no source of light. . . . You can't see by it—it is just a visual pattern that you get, and that's what pretty much every place does with the lighting. You are not supposed to see by the

lighting, but it adds flourishes or highlights some architectural feature.

The lighting arrangements of bar and lounge areas additionally emphasize the blinding neon colors of rainbow-saturated cocktails, devilish potions whose visual appeal adds an additional design element. At Continental, barhoppers swig from wide-mouthed glasses aglow with fruity concoctions like the Buzz Aldrin, a designer martini of orange drink, peach vodka, and triple sec in a bright Tang-rimmed glass; the Artic Melon Martini with Midori melon liqueur and a splash of lime juice; and the Champagne-A-Rama, a blend of bubbly and raspberry vodka in a grenadine-and-sugar-rimmed glass. Against the bar's smooth white backdrop, strategically placed lights illuminate these cocktails bursting with translucent brightness and brilliance.

On the other hand, the muted lighting of local nightclubs and restaurants also hides the weaknesses inherent in aesthetically pleasing designs featuring low-grade materials such as Styrofoam. As Jason explains during an afternoon interview, "The bars, when you see them with the lights on, they are nothing special. You are seeing behind the curtain at that point, because nobody is spending a lot of money on real quality construction on anything."

"Like a movie set?" I ask.

"It's *exactly* like a movie set; so when you dim the lights, you are also hiding some of the flaws." According to Jason, flimsy construction materials are not the only imperfections that remain hidden in the dimmed glow of dance clubs and cocktail lounges:

> Well, you are hiding the flaws. That's why you don't do direct lighting in the first place. You don't want to show off flaws in the location or the people who are there. So bars are dark. You get an impression of someone; you don't get an actual look at someone. That's why anybody who has been at a bar when they turn the lights on has seen that it is not as pretty as it was ten minutes ago. . . . You do it for effect.

Coco Henson Scales, a former hostess at Hue, a now-defunct Vietnamese restaurant and lounge in Manhattan's West Village, admits just as much: "If people are unattractive, I must seat them in corners or turn down the lights so as not to draw attention to them."[13]

Of course, the so-called "flaws" of an unattractive clientele pale in comparison to the unsanitary conditions hidden behind the facades of Philadelphia's hottest restaurants and nightclubs. As a rule, restaurants try to keep the messy work of food preparation out of their patrons' line of sight, and even dining establishments with exhibition-style kitchens keep their dry-goods closets, staff locker rooms, roach spray, and mousetraps out of view—and much more, as it turns out. According to the Philadelphia Department of Health, in 2004 local restaurants and nightclubs that received health code violations included Alma de Cuba (fly infestation), Bleu Martini (mouse infestation and feces contamination), Pod (uncovered/unprotected food in walk-in refrigerators), and Continental (fly infestation, contaminated ice, excessive mold, and inadequate frequency of employee hand-washing).[14]

URBAN NIGHTLIFE AS THEATER

In much of his work, Goffman employs a dramaturgical approach to explain norms of social intercourse, arguing that all interpersonal encounters represent elaborate theatrical performances, each of us playing a wide variety of roles in our conversations and provocations with family, friends, coworkers, and strangers. Cultural producers of urban nightlife also rely on the metaphor of the theater to describe how they engineer sensory, impressionable experiences for their guests. According to Blake, the manager from Barclay Prime:

> We [my fellow managers] are the directors, and the stage for Barclay Prime is a ninety-six-seat restaurant. . . . You know, the ambience is set, the mood is set, the food comes out, the wine comes out. . . . As part of the management staff you can go to one corner and feel the energy of the whole room, the same way

that you can feel the energy of the play that's about to go on, and the curtains are just about to be raised. And you feel that liveliness; you feel that intensity; you feel the nervousness in the bottoms of people's stomachs. That's exactly what happens every day here at five o'clock.

Five o'clock is not the dinner hour at Barclay Prime, but the time of the regularly scheduled preshift meeting between management and service staff. Blake explains the similarities between the preshift preparatory meeting and its counterpart in the theater held just before showtime:

I've brought up many times in preshifts that you look at a restaurant and its dining room as a stage. You look at its kitchen as the back of the house, you know. And as soon as you come through those doors, it's your curtain. You are a totally different person, you know; you go into character . . . that's your play for the night. The people are your audience; you can make them laugh, you can make them cry, you can make them have a memorable experience, but you are a professional actor and you have to be comfortable in front of people onstage and giving a spiel, because that's exactly what you are. And it's our job as managers to write the screenplay, produce it, be the photographers, be everything else, and just let the people do their thing onstage. And then every single day the preshift is like your pre- or postshift [in the theater]: you review last night's play, what could have been better. Maybe this line could be tweaked; maybe you didn't catch the attention of left-center. That's where you need to fine-tune things, and that's what we do in preshifts, and that's what we do as managers.[15]

Blake invites me to sit in on one of these preparatory sessions, and, sure enough, the meeting is run more like an actor's studio than a staff meeting. Actually, the one I attend begins more like a crash course in French Wine Snobbery for Dummies, or at least how to per-

form the role of the pseudo-sommelier for unwitting guests. Every Saturday night Blake begins the preshift meeting with a half-hour lesson in wine for all the servers. Since beverages make up about 40 percent of the restaurant's total revenue, with the majority from marked-up wine, servers are encouraged to showcase their so-called "expertise" to their guests in the hopes of persuading them to order an expensive bottle.[16]

On this particular night, Blake pushes the sale of half-bottles for those patrons too shy to commit to a full-size bottle and who therefore tend to order wine by the glass. He instructs his troops, "Our goal here is to get a beverage into every single hand that is in here and at least a bottle of wine onto every table." These lessons in shilling beverages emerge during the preshift meetings at other Starr restaurants as well. According to Jonas, a busboy at Continental Mid-Town, "We'd have a preshift meeting before the customers came in for dinner. And you'd talk about the goals for the night. And sometimes they'd say, like, 'Okay, the goal for the night is we have this new champagne in a can, and whoever sells the most tonight will get a case of it.' They are giving you incentives to sell more . . . so you are not actually being that honest." Allison, the cocktail waitress and hostess at Tangerine, agrees: "Sometimes our beverage manager will have a specialty cocktail that he has made up that we upsell, that we verbally specify as we would a meal. And whoever sells the most gets a bottle of wine or something like that—a freebie, some incentive for us. So there is stuff like that, and it is also a feather in your cap. If you are the top seller, you can take off for Christmas. You can get these great days off that everyone else is trying to get."

Back at Barclay Prime, Blake passes out handouts with maps of France's Bordeaux region. His goal is to teach his staff just enough about wine that they will be able to convince customers to trust the house recommendations regarding an expensive bottle. Blake begins his French geography lesson to his note-taking troops.

"On your first page, take a look at the country of France. You'll see areas where, in the top left-hand corner, it almost looks like a salamander or an amoeba, it's a long shaded area. That's the Loire

Valley, really known for Sancerre and Vouvray. If you go down just beneath it, you will see a medium gray—that's Bordeaux. Bordeaux is, I am sure everyone's heard the word before, that's almost the origination of wine. That's where your first roast, your second roast, your Lafites, your Margaux, that's where they come from. And if you go to your second page, you'll see Bordeaux as a region broken down into subappellations. And I know it's a lot of wording in there. There are really only five or six areas that I want you to know. . . . So this is a brief overview of Bordeaux, but again the main things that I want you to come away from this are (a) you know where France is, and (b) within France you know where the wine regions are, and we are strictly talking about Bordeaux.

"So it's on the left-hand side of the country, right in the middle on the coast. Within Bordeaux you have a river that splits it. On the Right Bank you really need to know Saint Emilion and Pomerol, and on the Left Bank you need to know things like Margaux and Pauillac and Haut-Medoc and Saint Estephe. Those are predominantly Cab, and as we add wine we will go into Entre-Deux-Mers and Sauterne and things like that. But those are the questions that you will get, you know, when people come to you and say, 'I am looking for a Bordeaux; what can you tell me about this?' Well, in the wine list where it has broken out into Pomerol, you can say, 'Well, okay, that is predominantly Merlot because it's Right Bank, so it is going to be a little bit softer than if you are going to go to the Pauillac region, and it's going to be a little bit more robust because that's predominately a Cab. . . .' I am telling you—if you understand that concept, you know more than 75 to 80 percent of the people who come in here, and you are already presenting yourself like you know what you are talking about—*and they are going to take any recommendation that you give them.*"

Like successful police detectives who pretend to know more about the facts of their investigation than the unwitting suspects they trick into confessing during interrogation proceedings, table servers learn the importance of appearing more knowledgeable than their customers as a means of gaining their confidence, so they might acquiesce to their recommendations without complaint.[17] To this end, Blake

coaches his team on how to handle a customer who turns down a bottle of wine upon tasting it.

"When you are at a table and you smell the wine, and someone says, 'Um, this is a little iffy,' and people have said that to me before—'What do you think about this?' Well, a certain percentage of time, yes, it is actually corked because they say 3 to 8 percent of all wines in bottles are bad because of the cork closure. But the other percentage of wine, people say, 'I just think it's weird.' It's just, they are not ready for it, or it hasn't opened up. But it's still a perfectly fine wine, so you should be able to repour the wine to a guest. . . . Still, if you think it's good, you never go back to the guests and say, 'Actually, folks, that's really good, you don't know what you are talking about, I'll come back later.'

"What do you *want* to say? You need to reconfigure your words, and you want to say, 'You know, folks, this type of wine, it might need a little bit of time in order to not only raise the temperature but soften. I can decant it, or what I would love to do is give it a few moments; I'll be back with the table; we'll revisit it if you are still unhappy with it; we can see if you'd like to go in a different direction or we can approach it at that time.' Nine times out of ten, you come back in five to ten minutes, and they've had a couple of glasses—they are in the mood of the night. They are like, 'This is perfect. This is fine.' You sidestepped either recouping another bottle [to the guest], or an opportunity where the guest says, 'This sucks.' . . . Even if it's corked, you *never* tell anyone, 'You shouldn't drink this.'"

Eventually, this cribbing session paves the way for the Actors Studio portion of the preparatory meeting, led by Colin, the general manager, and his associate Bianca, who introduces the session on performance. She begins, "I just want to talk a little bit about our opening spiel. I was hoping maybe some of you guys could volunteer to give us your spiel as if we were guests at a table. I think it might be kind of a fun thing to do, but more importantly, in terms of trying to keep things fresh and trying to not get into the monotony of every day, listening to each other's spiels might help a little bit. Does anybody feel like giving their spiel?"

"I think the situation is different at every single table, that's me. My spiel is usually not the same," protests Robert, one of the male servers.

Colin agrees. "It *should* be different. . . . Like literally, two tables that have never been in this restaurant before, sitting next to each other? Your spiel should *not* be the same for those two tables. It's redundant and it's less genuine. Specifically, it's why we didn't script this for you." As Edwin H. Sutherland's profiled con artist confirms in *The Professional Thief,* "Not many suckers could be beaten if every mob approached every sucker in the same stereotyped manner."[18]

Colin continues, "It's up to each of you to let your personality show through and have fun, read your table, see what they're looking for, and tailor it for that reason." He then solicits a volunteer to provide an example for their fellow servers, but there are no takers. "No one's going to do it? I'll pick somebody. . . . Peyton's doing it."

Bianca prepares her role as the patron, "Do you want me to sit here?" as Peyton explains his style to his fellow cast members. "Basically, like he said, everybody reads the table as they go. Everybody requires a different level of knowledge. Some people, I'll give them two sentences and they'll glaze over, because they know what they want, and the more I talk the more annoyed they become. So I'll go on as long as they want; I'll become their best friend, too, if they'll let me."

In this manner, high-end dining service is surprising similar to lap dancing, insofar as both require the worker to quickly yet accurately predict what kind of experience their client desires, and immediately respond in an appropriate manner. According to sociologist Lisa Pasko's analysis of exotic dancing as a confidence game, "Strippers quickly decide which role will furnish them the greatest tips—to be a sex object, devoid of facial expression or emotion, or to be the intimate partner. The stripper reads the behavior of the customer and acts accordingly."[19]

Colin agrees. "Just the one thing that you always want to remember when you are going through your spiel is that not everybody wants caviar; not everybody wants the most expensive bottle of wine. You can't shoot for the stars on every table. You have to read your table, accept what they need, and then adjust to them, and that's really what

you are looking for. Believe me, you guys all know that I served for a long time. You should know within probably fifteen seconds what type of experience people are looking for."

Joshua, a server pipes in, "My guest last night, she got a Porsche for her birthday, so I showed no mercy," to laughter from the cast. "For appetizers—lobsters. No mercy."

"They are going to give you clues, and they are going to give you body language and facial expressions," continues Colin. "Is there anything unique that anybody does in their spiel?"

Peyton continues, "You know what? I increase my sales in side dishes by highlighting that they are shareable. The complements are actually smaller portions of the actual whole items on the menu, so if you are not in the mood for a huge dinner that is another alternate way to go." On most restaurant menus, vegetable side dishes and salads represent high-profit items due to the considerable difference between the minimal wholesale price of their simple ingredients and their relatively steep markup value. According to the kitchen staff at Barclay Prime, other high-profit items in the dining industry include chicken dishes; day fish sold profitably at fluctuating "market prices"; evening specials (typically prepared with older cuts of meat and fish at an inflated cost); and desserts commonly made from inexpensive ingredients such as eggs, butter, flour, and sugar.[20]

"The important thing to remember is that hospitality is sales— that's what you are doing," Colin concludes. "You are not a restaurant order taker; we are tailoring people's experiences. Each person, you could possibly have four people at the same table who are looking for a different experience. You are supposed to react to that, and make it happen. And it's absolutely doable, and when you do it, you'll know right away. That's another thing you'll be able to read: when people are really, really blown away."

THE SCRIPTED IMPROVISATION OF PERFORMANCE

According to criminologist Richard A. Leo, the confidence artist must "be a skillful actor, one who is capable of shifting roles easily,

mustering impromptu performances from the slightest cues, and creating the appearance of unmistakable integrity."[21] While it has become a cliché that aspiring actors, models, musicians, and artists wait tables while preparing for their big break, the relationship cuts both ways, since creative personnel must often rely on their performing abilities and sense of style when serving food and beverages to high-paying customers. As John Nielsen reports in the *New York Times*, restaurant hiring in New York and Los Angeles has come to resemble casting calls for Broadway productions and feature films. "Cattle calls are now the rule, not the exception, while glossies— promotional photographs—are increasingly required. In the Universal Sheraton ballroom, for example, applicants were photographed, quizzed, interviewed, reinterviewed, divided by age and sex and then told to wait."[22]

Blake agrees that job interviewers take acting and performing skills into account during the hiring process because of the close similarity between fine dining and the theater: "Absolutely, because then you have a comfort level of being in front of people." Jason agrees: "You are acting. . . . If you are a server, you are acting; you are going up to a table and putting on a performance. You have a captive audience of six people or whatever, and they have all eyes on you. So, you are onstage—your environment is the stage." As masterful dramatic displays, these performances represent a stiff departure from the emotional reality experienced by nightlife workers, even as they appear charmingly authentic. As Jason asserts, during their role-playing servers and bartenders are "totally different, totally different. It's like saying Ben Affleck is his role. He's not; he's Ben. . . . You can't judge his personality from the roles that he has."[23]

But while most industry personnel agree that performance skills represent a set of core competencies essential for success in nightlife service positions, actual aspiring actors sometimes deemphasize the relevance of their stage training and experience for fear of devaluing their hard-earned expertise. Madison, a thirty-one-year-old former server at Alma de Cuba, holds a graduate degree in theater from Villanova University and in the last few years has accumulated a number

of off-off-Broadway acting credits. Like many struggling actresses, Madison also waits tables at an expensive Manhattan restaurant. However, while she identifies many of her workplace challenges as performance-related, she downplays her professional dramatic abilities as a necessary skill set for waiting tables:

> In the service industry, no matter what way you are serving the public, you really do need to act because problems arise, challenges arise, frustrations arise, and the more that shows on your face in front of the guests, the more the atmosphere is completely changed. So it's always a challenge. But people say, "Oh you are an actress, you can deal with that," and I think that's silly, I think anybody can hide their emotions . . . it's a skill that anybody can do.

Given Madison's efforts at building an acting career, perhaps it is not surprising that she distances her thespian aspirations from the working-class job that currently pays her bills, even if her theatrical training probably does help her generate more tips than she would otherwise procure. As she admits, "Now I wish I were to the point where my income was based on acting pursuits. . . . I am trying to work just part-time in the restaurant so that I have enough time to be auditioning and taking classes. . . . So, that's what I am doing right now, and just barely making ends meet in order to have that open time slot."

Others argue that this kind of role-playing is simply less of a stretch for young creative workers channeled into urban nightlife positions based on personal traits such as an exaggerated personality and wild fashion style. As Jason points out, "I am pretty outgoing in the first place, so it's not a huge stretch for me. It's just me being more *me*." In the attempt to generate a lively cast of characters to entertain their guests, restaurants and nightclubs frequently hire hip personnel like Jason who can draw on their stylistic peculiarity and nocturnal capital as a resource for performing the drama of urban nightlife.[24] According to Jason, Tangerine hires its employees on the basis of their nonconformist sensibility.

I was thirty-ish when I was working there. But I still have a little bit of a rock-and-roll edge to how I look. . . . It's people who work at the way they look—they have a look, they have a style, they are distinctive looking. Again, pulling into the theater, it's a character that you are playing, and people who work in restaurants usually play that. Sort of like how hairdressers look like hairdressers—you can tell a hairdresser when they walk down the street. You can tell restaurant people.

According to Jason, the shocking allure of subcultural style allows urban service personnel to differentiate themselves from one another in an otherwise regimented fashion context of dark pants, white oxfords, and compulsory ties: "It's a visual impression, so it's leaving something distinctive through clothes, hair, attitude, jewelry, just your style. And it's funny, because you are in uniform. So that's why hair and makeup looks are so important, because you are all generically wearing the same thing when you are in a restaurant."[25]

Still, the nature of service work always requires that employees negotiate the ever-present boundaries between their front and backstage personalities. As Jason remarks, "I can't necessarily say everything that's popping into my head. . . . I will keep the negative stuff out. . . . Like I could be pissed off at the bar back for not getting me beer, but that's not going to come out onstage—that's behind the stage." Caitlin, a former server at Morimoto and Barclay Prime, shares Jason's experience: "There was definitely a performance aspect to it. The worst is people that tell really dumb jokes and you have to laugh. You have to—you as a waiter can't even pretend that their joke wasn't funny. You have to tap-dance for it, and you do . . . and then you go in the back and you are like, '*I hate you, I hate myself, I hate you—I hate this business. Does anybody have any wine?*'" But while Caitlin experienced restaurant service as soul-crushing, more seasoned servers are even more cynical, or at least more resigned to the emotive requirements of the job. According to Misty, a thirty-eight-year-old former server at Le Bec-Fin and Susanna Foo Chinese Cuisine, two of Philadelphia's most elegant, high-priced restaurants, "You don't *have* a soul! They tell you not to have one."

In her comparative study of fast-food service workers and insurance salespeople, sociologist Robin Leidner compares differences in the regimentation of roles and face work expected of employees in their interactions with customers. McDonald's trains its cashiers to take orders according to systematized protocols of interaction, while insurance firms expect their salesmen to work off an improvised script, providing a warmer, emotional touch commensurate with their individual personalities. Service-providing institutions maintain this distinction largely on the basis of class-based expectations of customers and the differentiated levels of trust imparted to low- and high-wage employees by management.[26] However, high-end nightlife scenes blur these distinctions. Unlike fast-food burger joints, expensive restaurants often employ overeducated workers with advanced degrees who share many of the same class-based dispositions, communicative skills, and other cultural competencies as their customers. Moreover, patrons of high-concept nightlife venues take pleasure in what they interpret to be the authenticity of their encounters with service staff, particularly when they are of a desirably intimate or sexualized nature.[27] Therefore, seemingly naturalistic interactions with staff personnel would seem to greatly contribute to the customer's experience.

Then again, since servers and bartenders contribute to the overall atmosphere of nightlife establishments, management has an interest in maintaining tight control over their performances. Managers often direct service personnel to follow contradictory sets of performance strategies in their interactions with customers for this reason. On the one hand, to a large extent these performances are explicitly scripted. At Barclay Prime, although servers' uniforms do not include demeaning name tags, smiley-faced buttons, and assorted "flair" commonly associated with family-friendly restaurants like T.G.I. Friday's, they are obligatory all the same: dark brown pants, polished brown shoes, white button-down dress shirt, a dark brown vest with a Barclay Prime emblem, and a green tie.[28] The staff at Alma de Cuba wears a similarly formal costume of white suit jacket and black tie. According to Madison, "Apparently the idea was to mimic the old look in Cuba."

Many Starr employees find the restaurant's stringent dress requirements demeaning. "I felt like our role was more one of servitude," says Madison. "We, as women, really didn't like the uniforms. . . . I don't like anything on my neck, so I just didn't like the tie. I didn't like feeling like a non-entity, you know? I like being myself; I like being able to include more of my personality in my interactions with the customers. So I think that this kind of straight, white, constricting uniform . . . was just really keeping us in our roles as servants."

Madison complains that Alma de Cuba's dress code denied her adequate personal control over her performance, while Allison registers a similar grievance regarding the mandatory uniform worn at Tangerine:

We have tight, black, long-sleeved crewneck shirts. . . . You wear your own black skirt. It has to be a skirt, no pants. And your own black tights; they can be opaque or they can be patterned. . . . I have kind of experimented around with the skirt and the tights and stuff. At first, I just wore the short skirt like everyone else did, and opaque tights, and that was fine. In the lounge at Tangerine, the tables are really low, like, less than two feet off the ground. And it gets really busy, like standing-room only almost, and you have to fight to get through the crowds with your tray of these martini glasses. I mean, you don't want to spill all over everybody, so what you have to do is either bend over and wear shorts underneath your skirt or just squat like a catcher, put your drinks down, and then pick them back up. . . .

One of my biggest issues is having to squat down and serve someone, and there are some people that really eat it up. Like they just know you are serving them and they are in love with it. . . . So at first I started with the short skirt, and then I didn't like the way that people would look at me and watch. . . . I would see guys leering . . . or guys would, you know . . . you see people looking at you and talking. And guys would try and talk to me. . . . They

were always asking if I had a boyfriend, and then you are trying to remain professional and keep walking. . . . I switched to a skirt that went below my knees, and I made a lot less money.[29]

As Allison's experience makes clear, worker-unfriendly dress codes often place heavy burdens on female service personnel by pigeonholing them into sexualized roles that invite ogling and unwanted attention from boorish men. (Alas, there are no *male* cocktail waitresses.)

In addition to regulating attire, Tangerine, Alma de Cuba, and other Stephen Starr restaurants dictate specific employee guidelines on hygiene, grooming, and bodily adornment. According to the staff handbooks issued by the management wing of the Starr Restaurant Organization (SRO):

- Nails must be neat and trim at all times with clear or neutral polish only.
- Tattoos may not be visible.
- Use no perfumes or scents other than simple deodorant/antiperspirant.
- Hair, mustaches, and goatees must be neat and trim at all times and you may not grow facial hair on company time. If you are not clean-shaven, you will have to do so before we open for service in order to work, or you will be sent home.
- Radical hairstyles and colors may not be permitted.
- Jewelry, with the exception of small rings and watches, may not be worn unless it is part of the uniform.
- Piercings, other than ear (small hoop or stud), are strictly prohibited.

Organized by section in dense three-ring loose-leaf binders, SRO staff handbooks cover all aspects of the server's job, from arcane beverage terminology to procedures for pouring libations ("Beer should be poured along the side of the glass until about halfway full. Pour the rest of the bottle straight down in order to create a one-inch head")

to reminders to cocktail servers to "never pass up an opportunity to 'upsell.'" These guidelines include additional scripts for interacting with customers. According to the Alma de Cuba handbook:

> Smile and greet guests whenever you see them in the restaurant. If you know a regular customer, go out of your way to say, "Hello," or simply smile and acknowledge them. When a credit card is used for payment, check the name and use it in thanking them. People enjoy being recognized.[30]

According to a busboy at Continental Mid-Town, "You learn how to interact with the customers. They give you a rule—I think it is called the *Two-Foot Rule*, where you have to smile at somebody if they are within your little perimeter." The Barclay Prime handbook defines the Two-Foot Rule as follows: "Acknowledge all guests with eye contact and possibly a subtle greeting of the time of day such as 'Good Morning,' 'Good Afternoon,' 'Good Evening.' Practice this rule whenever guests are within two feet of you." Madison elaborates: "Absolutely, I remember specifically Stephen giving that instruction, of course, always yielding to the guest when you are going through the dining room if a guest is coming by. Even if you have hot food in your hands, just step to the side and let the guest go."

In its guidelines on scripted procedures in customer interactions, the staff handbook used by Barclay Prime instructs servers, "Smile easy and often. Smiling is a very big part of our business. Be ready with that smile at all times. Smile whenever you make eye contact." "Do not discuss money or tips during service or in front of the kitchen." Workers are reminded to "avoid the word 'I'—use words like 'Our,' 'We,' and 'Us,'" and to offer guests a "genuine" farewell upon their departure. In this same spirit, the handbook for Morimoto employees includes a section on "Our Vocabulary":

> In a restaurant setting, you can be sure of one thing: you never know who is in front of you. Do not be presumptuous or draw conclusions about guests based on the way they are groomed or

their behavior. This person could be a food critic for the *Philadelphia Inquirer*, a major meeting planner, or someone who will offer you a part in their next movie. You never really know. This is why we feel that your vocabulary is very important.

VOCABULARY YOU DON'T USE

- "No," or "You Can't."
- "How is everything?"
- "Are you still working on that?" or "Are you finished yet?"
- "Do you want your change?" or "Should I bring you your change?"
- "I don't know."
- "I don't like that menu item."
- Negative gossip about guests or coworkers.

VOCABULARY YOU DO USE

- "Certainly" or "It's my pleasure."
- "Is everything to your liking?" or "May I bring you anything else?"
- "May I clear that away for you?"
- "I'll be right back with your change."
- "Please allow me to find out for you."
- "I hope you enjoyed your evening. We look forward to seeing you again soon."

Focus on keeping your vocabulary positive and upbeat at all times.

By reminding workers that they "never really know" the potential importance of the customers they serve, waiters are always on guard, prepared to inhabit their approved script as a second skin. In fact, managers routinely give staff members at Morimoto quizzes on directives from their employee manual, just as many Philadelphia restaurants employ teams of "secret shoppers" who spy on their servers while pretending to be normal customers. According to Caitlin:

They hired this firm. . . . They pay them to come in and they pretend that they are regular customers and they grade everything: what the door looks like; are there fingerprints on the door; how the hostess greeted them; if they asked for them to check their coats. Did they want to sit at the bar? How did the bartender act? What kind of drinks? What was the drink like? Was it over-poured or under-poured? I mean, the reports that they give are *this big* [gestures with hands to indicate enormity of size], and they are all graded like a term paper. You get like an A or a 91 percent on this or that or the other thing. They have the lapel recorder; they tape everything. . . . They have to write down the times of everything, from how long it took you to get to the table and greet them, to how long it took for their food to get to the table. . . . They're offensive. Nobody likes them. It's like 1984, you know?

Like a panoptic prison in which all cells surround a central security tower that may or may not be occupied at any given time by an unseen watchman, secret shoppers achieve total social control through fear by maintaining a constant state of *potential* surveillance, even in its absence.[31] The Alma de Cuba staff manual even specifies how employees should address potential customers on the telephone:

You are Starr Restaurant Organization when you answer the telephone in one of our restaurants. We are judged by how you sound, your warmth and professionalism over the phone. For many of our guests, their first impression of our restaurants will be formed by the interaction you have with them on the telephone. Our goal when using the telephone is to create a memorable guest experience. Our telephone etiquette is another way in which our style of service sets us apart from the competition:

- Upbeat, enthusiastic voice. "Smile through the telephone."
- Answer the telephone with the appropriate greeting of the day.
- Warm, Engaging and Sincere voice.

- Regardless of activity around you, maintain a calm tone.
- End the conversation with phrases such as "It's my pleasure!" "Absolutely," "Certainly." This promotes an upbeat and positive feeling.

In addition to these explicit guidelines for interacting with guests, managers paradoxically want their employees to come off as natural performers by engaging the client in improvisational, free-spirited conversation rooted in their own sense of style and selfhood, but only to a point. Staff are given some flexibility to develop their own scripts, but are still required to fulfill an implicit set of behavioral expectations as defined by the establishment: always upbeat, forever obedient—like a Stepford wife, only with personality. Blake's criteria for a dutiful server insists upon an obligatory cheerfulness that can never come off as forced:

> You always want to encourage camaraderie or a relationship with the guest, wherever he might be. Whether it's as soon as you walk in the front door and it's the hostess, whether then they make their way over to the bar and it's the bartender, wherever you are. Again, you are onstage and every single one of the staff is instructed to be as friendly, as lively, as jovial as possible, and talk about anything. Again, that goes back to the comfort level—you know it's not a room full of robots. Staff-wise, you want them to know the guests by their first name and last name, and you know that's what's going to entice them to come back.

Misty expresses this idea of "encouraged camaraderie" somewhat more bluntly: "It's almost like a whorehouse. We all know what we're doing, and everybody's got to play their part. . . . I mean, that's it—it's a whorehouse. Every restaurant, every whore or whatever is someone you're paying to feel a way. . . . You're paying to distort your senses for a brief period of time. You're paying for a rush; you're paying for some kind of thrill."

Perhaps not surprisingly, the expectations of service personnel are almost inevitably prefigured within rather commonplace ideals of beauty and sexual magnetism, particularly among women workers. According to Jason:

> The hiring is sort of . . . it's a cattle call. It's the same as auditioning for a movie role: how you look, how you handle yourself, how you dress. All is taken into consideration, and Starr hires on the basis of who is going to make him money. So if you have a personality that is going to make him money, you are hired. . . . I mean, as far as *guys* go. With *women*, as long as you are hot, that's the only requirement.
>
> What any twenty-two-year-old guy wants is to go out and see hot women, in very little clothing. . . . At Delilah's [a local gentlemen's club], you know how little they are going to be wearing and you pay for it, whereas if you go out to a club, you are going to see equally attractive girls wearing almost as little, and it's a whole lot cheaper. . . . Hence, hiring really attractive female bartenders—that'll get guys in the door.

According to Allison, at Tangerine hostess applicants are often immediately flagged by the staff on the basis of their attractiveness and on-the-spot demeanor. "As a hired hostess, if someone fills out an application, we are permitted to write 'NRL' on the top—*Not Right Look*," she reveals. "They have to have the right look, everything from what you wear when you walk in to how you approach. Your confidence; if you are sweet; if you are nice." Tommy—a former staffer at 32 Degrees, a luxurious lounge in Old City—reiterates the advantages of hiring attractive women for service positions in urban nightclubs, and his remarks help illustrate how men perceive female employees within an aggressively sexualized industry:

Very rarely have I sat down in an establishment and felt like I was being totally worked by a sexy, beautiful, almost inappropriately dressed cocktail waitress. I felt that the first time I went to 32 Degrees. This woman was so beautiful, and she was wearing something that was gorgeous: it made her look unbelievable. At 32 Degrees, when they hire their wait staff—their bar and cocktail waitresses—they don't call it a job fair, they call it a *talent search*, and I think that'll give you a little insight into what they are doing. They would rather take a beautiful girl that you are going to want to look at, that you are going to want to flirt with, that is going to talk you into buying anything she wants to talk you into buying, and train her how to do her job. . . . And I am not a sucker—I am married, I'm not like an overly flirtatious guy, but I would literally buy anything those waitresses suggested because they looked so good. And that's a sincere part of the equation.

Tommy's remarks betray a common misperception among men regarding the supposedly innate eroticism of "naturally" attractive women: in fact, the very same tools of stagecraft employed by restaurants and nightclubs are also required of female employees. Not surprisingly, the emphasis on what sociologist Arlie Russell Hochschild refers to as "emotional labor" in nightlife service roles often requires women to accentuate a performance of sexualized femininity that they find incongruous with their more genuine sense of self.[32] Recalling her stint as a server and bartender at Philadelphia Fish & Co., an Old City restaurant, Alexandra describes this requisite transformation of self: "My voice range goes higher. Like, there is a little bit more of a soothing femininity, very nonthreatening. It feels like a lot more of an act, it feels like a lot more of a separation from who I am. . . . It would be like, 'Hi, I am Alexandra, and I'll be your server today.' Or, like, 'This is what's on the menu,' and, you know, 'Hi, how's it going?' Yeah, yeah, oh yeah, totally, I'll like, you know, 'Oh, you want iced tea with that?'"

As a tattooed woman who shuns the use of facial cosmetics, Alexandra points out how the dress codes associated with the restaurant made her particularly susceptible to workplace distress:

> I was encouraged to wear makeup, and I don't usually wear makeup. By the end, before I got fired, they were reinstituting some policies—it was actually required of women to wear lipstick. . . . I was not allowed to show my tattoo, which sometimes conflicted with the fact that I was supposed to wear this specific shirt that was low-cut enough to see my tattoo. So then what do I do? I tried to safety-pin it, so that was complicated. But it was really the lipstick thing that started getting instituted. . . . I was the only one that didn't wear lipstick or makeup on a regular basis, so some of it felt real fucking personal.

The mandatory dress required by nightlife industry employers serves as a constant source of complaint among female service workers. According to Molly, a twenty-one-year-old former server at Continental Mid-Town, "They have these striped polyester shirts with the collars, and what they don't tell you is that after you wash them, they shrink and *they never stay down*. I feel like I was always pulling the shirt down. So what ended up happening was you had a midriff going."

"Did the men walk around with their midriffs showing?"

"No, their shirts were big. I had a large and mine was still tight and I am not, I am like a size eight, you know. . . . The men's sizes were lots bigger.

"Now, during the wintertime they wear Lucky jeans that are pretty low," Molly continues, "and then in the summer, spring and summer they have a denim skirt that you wear. . . . The skirts weren't that bad, although you kind of did get the people staring and looking, and the jeans are tight. But I am so much more comfortable in pants. . . . I think even tights pants are better than a skirt, any skirt. Tightest pants possible are still better than any skirt."

If Continental Mid-Town's midriff-revealing apparel represents the downtown *Sex and the City* nightlife world and its affluent clus-

ters of cosmopolitan-swigging professionals, business travelers, tourists, and the Ivy League set, then perhaps the city's mellower and historically rich entertainment scenes present a more enlightened work experience for female employees—or not, as the case may be. For instance, since leaving Philadelphia Fish & Co., Alexandra has worked as a server at Ortlieb's Jazzhaus, an unassuming yet renowned jazz club located in the gentrifying neighborhood of Northern Liberties. However, Ortlieb's countercultural environment hardly diminishes the degree of emotion work expected of employees and the weariness it generates among female workers. In fact, its easygoing, friendly atmosphere creates a demand for performing a kind of intimacy for customers that support personnel can find constraining and depersonalizing.[33]

> What gets exhausting about it is when you start selling [patrons] this performance, and then you get busy or you get bored or you get tired, and they still want you to keep performing, and you are like, "Oh, right, see, you thought we had this connection and I don't have the time to talk to you about whatever it was we were talking about before, and now I just want to be your waitress and I want to close that door." And then sometimes people look at you like, I don't know, it's so deep and so weird how much people feel about their interactions with you. It's like they want to think they really are your friends. I have had customers that will come in and request me at a table and really want to talk to me about my life and stuff, and they'll come in and they'll be like this is our "friend" Alexandra. . . . And I am the waitress that they are talking about, and they are like, "Oh, hi, I heard so much about you," and I am like, "I'm just your fucking waitress."

This kind of treatment may be even more pronounced for women of color, particularly those perceived as exotic-looking by patrons and therefore singled out for intrusive discussions about their ethnic identity. According to Allison, who is racially mixed, "I pretty much always . . . Every day I can count on three people saying, 'What are you?' . . . My mom is Filipino, but she was raised in Hawaii, so I

got the Hawaiian culture. And there are a lot of Filipinos in Hawaii itself, so they either get it right [when they guess] Filipino or they say 'Hawaiian,' and I go, 'Oh, you are kind of right.' Sometimes they will be like, 'Are you Hawaiian?' Or, 'You're not from here—where are you from?' And then I'll say, 'Los Angeles.'

"Then the next thing is, 'What brought you out here?' Then that gets me in like this big huge discussion. . . . And then they'll go, 'Well, how did you get to the restaurant?' And it ends up into this fifteen-minute-long conversation. Then they feel like they know me; I feel like I know them. But sometimes it's hard to get away."

"At least once a day somebody asks you something about your race or ethnicity?" I ask.

"It's the eyes, and my nose is a little bit flatter, I guess."

"That would piss some people off a lot, to have to deal with that conversation every day, and while they are working. Does it bother you?"

"It gets to be like a script. So much of what I do at Tangerine and the other restaurants is acting, and we are onstage for eight hours. And you have to be happy and pretend that you really care about these people, even when they are being assholes to you. You still have to be as nice as if they were your best friend. And sometimes you have to put on a show when you are sick, when you are really tired, when you just want to go home, when something is pissing you off outside of work, when you have all this other stuff to think about. So I feel like it is a stage, and you have lines that you say so many times that they just sort of come out."

Many restaurants enforce guidelines to ensure that female service personnel conform to dominant norms of feminine beauty, submissiveness, and sexual allure. But in addition, nightclubs and lounges frequently employ informal door policies that ensure conformity among customers as well. According to Danny Lake, the best publicity for any venue is the word-of-mouth reputation surrounding the attractiveness of the establishment's female clientele:

You don't want your club full of men—you want your club full of women. . . . If the men come into a club that is packed with

hot women, they are going to leave talking, endorsing this place because it is packed with hot women. If women come into a place that is packed with hot women, I don't think they are going to complain—maybe if it's too bad a ratio they will, so there is a very subtle balance that has to be managed, and there is a real significant communication scheme between the bar, the door, and everybody in between to manage that. . . . You see the guys with earplugs in their ears? That's for security . . . but also for, you know, "We need some more women in here, stop letting the guys in," or stuff like that. It's very superficial; it's hard to even talk about because it's so superficial. . . . But that's the world. That's this world.

THE STAGED DERELICTION OF THE UNDERGROUND CITY

In some ways the staging of urban nightlife seems more characteristic of the city's martini bar scene than the gritty dive bars that attract chain-smoking bohemian crowds of visual artists, dancers, musicians, indie-rock fanatics, and surly late-night boozehounds. Maureen Tkacik, a journalist who reports on the local nightlife scene for *Philadelphia Magazine*, points out the strange duality of Philadelphia's entertainment landscape, noting that local scenes resemble two ideal types best represented by, on the one hand, the neon-bright gaudiness of South Beach, Miami (as exemplified by the theatricality of Cuba Libre), or else the too-cool-for-school hipster scene of Williamsburg, Brooklyn. Decked out in disheveled thrift-store ensembles, nightlife consumers who perform nocturnal cool through predictable subcultural style and proletarian chic reject the Stephen Starr Experience for suitably "rougher" ashtray pubs and other low-rent nightspots.

Yet as staged refuges of dereliction and drunken squalor in the heart of the city, Philadelphia's downtown dive bars are no less contrived than their upscale counterparts. In keeping with the messy working-class charms of the city itself as depicted in movies like *Rocky*, taverns with names like Ray's Happy Birthday Bar, Johnny

Brenda's, Doobie's, McGlinchey's, Tattooed Mom, Locust Bar, Dirty Frank's, and—what else?—the Dive joyously conjure up an underworld of jukebox jams and spilt whiskey while servicing a grungy yet curiously upwardly mobile set. The walls of Bob & Barbara's Lounge feature framed Pabst Blue Ribbon ads (for $3 patrons can order the "special," a lukewarm shot of Jim Beam chased down with an ice-cold can of PBR), while punk bands perform in a run-down room wallpapered with rock logos on the second floor of Doc Watson's. The grime-stained walls of Dirty Frank's Bar display carefully installed local artwork priced in the hundreds of dollars alongside piles of filthy newspaper, used hubcaps, stacks of worn clothbound books, fading beer signs, and a jukebox perennially tuned to the same motley mix of records from Tennessee Ernie Ford's classic "Sixteen Tons" to the Cars' 1980s postpunk pop hit "Just What I Needed."[34]

In Philadelphia and elsewhere, ersatz dive bars seem as artificially aged as the souvenir copies of the Declaration of Independence sold in the city's Historic District. According to a *New York Times* review of La Esquina, a latter-day speakeasy hidden behind an anonymous gray door in a downtown taco stand in Lower Manhattan:

> The décor, like the rabbit-hole descent, is so contrived as to feel uncontrived. . . . The rust on the wrought iron fence used decoratively throughout the restaurant was created by hydrochloric acid, not age. The brick walls were meticulously painted, scraped and repainted to match the naturally decayed columns. The bathroom wallpaper advertises a Mexico City "lucha libre" wrestling countdown that probably never took place.
>
> Old, La Esquina seems to declare, is the new new.[35]

Over cocktails at the Walnut Room, a downtown lounge, Tkacik pokes fun at the staged authenticity of Philadelphia's own dive bars and run-down corner taverns:

> I mean, that's one thing that's like really kind of inspired and amazed me about nightlife venues in Philadelphia that are sup-

posed to be unpretentious—a lot of them are really fastidiously worked on. If you think about the Standard Tap Room [an earthy neighborhood bar and restaurant], those guys are perfectionists. I think they spent a year working on the bar in the Tap. . . . I live near Grace Tavern and I like to go there a lot, and I just feel like they are so passionate about creating the perfect dive, you know.

When I lived in LA, all of the places that I went were concerned with looking new and hip and attracting the beautiful people. . . . But here, I feel like the dives try really hard to look like dives. I mean, even Dirty Frank's. Why does Dirty Frank's feel worked on? There is so much clutter and so much crap in there.

Misty, the former server from Le Bec-Fin and Susanna Foo, agrees. "They could clean up the bathroom [at Dirty Frank's] for about $5, you know what I mean? They *want* it to be the way it is. . . . In Philadelphia, in this [business] climate, with everything that's going on, you can't believe that *anything* is accidental or coincidental. How much money are they bringing in every night [at McGlinchey's]? They have no overhead; they are paying somebody $3 an hour. They haven't changed the decor in a hundred years—they're not going to. It's pure profit. They've intentionally not changed it."

Of course, just as the cosmopolitan sexiness of 32 Degrees draws a far less exclusive crowd than that suggested by its chiseled VIP image, romanticized images of rough-and-tumble saloon life and blue-collar culture are carefully crafted to attract investment bankers, law students, and an otherwise well-heeled set of revelers to downtown watering holes. In an article on local bar owner Avram Hornik, Tkacik observes that Hornik's bar Tom Drinker's Tavern relies on the symbolic rituals of alcoholic excess and proletarian camaraderie to draw middle- and upper-class crowds of fraternity brothers and New Jersey suburbanites to its affluent Old City neighborhood, where seemingly out-of-place tattooed bartenders from working-class Kensington pour specials for their upwardly mobile counterparts all night long. As she reports, "A can of Pabst is just a dollar if a patron agrees to consume its contents in one gulp, a

quarter landed in a special container behind the bar will buy everyone a round of shots, and if an especially giddy customer wants to buy a shot for each of his fellow patrons, the cost is a mere $30."[36] In the affluent world of Old City, even neighborly fellowship and conviviality represents little more than a purchased consumer experience, to be bought at a price.

3

SPIN CONTROL

PUBLIC RELATIONS
AND REALITY
MARKETING

In the competitive world of city nightlife, consumers flock to the nightclubs deemed most fashionable and will suffer long queues and suffocating crowds to luxuriate in the places considered to represent the hot spots of the moment, the epicenters of cool. Trendy urban clubs and lounges often compete in what economists Robert H. Frank and Philip C. Cook refer to as "winner-take-all" contests, in which only the hottest venues succeed at any given moment in time. Winner-take-all contests are positional insofar as minor differences among the quality of competitors frequently amount to significantly larger profit margins.[1] In addition to the various theatrical characteristics of nightspots discussed in the last chapter—the sexual magnetism of service staff, the illusory glamour evoked by lighting effects and designer swank—the degree of a venue's hotness is most significantly reflected in the stylishness, attractiveness, and nocturnal status of its patrons. For urban restaurants, nightclubs, and cocktail lounges, popularity among the nightlife elite begets financial success and cultural prominence.

Of course, hotness is not only a manufactured quality of nightspots but by definition an ephemeral one as well. It must therefore

undergo constant artificial regeneration, lest it wither away into middlebrow obscurity. The compatibility of late twentieth-century advertising style with nonconformist ideology and countercultural aesthetics makes print media advertising an integral part of the promotional machinery of hip restaurants and nightclubs.[2] But in recent years, dominant trends in marketing have emphasized the creative use of public relations over traditional advertising practices. In *The Fall of Advertising and the Rise of PR*, Al Ries and Laura Ries argue:

> Compared to the power of the press, advertising has almost zero credibility. Suppose you were offered a choice. You can run an advertisement in our newspaper or magazine or we'll run your story as an article. How many companies would prefer an ad to an article? . . . In building brands, advertising has become irrelevant. What builds brands are media messages. The more messages, the more favorable the messages, the stronger the brand.[3]

Of course, there is nothing new or faddish about the so-called "rise" of public relations. As early as 1922, Walter Lippman recognized the press agent's role as a necessary tool of impression management in an expanding media age: "The enormous discretion as to what facts and what impressions shall be reported is steadily convincing every organized group of people that whether it wishes to secure publicity or to avoid it, the exercise of discretion cannot be left to the reporter."[4] The following year Edward L. Bernays observed in *Crystallizing Public Opinion* that public relations consultants are not just responsible for publicizing the qualities of their clients to news reporters, but are in a position to literally "make news happen" through creative event planning and editorial placement. In a laudatory ode to the emergent public relations industry, Bernays weaves together hilarious tales of strategic news making. He details the attempt by a meatpacking house to generate attention around the medical benefits of bacon as a nutritious breakfast food; the war against newly fashionable bobbed hairstyles among women as executed by a nervous hairnet manufac-

turer; the hotel that contrives its own thirtieth-anniversary commemoration in order to convene a planning committee of business leaders and socialites whose participation would improve the hotel's prestige in the community. According to Bernays, the public relations counsel "is not merely the purveyor of news; he is more logically the *creator* of news."[5] Years later, in an essay on the degradation of journalism in his eerily prescient 1961 book *The Image*, Daniel Boorstin poked fun at the rise of "pseudo-events," or planned affairs designed for the immediate purpose of being reported or reproduced as media content. Such events include contrived photo-ops, publicity-generating gala celebrations, and staged press conferences disguised as spontaneous happenings.[6]

But if the art of public relations is nothing new, its importance in the marketing of urban nightlife has never been stronger. The last several decades have witnessed a shift in media industry attention away from the local landscape of street-level entertainment and toward the global economy of mass-consumed popular culture. While advertisers have more and more opportunities for disseminating promotional copy and image (product placement in cinema and television, invasive Internet pop-up ads), most of this media is reserved for the world's most ubiquitous brands—Coca-Cola, McDonald's, Starbucks, Nike, Microsoft. Dining franchises such as Applebee's Neighborhood Grill and Bar and Outback Steakhouse can afford to buy commercial television airtime, while global chains like Planet Hollywood, Hard Rock Cafe, and the House of Blues can rely on their internationally famous logos, print ads, and celebrity owners for their continued success. Local restaurants, nightclubs, and music venues can hardly compete with the juggernaut of the corporate-dominated entertainment industry by relying on traditional advertising or promotional techniques.[7]

For this reason, local urban nightspots increasingly call on the services of high-end PR consultants. According to publicist Danny Lake:

Okay, my agency is very specialized in the hospitality industry. We represent casinos, restaurants, hotels, vacation destinations. . . .

Here in Philadelphia I'd say we have a premium roster of clients. . . . The agency does several things. We help develop brands and then market them. We create stories and then sell them to the media—publicity placement, if you will. We do marketing, mostly guerilla, a lot using the Internet, e-mail, and creative marketing strategies, nontraditional—traditional being big-dollar print or broadcast campaigns. A lot of my clients, either I'll convince [them] or they'll come to me with the rationale that their budget for media campaigns should better be spent on creating editorial by using my services. They don't believe that traditional advertising is going to get them what I can get them in the way of editorial coverage.

In the postindustrial city, branding and image production play a crucial role in the marketing of urban nightlife. During the last few years, nightlife promoters have employed a set of interrelated vocations—public relations, media consulting, event planning, and what in recent years has been termed *reality marketing*—to create elaborate hustles bolstered by the opportunistic relationships existing among PR consultants, nightlife entrepreneurs, and media outlets. Understanding how these hustles work in concert with one another can help explain why the contemporary terrain of urban entertainment looks as it does today and may additionally shed light on a number of local peculiarities characteristic of Philadelphia's downtown cultural scenes. For example, why does Barclay Prime charge $100 for its cheesesteak? Why can customers pay their bar tab at 32 Degrees entirely in euros? And why does a city with only 2,730 Cuban residents (or 0.2 percent of its population) have *five* Cuban fusion restaurants?[8]

LEADING THE PRESS IN AN ERA OF SPIN

Even in an age of declining popularity in traditional marketing and branding, advertisers continue to crank out the most tired of campaigns to promote Philadelphia's nightlife scene with a questionable degree of effectiveness. This is particularly the case for the slogan-

eering of the city's business improvement districts, private-public partnerships, and other local booster organizations. Center City District and the Central Philadelphia Development Corporation urge consumers, "After your day in Center City . . . Make It a Night."9 The Greater Philadelphia Tourism Marketing Corporation promises that "Philly's More Fun When You Stay Up Late," its website burnished with ad copy as contrived as any tourist guidebook. It features a "Real Young, Real Fun, Real Philly Itinerary—How the Young and Fun Do Philadelphia," its recommended excursion showcasing "stops at the city's most happening spots for the 'twenty- and thirty-something' set: extreme history, funky neighborhoods . . . superb restaurants and trendy nightspots." In cheesy prose, out-of-towners are promised that at Denim, a Rittenhouse Square nightclub, they can "look for snazzily dressed college students, city scenesters and club types— the perfect inspiration to get your hips down on the dance floor."10

In contrast, today's public relations consultants take promotional campaigning to an entirely new level of sophistication. According to Danny Lake:

> My intention is to gain as much editorial space as I can for every client I work with, pretty much. I am going to look at every single possible way I can gain those inches, from the personnel that build the brand to tangential relationships that might somehow be newsworthy to that brand. . . . My clients seem to mostly all really understand branding and understand that I can get a story in any publication pretty much any day of the week, because I know how news works. I call myself a *masterful media manipulator*—it's easy if you know how to do it.

The chief goal of media placement is to proactively direct the press coverage of a client's business by crafting myths about every aspect of their product, from the selectivity of a restaurateur's ingredients to the exotic images evoked by a nightclub's decor. To this end, Lake has successfully landed stories in a range of media outlets, including powerhouses such as the *Wall Street Journal*, *New York Times*, *USA Today*,

U.S. News & World Report, CNN, and NBC's *Today Show*. He explains that since brands rarely attract media attention on their own, they require aggressive strategies of content development if they are ever to appear in print. Lake explains how the marketing of one Cuban restaurant (which to protect Lake I will call "Cohiba") relies on not only an inspired concept, but the relentless generation of new editorial content for local newspapers, magazines, and other media:

> Cohiba's proprietors came to us and they had a concept for an intriguing restaurant that sort of represents a "forbidden fruit"— a pretty destination that is illegal to go to. . . . It's certainly not enough to rely on. I think if I was naive, if I was just starting out, I might believe that that was a good-enough story to bank on to let the brand develop. We know better, and because of that we've developed hundreds of stories to put that brand in its place in the market: stories about the mojitos, stories about the food, stories about the Latin dancing.

In a certain sense, the proliferation of editorial coverage in Philadelphia's newspapers and magazines not only helped Cohiba attain notoriety but generated an even wider market among local consumers for Cuban-themed cuisine and entertainment, as illustrated by the runaway success of five such restaurants: Alma de Cuba, Café Habana, Cuba Libre, Mixto, and Tierra Colombiana.

Nightlife entrepreneurs desire this type of media placement so strongly that they bundle their businesses' branding capacities into the production process itself. Club owners and their PR agents incorporate specific marketing ploys into their entertainment programming, whether an item on a dinner menu, the selection of music, or even the kind of currency accepted by bartenders. Take 32 Degrees, a highly stylized lounge catering to an exclusive VIP clientele and the city's first nightclub to offer expensive European-style bottle service, a profitable scheme in which the patron purchases an entire bottle of liquor at a super-inflated cost. In 2007 these prices ran anywhere from $180 for Captain Morgan Spiced Rum to $225 for Belvedere Vodka,

to a whopping $2,000 for Louis XIII de Rémy Martin Cognac. (Bottle service succeeds because its prohibitive expense makes it effective as a means of signaling distinction among anonymous groups of nightclub partiers.) A few years ago, the marketing team employed by 32 Degrees decided the staff should begin accepting euros and dispersing them as change to all desiring patrons. They began publicizing the new policy on January 1, 2002, the day the euro was introduced as the European Union's official currency. According to the PR agent responsible for the campaign, the goal of the policy was not really to attract transatlantic travelers tickled by the Philadelphia nightclub's worldliness (after all, who carries around euros in Philadelphia?) but to bathe the club in a Continental aura and portray the club as the sort of place where an internationally cosmopolitan elite might actually socialize—as well as garner press coverage from curious journalists. Sure enough, in February 2002 USA Today reported on this thinly veiled ploy as a newsworthy item.[11]

When Stephen Starr opened Barclay Prime a few years later, he introduced the most expensive sandwich in the city, the $100 cheesesteak. Prepared with Kobe beef, $50-a-pound sautéed foie gras (which was replaced by lobster meat after protests from animal-rights activists), shaved truffles, heirloom tomatoes, caramelized onions, and melted triple-cream taleggio cheese on a brioche bun, and served with a complimentary bottle of Veuve Clicquot Champagne, the dish is the very portrait of decadent kitsch.[12] As it happens, due to the exorbitant and mercurial price of Kobe beef (not to mention the free champagne), the $100 cheesesteak is actually a loss leader for the restaurant, and they do not serve very many in any given evening. But that is clearly beside the point, since its purpose was never to satiate the restaurant's diners or compete with the city's cheesesteak kings (Pat's, Geno's, Jim's, Tony Luke's), but to create a newsworthy story that would publicize the opening of the establishment. According to Blake, the manager of Barclay Prime introduced earlier, "You want to bring in steakhouse traditions . . . meats and potatoes, spinach and chicken, and things you would find on a normal menu, but add some kick, and what are people going to talk

about? People are going to talk about a $100 cheesesteak." Just as planned, the stunt spawned a nationwide story on CNN.com and was enthusiastically covered by nearly every media outlet in Philadelphia, including the *Inquirer*.[13]

Not to be outdone, Danny Lake borrowed a page from Barclay Prime's playbook by introducing a dessert *purely* designed to make headlines, if not necessarily sales—a chocolate hazelnut brownie with Sicilian pistachios and pistachio ice cream, dusted with edible gold powder and served alongside a rare 1996 Quinta do Noval Nacional port wine presented in a Baccarat crystal perfume atomizer, for $1,000:

> There is an art in creating a program that is going to be newsworthy. . . . I placed a front-page story [in the Local and Regional section of the *Philadelphia Inquirer*] last Sunday for Brulee, the dessert experience in Atlantic City . . . a $1,000 dessert. Well, I came up with the $1,000 dessert, and I came up with it because I knew it would be newsworthy. . . . I was at an event a few years ago, and a very renowned pastry chef gave me a bite of a brownie and then told me to open my mouth . . . and he sprayed, with a squirtbottle, port on top of the brownie. And I thought that was really cool, it was interactive, it was newsworthy because it's different.
>
> I said to my client, "The $100 cheesesteak at Barclay Prime gets so much press, we should do something for $1,000. . . . And if we do it with a crystal perfume atomizer for the port [so the dessert manager might spray the port wine into the customer's mouth while they chew the brownie], let them keep the crystal perfume atomizer and that's how you justify the $1,000." So I freaking love it; it's brilliant. We haven't sold many, but we are starting to get a lot of press. . . . It's not to sell the item. It's to sell the brand.[14]

Not to be outdone, a number of high-end nightclubs, restaurants, and lounges have begun serving outrageously unaffordable novelty cocktails priced to simply publicize their own extravagance. In December

2005 the *New York Times* reported on the most expensive concoctions available in the country. Chicago's Reserve cocktail lounge offers the $950 Ruby Red, prepared with Grey Goose L'Orange vodka, Hpnotiq liqueur, cognac, orange and pomegranate juices, a splash of Dom Pérignon, and a one-carat ruby. The Duvet Passion, mixed with vintage cognacs and champagnes and spruced up with a vanilla orchid petal, sells at New York's Chelsea restaurant-lounge Duvet for $1,500. And at MGM Grand Las Vegas's Teatro Euro Bar, the High Limit Kir Royale is served with Louis Roederer Cristal Champagne and 140-year-old cognac for a whopping $2,200, and that's *without* the precious jewels or a crystal perfume atomizer.[15]

THE PRESS AS BOOSTER AND GATEKEEPER

Traditional organizational studies of the culture industry emphasize the mass media's role as a gatekeeper designed to filter and disseminate to the consuming public only the most worthwhile content promoted by culture-producing firms.[16] But in the examples cited above, the press seems little more than a mouthpiece for local business interests. In fact, for a number of reasons, urban and regional media outlets regularly serve as diligent and enthusiastic boosters for local entertainment enterprises, all while under the guise of maintaining journalistic standards of objectivity and public trust.

Certainly, urban residents (and thus potential readers) share a predictable enthusiasm for their city's local popular culture, best evidenced in Philadelphia by sports fans' maniacal interest in the minutiae of the personal dramas and contract negotiations of the NFL star athletes of the Philadelphia Eagles.[17] More insidiously, mass media outlets are typically governed by city elites and local corporate powers with a vested interest in regional economic growth—note the dominant presence in Philadelphia maintained by the Comcast Corporation, the cable service provider and entertainment giant. This is especially the case in instances where parent companies (like Comcast) own a sizable stake in the city's major concert and sports venues, as well as the cable media outlets that promote

them. Likewise, the metropolitan area's media industry benefits greatly from local economic development, which can attract and sustain a rich pool of hometown advertisers. Local and regional economic expansion also contributes to population growth, which ultimately inflates the available market of media subscribers, readers, and viewers, along with the rates advertisers must pay for the privilege of attracting so many potential consumers.[18]

In Philadelphia dominant media and journalistic outlets include the two major newspapers, the *Philadelphia Inquirer* and *Daily News*; two weekly independents, *City Paper* and *Philadelphia Weekly*; glossy magazines such as *Philadelphia Magazine* and *Philadelphia Style*; free tourist-oriented guides such as *Where* magazine; local radio and television stations; and a limitless array of Internet sites, from Campus Philly.org to Philebrity.com. But while all serve as booster organs for the city's nightlife industry, they do so with varying degrees of intensity and purpose depending on their revenue streams, reliance on advertisers and sponsors, and the relationship between their editorial and advertising departments.

Take *Where* magazine. As a free publication, it raises revenue solely through advertisements and relies on its friendly relationships with exclusive merchants, hotels, restaurants, and entertainment venues for its efficient distribution to affluent vacationers, business travelers, and other attractive consumers. Consequently, its content is largely determined by the needs of its sponsors. All advertisers receive a listing in the magazine, almost regardless of their quality or suitability for out-of-town guests. In spite of the firm boundary that would ideally exist between the editorial and revenue-generating wings of the magazine, the editors of *Where* frequently take their cues from the advertising department. According to Rick, one of the magazine's contributors, a close relationship between advertising and editorial can be beneficial for the smooth functioning of the publication: "If things are going right and you have the right kind of team, your advertising department is pitching the kind of businesses that you would want to write about anyway, so your whole magazine comes together."

Like similar booster publications, *Where* relies very heavily on the local public relations machinery to guide its editors toward stories deemed appropriate for its readership, and as a matter of editorial policy the magazine prevents its writers from critically evaluating local businesses. Of course, this requires its staff to walk a thin line between promoting local entertainment venues and deceiving potential nightlife patrons lacking the savvy necessary to know the difference. As Rick explains, "I can't really say too much negative about a place—again, that's not in the mission of the magazine. But you can say what's good or steer your reader into what is good about that place. That's one way to handle it." Since the readers of *Where* are nearly all out-of-towners, the magazine can exploit the tourist's unfamiliarity with the city to strategically direct him or her to a variety of nightspots whose advertising dollars buy them not only ads, but editorial visibility as well. Even ostensibly straight pieces read like advertising copy, as in this May 2005 review of "Philadelphia After Dark":

Eastside or west—Center City nightlife heats up from river to river and points in between. Choose your scene and head out for a night of revery or low-key diversions. After a long and hard winter, Philadelphians look forward to May as longer days and warmer nights culminate to create the perfect climatic cocktail in which to enjoy the moment. Join the party and step out tonight for a drink, people watch—or dance into the late hours.

Those who enjoy basking in minimalist digs will enjoy *Red Sky Lounge*. This glamorous bar does double time as a small-plate eatery with sidewalk seating when weather permits. Towering ceilings and a two-story plate-glass window create an airy atmosphere that leaves little room to hide, but rather a well-lit backdrop in which to be seen. Saunter up to the concrete bar and order yourself a specialty cocktail or old standard while up-tempo music pulsates. A back-lit plexi-glass staircase is your queue to more space and a hidden lair above.

The place that redefined stodgy Rittenhouse and neglected Chestnut Street is *Continental Mid-Town*. The westside's answer

to Old City's wildly successful decade-old diner cum cocktail lounge, this one-time mid-range retailer gone retro, rocks three floors for lunch through late night. Check out the cool roof-top lounge—a real gem—with circular bar, lounging pit, '70s-style fireplace and gas heat lamps for cooler nights.[19]

Where traffics in flattery and hype because its readership of tourists and weekenders do not stick around Philadelphia long enough to demand accountability from the magazine's "reporters." Unlike publications answerable to local residents, *Where* hoodwinks its out-of-town readers (who by definition promise a readership turnover approaching 100 percent) without much fear of repercussion.

On the other hand, the Pulitzer prize–winning *Philadelphia Inquirer* is not only accountable to its advertisers but a loyal hometown readership as well. Consequently, its entertainment critics take their reviews of eateries, music venues, and other nightlife options very seriously, and this makes Craig LaBan, chief restaurant critic of the *Inquirer*, one of the most feared journalists in the city. To prevent himself from being recognized, he rarely makes public appearances. When researching a hot spot, LaBan travels incognito, lest he fall victim to the preplanned strategies of restaurateurs and their staffs attempting to curry favor with him. However, according to Joshua, a server at Barclay Prime, LaBan's aliases rarely guarantee his anonymity:

You should have been around here during the review period. That was very exciting, because every night we had to read this four-page document about what we do when we are in a review process, when LaBan comes in. . . . He doesn't wear disguises, but he has certain aliases—he comes in as "Joe Schmoe." And if "Joe Schmoe" is one of those reservations, then we got to be ready for LaBan. But we were ready for LaBan—how long was it, three months? Every night we had to have a set table, a set amount of, four glasses, four knives, set silverware, set menus. . . . We know what he looks like; his picture is in the [back]. . . . And they'd

have an assigned team every night, a dream team, a set team that was going to take care of him.

Restaurant critics often mistakenly presume that their reviews of new dining establishments reflect the experience of the average consumer, since they go to great pains to mask their identities in public and thus avoid special treatment by managers, chefs, and servers when on assignment. Craig LaBan himself relies on aliases, accomplices, and the occasional disguise. At a recent book reading at a local Barnes and Noble, he wore a wizard costume shielding his face from the audience. He even declined to accept his 2000 James Beard Award for top newspaper restaurant reviewer in the country in order to protect his identity from the public.[20]

But in his exposé *The Gospel of Food*, sociologist Barry Glassner rejects what he calls the "anonymity myth," given that most restaurant critics employ these ruses in vain.[21] In a 2002 profile in the *Philadelphia City Paper*, LaBan himself admitted just as much: "Your anonymity, if people take you seriously, starts to erode from the minute you arrive in town. It's always been an important part of what I do and I strive to maintain it, but it's something that chips away over time and there's nothing you can do about it."[22] Joshua confirms LaBan's fear when he explains to me the extensive efforts Barclay Prime's service staff exerted in order to accommodate LaBan, all without him knowing that he had been "made" by the establishment:

We had this four-page document. "Make sure the waiter's tie is in place, and the cuff links are clean, and the table is taken care of. All the tables around Craig LaBan's set table [should be] VIP tables. . . . Make sure the bookcase is clean. If this chair wobbles, you get a brand-new chair in here. If that table is sloppy, you get a brand-new table from the back in there." Everything had to be 120 percent perfect for that specific table, and everywhere else around it. So it was OCD [obsessive-compulsive disorder] to the nth degree every night. There was a high level of stress here.

Some of the highlights of this four-page document, a highly detailed checklist better known as the "LaBan Memo," include:

- Re-allocate station assignments to ensure that the reviewer is served by the restaurant's BEST server, runner, and busser.
- The table should be considered a "premium" table. Reviewer should be seated where there is energy in the room. Seat other interesting parties around the table and be sure to VIP them.
- Reviewers are likely to wait until his party is seated and then go and join. He will attempt to slip by the host stand.
- Make sure the restrooms are clean, stocked and in good repair— Do this every 5–10 minutes when the reviewer is in the restaurant.
- Make sure there are no scratches on the [table] surface and check underneath for chewing gum.
- If you know in advance, make extra great specials that have already been approved by your director. To create perceived value, price them below what you might normally charge.
- Prepare TWO orders of every item so the director can taste it before it goes to the table.
- Pull ingredients (chicken, steak, dumplings, etc.) from the walk-in [refrigerator] rather than use food that has been sitting on the line.
- Fire dishes you know will take a long time to prepare whether or not he orders them. Food cost is not an issue when the reviewer is in the restaurant.
- If necessary, slow down seating of other parties in order to give the kitchen time to perfect food preparation.
- Craig LaBan's aliases should all be flagged. . . . Here is a list of his aliases. If you know of others we have missed or if he uses one that is not listed below you must contact your director with the additional name: *Sebastian Mark, Richard Hall, Ronna Hall, Bill Borge, Oliver Miles, Jennifer Miles, Jennifer Weiner, Terry Rich, Patty Rich, Elizabeth Trostler, Barbara Trostler, Howard Fried, Henry Fried.*
- It is imperative that it appears to the reviewer to be business as usual.

This last line is especially revealing—just as the food critic must disguise himself as a regular customer, the service staff must pretend not to notice his ruse. In such instances, exactly who (if anyone) is really hustling whom?

In any case, the sheer existence of the LaBan Memo aptly illustrates not only the perceived asymmetrical relationship between nightlife hot spots and the media establishment in Philadelphia, but the lengths that management will go to strategically maintain control over their carefully crafted identity in the public imagination. According to the Alma de Cuba staff manual:

> All phone calls from the press should be referred to the General Manager. This includes newspaper, magazine, radio, television, etc. All press phone calls, no matter what the person is inquiring about, must be referred to the General Manager. We work very hard at Public Relations and want to ensure that a clear and consistent message is always delivered.

URBAN NIGHTLIFE AS A PSEUDO-EVENT

Even the most reputable media personnel can succumb to the pleasures of the occasional press junket, complimentary gift bag, or celebrity party. Diana Redstone of the Philadelphia PR firm Redstone Productions—a firm specializing in image and branding consulting for local restaurants, nightclubs, and lounges—describes the high rate of return on their clients' investments in what they call "media dinners":

> That's a small, private dinner that we do for the media, especially when it comes to a restaurant. And sometimes we do it in a lounge environment, where we don't invite the general public. We invite specifically just the media in to experience the food, have some more one-on-one time with the chef, be able to walk around and see the interior, see the back of the house a little bit easier. . . . We probably get 80 percent of our stories from a media dinner.

The media dinner not only serves as a type of bribe but also gives a venue ample opportunity to present itself in the most positive light to journalists and reviewers. Presumably, the cooking staff takes pains to empty the mousetraps in the storeroom, discard the buggy flypaper hanging from the ceiling, and hide the remains of last week's delivery of seafood before the press takes its tour of the backstage facilities. Unlike most patrons, food critics are restaurant professionals who can spot a bad batch of hollandaise sauce from across a crowded kitchen, and during media dinners no restaurateur ever wants to take their chances on a rotten mussel or dirty fork.

But when it comes to inflating the "hot" factor of a high-end urban restaurant or nightclub, proprietors can't afford *not* to take chances on the company they keep. And so, if a club owner thinks that the reported presence of celebrities will help him or her develop a desirable level of buzz, there are public relations firms that will recruit actresses, models, and pop stars to make seemingly casual appearances at their clients' most fashionable hot spots, for a price. According to Danny Lake:

> There is a very famous PR firm in New York and Los Angeles. Jackpot [a pseudonym for an Atlantic City hotel and casino] hired them, and for $10,000 a month they'll bring you stars and then make news about that. Cameron Diaz was at Jackpot, Drew Barrymore; pretty much all of the stars that have been to Jackpot have been paid to go there, or there is a PR firm involved. . . . Usually stars get paid for appearances . . . it varies. Howard Stern's guys, for instance, a couple thousand dollars, maybe $5,000 for the night. . . . Daryl Hannah—probably $10,000. . . . She has a period of time that she has to be there. So she's got to hang out for a period of time and be nice, or try to be nice, be accessible . . . and usually there is a bodyguard or two protecting the star from people that are inappropriate or getting too close.

Hiring movie stars to pose as bar patrons can be a pricey marketing expense, and so the most glamorous PR firms attempt to nourish

more intimate (although no less transactional) relationships with the rich and famous. As part of their overall business strategy, Redstone Productions specializes in cultivating relationships with "national celebrities that come to town, movie stars, [and] television stars that come in for press junkets when they are doing their movies." According to Ashleigh Roberts, director of public relations, "We have the capacity to hook up with them, and if they know they need something, or they want to go out somewhere, we've created a reputation for ourselves. . . . [They] call us and we'll take care of it. [They] know [they'll] have a wonderful time." Redstone nods in agreement: "I got this crazy call from the Hilton sisters' personal assistant: 'The Hilton sisters are going to be in town, and where should they go? What should they do?'"

Film and television stars make up a key sector of an even larger talent pool of approximately two hundred local and national trendsetters cultivated by Redstone Productions, an exclusive network that includes professional athletes, musicians, movie directors, local news anchors, radio personalities, and exceptionally prominent businesspeople. This group is regularly recruited for restaurant and nightclub openings, anniversaries, and other manufactured publicity-generating celebrations and events. Club owners hope that the mere presence of even C- and D-list celebrities at their downtown openings will infuse their branded image with a shot of nocturnal cool. According to Roberts:

> You know how it is, when you read, like, Us Weekly or when celebrities are seen at places: no matter who it is, people want to go. So even on a local level, when the athletes are, you know, at the Metro Lounge opening, all the Phillies [baseball players] came after their game, they all came . . . Pat Burrell, Randy Wolf. . . . So people read that and go, "Oh, I want to go, the Phillies hang out there." And the image starts creating that cachet. . . . We don't get quantifiable television coverage or radio time from inviting these people, but what we do get is the cachet of having local celebrities at all of our events. . . . We'll get another different

kind of publicity, too. We'll get this sort of like gossipy "*Who* was *where?*" publicity out of that also.

In the social world of Philadelphia's urban nightlife, the publicity-generating gala celebration is Daniel Boorstin's pseudo-event par excellence: a thoroughly contrived event executed for the purposes of being reported in "The Public Eye" gossip columns of the *Daily News*, reproduced in the color photographs of *Philadelphia Style* magazine's "Social Studies" pages, and convincing its attendees that all this media attention is a *response* to the venue's prestige as opposed to its cause. At its most successful, event planning serves as a self-fulfilling prophecy, succinctly defined by sociologist Robert K. Merton as "a false definition of the situation evoking behavior that makes the originally false conception come true."[23] Again, according to Redstone:

We are doing [a local nightclub's] third anniversary this fall. Fifth anniversary is a big milestone. The third anniversary, typically you know . . . A club won't in a big way, like, hire a firm like ours and spend the money to do a big third anniversary if it didn't need a shot in the arm. I'm not saying Lava Lounge [a pseudonym] needs a shot in the arm. I'm saying, hypothetically, to celebrate a second or a third anniversary in the nightlife world, or in the lounge world, is usually just to make sure you maintain and sustain that momentum, because new places pop up. You know, new places pop up and they fall out very, very quickly in this business.

As Boorstin argues, an over-the-top public celebration of its anniversary can give a business "the prestige to which it is pretending" through the celebration itself.[24] Therefore, the guest list at such publicity-generating events is paramount, largely because the presence of celebrities, nocturnal elites, and other beautiful people will legitimate the venue among an even broader crowd of wannabes and hangers-on while attracting the paparazzi and entertainment news media. Moreover, nightclubs prioritize guests believed to be movers and

shakers who can efficiently publicize the venue to their informal friendship networks of partygoers and big spenders. According to Lake:

> You only get one chance to make a first impression. When a restaurant comes to me, or a nightclub, and says, "We want to throw an opening party," I say, "Fuck, shit, motherfucker, *why? Why do you want to do that?"* *"Well, we want the right people there."* Who are the right people? The right people are the sports players; anybody who the press is going to write about being there; movie stars who are in town; or stars that live here; and the hip and fashionable.

How does a PR agent recruit "the right people"? Lake explains that one strategy is to slyly appropriate the hotness factor of the competition while appearing to honor their prestige:

> I think this is a brilliant strategy. Identify the movers and shakers in the market, and if they are business owners, develop a "tribute series" where you pay tribute to them. . . . What you do is you end up making news.
>
> Follow me on this. I was branding [a local bar and restaurant], and they wanted to be hip and cool, like 32 Degrees. So we created a tribute series. First, we paid tribute to the guys at [a popular downtown espresso café that attracts a European clientele] because they make the best coffee in the city. We told them we were going to do this: we were going to have a party in their honor on a Wednesday night in June. And what did we want from them? We wanted them to invite all their friends, colleagues, allies, customers, everybody that's hip and cool like them. And we threw that party, and it was a great success and we exposed all of their people to our brand. Freakin' brilliant. I don't think I came up with the idea, so I can say "freakin' brilliant." (I am not in love with all my ideas—*many* of them, but not all.) Then we decided we wanted a culinary market to know about our brand; we paid tribute to [a renowned local restaurateur], same thing.

He brought all his people, we threw a party, and all that it entailed was in the middle of the party, we made a toast.

. . . We identified twenty hip and cool movers and shakers, people that could expose our brand to people that they were connected to. You know the word *connectors*? . . . Yeah, so we used that strategy as a major connector. [That restaurateur] probably didn't even realize he was giving us his entire client list by inviting them to come to our tribute to him. So it was a huge success, and it really expanded their visibility through the right audience. . . . When the guests came in, we asked them for their e-mail address. So we said, "Welcome to the party, it is complimentary admission, but we'd really like one thing: your e-mail address. . . ." Attract a better element; make it look better; create this perception that the place is *a place to be* because the right people are there.

The overriding theory among PR agents is that the "hip and fashionable" not only make desirable future patrons, but have access to staggeringly large collectives of glamorous and cosmopolitan fellow travelers like themselves. In recent years *New Yorker* writer Malcolm Gladwell's book *The Tipping Point* has served as gospel throughout the public relations universe. In particular, marketing and advertising executives have grown attached to his discussion of the role that the well-connected play in generating contagious word of mouth and buzz necessary for the viral marketing of various cultural fads and fashions in a post-advertising age.[25] Borrowing heavily from sociologist Mark S. Granovetter's work from the 1970s on the surprising utility of weak yet boundary-spanning network ties in job hunting, Gladwell designates individuals who bridge multiple and discrete sets of non-overlapping networks as *connectors* because they effectively communicate cultural trends and knowledge across distinctively unique groups who would otherwise never interact. In his more recent research on business firms, strategic management professor Ronald S. Burt similarly argues that uniquely positioned individuals who broker across network gaps or "structural holes" within orga-

nizations, industries, or communities are likely to express creative ideas recognized as valuable, and thus maintain influence among their peers.[26]

But ironically, while public relations personnel have increasingly relied on the power of word of mouth and other informal network-oriented strategies of publicity making, their obsessive emphasis on selectively recruiting the "hip and fashionable" for such events—models, celebrities, and infamous nightclub denizens who essentially all know each other from socializing at the same parties and openings—drastically limits their ability to reach more heterogeneous, wider webs of consumers who make up the bulk of the city's nightlife market. Moreover, there is limited evidence that these venues actually attract return customers among this pool of playboys and glamour queens; one might easily imagine that each weeknight demands their attendance at yet another exclusive party, replete with gift bags and an open bar. This may present a particular challenge for restaurateurs; as Manhattan chef Zak Pelaccio told the New York Times, "You can hype a place all you want, but there has to be something there to sustain it, not just a bunch of celebrities. . . . PR does a lot to spread the word, but then you have to sustain it with word of mouth, and that depends on the food."[27]

To explore this question further, I met with Jessica Pressler, a former Philadelphia Weekly gossip columnist who now reports on urban nightlife for Philadelphia Magazine and occasionally writes for the Sunday Styles section of the New York Times.[28] In 2005 Philadelphia Magazine published "Girl Power," her critical profile of the local PR industry, and I asked her about her own experiences at publicity-generating open-bar parties thrown by Redstone Productions and others.[29] According to Pressler, "I went to a lot of openings . . . those big marketing parties when a place opens, and you go and they're giving you free booze, and that's why you go. . . . But after a while it got incredibly tiresome. . . . I've been to this party eighty times now. It seemed like a good idea the first nine times that I went, but then you realize that you are going to the same party in a bunch of different places. It doesn't say anything about the flavor of the place.

"One of the first times that I was writing about going to a bar opening, I was in there going, 'Where did all these people come from? Who are these strange people dressed to the nines on South Street on a Thursday, drinking Pravda martinis? What is going on?' And then later, after going to a number of those parties, I realized that that was just the trademark crowd that that PR company brings in.

"All of the parties are the same . . . it's always the same exact people, and you don't see them at the place after it opens. . . . They come for the free vodka that comes with the opening party. I went to a gazillion of those parties, and I saw the same people at them every time, and they weren't the clientele of the particular place. . . . It was a good thought to have that party, but the marketing companies in Philadelphia are too insular. They have their crowd of people that are coming. . . . They are coming for an event by the publicist, not because they are interested in this new venue especially. And once it's over, there's just a bunch of plastic vodka glasses on the ground and you don't see the people ever again. . . . Are they going to really talk it up to their friends? 'We went to this great place, you know?' Probably not, they are pretty generic—the parties are all the same. So they are not really getting an experience of what going to that place would be like. . . . They are just all very narrowly focused, the PR companies."[30]

Still, while public relations personnel might misinterpret Gladwell's concept of the socially dynamic connector, they are in agreement that the recruitment of celebrities and nightlife royalty for publicity-generating events creates value for their brands. This is largely because by publicizing the attendance of Philadelphia's hip and fabulous at their media-friendly pseudo-events, nightspots are able to attract the much greater masses of average-looking, thirty- and forty-something patrons (including tourists, business travelers, and suburbanites) responsible for filling up the restaurants, clubs, and lounges of the city on profitable weekend evenings. Negotiating this social terrain can be tricky business, as Starr himself told the New York Times in a story about his attempt to open a Morimoto in New York's Chelsea neighborhood. "Mr. Starr said he wanted to attract a combination of the hip, the cool

and food enthusiasts. 'But,' he added, 'regular people are the ones that will ultimately pay the bills, like the lawyers from Long Island.'"[31] Diana Redstone emphasizes the importance of this variety of bait-and-switch marketing: "Oh yeah, there's an article in the [South Jersey] *Courier Post*, a feature—'Hot Nights, Cool Bars'—and they love to be in that, all my Philadelphia clients. . . . As soon as people read that, they are coming over immediately, *immediately*."

Yet in the same breath, Redstone and Roberts identify southern New Jersey residents as "Ben Franklin–Walt Whitman," named after two of the bridges connecting Philadelphia to the New Jersey side of the Delaware River. Just as New Yorkers denigrate the many commuters who drive into Manhattan for their evening kicks as "the bridge-and-tunnel crowd," Philadelphia nightlife mavens retain similar prejudices against the city's suburbanites. Public relations personnel walk a fine line in their selling of urban nightlife to this less prestigious yet extraordinarily lucrative market because while suburbanites represent a highly profitable and reliable clientele, their image conflicts with the status and exclusivity that publicists want consumers to attach to the branding of the nightclubs and venues they promote. As Redstone notes, "I think that you need a core customer, but our goal is to make sure that the VIP rooms always have the best people in them." Ultimately, for Redstone and Roberts, the goal is to create the sort of "place that everybody that lives in South Jersey *wishes* they could get into. . . . These people may say, 'Well, I can never get in on a Friday night, but I am going to go on a Thursday. . . . Or, I can definitely get in on a Wednesday. . . . Or, I have to go before twelve.'"[32] Or, as Danny Lake points out, "if you build it for the hip and cool, and for the young, the older patrons that converge on the product are going to feel hip and cool and young. If you build it for the older people, you are never going to get the younger people." The end result, however, is still the same: a nightspot full of middle-aged strangers from New Jersey, all hopeful that Ashton Kutcher, Paris Hilton, and the Strokes are all lounging away in the VIP room with all the other big-city hipsters and youthful television stars.

In the classic confidence game, swindlers recruit accomplices to perform the small but necessary role of "innocent" bystanders who encourage the mark to follow through on a proposed deal or gamble. During the production of a rigged betting game like three-card monte, any number of accomplices, or *shills*, will play the role of seemingly trustworthy onlookers ready to cheer on the participants at the moment the mark arrives at the table, in the hopes that he or she will volunteer to pony up a wager themselves. In doing so, shills and other confederates contribute an "atmosphere of synthetic excitement" during the climaxes of shell games, staged encounters, and other hustles performed in public.[33]

The support personnel hired by music venues and other night-life establishments (bartenders, servers, bouncers, DJs) are often called upon to perform similarly deceptive ruses. The emotional labor required of female servers in particular includes handling rude and suggestive comments from slobbering male patrons with playful come-ons and tactful wit, all while balancing unwieldy cocktails on small trays for hours on end.[34] These deferential roles draw on the most simplistic of male heterosexual fantasies; for example, at franchised bars such as Coyote Ugly, young, tightly clothed female servers flirt with their male customers, ply them with body shots, and dance provocatively on the bar in a dripping shower of soda water. Of course, such establishments merely represent tamer, PG-13-rated versions of the city's high-end gentlemen's clubs such as Delilah's, where G-string-clad strippers perform $20 lap dances for bachelor parties and ogling businessmen.[35]

For seasoned consumers desiring a more seemingly authentic environment, these sexual performances can evoke feelings of guilt or else come off as uncomfortably transparent. In response, one Philadelphia PR firm has taken a bold adventure into the depths of *reality marketing*. According to Katie Klein, the founder of the Katie Klein Company, for a fee of $500 per week, a client can arrange to have Klein, along with her paid team of four attractive female friends,

patronize their nightclub or lounge with the expressed purpose of engineering a fun-loving, party-hearty environment, all without disclosing their contractual relationship with the client to fellow revelers. En route to the club, each teammate sends a text message from their cell phone to twenty good-looking, fashion-forward acquaintances alerting them to show up at the establishment, where they will inevitably spend money as well as enliven the setting. The next day the team posts detailed reports on the Internet about last night's fun at this-or-that swanky lounge—again, without revealing their identity as paid nightlife promoters.

Klein explains how she conceptualizes the art of reality marketing:

> I think that PR is what happens by accident, when you've got something interesting going on. So my whole focus was to make something interesting going on for these bars. And the lowdown about work—basically, we have a team of really desirable, young, hot women and we go to a bunch of different spots. We have kind of built ourselves up to be these celebrity types in the city that everybody wants to know. . . . Everybody hears about where we are going, and then we just talk about the places that we are representing. So it's like we are paid to go to these places and then talk about them.

The women who make up Klein's team are nightlife industry personnel and creative types in their mid-twenties whom she describes as "the social leaders of their groups of friends." In former lives they worked as bartenders, photographers, designers, stylists, restaurant managers, and in one case a promotional model for a liquor company. Like such models, their success depends on their ability to charm a large room full of customers, to create an atmosphere of artificially delicious fun where, according to Klein, "all eyes are on us":

> Everybody is dressed up; we get people to dance on the dance floor. . . . I always made a joke—you know how when you are younger and you go to a bar mitzvah, and the DJ has one hype girl

that gets everybody dancing and kind of gets everybody to calm down a little bit, to have a little bit of fun, loosen up? It's like that's what we are doing if we are at these clubs. And you know some of our clients would even come and be like, "All right, it's that crucial time. If nothing exciting happens, people are going to start leaving; it's starting to get a little stale." All of a sudden, we'd show up and it's like two people go and start dancing and pull their friends onto the dance floor. And two other people are, you know, have a booth on the side and are laughing and telling stories, and there is just a certain energy. It's not tangible, but when it's at a party, it makes the party so much better.

During our interview Klein is very upfront about the central role that sexuality plays in their overall performance of sociability: "Obviously, in the nightlife business, hot young women are going to be more successful at getting people to come out to places. So wouldn't you rather accept your drink from a hot girl than just some dude in a suit?" But in addition, the team behind the Katie Klein Co. succeeds not only because of their sexual allure in the context of the cocktail bar setting, but also their collective influence among other support personnel who labor within Philadelphia's nightlife industry—the bartenders, servers, cocktail waitresses, disc jockeys, and club owners who wield high levels of nocturnal capital and therefore represent the most truly connected and influential cultural tastemakers in the city.[36] According to Klein:

It's no lie that people use hot girls in the nightlife industry, exactly like liquor promotions, promotional modeling. . . . A lot of times they just want a pretty face, they want eye candy, they want someone hot, you know in their bar because, obviously, they always say where the women are, then the men come. But the thing about all the girls that I am working with is they *happen* to be hot. They are the types of people that know everyone in the city; you know, that energy that I was talking about, it's really their influence. They are the kind of people that if they say go to

this place on Friday night, then fifty people are going to go to that place on Friday night. So it's really about, they are very powerful, they are very influential, maybe without even meaning to be or knowing they are. So we have all kind of naturally evolved to be in this business and then kind of hooked up and started working together because it made sense.

But none of it was contrived. . . . It's not like I thought ahead of time, "I'm going to go look for four hot girls that can help me do promotions in nightlife." It's like everyone, you know they are almost like the popular girls in high school and it still comes down to that. These are the popular girls of the city that are telling everyone where to go and what to do, and we have been able to put it on paper as a contract so that it makes sense for these bars.

And so the truly postmodern quirk of Klein's business plan is that she is essentially paid to be Katie Klein as she luxuriates in the hottest nightspots of the city, a nightly ritual that she claims she was only recently giving away for free: "It is just the everyday living of your life and the certain things that you do when you are twenty-something, living in the city, going out all the time, single, no obligations. . . . I just think I am smart enough to have thought how to make money off of it." In fact, since she has discovered the market value of her participation in the city's nightlife scene, she will only patronize venues that contract with her for paid services.

It is very valuable and it could be done anywhere, but we won't bring it anywhere. We'll just bring it to the places that we are being paid to bring it to. So we definitely can manipulate the crowd and the atmosphere, and we definitely can engineer it . . . and we know that, and so we are very careful not to do it to places unless we are getting paid for it. . . . I know how much a bar can benefit from it. So unless I am going to be compensated for that, you know, just like any other job, that's our business.

I know that there is a certain amount of credibility that I may lend by going to these certain spots. So I am very particular and

protective of that. . . . I don't even want to go to a party unless I somehow have some involvement and am getting paid in some way. And removing it from me: Just because this character of Katie in the Katie Klein Co. is supposed to be this nightlife expert and, you know, it does lend credibility to these places that I am going to, so I don't even like to go to a party unless I am being paid for it or in some way compensated. . . . It's an image. I mean, essentially what we are doing is people are paying for the associations. We have built characters that are supposed to be nightlife experts, and so people are paying for the associations. So I don't like to necessarily give that away. And like I said, that's my business. That's why I wouldn't want to do it for free.

This desire for payroll status among nightlife consumers extends to amateur publicists as well as professions like Klein. In October 2005 Penn's newspaper, the *Daily Pennsylvanian*, reported that four undergraduate students received regular cash payments, beverage tabs, and complimentary meals from the owner of Marbar, a West Philadelphia nightspot near campus, in return for promoting the establishment to their circle of friends and fraternity brothers. According to one of the students, "You are in charge of getting people there, but the goal is to get money from those people to make the bar successful . . . and to not make it seem like you're using them."[37]

REALITY-MARKETING REALITY

What is perhaps most fascinating about reality marketing is that it represents the hustle of public relations taken to its logical conclusion. At one time public relations personnel simply sent out press releases and cold-called the media in the wake of identifiable news; this progressed (or devolved) into event planning and content programming as a means of creating reportable items. But in the case of the Katie Klein Co., *public relations personnel have become the content itself*, morphing into the main attraction that seduces everyday patrons

into a false sense of reality. Of course, the same could be said of Diana Redstone and many of the city's other PR agents. As Jessica Pressler observes of the current state of affairs in the promotion of urban nightlife in Philadelphia, "The publicist isn't just selling the drink—the publicist *is* the drink."[38]

Of course, not all publicists desire this kind of spotlight, preferring to work their stagecraft behind the red velvet curtain. As one of the top PR agents in the city remarked to me in her explanation for refusing to be interviewed for my book alongside Redstone, Roberts, Klein, and Lake, "To be honest with you, I'd rather not. I just don't want to be included in that group. We generally prefer to stay behind the scenes and give the limelight to our clients."

But the pendulum relentlessly swings both ways, particularly when publicists wind up getting hired to perform as party revelers for *another* publicist's event. Klein describes the promotional event for which Redstone Productions hired her out to be Katie Klein, to engineer the fun that the invited guests could not be counted on to generate for themselves.

> It was for *Esquire* and it was at Brasserie Perrier. . . . And the way they put it to me was they wanted to make sure they got some good fun people to be there, so that it would make the party fun . . . and they knew I would never come to this party if I wasn't somehow involved in it. . . . Bottom line—I got paid to go to a Redstone party.
>
> It's like we've made ourselves the local nightlife celebrity. . . . They wanted me to come so that I would bring some fun people so that the party would be fun, because they are aware of that intangible thing that you need at an event.

One can only imagine an absurdist world in which all events are pseudo-events, with all the necessary participants in on the joke: the hosts offering their false smiles; the guests pretending to have a wild time; the journalists complicit in the contrivance of the event

as "news"; and their savvy readers taking in this whole charade with a wink and a smirk. And yet this is the reality of reality marketing, a series of hustles for which there are increasingly fewer and fewer marks—as long as you don't count the clients themselves, as the publicists take the money and run while everyone else drinks for free, gift bags in tow.

4

WINNING BAR

NIGHTLIFE AS A

SPORTING RITUAL

The preceding chapters illustrate how cultural producers manufacture and promote the nightlife of the city and its glamour by relying on the art of the hustle and its many techniques, including the staging of restaurant and nightclub interiors, the scripting of interactions with customers, the exploitation of attractive women workers, the engineering of creative publicity and editorial placement, and the employment of reality-based marketing schemes. Of course, it would be naive to assume that all consumers blindly fall for these dodgy gambits. Many diners and nightclub patrons are sufficiently wary of the emotion work performed by bartenders and servers, and critical of the sexist procedures used for hiring cocktail waitresses and hostesses. Others are quick to point out the inconsistencies in menu pricing and food preparation, and easily recognize the staged artifice of Pod, Morimoto, and similarly theatrical Starr restaurants and their copycats.

However, just as movie buffs willfully ignore the well-known realities of film production (elaborate scripting and blocking of actors, use of stuntmen and body doubles, multiple takes, computer-generated imagery, sound effects editing) in order to blissfully enjoy

their popcorn thrills at the cineplex, nightlife consumers often find that it is also in their best interests to suspend disbelief—all the better to enjoy the excitement of urban glamour, no matter how contrived. More cynical consumers take pleasure in gleefully deconstructing the more transparent gimmickry employed in local hot spots—Barclay Prime's White Castle–inspired Kobe beef mini-hamburgers, or "sliders"; Alma de Cuba's Chocolate Cigar (an almond cake wrapped in chocolate mousse, dusted with chocolate, and served with *dulce de leche* ice cream); Continental Mid-Town's peanut-butter-and-jelly-sandwich cookies—while ironists playfully plunge headfirst into such silliness, lapping at the trough with a wink and knowing smile.

Young consumers experience a variety of contradictory emotions upon discovering the hustle of urban nightlife. Certainly, some club-hoppers (particularly those who are underage) approach Old City's exclusive velvet-roped nightclubs with wide-eyed awe and anxious desperation. They wonder, *"How will I ever get in? Can I afford the steep cover charge? Will I get served once I gain admittance? Is this where the city's most beautiful people rendezvous, and am I hot enough to be included in their company?*

Yet in the face of anxiety, plenty of young men and women respond to the exclusionary world of urban nightlife as if it presented a challenge worth subduing. Consequently, they turn their entire evenings into a series of *sporting rituals*, or cultural scripts oriented around competitive gamesmanship and strategic interaction. Negotiating nightlife scenes drives young people to engage in sporting rituals that incorporate the skills of the hustler and the confidence artist. They include the art of imposture through fashion, grooming, and style, and the performance of social status through effective techniques of role performance and theatricality. These sporting rituals demand a reliance on trusted confederates when approaching strangers. They additionally require the targeted deployment of physical dominance and dexterous wit necessary for buttering up bouncers and bartenders, tactfully sliding through crowds, slipping in and out of conversations, and disarming the most protective of souls. The anonymity of the urban metropolis makes these sporting rituals possible for young people to perform in public, and in some instances may even

require them as a condition for participating in the nightlife of the city in the first place.

The sporting ritual represents a kind of hustle designed for negotiating the city at night, and young people enduring the rocky transition from adolescence to adulthood perform such hustles with varying degrees of skill, and all under tremendous pressure to avoid embarrassing themselves in front of their peers. These sporting rituals include *the masquerade*, *the girl hunt*, and *winning bar*, and illuminate how young people experience urban nightlife as a rite of passage. The city's downtown entertainment zones—along with their many restaurants, nightclubs, and cocktail lounges—represent an upscale playground where affluent young adults prepare for the postadolescent life by learning, practicing, and refining a set of nocturnal selves and high-status cultural competencies. This playground provides the theatrical backdrop where these young people perform the art of the hustle before an audience of anonymous strangers.

THE MASQUERADE OF URBAN NIGHTLIFE

For most affluent young women, urban nightlife almost always presents opportunities for masquerade. It begins with the everyday strategies of impression management required by contemporary gender norms and ideals of feminine beauty and sexual attractiveness. As Simone de Beauvoir observes in *The Second Sex*, a woman endures many burdens, not the least of which is the expectation that she will exert great effort to adorn herself in her "evening costume" so that she is "disguised as a woman," just as Erving Goffman describes the arduous performative aspects of playing a woman as a "pose," as "a mask of manner." Both remind us that femininity itself is an accomplished performance, and its success requires a great deal of strenuous training, preparation, and expressive control.[1]

Abigail, a nineteen-year-old sophomore, describes her own laborious preparations for an evening at Tangerine by listing off the endless catalog of activities and accessories necessary to pull off such a production:

I undergo the usual one-hour getting-ready ritual of showering, ironing my hair, and applying my makeup, which all takes a combined thirty minutes. The rest of my time is spent pondering over the most important question of the evening: "What am I going to wear?" After trying on about five pairs of jeans, all Sevens and Diesels but varying slightly in shades of washed-out-ness and having rips in slightly different places, I finally decide on my lightest Sevens. Then I spend the rest of the time accessorizing the outfit with a hot pink belt and fun earrings. . . . After frantically running around my room collecting my belongings for the evening (the usual—wallet, cell phone, keys, gum, mints, lip gloss, lip liner, and any other makeup that I can squeeze into my undersized but fashionably overpriced Christian Dior handbag), I'm finally ready to go. "Oh shit, what jacket should I take?" I throw about six jackets off my coat rack, [my boyfriend] grabs my long, black, puffy one, and we're out the door.[2]

While women's daywear is notably varied in style, formality, and level of androgyny (particularly on university campuses, where both male and female students commonly wear sweatpants, flip-flops, and baseball caps to class), downtown nightclubs and upscale restaurants demand a more precisely gendered uniformity in fashion.[3] In keeping with those structured tastes and expectations, college women model themselves at night according to high-status feminine norms as expressed through brand-name fashion and celebrity style. While exceptions obviously prevail (as they inevitably do), the standard nightlife attire for women typically consists of "premium" or "luxury" designer denim jeans (currently represented by labels such as Seven, Diesel, and Dolce & Gabbana), dark revealing tops, and impossibly high-heeled shoes.[4] As Cynthia, a twenty-year-old sophomore, remarks on her preparations for dining at Tangerine: "I knew this place was really trendy, so I wanted to dress the part. That includes Seven jeans, a James Perse off-the-shoulder black shirt, and of course stilettos. I knew it was going to be an older crowd, and I didn't want to look like a college student."

The ubiquity of stiletto-heeled shoes among affluent young women merits special attention. In her 1963 exposé "I Was a Playboy Bunny," Gloria Steinem reports on the footwear policy of the New York Playboy Club, a source of Steinem's permanent scars from her employment—including the half-size enlargement of her feet. As her club's wardrobe mistress demanded, "Make sure you get three-inch heels. You'll get demerits, you wear 'em any lower."[5] Decades later in a turnaround that must fill every second-wave feminist with dread, stilettos regained popularity in the 1990s when British designer Manolo Blahnik's oppressive mules were worn by (and relentlessly photographed on) notables from Madonna to Princess Diana and television characters from *Sex and the City*, *Absolutely Fabulous*, and even the animated sitcom *The Simpsons*.[6] Today high-heeled stilettos once again serve as a common piece of sexual armor in the arsenal of women's nightlife fashions, even among teenagers. In spite of the protests of some young women—"I don't like wearing heels; I feel uncomfortable; I feel like I am going to fall or something"—others argue that the exaggerated heel size gives a much-desired height augmentation to short women who want to literally level the playing field of the city's nightspots. Speaking in a focus group of sophomores, Cory remarks, "I am just really short. . . . I am five two. People always look down on me. Heels just give me a little help in this department. . . . I just really need the height. Most of my guy friends are six foot two-ish and most of my girlfriends are at least five five—at home most of my girlfriends are five seven, five nine—so I definitely I need height just to catch up to them, for that reason alone."

Another group of sophomore women led by Lauren, a college senior, associate the erotic properties of the pencil-thin high-heeled shoes with their own coming-of-age: "To me it's mood altering, almost. I feel like stilettos are kind of symbolic of sexuality. Like when I was ten, I was *not* wearing stiletto heels. I distinctly remember what my first pair of stilettos looked like, and I was so happy to have those things it was unreal."

"I think you walk a different way, too."

"Yeah, exactly."

"When you say you walk a different way, what do you mean?" asks Lauren, the group leader.

"It changes, you feel a little more confident."

"I guess part of it is just the way the heel is shaped—you have to walk a certain way when you wear them."

"Otherwise you look like a goofball."

"They make you focus a little bit more on how you are walking than just walking around in flats."

"And like when you are wearing a skirt with stilettos, it makes your legs look better and longer. It's kind of like a confidence booster in a way."

Just as they do with shoes and clothing, young women describe their cosmetic preparations for the masquerade of urban nightlife in strategic terms as well. According to Deborah, a twenty-year-old junior:

> Since Continental is a very trendy Stephen Starr restaurant with an average patron age between twenty-five and thirty-five, I had to make myself look older through hair styling and makeup. I applied a white base eye shadow, a light pink shade to the middle of the eyelid, and a dark charcoal shadow at the base of the eyelid. I was taught this makeup trick by my older cousin, who says this is a professional technique used to make the eyes look larger. I straightened my hair with a flat iron and a blow dryer and flipped under the ends of my hair to create an older, more sophisticated look.

In addition to expressing a highly strategic orientation toward her presentation of self, Deborah's remarks are notable for two reasons. First, her confidence in the aforementioned "makeup trick" relies on the merit she attributes to the "professional" (whether real or imagined) basis of the technique and the folk wisdom of her "older" cousin: both suggestive of the authority she invests in adult status (relative to her age and life experience) as an objective measure of one's expertise in the area of gendered impression management.

Moreover, Deborah's attempt at forging a "more sophisticated look" suggests a feminine performance of upper-class status. Like gender, the dramatization of social class requires the accomplishment of a related set of styles, gestures, and behaviors considered culturally appropriate to a given status category and recognized as such in public.[7] Just as young women desire to exude maturity and adult sexuality, and often succeed in spite of their young age and otherwise adolescent appearance in less formal contexts, the enactment of elite class status as a wholly contrived presentation of self is hardly limited to those who hold such lofty positions, as becomes readily apparent in depictions of confidence artists from Patricia Highsmith's The Talented Mr. Ripley to reality TV's Joe Millionaire.[8]

Still, for the uninitiated, a performance of high-status savoir faire can come off with varying degrees of success. According to Eve, a twenty-year-old junior with plans to dine at Alma de Cuba, attempting such a role without the requisite cultural capital necessary to pull off such a caper presents an array of anxiety-producing challenges:

During the day on Friday, I couldn't stop thinking about what I was going to wear. I had never been to a place like this before, and no one I knew had ever gone, so I didn't know what would or would not be appropriate. I finally decided that I would wear an aquamarine wool/silk turtleneck, a short, brown tweed-patterned skirt, nude stockings, and brown slingbacks. I had showered earlier that day and straightened my hair, so I only really needed to shower my body, not my hair. After I got out of the shower and dressed, I re-straightened my hair and put on makeup.[9] I wore my hair down, and my makeup was relatively the same as it usually is when I go out, except I wore my lipstick slightly darker (for a more grown-up look). Unfortunately, I did not have a pair of nude tights, so my boyfriend and I had to quickly go to CVS to pick a pair up before we went to the restaurant. I was dashing around and getting strange looks from people as I put them on in the car. . . .

As were walking up Walnut Street, I could barely keep my shoes on my feet, literally! Because they were slingbacks, they

couldn't grip anything because I was wearing stockings. I started to feel like people were looking at me; I started to doubt my "sophisticated" style that night. The streets were crowded with young adults, and I was feeling like a kid. I shook it off, and we finally made it to the restaurant.

For young people undergoing what has become in recent decades an elongated transition to adulthood, adopting a grown-up style is always an inherently risky proposition. This is particularly the case when such an appropriation includes a so-called "sophisticated" wardrobe of short skirts, stockings, and slingbacks borrowed from the glamour-drenched divas and dating games portrayed on popular television shows like *Sex and the City* and *Ally McBeal*, women's fashion magazines from *Vogue* to *Cosmopolitan*, and cheeky chick-lit titles such as Lauren Weisberger's *The Devil Wears Prada* and Plum Sykes's *Bergdorf Blondes*.[10] For Frida—a Chinese-Swedish sophomore going to Red Sky, an upscale restaurant and nightclub in Old City—role-playing represents a self-conscious process of negotiation in which one inevitably settles for seeming at least a little out of place:

> The clientele was definitely older than my nineteen years, and I felt like a little kid playing grown-up. The few men at the bar were wearing slacks and button-down shirts, while the even fewer women wore either dress pants or nice jeans with heels and a nice shirt. No sneakers to be found anywhere. Sophia and I were definitely overdressed for this bar. . . . We were both wearing cocktail dresses, but I decided that that was better than being underdressed and the youngest person there.

Both Eve and Frida describe the sensation of feeling "like a little kid" even when donning slingbacks or a cocktail dress. In these instances, such attire wears more like a Halloween costume than a well-worn outfit. In fact, for young people "playing grown-up" often involves the contradictory demonstration of juvenile inexperience in a world of adult expectations.[11] Once Abigail (the nineteen-year-old sopho-

more) and her friends arrive at Tangerine, they attempt to conceal their display of an inappropriate yet all too conventional adolescent faux pas:

> I chose my typical apple martini, never veering from what is an excellent drink choice. I then realized I had gum in my mouth, which is most certainly not a surprise, and had to figure out the most discreet, polite method of disposing of it. [My friends] revealed that they also had gum in their mouths, and I volunteered to have everyone spit their gum in my hand so that I would have an excuse to [visit] the bathrooms. Okay, so maybe this wasn't the most discreet, polite method, but it worked.

For some young women, the challenge of contriving a more mature appearance is purely expressive and rooted in a desire to achieve a heightened sense of adult sexuality and social status. Strategies of impression management among Penn women range from donning push-up bras to indulging in elective nose reshaping and breast augmentation surgery.[12] But for others, particularly those underage, full-fledged participation in the nightlife of the city additionally requires that they successfully masquerade as twenty-one-year-olds. According to one female student, "I hope that when I go to a bar, people can't recognize me as underage, so maybe that is one thing about when you dress up to go out—I try to be older. When you are going downtown, you want to look older, present yourself as older than you are."[13]

Young women describe a variety of strategies for pulling off such an imposture. Some express the challenge as one of face-work at the moment of interaction with a doorman or bartender. According to Kristen, a junior: "Don't waste a lot of time—act like you belong inside, and not like you are a little child trying to sneak through the doors." Young women also gain encouragement from their abilities to choose an appropriately "grown-up" cocktail (they cite cranberry vodkas and sour-apple martinis as no-no's), calmly order, and graciously tip their bartender without giving themselves away.

Many young women will additionally manipulate their appearance in order to appear older, whether by laboriously straightening their hair, applying makeup (but not too much makeup, they insist, or else they might look like a "clown"), or wearing expensive designer clothes. In some ways, the effort itself makes them feel more grown-up and conveys to outsiders an expertise in self-presentation, although as Felicia, a sophomore, observes, "You don't want to look like you are trying too hard." Since so many undergraduates rely on counterfeit identification to gain entry into bars and nightclubs, some dedicate their time not only to masquerading as older women, but specifically as the older women depicted in the photographs on their fake IDs. According to Sharon, "With my ID, the girl that's on my ID has long blond hair. So I always make sure my hair is down, and so I at least look like her." To ease this transformation of self, many young women appropriate the driver's license of an older sister or other closely related lookalike. (The familial tie also makes it easier to remember the name and address on the ID, just in case the bouncers quiz them.)

For others, the challenge of the masquerade is interpreted more explicitly as one of sexual display. Just as when wearing cosmetics, upon choosing their nighttime apparel, young women must walk the narrowest of tightropes in their attempts to dress in sexually attractive attire without coming across as stereotypically "trashy" or "cheap" in public according to middle- and upper-class norms of propriety.[14] Nevertheless, for underage nightlife consumers, access remains a paramount concern, which often encourages pandering to the sexist expectations and discretions of male bouncers and security guards. According to Carol, a sophomore, "I've actually noticed that the way I am dressed sometimes makes a difference. Like one night I went out wearing a T-shirt and jeans and a blazer—definitely a cute outfit—but my cleavage was not out in any way, and I got denied twice using an ID that I always get in with. And then on other nights, it's like not even a problem when the boobs are out." Felicia acknowledges the persistence of this sad state of affairs: "If you are wearing a low-cut shirt, you have a much easier time getting in. It's true—sometimes they won't look at your ID as much. . . . Lower-cut

shirts, higher skirts, higher heels . . ." Or as Mandy, a junior, remarks of many male nightclub bouncers, "Show a little skin and be a little flirty, and then they don't care."

MALE VANITY AND METROSEXUALITY

If these young women unfortunately seem to conform to a stereotype of the urban female as overly concerned with her appearance, they hardly differ much from their heterosexual male counterparts. Just as Abigail, the nineteen-year-old sophomore, juggles multiple pairs of Sevens and Diesels, Ryan, an upperclassman, describes his hierarchy of dungarees suitable for eveningwear: "I have different levels of jeans. I have expensive jeans that I'll basically just save for the nights when I go downtown that I won't ever wear around [campus]." Bill, a twenty-year-old sophomore, challenges typical assumptions about the carefree slovenliness of the modern straight man:

> After my shower, I headed back to my room to change, and as is often the case, I tried on four pairs of pants and five button-down shirts before selecting my "choice" outfit. My choice of clothing was determined by the following: Before ever attending Denim [a Rittenhouse Square nightclub], I was under the impression that it was one of Philadelphia's premier social scenes. I went with a blue, yellow, and green Burberry button-down shirt, gray flat-front pants from Express Men's, a lucky pair of Hawaiian shirt-style boxers, and black Prada shoes.

Like similarly aged women, a weekend night on the town presents itself to young men as a kind of masquerade as well. By dressing up "without the glasses" and in a "messier, higher, and spikier" hairstyle, Evan, a straight twenty-four-year-old senior, jokes that his expensive attire and application of fashionable facial products suggests a transformation of self that makes him "feel like Clark Kent and Superman":

I showered and put on my gray Diesel jeans and white long-sleeve undershirt. Over my long-sleeve shirt, I chose to wear my stone-gray and navy blue–trim Asics T-shirt that says "Onitsuka Tiger Japan" on the front. I put on my contacts and unscrewed my orange peel molding crème hair product—controlled messiness, with the front part of my hair really high and spiky. I slid on my retro ACG Nikes and went back to the bathroom for the final touch. Which cologne? Dolce & Gabbana, or Creed?[15]

Affluent young men prepare for their evenings out by crafting a highly stylized and tirelessly groomed performance of sexuality, in this case one deemed attractive to young heterosexual women.[16] According to Tyler, a nineteen-year-old sophomore:

> When I go out, I love meeting new people, especially those of the opposite sex. With this in mind, I take pride in getting ready before I go out. I try to wear certain clothes and scents that are palatable to females. This process includes taking a shower, putting on deodorant, aftershave lotion, cologne, and my "clubbing clothes," which are comprised of jeans and a dark collared shirt. The process of getting ready usually takes anywhere between ten and twenty-five minutes.

Tyler is confident that his preparations are well worth the trouble: "Back at the club I was very thankful that I spent a good amount of time getting ready because there were some very good-looking women." But even as men rely on some of the same exact strategies of impression management as women, they try to distance themselves from what have traditionally been considered feminine grooming activities.[17] For instance, since dressing up is not necessary compatible with conventional visions of masculinity, men will often expend much effort to contrive a "devil-may-care" look, as if their appearance requires no preparation at all. According to Sammy, an eighteen-year-old freshman:

I showered, gelled my hair, applied deodorant and cologne, and gargled Listerine: the next step was getting dressed. I am not nearly a trendy guy; however, I do recognize that my attire reflects my personality and image to some extent, so I am careful when deciding what to wear. I picked out a recently purchased long-sleeve, button-down Tommy Hilfiger shirt and a pair of khaki pants. I had a white T-shirt underneath, and I left the top button open, giving me the desired "I don't care how I look" image.

Edward, a twenty-year-old sophomore, cynically describes his preparations for a night of club hopping with his friend Jordan by emphasizing the strategies of impression management necessary to pull off such a feat, apologizing each step of the way:

Jordan and I go way back. He is the kind of kid whose insecurities manifest in him trying to make himself as trendy and fashionable as possible. He is what is commonly referred to as "metrosexual." Jordan was wearing designer jeans with strategically placed tears and some burgundy shirt that looked like a hybrid silk-and-velvet material. All this was topped off with a strategically placed wristband (which I refused to let him wear). Judging by Jordan, he dressed for the club in a manner that made him look as wealthy, hip, and attractive as possible from the assets he had.

Upon critiquing Jordan I realized I fell into the same category. I also tried to make myself look as nice as possible with the limited wardrobe I had. I wore a pseudo-designer shirt, jeans (that I stole when I worked for Abercrombie), and a pair of nice black shoes. . . . Our dressing styles represented a microcosm of male American men trying to ingratiate themselves to a more affluent lifestyle and social group. It didn't so much concern us that we were becoming part of a stereotype, because in the end you have to dress this way if you want to get laid. I hadn't hooked up with a girl in a couple of weeks, and I needed to break my slump (the

next girl you hook up with is commonly referred to as a "slump-bust" in my social circle). So I was willing to dress in whatever manner would facilitate in hooking up.[18]

In his strategic preparations for meeting women in the city at night, Edward only tentatively embraces what he refers to as the slickly stylized guise of a so-called "metrosexual" since it contradicts his vision of an appropriately *heterosexual* masculine performance. As reported in the *Washington Post*, a metrosexual "is a straight man who styles his hair using three different products (and actually calls them 'products'), loves clothes and the very act of shopping for them, and describes himself as sensitive and romantic. In other words, he is a man who seems stereotypically gay except when it comes to sexual orientation."[19] At the very least, Edward is willing to forgo a more rugged, detached performance of manhood in exchange for success at "hooking up," for him the ultimate expression of masculinity, particularly as filtered through the collective expectations of his collegiate peer network.[20]

Gay men are often stereotyped as being more concerned with body image and fashion sensibility than their heterosexual brethren, and certainly many internalize these social expectations. According to Bradley, a gay nineteen-year-old freshman:

My night began at 10:30 p.m. on Wednesday when my friends came over to my room . . . but my preparations for my evening began before that. Earlier that night I had gone to the gym to work out. I knew that if I wanted to look like anything close to all those guys that look perfectly toned and like they just stepped out of the gym, I would need to lift some weights before I went to Woody's [a downtown gay bar]. With the intense obsession with body image that is rampant in the gay community, I often feel the pressure to have that "perfect body" or something close to it if I want to pick up a guy when I go out. I got back from the gym at 10:00 p.m. and took a shower. After meticulously picking out what I was going to wear and trying it on for my next-door neighbors, I was ready.

However, while women and gay men are generally stereotyped as being more concerned with fashion and grooming than their straight male counterparts, their habits are not as different as one might suspect. In fact, the metrosexual look is fairly common among straight and gay affluent young men, just as a wide range of men have popularized other formerly gay signals (such as wearing earrings in both ears). In my one-on-one interview with Miles, a gay junior who is also a member of a traditional campus fraternity, he revealed that straight male students wear designer jeans as often as women and gay men, and similarly take their time preening for a night out:

It's surprising how pretty fraternity boys are, in terms of how much time they take to get ready. I mean, having lived in the house, I definitely know they take just as long as I do. So it's not related to sexual orientation at all—or maybe it is, and they are all just repressed. But they all wear the same stuff. . . . They definitely wear "designer." Not like "designer" in the sense of high-end designer, like Dolce & Gabbana or one of those fashion houses, but better than mall stores—in between the two. Especially at a place like Penn, where people seem to be much more conspicuously consuming what they wear, where everything is a parade, the guys definitely do wear very expensive clothes out. And not all of them, certainly, but a lot of them, and certainly the ones who are of that scene, the hip scene, the cool scene, because if you know where to go, you also know what to wear, right?

All of them spend a significant amount of time getting ready, and certainly go through nearly the same steps. I will say that I am probably more conscious of it than they are, in terms of my appearance and how I look. I definitely feel much more aware of that than they do, in my mind. But at the same time, they have all the same stuff—most of it is, in fact, nicer. They are all Easterners, so I guess they are accustomed to that whole thing, but they do the same thing with the face washes, and the creams, and the hair gel. . . . But anyway, when they get dressed, I think they are actually very similar to women in terms of the stereotype. They

will pick out several outfits. . . . I don't know who trains single straight men to behave in the way that they do, and then also to cover up for it. But they definitely do . . . even in our bathroom. It's weird in our apartment: whereas my stuff is all out, theirs is all put away, like it can't be seen, especially the high-end stuff. I mean, the stuff where they spent like $40 on some face wash and that gets put away. . . . And they don't really talk about it, except to like say, "Look, I am like you, Miles, it's like I'm gay—I'm using face lotion."

Many men (straight *and* gay) explicitly identify their elaborate preparations as overtly feminine and thus socially stigmatized to the point where they obligate themselves to defend their decision on the basis of their sexual pursuits.[21] As Jay, a twenty-one-year-old junior, reports:

It was to be a good, long night of partying, starting with dinner and ending with dancing. I got ready for the night in my usual way. I took my normal twenty-minute shower to start, and then tried on several outfits before deciding on a nice pair of jeans with a button-down shirt and aviator glasses to top it off. I put on my trusty old sport deodorant along with Polo Blue cologne (the ladies love this stuff) and a little wax-based hair stuff to keep my hair lively throughout the night. I brushed my teeth, tied up my shoes, grabbed my jacket, and headed out with two of my roommates. Some may call my grooming habits feminine, but hey, how are you supposed to attract women looking and smelling like a slob?

John, a twenty-one-year-old sophomore preparing for an expedition to Club 27, an Old City dance club, is similarly defensive while explaining his elaborate strategies of impression management:

I use Coconut shampoo, a particular favorite of one of my closest lady friends. I then pull out the razor and shave from my chest down past the mid-region. (It just looks better and feels smoother—don't judge me). I shave my face, put on some mild

aftershave and two sprays of Cool Water cologne, and brush my teeth. I perform all of these minor tasks with the future goal in mind of bringing back a girl, or multiple girls if I play my cards right. I run back to my room and put on the dark blue Banana Republic shirt along with my boot-fit blue jeans to accentuate my eyes.

Likewise, according to Jake, a twenty-three-year-old senior on his way to Finnigan's Wake, an Irish-themed bar, on a Friday night:

I started my evening off around 7:30 p.m. by showering and shaving and picking out my finest Abercrombie size small shirt that I could squeeze into. (My normal shirt size is a large to an extra large.) It's a bad fashion habit of mine—buying shirts that probably would have fit me when I was in third grade—but it's always good to look as buff as possible when you're going cruising for girls downtown. I always catch crap from my friends for this, but at the end of the night with a couple of new phone numbers in my phone, I don't seem to mind.

THE PREGAME SHOW

After these cosmetic preparations for the night out have been made, young men and women commonly hunker down for the collective ritual known among American college students as "pregaming." Harry, an eighteen-year-old freshman, explains:

Given that this was a Tuesday night, I would not be accompanied by my usual cast of characters. . . . That didn't stop my other friends from drinking with us before leaving in what has become a sacred ritual, known as "pregaming." Pregaming consists of drinking with your boys so that you don't have to purchase as many drinks while you are out to feel the desired buzz. On top of being cost-efficient, the actual event of pregaming can get any group ready and excited to go out.

Students usually describe pregaming as an economical and efficient method of getting drunk on shots of bottom-shelf vodka, cans of Keystone Light, cardboard boxes of Franzia white zinfandel, and all other varieties of bargain-basement booze before going out into the city. Although colleges and universities have been cracking down on pregaming over the last several years, students continue to work around such measures.[22] Once again, according to Edward, age twenty:

> Jordan and I wanted to drink before we went out for three reasons. First, we are broke college students. Money is at a premium. So we wanted to drink alcohol in my dorm where it is cheap, as opposed to buying one beer for the price of five at the club. Second, drinking lowers your level of inhibition. . . . When I go out at night, I am typically a lot more affable, approachable, and charismatic. Alcohol facilitates my transformation into a more gregarious person. Last, we had an hour to kill before we were going to leave. Drinking seemed like a fun way to pass the time.

Edward defends pregaming for its utility: the ritual provides an efficient means of getting drunk *cheaply*, in order to offset the costs of drinking downtown; insures that one is drunk *prior* to going out in public, thereby decreasing their inhibitions; and offers a convenient means of *stalling* the more formal proceedings in order to hit the downtown scene at an optimally exciting time. Yet I would argue that something else is going on as well. For many young people, partying downtown may prove anxiety-producing since it entails the risks that come with breaking the law (at least for underage drinkers); negotiating the city at night and its anonymous world of strangers; and handling the stress generated by meeting new people, particularly potential sexual or romantic partners.[23]

Shown in this light, the goals of pregaming make a lot more sense. If interacting in public ordinarily fosters anxiety among young people, then some students may imagine that alcohol provides the liquid courage to relieve them of their nervousness. But more importantly, the pregame provides young people with a ritual of solidarity

designed to engineer cohesion within their peer group, in order to mentally prepare them to negotiate the human traffic of city night-clubs and bars, just as players on an athletic team might warm up together before a sporting contest. In the company of their friends, they are able to build up their confidence; the alcohol may start the party early, but ultimately it is the *sociability* of the gathering itself that lowers the anxiety associated with the challenges surrounding the experience of urban nightlife.[24]

For this reason, young people often structure the pregame around a series of competitive drinking rituals that while evidently designed for the efficient delivery of excessive amounts of alcohol to the brain, also function as machines for generating camaraderie and collective unity among participants, even as their behavior becomes increasingly slovenly and antisocial. Some students engage in racing contests by "shotgunning" cans of beer, while others join in a decidedly dangerous Power Hour in which contestants chug a shot of beer per minute for one solid hour—often in sync with customized music mixes that flip songs every minute. (An extended version of this vomit-inducing game called Century Club requires drinking a shot per minute for one hundred minutes.)[25] Other contests turn common parlor games into alcohol-soaked competitions, such as Beer Pong and Beirut (both variants on table tennis), Quarters (in which players bounce coins into a shot glass), or Kings (played with a regulation deck of playing cards). According to Thomas, a twenty-one-year-old African American junior, even informal coed drinking involves an organized pattern of action—lined-up cocktails, familiar toasts, and the use of nicknames geared to express intimacy among partners in crime as they nervously await the pressures of the city at night:

> I don't enjoy the club scene very much—I am too shy to approach strangers on the dance floor, and I don't like to pay the cover charges just to be a wallflower. . . . Knowing that I normally don't go to the clubs, [my friends] begin to plead with me to go. I only consent because another one of my housemates is going, so I will have a wingman once they start dancing by themselves. . . .

I am contemplating not going, but Jason convinces me that going to the club and having a good time is exactly what the doctor ordered. So, it is on to Phase Two of my preparty activities—relaxing the nerves with a little alcohol.

I pour out the correct number of shots of either the cheap vodka or the equally cheap rum, and line them up on the table. Everyone grabs their shot glass and waits for a toast to be offered. The first toast is a silly sorority saying: "This is to being single, seeing double, and sleeping triple!" It elicits lots of happy cheers from Johanna and her girlfriends, while Chris, Reefer, and I just down our shots. . . . Whenever we start drinking, we start using each other's nicknames. So as we continue to pound four or five shots, Jason becomes "Reefer," Chris becomes "Belly" or "Macho Man Savage," and I become "B. Jizzle," or "Jizz" for short (and it is a long story how I got that nickname that has absolutely nothing to do with what it sounds like it does).

WINNING BAR

Earlier I discussed how underage women draw on the art of the masquerade to gain entry into bars and nightclubs. Upon arriving at their destinations for the evening, young men also rely on a series of strategies for gaining entry to entertainment venues in the face of legal and emergent barriers and for negotiating the confrontational human traffic of excessively crowded public places. Just like adults, young people do not always enact these strategies in a self-conscious manner, and their tactics are usually less successful than originally anticipated. Nevertheless, the anonymity and competitiveness among strangers in the city makes the implementation of at least some types of strategic action both desirable and necessary for participation in scenes of urban nightlife, at least for these consumers.

Of course, these methods for achieving entry vary in degree of craftiness and sophistication. At the lower end of the spectrum, Edward, the twenty-year-old sophomore, describes what he refers to as his "'hot girl' strategy":

Dominic persuaded us that there were the most girls at Finnigan's Wake. He dropped us off there. Much to Jordan's chagrin, it was time to test out if his ID would work. . . . I was permitted in, but Jordan was not. . . . The battle was lost, but the war was still to be won. We walked the block and a half to Tiki Bob's Cantina. This time we were fortunate enough to walk behind one really attractive girl and her two friends. The bouncer almost let us in because he thought we were with the girl. But she was quick to dispel that myth, and we were sent outside again. Seeing that beautiful girls seemed to have more clout with bouncers than bad fake IDs, we decided to find some girls before we tried our luck at the next establishment.[26]

Jam-packed queues of eager would-be patrons signal a nightclub's fashionableness and exclusivity, which is why half-crowded establishments artificially burnish their desirability by preventing customers from entry under false pretenses. As these audiences wait in vain behind velvet ropes, the gathering queue showcases the club's inflated popularity to sidewalk passersby. Moreover, the extended wait increases anxiety among nightlife revelers, who impatiently wonder if they will ever get to the head of the queue to eventually gain the admittance they crave. Similarly, in his comparison of police techniques and confidence games, criminologist Richard A. Leo reveals how detectives purposely make their suspects stew in a secluded interrogation room for fifteen minutes before joining them, with the goals of augmenting their anticipation and anxiety level while simultaneously persuading them of their insignificance to the proceedings at hand.[27] Joey, an eighteen-year-old freshman, emphasizes the challenge of achieving entry to Red Sky while waiting on a queue of young warriors with stone faces but nervous bellies:

Once in front of the club, no matter if you were mad at someone or not, no one really communicates with each other. I looked around and saw each kid I had come with—each of them was peering around and checking out the whole situation outside the

club. Most of them had this mature and stern look on their face. I believe they were trying to look older so that they would get into the club. Everyone always gets a little nervous before getting into a club, and so no one really talks, just a lot of fidgeting. You always think that you're the only one that won't get in, and then what are you going to do?

I could see that each person was worrying only about himself and whether his/her fake ID would work. While the line moved up, we finally reached the front door. I witnessed a number of people try to make small talk with the bouncers running the club, really just trying to get in good with them. The bouncers looked stereotypically Italian and muscular, with gold chains and slicked-back hair. A couple of kids got laughs out of the bouncers and were let in. I tried to listen to what they were saying in the hope I could figure out something clever to say, but it's almost as if I froze. I couldn't think of anything quick-witted, so I figured I would try my usual—look cool and try not to stand out—which usually worked for me. I made sure not to look the bouncer right in the eye. I moved quickly into the club, but the bouncer stopped me and asked me my date of birth and my street address. I quickly rattled them off with perfection. I then said a couple of things in Italian because I am now enrolled in Italian 120 at Penn. I lied and told him that my dad is Italian and is from Milan. He didn't say anything but looked down at me, and let me go. He said in my ear, "Don't drink too much, buddy." I didn't respond and walked straight into the club, and gave a huge sigh of relief.

American nightlife establishments are caught in a bind as they are legally prohibited from serving affluent college students younger than twenty-one years of age—the very customers who possess the sort of disposable incomes, lack of familial and occupational responsibilities, and flexible waking hours that encourage unrestrained spending on excessively indulgent drinking, thereby contributing to heightened bar revenues. Given that according to the University of Pennsylvania's Office of Health Education, 37 percent of Penn stu-

dents (not including abstainers) enjoyed the majority of their alcohol consumption in bars and restaurants in 2001–02 (whereas only 17 percent of students did so in fraternity and sorority houses), it would appear that—at least in Philadelphia—local drinking establishments often turn a blind eye to underage drinking.[28] During the Barclay Prime staff meeting discussed in an earlier chapter, one of the managers explained why university students in particular may occasionally be given preferential treatment at expensive restaurants as well as shady nightclubs in Philadelphia:

> While we are on beverage, just some clarification here. As we get more popular, Starr Restaurant Organization restaurants are a draw to specifically University of Pennsylvania students. We need to be aware of our responsibility, legally, to not serve underage guests. My experience often has been that when someone tries to present a fake ID or get drinks, that sometimes we get indignant—we forget that we were once under twenty-one or used to get carded. *They may not be of age to drink now, tonight, but at some point they will, so we want to treat them courteously.*

Yet despite the potential revenue represented by affluent and spendthrift youth, service employees throughout the city share near-universal disdain for Penn students. As is common among college populations enmeshed in typical town-gown animosities of this sort, Penn students find themselves consistently singled out as an undesirable class of consumers assumed to be crippled by a combination of clumsy naïveté and upper-class snobbery. According to Jason, who recently tended bar at a restaurant just off the university campus:

> They are assholes. They are! They are elitist. . . . The problem is, and I guess it comes with the Ivy League territory—they feel like they are above us, especially waiters. Waiters are there to serve, and yeah, they are, but you don't have to be an asshole about it, and they are very *good* at being assholes about it. . . . Penn people, they are socially retarded. They don't know how to act. That's

the biggest indicator: they don't know how to act. It's like being in that environment is so alien that they act out of place. . . . It's like if you are not Ivy League they don't know how to deal with you because that's their world, and I guess some of it is being eighteen and being at an Ivy League school thinking, somewhat rightly so, "Oh, I am better than these people."[29]

Of course, Penn undergraduates are not necessarily distinguishable on sight from affluent students attending other local elite colleges and universities like Swarthmore, Haverford, and Villanova. (In this manner, the Penn student unfairly emerges as an imaginary boogeyman, stereotyped as characteristic of *all* obnoxious collegiate behavior in Philadelphia.) Consequently, when bouncers admit students of *any* university into their venues, they frequently treat them with condescension, even those of legal drinking age. Drew, a twenty-one-year-old junior, observes, "One club we went by, 32 Degrees, had a cover charge and it was past 1 a.m. already. We told the guy we weren't going to pay for less than an hour of being in there, and he said something about how 'we should go home then and play our Nintendo.'"

Remarks like these only add to the nervousness of college students attempting to gain entry to popular nightspots. Moreover, many nightclubs in the city enforce a prohibitive dress code that forbids clothing popularized by young black men but celebrated as a staple of global youth culture—long T-shirts, tank tops, baggy pants, athletic attire. For instance, at Tiki Bob's Cantina, a nightclub on the outskirts of Old City, this imperative could not be plainer; regarding their dress code, one employee revealed, "No Timberland boots, no jerseys, no hats, no sweats . . . *no ghetto.*" Given that young people representative of almost *all* races, ethnicities, and class backgrounds wear these kinds of clothes on a regular basis, such policies grant club bouncers and security guards a great deal of discretion when denying admittance to young patrons on the basis of appearance.

If and when young men actually do gain admittance to a bar or nightclub, next they must maneuver their way through drunken

crowds to place their order at the bar. This endeavor often entails bumping into strangers and their precariously balanced cocktails along the way, only to be rebuffed by a busy bartender who cherry-picks his customers based on their recent tipping histories. As Jason explains, "I bought two drinks the other night, and it came to $14. I gave the bartender a twenty, and I told her, 'Keep it.' It was the right thing to do. Number one, if I want anything else, that bartender is coming back. Because when you get tipped well, you pay attention upfront. You can even lower your tip ratio as the night wears on—as long as you have that upfront hit, that's what the bartender is going to pay most attention to."

I ask Jason, "When you are a bartender, do the tips keep you . . ."

"Attentive? Yes, if I know I am getting money, damn straight—whatever you want is going to be like *that*, even if I have to hop over other people."

For this reason, all newly arrived anonymous customers suffer a long wait for service during crowded weekend evenings at downtown bars and nightclubs, particularly university students whose reputation for being stingy (or more likely inexperienced) tippers precedes them. In the midst of this idle waiting, the defensiveness displayed by young men at this crucial stage of the evening cannot be underestimated. This is particularly the case when they are in the company of a desirable female companion, as illustrated by Allan, a nineteen-year-old sophomore, attempting to remain composed while ordering liquor illegally at Tangerine:

> Our waitress had not made it to our table, and we became suspicious. Was she ignoring us because we looked young, and hoping we would get the hint and leave? Were we not Tangerine caliber? Or maybe she was just busy? We discussed the possibilities and remained steadfast in our positions. Finally, Cassandra informed us that she would be our waitress for the night. I was thinking, "No shit," because she was the only waitress in the room. She asked us what we wanted to drink, and we asked her for a menu. We were reluctant to send her away, fearing she

would take another twenty minutes to come back, but she was speedy this time. We had our fake IDs ready and were hopeful that they would work.

Eliza decided to order the house drink, the "Tangerine" (ingredients consist of tangerine puree, vanilla vodka, and a splash of club soda). I asked for a dry martini, assuming they had a house gin to make it with. I ordered a martini in order to look cool, and I ordered it dry because I wanted to look like I knew what I was talking about. "Vodka, or gin?" she wanted to know. I chose gin. She inquired, "What kind?" I chose Bombay. She replied, "Bombay, or Bombay Sapphire?" I asked her if I said Bombay Sapphire, because if I didn't, I probably meant Bombay. She asked, "With olives?" I wanted to wring her neck! This bitch! This stupid bitch is treating me like a fucking idiot! I know what a fucking martini is! I said, "Yes." What she assumed is that I knew nothing about alcohol. What she did not know is that I have my bartending license and knew perfectly well that unless specified, martinis come with gin, not vodka. I also knew that I should take this question as a condescending insult, unless I was just being analytical, and she was the one who did not know what she was talking about . . . fucking idiot.

Losing his cool, Allan dramatizes what should otherwise seem to be an easily forgettable encounter by interpreting the server's behavior as deeply patronizing—although as I was informed by Allison, the cocktail waitress at Tangerine, management requires *all* employees to follow the same inquisitive script when taking martini orders. "Gin or vodka? Up or on the rocks? Olives or a twist?" Allan's internalization of this imaginary drama with Cassandra soon snowballs to include his fellow patrons:

There was a couple who looked our age. . . . They sat symmetrical to us and reminded me of us. Diagonal sat five Indian males and one girl. They were dressed like they had just come from a club and were abnormally loud. By the bar some new couples

stood. They paced about, and all looked like they owned the place. Black pants seemed to be a requirement, as did greasy hair with frosted tips. The bar posse was having a group discussion, while us "tablers" kept amongst ourselves.

Were they cooler than we were? Probably. Everyone seemed to be confident and purposeful, and their purpose was to win. To win the game of—*bar*. I told this to Eliza. . . . We decided that *bar* is a game that people at Tangerine play. Each person tries to sit with their legs crossed the longest, be the most attractive, and sip their drink the sexiest. Eliza and I were losing, as we were still waiting for our drinks—she for her Tangerine, and I for my dry martini made with gin, not vodka, branded with Bombay, not Bombay Sapphire, garnished with olives.

The irritation that emerges from Allan's perceived competitiveness among his fellow strangers for situational status is palpable: as he later reports, "We wanted to talk to people but were intimidated by their drive to win *bar*. So instead we just continued to chat with each other." Yet this is a familiar trepidation among strangers in close physical proximity to one another in upscale public settings, and a reason why nightclub customers typically do not converse with one another across groups of friends even when excited by the charged atmosphere provided by the pleasure of their collective company. Patrons thrive on the social energy generated within crowded public spaces, but only if the nuisance of undesirable face-to-face encounters does not shatter the illusion of invulnerability provided by their vaguely bounded interpersonal comfort zones—as Allan yet again illustrates:

Eliza began to tell me the story of her first love, and I got bored. I remembered that I had wanted to rub my fingers through the beaded curtain to my side, and I did this. The guy who was part of the couple that reminded me of us also did this. We both sat listening to our partners talk, and let the cold small beads massage our hands. I was perfectly happy and never wanted to part

with the beads. I began to compete with the other person finger-
ing the beads, and I was winning. I was making the curtain wave
more and was gentler with the beads at the same time. My bead
nemesis gave up and stopped playing with the beads. So did I.

The choice of terms here—"competing" for beads with a "nem-
esis"—is laughably hyperbolic yet provocative. Is Allan's goal to
become King of the Beads, to win at bar? Allan wants to reign victori-
ous, but he is doubtful: "I felt honored to be a part of such a seem-
ingly high-class group of people. I felt elite. I felt like I could afford
$10 drinks and become a regular at Tangerine, and one day maybe
even win bar! But in my heart I knew this was not true."

In fact, the competition inherent in winning bar can become so
heated that large clusters of men will direct such rivalries inward
as close friends compete *among themselves* by trying to one-up each
other for the smallest of hierarchical status gains. According to
Allison:

> Most of the time when I get a group of guys, they are all trying
> to outdo themselves in some way. If someone gets a Jack and
> Coke, the next guy is getting whiskey on the rocks with a *splash*
> of Coke. Then the next guy is getting a Manhattan, on the rocks.
> And the next guy is just getting straight whiskey or bourbon on
> the rocks. Stuff like that. Or someone orders an Amstel Light.
> Well, the next guy has got to have a Heineken; the next guy's
> got to have a Stella Artois; and the next guy's gotta have a Fin du
> Monde [a Belgian-style ale brewed in Quebec]. He's never had it
> before; he doesn't know what to expect—he doesn't know how
> to pour it. It's a mess because he'll start pouring it and then it'll
> start foaming out.[30]

Sometimes the combativeness among male patrons grows
decidedly more impassioned. This particularly occurs among strang-
ers engaged in ambiguous and confusing encounters rooted in
testosterone-fueled competitiveness and a desire for risky action, as

symbolized through interpersonal confrontations with strangers in public.[31] According to Karl, a twenty-two-year-old senior attending a sorority-sponsored party at Plough and the Stars, a popular Old City bar and restaurant:

> There were tables scattered around the large floor, but most people were standing since it was fairly crowded. I attempted to move up toward the bar with my friend, but apparently during this voyage I kept bumping into a girl behind me. This was a complete accident, which I think was quite clear, but her boyfriend (or whatever he was) got upset that I was "knockin' his girl." I apologized to the girl, but in so doing went to touch her arm as I was apologizing. This seemingly benign gesture got the boyfriend even more heated, so he pushed me a little and suggested that I "keep walkin'" and warned me not to "touch his girl no more." Rather perplexed by this encounter, I did.

Hollywood films feature plentiful barroom brawl scenes, but in real life bar fighting occurs with much less frequency than one might otherwise predict. They are a few reasons for this. First, alcohol-related violence tends to be concentrated within specific neighborhoods, types of establishments, and bar environments. In several studies a number of environmental variables have been correlated with barroom aggression, including crowd density, the presence of competitive games (e.g., billiards, pool, darts) and illegal activity, poor ventilation, smoky air quality, high noise level, dirtiness, hot temperatures, and a preponderance of male employees, particularly bouncers.[32]

Additionally, as sociologist Randall Collins argues in his book *Violent Interaction*, a very low percentage (typically 15 percent or less) of almost any population known for violent behavior—soldiers, police officers, bar brawlers—actually carries out that violence. Although men who do engage in bar fighting and carousing might desire to perform masculinity through physicality, they often only begin fights in public settings in which there is a greater chance the fight will be broken up before it spirals out of control beyond the first punches;

perhaps for this reason barroom aggression rarely escalates into incidents involving significant physical injury. Moreover, the emotional energy required to jump-start a bar brawl quickly dissipates after the fight concludes—making it highly unlikely that a *second* fight will come off in the same bar later in the evening.[33]

Perhaps because of this latter set of reasons, the moments of conflict that do emerge in nightclub settings tend to reveal abrupt yet flighty displays of aggression and bravado during moments featuring highly ambiguous signaling among male participants: a spill of the drink or gentle shove against one's arm in a crowded pub; a barely stolen glance at another man's girlfriend across a poorly lit dance floor; an oblivious cutting of a restroom queue. These moments of ambiguity typically occur in high-traffic areas of nightclubs and bars where opportunities for physical interaction are most likely to occur (whether accidentally or intentionally), such as dance floors, gaming and service bar areas, entrances and exits, parking lots, and sidewalks alongside venue doors.[34] Given the density of potential targets of aggression as well as available audience members, these crowded spaces conveniently provide enterprising young men with the opportunity to dazzle friends and onlookers by displaying situational dominance against a genuinely startled victim, all as a self-conscious performance. According to Sid, an upperclassman describing a particular evening out, "I mean, there were no actual fights or whatnot, but so many times I think things would come down to people, usually guys, trying to impress girls. . . . I would see guys pushing—you know, because it's crowded—to get a drink, and if a guy pushes a guy the wrong way and it's one of those types of guys who decides he is going to make a scene and draw attention to himself, he'll like, first of all, make sure there are girls around before he does it, like 'Hey man, come on, what are you doing?' and a shove or a shoulder or something. Those are things that I see the most of—things that (in my mind anyway) it's pure trying to be macho and impress people."

Male nightlife patrons commonly antagonize one another in drunken bouts of competitive braggadocio in which the sources of these contests are generally devoid of substance, often farcically so.

On the crowded streets of Old City on a Thursday night, Nancy, a twenty-one-year-old Chinese senior, reports on such an encounter, laden with empty threats and overblown bluster:

> We were rounding the corner to go to Plough and the Stars, when Brian tried to change the subject and said that he was planning to go to Atlantic City on Saturday. We were passing a group of maybe ten people. They were mostly white except for one Asian male. . . . Brian walked by, saying, "I wanna go to A.C.," and the Asian person, drunk, overheard and butted into the conversation, yelling to his friends, "Hey, they want to go to A.C. They think they're going to win some money." We were rounding the corner, and Brian kind of nodded and moved the drunken person out of his way. Maybe seven feet ahead, we felt water hit our feet. The Asian fellow was mad that Brian ignored his comment and flung the water from his water bottle at us. We turned back surprised; his group of friends was holding him back. My other friend James kept on saying, "Ain't that some shit?! He was such a wuss. If I wanted to hit someone with water, I would have walked straight up to them and thrown that water at them, to not miss. I wanna hit him so bad. If I wasn't here, and was anywhere else but here, I would have socked him!" That group ended up catching up to us. The Asian fellow with his four white friends kept asking us about A.C.

Typically these kinds of incidents speedily deflate into a soft whimper rather than all-out fisticuffs, and frequently the violence that opponents *do* inflict is of a purely symbolic nature—a kind of chest beating performed after the dramatic confrontation has safely played itself out. According to J.J., a senior discussing bar fighting with his fraternity brothers, "The only time I did have a fight with a bouncer, I was at the Irish Pub on Chestnut Street and they had a tank of something at the door and I was really drunk with a bunch of my friends, and I tried to steal it. . . . It was like a gas tank, a nitrogen tank. It was heavy, but I was with a couple of my friends and we were

all really drunk. . . . We tried to steal it, and the bouncer accosted us and was basically very threatening—threatened to break my arms, et cetera, or call the police. Of course, we ran away, came back, and took a piss on the door."

Much literature on urban violence suggests that the desire for physical confrontation with strangers and its attendant heroics often emerges out of the peer influence generated by interpersonal dynamics within small groups, whether college pranksters, inner-city youth gangs, or even networks of male friends residing in middle-class suburban areas.[35] But often young men desiring the risky action provided by open confrontation in public spaces may do so despite (and perhaps in some instances *because of*) the more risk-averse orientations of the group majority. According to Julian, another upperclassman:

> I have a few friends who can be real sloppy. Like they get beer muscles a little bit. I mean it doesn't come out all the time, but like every once in a while we'll have a little incident or something and just for, I guess, for no reason other than to just try to be funny and humorous and impress some people, they'll start with somebody. . . . They'll just say something usually just mocking someone else in the room or something, and they'll say it loud. I mean, it's never really gotten to the point where there has been a huge, crazy, physical altercation or whatever. And usually the rest of us that are there will just be like, "Shut up, you're being an asshole, just relax."

There are good reasons why risk-averse group members might frown upon the confrontational behavior of a fellow member: his aggressiveness may mistakenly signal to other groups of men spoiling for a brawl that his *entire group* is interested in pursuing the initiation of violence, thus making his friends collectively susceptible to attack. In the event that the pugnacious group member does find himself amidst physical conflict, conventional codes of honor among American men may require his friends to protect him from harm and perhaps join in the fray themselves. In fact, it is common during bar-

room incidents for participants to change roles from conciliator to aggressor as conflicts progress—or quickly *devolve*, as is generally the case.[36]

THE PICKUP AS A SPORTING RITUAL

While every romantic comedy may suggest otherwise, the challenges of meeting total strangers in public—even on a platonic basis—can be insurmountable, particularly as young adults age into their late twenties and beyond. As Avram Hornik, a local bar and nightclub owner in his thirties, observes: "It's not appropriate [to approach strangers], even in a public space. Some people walk up and say, 'Hi, my name is Joe,' and it's out of the blue—walks up and introduces himself to people. *Five* percent of people can pull that off—you have to be the right person. . . . If you go to a wedding, you can pretty much walk up to anyone and say, 'Hi, how are you? I am a friend of the groom.' At a bar you really can't—you don't know why that person is there, so you may not be able to do that. Or you have to be able to do it in a subtle way, where you get a signal whether or not it's appropriate or inappropriate. So some people are good at it; some people aren't. . . . In general, at this age I have established who my friends are and who aren't. When I go out, I am not looking for another best friend."

Jason agrees. "I think it's a bigger problem than the bar scene. I mean, we are so compartmentalized in our lives that we don't know how to meet people. . . . And how quickly do you want to get personal with people? I think that's a big impediment to meeting people. How much do you want to give up about yourself with somebody you just met at a bar?"

"In what kinds of circumstances do strangers talk to each other in bars and nightclubs?" I ask.

"All right, the most common is the guy hitting on the girl, to varying degrees of success. I guess if you add a little alcohol, people will loosen up a little bit. But then, *how do you go about it?* If you are attracted to someone, how do you open that up? As a bartender,

they've got to come to you, so you instantly have the opening. But if you are on the other side of the bar, it's a lot harder.

"I think that everybody's got a comfort zone. Adding alcohol will stretch your comfort zone, but only so far. Approaching anyone you don't know is a fairly tough proposition. Just like cold-calling, it's tough. It's hard—you've got to have some kind of connection, some kind of connecting point. Especially with these larger places, people go out in their crowds as insulation, to look like they know everybody, even though they don't know *anybody*. So you are still being seen, and you are seen being social, but you are talking to the same eight people that you always talk to. But to everybody else looking . . . nobody knows if you have known each other for a long time, or if you have just met."

In a context in which the expectations of meeting singles are significantly greater than the average nightclubber's actual potential to do so, rituals of deception and guile often appeal to even the most otherwise upstanding of individuals, especially considering how little is actually at stake. For instance, according to an unpublished paper by economists at MIT and the University of Chicago, Internet daters regularly lie about their physical appearance. Less than 1 percent of both men and women describe themselves as having "less than average looks"; men report heights that are one inch taller than the national average, while women underreport their weight (compared to the national average) by a difference of twenty pounds for women in the 30–39 and 40–49 age ranges; and women are far more likely to identify their hair color as blond or auburn than are men. As Jennifer Egan reports in the *New York Times Magazine*, "Most online daters have at least one cranky tale of meeting a date who was shorter or fatter or balder or generally less comely than advertised. Small lies may even be advisable; by dropping a year or two off her age, a 40-year-old woman will appear in many more men's searches, and the same is true for a man shorter than 5-foot-11 who inflates his height even slightly."[37]

In the face-to-face dating world of pickup bars, these measures are difficult to fake (except for natural hair color, of course); however, singles still find a wealth of personal characteristics about which to

exaggerate, including age and occupational status. While conversing with other patrons, underage men sneaking into bars will create an identity for themselves in order to appear old enough to legally gain entry and pass as equals among older and more mature customers.

"I just tell them I am in graduate school or something," explains one male student. "I just graduated from Penn or something like that. Something modest, so they don't ask me something like, 'Oh, I am a _____, too!' and ask me some question. So I usually try to keep it pretty simple." In other instances when faced with an older pool of strangers, affluent college men will falsely claim to be investment bankers, as revealed in a discussion among a focus group of fraternity brothers.

"I definitely did that once, down at Alma de Cuba. I was there with another fraternity and two of my other friends: we talked amongst each other, and we came up with a storyline that we were investment bankers at Commerce Bank. And we proceeded to talk to these four girls and they believed every part of it. It was pretty funny."

"Why did you choose that story? What were you trying to get out of it? What made it funny? What made it work?" his fraternity brother (and my research assistant) Andrew asks.

"We were all in suits, so we figured it might as well be something business-related and . . . I don't know, they asked us what bank we worked for, we hadn't really come up with much of it, and my friend just said 'Commerce Bank' randomly, which is pretty funny, and we just went with it.

"As far as posing, I was in Georgia for spring break and I met this woman who was working as a nurse, and I told her that I work for Merck. I thought that she would find it interesting, and women generally tend to sleep with older men anyway, who are a couple years older, like three to four years older. So I've done that only once."

"And it was to actually sleep with her, ideally?"

"It was to sleep with her. It was over spring break, and it was to basically get laid."

"Did it work?"

"It worked, yeah."

"Have you been with other guys . . . [who have] posed as people who they are not?"

"Oh yeah, some of my fraternity brothers were at a club downtown down in Florida, and some of them were investment bankers, and I think that particular person uses that ruse pretty often."

"Why does he use the ruse? How does he go about using it? Are there support roles or is it just him out there as an investment banker?"

"He does it, I think, because that is probably what he is going to become when he graduates, and he likes the whole sexiness of the job. And there are support roles, usually some other fraternity brothers will come and persuade the fine young lady that he is actually an I-banker."

"So it's generally to get the girl in the end?"

"Yes."

On less frequent but likely more memorable occasions, physically robust college men will try to pass themselves off as professional athletes. According to one male undergraduate:

> A couple of my friends, they were down in Florida for spring break and they said they played for the Eagles, and this girl totally believed them . . . and the other guys, the smaller guys were their agents and stuff, and they totally had this girl going. . . . Just because I think they found her kind of naive, and they are big guys, like three hundred pounds, two-ninety. So they thought it would be funny to make stuff up to see if she believed it. . . . She just kept buying them drinks. It was weird. You would think that professional athletes would be paying for the girl's drinks. . . . They just wanted to make up a story that was funny.

Many young men are single-minded in their heterosexual stalking of women as a sporting ritual and employ a philosophy of strategic gamesmanship to enliven their pursuit. Brian, a nineteen-year-old Cuban sophomore, refers to the game as a *girl hunt*:

Whether I would get any girl's phone number or not, the main purpose for going out was to try to get with hot girls. That was our goal every night we went out to frat parties on campus, and we all knew it, even though we seldom mention that aspect of going out. *It was implicitly known that tonight, and every night out, was a girl hunt.* Tonight we were taking that goal to Philadelphia's nightlife. In the meanwhile, we would have fun drinking, dancing, and joking around [emphasis added].

Young men consistently remark on the girl hunt as a strategic and competitive goal of going out, and some discuss their attempts to successfully interact with women (while besting their male rivals) as if explaining the relationship between predators and their prey. According to Joey, the freshman who talked his way into Red Sky:

Once I reached the dance floor, the first thing I noticed was that a few guys were hanging out on the perimeter with their eyes each on a specific girl. I watched the guys from a distance before going over to Jessica's area. I wanted to see if anybody was looking at Jessica. *I saw a guy make a circle around the girl he was interested in. It reminded me of how a shark might move around its prey.* I realized that I often do the same thing. I focused my attention on a pair of girls dancing together. I witnessed a guy circling around them until he made his move and came up behind one of the girls, trying to grind her from behind. She didn't push him away, so I figured she either knew him or actually liked it. I preferred to believe that they didn't know each other. I don't know if I could have done that with someone I didn't know at all. I hate getting rejected, especially when I haven't even had one drink. I thought about the fact, though, that it may be better to approach a girl on the dance floor from the rear, since you don't have to worry about her looking in your face and pushing you away. I figured I was going to try that tactic with Jessica. I circled around her and gave her a couple of looks from the front. I came up behind her and started dancing wildly. I was really just having fun imitating

the guy I had just seen. I was hoping he wasn't watching me, thinking that I could possibly get a fist in my jaw if he really knew what I was doing. Jessica and I started dancing and moving to every beat and every word. We were having so much fun. It was amazing [emphasis added].

Of course, the city at night also provides an opportunity for young *women* to employ strategic cunning in their own sexual pursuits. For both men and women, a successful encounter with a member of the desired sex may not evolve into romance or physical intimacy (nor is this necessarily preferable by either party), but their ability to reduce the social distance between themselves and a *potential* sex partner (no matter how remote its realization might be) can at the very least provide confirmation that one has successfully performed a recognizably desirable gender and sexual role in public.[38] In addition, as young women discover the high-ranking prestige attached to the performance of feminine sexuality in public, they learn to exploit its situational advantages in the context of urban nightlife. Vanessa, a twenty-year-old sophomore, acknowledges the privileges granted to attractive women at World Fusion, a bar and restaurant:

There was an immense crowd of people trying to get drinks, so I pushed through and stood in between two guys who both looked around twenty-one. Riley handed me her credit card to start a tab. The guys next to me seemed annoyed because they were standing there for a while waiting for the bartender, but the fully tattooed bartender with a shaved head saw me right when I squeezed through and asked me what I wanted. It seems like the male bartenders love to serve the females first because they enjoy flirting with them.

As Vanessa's remarks suggest, young women may not initially recognize the distinctive social value attached to the public display of feminine sexuality (or describe it in these terms). However, after repeat encounters they will likely begin to appreciate the *consequences*

of this valuation, as signified by solicitous bar service in crowded lounges, attention from male passersby, envy from female onlookers, and so forth. During subsequent encounters, they may choose to rely on specific strategies of interaction designed to capitalize on the rewards associated with its elaborated performance, particularly by flirting with male service staff. As Shannon, a junior, observes, "When it comes to getting in bars and getting cheap or free drinks, totally. . . . Because yeah, it's not like the bartender really thinks you are going to go home with him, but he enjoys the flirting so he'll come to you more." According to Aimee, a nineteen-year-old freshman at Marmont, a bar and lounge:

> A thirty-something sleazeball trying to look about twenty-three with spiky black hair immediately started talking to Amber . . . and buys us both a Blondie and a Leetini [both designer cocktails mixed with vanilla-flavored vodka and pineapple juice]. It is then that I realized how easy it is in the bar scene being a girl, compared to [our friends] John, Larry, and Christopher, who were unsuccessfully eyeing the older professional chicks. . . . "Hey, missy, what's next?" the muscled bartender breaks my nebulous night-dream. I notice his yellowish tinted eyes and let my hand linger as I leave him my crumpled-up ten-dollar bill in exchange for a shot of Stoli Razberi. This little economic incentive and splash of flirting insures a night full of quicker drinks and casual conversations.

As young women, particularly those transitioning from adolescence to adulthood, gradually develop confidence in bars, nightclubs, and lounges, they become more skillful in engineering interaction rituals with male strangers that allow them to trade on their performance of feminine sexuality in exchange for free or discounted cocktails, and potentially desirous attention from good-looking, upper-class men. Along with her girlfriends at Alma de Cuba, Tracy, a twenty-one-year-old senior, strategically positions herself to attract a group of young professionals:

Being the girls that we are, we automatically comb the scene for cute guys to talk to or to buy us more drinks! After five minutes of making eye contact with a group of guys, we are eventually approached. They are young professionals who work downtown and are definitely a little older than us. After introducing ourselves, we innocently flirt back and forth. Their names are Andrew, Jack, and Mike. They are pretty sure of themselves, a little on the cocky side. Not really my type, but nice guys nonetheless. They, too, seem to be wearing the "official" going-out dress code for guys: dark pants and a button-down shirt. We are asked the usual questions: "Where are you from? What are you studying? Where else have you been tonight? Do you want another drink?" They buy us a round of drinks, and at this point everyone is feeling pretty good.

For these young women, flirting is a game played for cocktails and compliments, a sporting ritual that serves as its own kind of urban hustle. Of course, women may enthusiastically enter such contests only to find their male opponents hopelessly exhausting, boring, creepy, and occasionally dangerous, and in these instances they develop strategies of mild deception in order to tactfully exit such interaction rituals with grace. Just as men are highly strategic in their approach to meeting potential sexual partners, Tracy's account suggests that women must become equally savvy in handling these encounters as well:

Although I am not attracted to any of them, we trade cell phone numbers. The guys push for us to come with them to Twenty Manning, another bar down the street. They are meeting up with some other friends there. We decline the offer, knowing that none of us are really interested in pursuing them past this conversation or locale. So we tell them we are going to stay longer at Alma de Cuba, but tell them we will call them if we decide to leave anytime soon. We know that's a lie and they probably do too, but it's a nice way to close the night with them. We smile

and thank them for the drinks and conversation, and wave good-bye as they leave.

To be sure, the discomfort produced by these strategic games of interaction often disagrees with young men and women alike. According to a female sophomore, "Sometimes I do feel a little guilty. . . . I wouldn't let someone keep buying me drinks if I were totally not interested in them, because they would get the wrong idea." And as Joey himself admits in his frustration, "Often when I walk over to a girl that I want to talk to, I get a little insecure if she doesn't acknowledge me right away but continues her conversation with her friends. The first notice of a girl that you want to say 'hi' to can be weird, because you don't know if you should wait for them to come to you or actually walk past the other people and go straight to her. It seems like everything is a game."

In the end, the emphasis on strategies of gamesmanship and the presentation of a nocturnal self among young singles likely *prevents* them from meeting one another despite their best efforts to dress and impress. As Jason reminds us of the hustle of urban nightlife, "You get into costume and you go out, and it's kind of looked down upon if you *don't* in some places. There are places where it's cool to just be you, and go and hang out, and there are places where you are expected to be *more*. And I think it's the expectation of being *more* that actually may prevent people from talking to each other. . . . Because *you* are not more than *you*. You are playing this role, but that's the *only* place that you play the role. It's not necessarily a role you are comfortable in.

"That's the problem. When you go out and you make it like a 'big night,' you are becoming somebody that's a little further away from you, which makes it harder to socialize—because you are *not* you. Because you are being the thing you *created*, not being yourself."

5

IN THE
COMPANY
OF MEN

THE GIRL HUNT
AND THE MYTH
OF THE PICKUP

From Chicago's jazz cabarets to New York's gay discos to Las Vegas's strip clubs, downtown zones of urban nightlife have historically been defined by their sexually suggestive environments. Hot nightclubs and cool lounges enforce sexualized norms of dress and body adornment, inviting playful banter, flirtation, innuendo, and physical contact among patrons engaged in rituals of courtship. Nightspots also rely on the attractiveness and allure of service staff to recruit customers, while sexual relations among staff are frequently the norm. Moreover, young urbanities identify downtown entertainment zones featuring clusters of nightclubs, lounges, and cocktail bars as sexual marketplaces for singles seeking casual encounters with potential romantic partners.[1]

For these reasons, scenes of urban nightlife serve as fitting laboratories for observing how men and women initiate sexually driven hustles as games of deception and chance. Therefore, at this point I want to revisit in closer detail what one group of adolescent men described in the last chapter as the *girl hunt*, in which heterosexual males aggressively seek out female sexual partners in nightclubs, bars, and other public arenas of commercialized entertainment. Recent socio-

logical studies of romantic and sexual behavior analyze courtship patterns by relying on survey research to understand the logistics of sex partnering and mate selection in cities.[2] However, shining a spotlight on the more *cultural* and *ritualistic* nature of contemporary sexual behavior illuminates how male-initiated games of heterosexual pursuit function as strategies of impression management. These games represent hustles in which young men—particularly those of college age negotiating the gradual, yet erratic, transition from adolescence to adulthood—sexually objectify women in order to heighten their own performance of masculinity. While we typically associate heterosexual behavior with interactions between individual men and women, these public rituals actually proceed as *collectively* initiated hustles conducted largely in the company of men.

YOUNG MEN AND MASCULINITY

At its most elementary level, masculinity represents a range of social performances exhibited through face-to-face interaction. Like femininity, masculinity is not innate but an accomplishment of human behavior that appears natural because gendered individuals adhere to an institutionalized set of myths they learn through everyday encounters and thus accept as social reality.[3]

The normative cultural myths surrounding masculinity in contemporary American society today are as familiar to young men as they are likely foreboding. Throughout their formative years and beyond, young men are encouraged by their parents, teachers, coaches, and peers to adopt a socially constructed vision of manhood, a set of cultural beliefs that prescribe what men ought to be like: physically strong, powerful, independent, self-confident, efficacious, dominant, active, persistent, responsible, dependable, aggressive, courageous, and sexually potent. In the fantasies of many boys and men alike, a relentless competitive spirit, distant emotional detachment, and an insatiable heterosexual desire, all commonly (but not exclusively) displayed by the sexual objectification of women characterize the masculine ideal.[4]

Essentialist visions of masculinity obscure how both women and men resist, challenge, and renegotiate the meanings surrounding masculinity and femininity in their daily lives.[5] The inevitable disconnect between dominant expectations of normative masculinity, on the one hand, and actualized efforts at what sociologists Candace West and Don H. Zimmerman refer to as "doing gender" as an everyday performance, on the other, presents a challenging problem for men, particularly since "the number of men rigorously practicing the hegemonic pattern in its entirety may be quite small."[6] It is an especially acute dilemma for young men of college age (18–25) who, as emerging adults, display many of the physical traits of early adulthood along with the emotional immaturity, diminutive body image, and sexual insecurities of late adolescence.[7]

The competitive ritual of girl hunting as performed in the context of dance clubs, cocktail lounges, and other nightlife environments epitomizes this dilemma. As the sporting metaphor suggests, girl *hunting* affords men the opportunity to compete with like-minded rivals for anonymous women as sexual trophies, a game in which success validates the male sharpshooter as an embodiment of the masculine ideal. While rituals of courtship are by no means confined to nightlife settings—as evidenced by the relatively large numbers of romantic couples who meet through work and school—in American culture, nightclubs and bars are widely considered more normative environments for actively pursuing anonymous sexual partners in a strategic manner.[8] In contrast to occupational and educational domains in which masculine power can be signaled by professional success and intellectual superiority, sexual prowess serves as a primary signifier of masculinity in the context of urban nightlife. (Other such signifiers include physical dominance and assertiveness relative to other men, skill at competitive bar games, and a high tolerance for alcohol.) Indeed, the importance placed on competitive "scoring" among men in the highly sexualized universe of cocktail lounges and singles bars should not be underestimated.[9]

However, a wealth of data suggests that contrary to representations of urban nightlife in popular culture, notably *Sex and the City*

and MTV's *The Real World*, rumors of the proverbial one-night stand have been greatly exaggerated. According to the National Health and Social Life Survey, relatively few men (16.7%) and even fewer women (5.5%) report engaging in sexual activity with a member of the opposite sex within two days of meeting them.[10] About 90 percent of women aged 18–44 report that they would find having sex with a stranger unappealing.[11] (Although conventional wisdom suggests that college students would be much more likely to engage in casual sex with random strangers than the general population, a recent study conducted by sociologists Paula England and Reuben J. Thomas at Stanford University finds that only 14 percent of student hookups occur between students who do not know each other.)[12] Findings from the later Chicago Health and Social Life Survey demonstrate across a variety of city neighborhood types that typically less than one-fifth of heterosexual adults aged 18–59 report having met their most recent sexual partner in a bar, nightclub, or dance club.[13]

Moreover, the efficacy of girl hunting is constrained by the ability among women to resist unwanted sexual advances in public, as well as initiate their own searches for desirable sex partners. Whereas the ideological basis of girl hunting stresses vulnerability, weakness, and submissiveness as conventional markers of femininity, young women commonly challenge these stereotypes by articulating their own physical strength, emotional self-reliance, and quick wit during face-to-face encounters with men.[14] Despite the recent proliferation of sensationalistic tales of sexual promiscuity with random partners among exaggerated caricatures of college women in both literary and lowbrow American popular culture (from Tom Wolfe's 2004 novel *I Am Charlotte Simmons* to Tucker Max's supposedly autobiographical tell-all *I Hope They Serve Beer in Hell*), actual female undergraduates are far more circumspect in their sexual relations. Young women tend to regard the lounge lizards they meet off-campus in downtown nightclubs as little more than lecherous losers. Many find themselves even less trusting of strangers in nightlife settings *after* graduating from college.[15]

For all these reasons, girl hunting would not seem to be an especially efficacious strategy for locating sexual partners, particularly

when compared with other methods, such as meeting through mutual friends, colleagues, classmates, or other trusted third parties. This may help explain why successful Lotharios are granted such glorified status and prestige among their peers in the first place.[16] And to a certain extent, college men recognize and accept these low odds, at least within the context of early adulthood. According to J.J., a senior discussing the issue with his fraternity brothers, "I believe at our age, getting laid the first time you randomly meet someone is very rare. . . . Most college-age women do not sleep on the first date. Or maybe I've just met a subset of women who don't sleep on the first date or who are not sleeping with a random guy. . . . Actually having sexual intercourse, that's pushing it." But if this is the case, then why do adolescent men of all ages persist in their often-obnoxious attempts to pick up women, particularly when their chances of meeting agreeable sex partners in this manner are so slim?[17]

According to a rational choice or economic perspective, young men persist in girl hunting for the same reason gamblers play the lottery: the potential rewards appear so extraordinarily desirable they make the low odds of winning seem negligible by comparison. However, I would argue that framing the question in this manner misrepresents the actual sociological behavior represented by the girl hunt, particularly since adolescent males do not necessarily engage in girl hunting as a means of generating sexual relationships, even on a drunken short-term basis. Instead, three counterintuitive attributes characterize the girl hunt.

First and foremost, the girl hunt is as much ritualistic and performative as it is utilitarian—it is a social drama through which young men perform their interpretations of what it means to be a man. Second, girl hunting is not always a purely heterosexual pursuit but can also take the form of an inherently homosocial activity for which one's male peers serve as the intended audience for competitive games of sexual reputation and peer status, public displays of situational dominance and rule transgression, and in-group rituals of solidarity and loyalty.[18] Finally, the emotional effort and logistical deftness required by rituals

of sexual pursuit (and by extension the public performance of masculinity itself) encourages some young men to seek out safety in numbers by participating in the girl hunt as a kind of collective activity, in which they enjoy the social and psychological resources generated by group cohesion and dramaturgical teamwork. Although tales of sexual adventure traditionally feature a single male hero, such as Casanova, the performance of heterosexual conquest more often resembles the exploits of the dashing Christian de Neuvillette and his better-spoken conspirator Cyrano de Bergerac. By aligning themselves with similarly oriented accomplices, many young men convince themselves of the importance and efficacy of the girl hunt (despite its poor track record), summon the courage to pursue their female targets (however clumsily), and assist one another in what sociologist Patricia Yancey Martin refers to as "mobilizing masculinity" through a collective performance of gender and heterosexuality.[19]

If we draw on the ritual of girl hunting to examine how young men perform masculinity as collective activity in the context of urban nightlife, we discover that young men employ a set of collective "hunting" strategies designed to accomplish three goals. First, they culturally reinforce what I call the myth of the pickup and other dominant expectations of masculine behavior. Second, they assist young men by boosting their confidence in their display of masculinity and heterosexual power. Finally, these strategies help young men to perform masculinity in the actual presence of women.

This is not to suggest that the presentation of a masculine self and its attendant peer status serve as the only desired purposes or outcomes of the girl hunt, an activity also clearly motivated by the desire for physical gratification and romantic solidarity.[20] But this obvious point hardly changes the fact that groups of young men employ the power of collective rituals of homosociality to perform heterosexual competence and masculine identity in the public context of urban nightlife. Moreover, by doing so they illustrate how interaction rituals associated with the girl hunt reproduce structures of inequality within as well as across the socially constructed gender divide between women and men.

Of course, not *all* young men follow the protocols of girl hunt-ing in their sexual pursuits. Just as there is not one single mode of masculinity but many *masculinities* available to young men, college men frequently exhibit chivalrous and otherwise respectable behav-ior.[21] But as gender scholar R. W. Connell argues, the dominance of idealized models of masculinity is often sustained by the aggressive actions of a minority within a context of normative complicity by a more or less "silent majority" of men that nevertheless benefits from the subordination and sexual objectification of women.[22] Insofar as the ritual of the girl hunt symbolizes a celebrated form of hegemonic masculinity, it is therefore imperative that we examine how it is prac-ticed in the context of everyday life, even if its proponents and their activities represent only one of many possibilities within the con-stellation of masculine performances and sexual identities available to men. Given that masculinities are constituted in interpersonal encounters between men and women, an examination of how girl hunting works can help clarify how group interactions link gender ideologies to everyday social behavior.[23]

THE GIRL HUNT AND THE MYTH OF THE PICKUP

As I mentioned, it is statistically uncommon for men to successfully pick up women in bars and nightclubs. However, as suggested by a wide selection of mass media from erotic films to hardcore por-nography, young men nevertheless sustain fantasies of successfully negotiating chance sexual encounters with anonymous strangers in urban public spaces, especially dance clubs, music venues, singles bars, cocktail lounges, and other nightlife settings.[24] According to Aaron, a twenty-one-year-old mixed-race junior:

> I am currently in a very awkward, sticky, complicated, and bizarre relationship with a young lady here at Penn, where things are pretty open right now, hopefully to be sorted out during the summer when we both have more time. So my mentality right now is to go to the club with my best bud and seek out the ladies

for a night of great music, adventure, and female company off of the grounds of campus.

Young men reproduce these sexual expectations—what I call the *myth of the pickup*—collectively when interacting with their male peer group. Again, according to Brian, a nineteen-year-old Cuban sophomore:

> Whether I would get any girl's phone number or not, the main purpose for going out was to try to get with hot girls. That was our goal every night we went out to frat parties on campus, and we all knew it, even though we seldom mention that aspect of going out. *It was implicitly known that tonight, and every night out, was a girl hunt.* Tonight we were taking that goal to Philadelphia's nightlife. In the meanwhile, we would have fun drinking, dancing, and joking around [emphasis added].

For Brian and his friends, the girl hunt articulates a shared orientation toward public interaction in which the group collectively negotiates the city at night. The heterosexual desire among men for a plurality of women (hot *girls*, as it were) operates at the individual as well as the group level. As in game hunting, young men frequently evaluate their erotic prestige in terms of their raw number of sexual conquests, like so many notches on a belt. Whereas traditional norms of feminine desire privilege the search for a singular and specified romantic interest—Prince Charming, Mr. Right, his less attractive cousin Mr. Right Now—heterosexual male fantasies idealize the pleasures of an endless abundance and variety of anonymous yet willing female sex partners.[25]

Despite convincing evidence to the contrary, these sexual fantasies seem deceptively realizable in the context of urban nightlife. Cities have been traditionally defined on the basis of their seemingly infinite population sizes, celebrated diversity and unconventionality, and anonymity among strangers liberated from the constraining influences of small-town social mores. For many urban denizens, the city and its never-ending flow of anonymous visitors suggests a sexualized

marketplace governed by transactional relations and expectations of personal noncommitment, particularly in downtown entertainment zones where nightclubs, bars, and cocktail lounges are concentrated. The density of urban nightlife districts and their tightly packed venues only intensifies the pervasive yet improbable male fantasy of successfully attracting an imaginary surplus of amorous single women.[26]

Adolescent men strengthen their belief in this fantasy of the sexual availability of women in the city—the myth of the pickup—through collective reinforcement in their conversations among themselves in the hours leading up to the girl hunt. While hyping their sexual prowess to their peers, young men legitimize the myth of the pickup and increase its power as a model for normative masculine behavior. According to Dipak, an nineteen-year-old Indian freshman:

> I finished up laboratory work at 5:00 p.m. and walked to my dormitory, eagerly waiting to "hit up a club" that night. . . . I went to eat with my three closest friends at [a campus dining hall]. We acted like high school freshmen about to go to our first mixer. We kept hyping up the night and saying we were going to meet and dance with many girls. Two of my friends even bet with each other over who can procure the most phone numbers from girls that night. Essentially, the main topic of discussion during dinner was the night yet to come.

Competitive sex talk is common in high-testosterone environments and often acts as a catalyst for sexual pursuit among groups of adolescent and young adult males. Moreover, this type of one-upmanship heightens the myth of the pickup while creating a largely unrealistic set of sexual and gender expectations for young men seeking in-group status among their peers. But while competitive sexual boasting may have the immediate effect of energizing group participants, in the long run it will more likely *deflate* the confidence of those males who inevitably continue to fall short of such exaggerated expectations, and consequently experience the shame of a spoiled masculine identity.[27]

COLLECTIVE RITUALS OF CONFIDENCE BUILDING

Armed with their wide-eyed expectations of the nightlife of the city and its opportunities for sexual conquest, young men prepare for the girl hunt in a collective fashion. Among college men, particularly those living in communal residential settings (such as campus dormitories and fraternities), these preparations for public interaction serve as *collective rituals of confidence building*—shared activities that generate group solidarity and cohesion while elevating the self-assuredness of individual participants mobilizing for the girl hunt. Frank, a nineteen-year-old sophomore, describes the first of these rituals:

> As I began observing both myself and my friends tonight, I noticed that there is a distinct pre-going-out ritual that takes place. I began the night by blasting my collection of rap music as loud as possible, as I tried to overcome the similar sounds resonating from my roommate's room. Martin seemed to play his music in order to build his confidence. It appears that the entire ritual is simply there to build up one's confidence, to make one more adept at picking up the opposite sex.

During these collective rituals, friends recount tall tales that celebrate character traits commonly associated with traditional conceptions of masculinity, such as boldness and aggression. Accompanied by the soundtrack of rap music—a genre known for its misogynistic lyrics and sexual boasting—these shared ritual moments generate group resolve while bolstering the self-confidence of each participant. According to Frank, "Everyone erupted into stories explaining their 'high-roller status.' Martin recounted how he spent $900 in Miami one weekend, while Lance brought up his cousins who spent $2,500 with ease one night at a Las Vegas bachelor party. Again, all of these stories acted as a confidence booster for the night ahead."[28]

Perhaps unsurprisingly, this constant competitive jockeying and one-upmanship so common in male-dominated settings often

extends to the sexual objectification of women. While getting dressed among friends in preparation for a trip to Signatures, a downtown strip club, Garrett, a twenty-year-old sophomore, reports on the banter: "We should all dress rich and stuff so we can get us some hookers!" Like aggressive locker-room boasting, young men bond by laughing about real and make-believe sexual exploits and misadventures. This joking strengthens male group intimacy and collective heterosexual identity while normalizing gender differences by reinforcing dominant myths about the taken-for-granted social roles of men and women.[29]

Among young men in general, and college students in particular, decisions regarding what to wear are often made collectively during these early preparatory stages of the evening as well. Specifically, in an example of life imitating art—or at least the reality-television series *Queer Eye for the Straight Guy*—it is not uncommon for fraternity brothers or other students to solicit their gay male friends for grooming advice and fashion tips. In doing so, they perpetuate the stereotype that gay men naturally have more fashion sense (and by extension, other "feminine" qualities). As Miles, a gay junior and fraternity brother, explains, "When living in the fraternity house, there would be a line of guys at my door at nine o'clock on Thursdays and Fridays: 'Does this shirt look good on me? Can I wear this with these jeans? How does this work? What sort of outfit should I wear to this type of restaurant?' . . . One of my roommates will always come in and say, 'Oh, well you should know this—you're gay.' It's like, 'Yeah, but you guys are all really pretentious—wouldn't *you* know?' It always comes back down to matching stuff. Straight men seem to have a lot of problems matching colors in clothes. And I think what's really interesting is that there is some sort of production of cool that some of them think that they are lacking, and need lessons in. So like they'll come in and say, 'Does this look cool enough? . . . Does it match? . . . Does it look cool? Like, will girls like this?'"

I ask Miles, "Will they ask other guys in the house, or just you?"

"Mostly just me. And this was all last year."

"So they ask you in particular?"

"Yeah, and [the fraternity house] was divided into floors, so most of the time it would be my floor-mates who would come in. I had a single. But sometimes other people would ask. One of my friends would always come up. He'd come in wearing normal jeans and a polo and say, 'Does this look too weird?' And I would ask, 'Does this look weird? You look like *every* other man in the city right now. I don't even know what you are talking about.' And he would just be like, 'Does this look cool?' He needed some sort of stamp of approval—as if my mind-set would be close enough to a woman's that I would be able to tell whether he was attractive enough. From my experience, once straight guys are comfortable with gay guys, they will always ask—I don't know a friend who hasn't asked me—'Do you think I am attractive? Like am I more attractive than he is? Do I look better than he does?' It's just weird."

"And what do they want you to say?"

"They want me to say, 'Of course you do.' But then, what do I say? It is just awkward for me because either (a) I don't think it, or (b), if I say that, it puts me in such a weird position, because it's like, well, 'Then, are you attracted to me?' 'No, I am not attracted to you!'"

"So they would take that as a compliment?"

"Yeah, they'd love me to. And I refuse, and I always refuse to even acknowledge the question, and they get really mad, they take offense. . . . Especially when getting ready, like, 'Do I look good?' 'I don't know.' 'What do you mean?' 'I don't know—I gotta change.'"

"So they really want to impress you."

"I think some of them, not all of them."

"Because it would be a sign that you have this kind of insight that you might share with women that they are interested in?"

"Yeah, as if like, 'Hey, you know, Scott looks good tonight, you should hit on him . . .' But yeah, it definitely is like that."

"Do you think they feel more comfortable asking you than a female friend?"

"I think they would feel more comfortable asking me, I guess. I mean they wouldn't walk up to some random, very attractive woman and say, 'Hey, do you think I look good?' . . . Yeah, so I am safe. I am the safe litmus test of hot."

As I discussed in the last chapter, after preparations for an evening out have been made, young men (as well as women) commonly pregame as a means of solidifying group cohesion. However, in the context of sexual pursuit, pregaming additionally serves as a bonding ritual that fosters social solidarity and builds confidence among young men in anticipation of the challenges that accompany the girl hunt. According to Joey, the eighteen-year-old freshman introduced in the last chapter:

> My thoughts turn to this girl Jessica, who I've been hanging out with lately. She's in my group of friends, but lately we've been having some flirtatious conversations, and I was thinking about whether or not we might hook up tonight. . . . I place the call to my friend Adam. He says, "301 Preston Hall, baby," and that's all I need to hear to know the "pregame" destination. 301 Preston is Adam's address in the quad, and he always has the best "pregame" party, so I'm pretty excited. I begin to make my way through the quad. . . . While walking, my mind is thinking about what will happen later at the club. Of course, I am also thinking that I look pretty good and that I'm definitely going to try with Jessica.
>
> As I turn to face the door to 301, I feel the handle, and it is shaking from the music and dancing going on in the room. I open the door and see all my best friends just dancing together. I look at them and smile. I quickly rush into the center of the circle and start doing my "J-walk," which I have perfected over the years. My friends love it and begin to chant, "Go, Joey—it's your birthday . . ." It's just a song, but I'm feeling connected with my friends and just know that we're about to have a great night. In fact, I'm not thinking about anything else except having fun with my boys. That is the beauty of the pregame: I could tell that every guy had left all his problems and thoughts at the door of 301, and when each kid walked inside, all they thought about was having a good time. Girls keep coming in and out of the door, but no one really pays close attention to them. Just as the pregame

was getting to its ultimate height, each boy had his arms around each other jumping in unison, to a great hip-hop song by Biggie Smalls. One of the girls went over to the stereo and turned the power off. We yelled at her to turn it back on, but the mood was already lost and we decided it was time to head out.

In this example, Joey's confidence is boosted by the camaraderie he experiences in a male-bonding ritual in which women—supposedly the agreed-upon raison d'être for the evening—are scolded or otherwise ignored altogether. As these young men energetically dance arm in arm with one another in an entangled web of male bodies, they generate the collective effervescence and sense of social connectedness necessary to plunge into the nightlife of the city. As such, pregaming fulfills the same function as a last-minute huddle (with all hands in the middle) does for an athletic team.[30] It is perhaps ironic that Joey's ritual of "having fun with my boys" prepares him for the girl hunt (or more specifically in his case, an opportunity to "hook up" with Jessica) even as it requires those boys to exclude their female classmates. At the same time, this men-only dance serves the same function as the girl hunt itself: it allows its participants to expressively perform masculinity through an aggressive display of collective identification. In this sense, the pregame resembles other campus rituals of male socialization and boundary maintenance, particularly those associated with fraternity life and violence against women.[31]

During similarly collective rituals leading up to the girl hunt, young men boost each other's confidence in their skills of sexual persuasion by watching films that are literally about male heterosexual exploits in urban nightlife, such as Doug Liman's 1996 film *Swingers*, which chronicles the storied escapades of best friends Mike and Trent as they attack the nocturnal hot spots of Los Angeles and Las Vegas. According to Kevin, an eighteen-year-old freshman:

Darryl, Marc, and I were on a mission to find our ties. Alpha Beta Omega sorority girls had taken them the previous day for their

annual My Tie event in Center City. The rules: find the ABO sister wearing your tie at the bar, and you've found your date for the night. In the cases of me and Marc, we already knew who we were looking for—our girlfriends. Darryl, on the other hand, was bouncing off the walls all day in anticipation of his first-ever blind date.

I knew that Darryl needed to calm down if he wanted any chance of a second date. At about 8:15 p.m., I sat him down and showed him (in my opinion, the movie that every man should see at least once—I've seen it six times) *Swingers*. . . . Darryl immediately related to Mike's character, the self-conscious but funny gentleman who is still on the rebound from a long-term relationship. At the same time, he took Trent's words for scripture (as I planned): "There's nothing wrong with showing the beautiful babies that you're money and that you want to party." His mind was clearly eased at the thought of being considered "money." Instead of being too concerned with not screwing up and seeming "weird or desperate," Darryl now felt like he was in control. The three of us each went to our own rooms to get ready.

This collective attention to popular culture helps peer groups generate common cultural references, private jokes, and speech norms as well as build in-group cohesion.[32] Perhaps for this reason, other parts of Kevin's narrative account consistently draw on the slang employed by the film's lead characters: "Darryl, our newly decreed 'money' friend, shifts around, playing it cool, scanning the room for his tie." "Darryl was definitely in 'money' mode, because she sat close to him (after only a little to drink—so she must have seen something in him)."

In this case, globally distributed mass media texts (i.e., films, music recordings and videos, television programs, computer games, graphic novels) supply audiences with a familiar set of shared discursive strategies and symbolic resources that influence daily social behavior pertaining to gender performance and sexual interaction.[33]

Similar to their shared immersion in rap music, young men incorporate collective film viewing into their pregame rituals to bolster male group solidarity while absorbing a set of cultural frames useful for making sense of the girl hunt, just as the anthropologist Peggy Reeves Sanday documents how fraternity brothers habitually watch pornographic films together in their preparations for late-night parties.[34] Of course, *Swingers* represents much tamer fare: yet like pornography, the film encourages the development of a hypermasculine identity while supplying young men with cultural scripts for upcoming social interactions with women; reduces women to infantile objects of sexual desire (or "beautiful babies"); generates collective excitement for the girl hunt; and gives young men the self-confidence necessary for competing in such a contest.

These themes are hardly uncommon among popular films pitched to audiences of adolescent boys of all ages. Over the last several years, my classroom surveys of undergraduate students and their favorite motion pictures have revealed that male respondents consistently cite films that draw on similar themes to those in *Swingers*. These movies emphasize the party-hearty campus high jinks of college life (*National Lampoon's Animal House, Old School*); male vanity and the meaning of manhood (*American Psycho, Fight Club*); the camaraderie of violent men in secret societies and criminal gangs (*The Godfather, Goodfellas, Scarface, The Usual Suspects*); and, of course, the relentless pursuit of attractive women (*There's Something About Mary, American Pie*).

GIRL HUNTING AS COLLECTIVE ACTIVITY

Once the locus of action moves from the pregame party to a more public venue such as a bar or nightclub, the much-anticipated girl hunt itself proceeds as a more or less scripted performance, and young men are all too aware of its predictability. For Christopher, a twenty-two-year-old senior, and his cousin Darren, *Swingers* provides the Ur-text for their evening out at Continental: "As we sip our drinks, my cousin and I scan the crowd looking for women. Every

time I go out, I feel like I'm living a scene from the movie *Swingers*. We get dressed, go out later than we planned to, look for girls, get drunk, and leave places that are still packed because we think that they're 'beat.'"

Just like the pregame, the girl hunt persists as a collective display of masculinity as pairs, trios, and larger groups of young men follow each other in their strategic search for available women. According to Christopher, he and his cousin Darren "go out together a lot. We enjoy each other's company and we seem to work well together when trying to meet women." Reporting on his evening at Club Egypt, Lawrence, a twenty-one-year-old junior, illustrates the collective nature of the girl hunt:

> After we finish our Red Bull and vodkas, we order three Jack and Cokes at six bucks each. We walk around the bar area as we finish these. After we are done, we walk down to the regular part of the club. We make the rounds around the dance floor checking out the girls. There were definitely a few hotties in the crowd. Most of the girls are dressed in backless shirts and tight pants, which of course is definitely a good thing. We walk up to the glassed dance room and go in but leave shortly because it is really hot and there weren't many prospects.

At Club Egypt Lawrence and his friends deploy their elaborated performance of masculinity by making their rounds together as a pack in search of a suitable sexual target. Therefore, perhaps it is not surprising that the collective and performative nature of their pursuit should also continue *after* a female mark has been identified:

> This is where the night gets really interesting. We walk back down to the main dance floor and stand on the outside looking at what's going on, and I see a really good-looking girl behind us standing on the other side of the wall with three friends. After pointing her out to my friends, I decide that I'm going to make the big move and talk to her. So I turn around and ask her to

dance. She accepts and walks over. My friends are loving this, so they go off to the side and watch.

. . . After dancing for a little while, she brings me over to her friends and introduces me. They tell me that they are all fresh-men at Mercer County Community College [in New Jersey], and we go through the whole small talk thing again. I bring her over to my two boys, who are still getting a kick out of the whole situ-ation. . . . My boys tell me about some of the girls they have seen and talked to, and they inform me that they recognized some girls from Penn walking around the club.

Why do Lawrence and his dance partner both introduce themselves to their friends? Lawrence seems to gain almost as much as pleasure from their excitement as from his own success, just as they are "lov-ing" the vicarious thrill of watching their accomplice command the young woman's attention, as if their *own* masculinity was validated by his exhibition of prowess and daring.

In some ways, that does not seem all that far off-base. In this instance, arousal is not merely individual but represents a collectively shared experience as well.[35] For these young men, the performance of masculinity does not necessarily require successfully meeting a potential sex partner so long as one enthusiastically participates in the ritual *motions* of the girl hunt in the company of men. When Law-rence brings over his new female friend, he does so to celebrate his heroic achievement with his buddies, and in kind, they appear grati-fied by their *own* small victory by association—perhaps not the stuff of legend, but plainly enough to get them through the night. (And while Lawrence celebrates with them, perhaps he alleviates some of the pressure of actually conversing with her.)

Along these lines, the collective quality of the girl hunt makes each male participant accountable to the group as well as to himself, and therefore young single men will goad each other on to persist in the hunt, deriding those who turn away potential pickups. Michael, a nineteen-year-old junior, reports on his evening out at McFadden's, an Irish-themed sports bar and nightclub:

My friend Buddy beckoned to me from the dance floor. Not knowing what he wanted, I snaked my way through the crowd to join him. As I approached him, a girl several years my senior smiled at me. She looked like she wanted to start a conversation, but waited for me to initiate. Not particularly interested in her and with my friend waiting, I awkwardly moved past with what I am sure was a weird smile on my face. *Buddy had seen this entire exchange and said he was disappointed in me for not trying to hit on her* [emphasis added].

In their private conferences, young men make one another accountable for their interactions with women, and their vigilance increases the chances that over time these men will eventually comply with the set of practices that sustain the ideals of hegemonic masculinity and the myth of the pickup, even in instances when such men disagree with those expectations.[36]

The collective aspects of the girl hunt also highlight the efficacy of conspiring with accomplices to meet women. In the argot of the confidence game, often men will eagerly serve as each other's *shills*, or confederates, and sometimes get roped into the role unwittingly with varying degrees of success.[37] Michael continues in his report by describing Buddy's exploits:

Buddy, a twenty-five-year-old University of Pennsylvania alumnus, is the kind of guy who is not afraid to flirt with as many girls as possible. Tonight he was putting his charm to good use, dancing with any girl who would give him the time of day. I realized he had called me over for the purpose of finding a girl for me. Turning to the girl nearest him on the dance floor, he said to her, "This is my friend Michael. He's a little shy." Waiting for him to introduce me to her, I realized after a moment that he didn't know these girls either. His introduction was actually one of the cheesiest pickup lines I had ever heard used that wasn't the punch line to a joke. I introduced myself to the girl whose name I found out was Rebecca, a twenty-four-year-old professional

from South Philadelphia. I talked to her for a few minutes and admitted my true age to her; surprisingly, she didn't blow me off too quickly, but her interest was definitely in Buddy rather than me at that point. Deciding to leave the two of them to get better acquainted, I excused myself to the bar to get a second beer.[38]

Among young singles, the role of the passive accomplice is commonly referred to in contemporary parlance as a *wingman*. Popularized by the 1986 film *Top Gun*, the term literally refers to the backup fighter pilots who protect the head of a military flying formation by positioning themselves outside and behind (or on the wing of) the lead aircraft to engage enemy fire when necessary. In recent years the term has been appropriated to refer to a confederate who assists a designated leading man in meeting eligible single women, often at costs to his own ability to do the same. In male-oriented popular culture, the wingman has become institutionalized in men's magazines such as *Maxim*, humor-driven literature documenting young men's real and imagined sexual lives (or what Warren St. John of the *New York Times* refers to as "fratire"), and how-to manuals with such dubiously promising titles as *The Guide to Picking Up Girls*.[39] This last volume provides a vulgar and sexist description of the wingman's social role:

> Everyone knows what a wingman must do. Your wingman must take the extra girl for you if there are two girls and you want to talk to one of them. The wingman must lay rap on your girl's friend as long as you rap with your girl. It does not matter that the girl's friend may be very ugly. The wingman must do his job at any cost. He must be able to pull his own weight and back you up. Otherwise, your girl may get pulled away by her friend whom your wingman has failed to entertain.[40]

In public rituals of courtship, the wingman serves multiple purposes: he provides validation of a leading man's trustworthiness; he eases the interaction between a single male friend and a larger group of women; he serves as a source of distraction for the friend or

friends of a more desirable target of affection; he can be called upon to confirm the wild (and frequently misleading) claims of his partner; and perhaps most of all, the wingman helps to motivate his friends by building up their confidence. Indeed, men describe the role of the wingman in terms of loyalty, personal responsibility, and dependability, traits commonly associated with masculinity.[41] According to Robert, a nineteen-year-old sophomore, "After walking about a block, a group of girls sitting in a pizza parlor waved at a friend and me. . . . Although I already have a girlfriend, like any good wingman I told my friend this was definitely something worth pursuing." The prominent role of the wingman further illustrates the extent to which the girl hunt proceeds as collective activity. According to Nicholas, an eighteen-year-old freshman, "As we were beginning to mobilize ourselves and move toward the dance floor, James noticed Rachel, a girl he knew from Penn who he often told me about as a potential girlfriend. Considering James was seemingly into this girl, Dan and I decided to be good wingmen and entertain Rachel's friend, Sarah."

Hegemonic masculinity is not only expressed by competitiveness but loyal camaraderie as well, and so many young men will take their role as a wingman quite seriously and at personal cost to their relationships with female friends. According to Peter, a twenty-year-old sophomore:

> "It sounds like a fun evening," I said to Kyle, "but I promised Elizabeth I would go to her date party." I don't like to break commitments. On the other hand, I didn't want to leave Kyle to fend for himself at this club. . . . Kyle is the type of person who likes to pick girls up at clubs. If I were to come see him, I would want to meet other people as well. Having Elizabeth around would not only prevent me from meeting (or even just talking to) other girls, but it would also force Kyle into a situation of having no wingman.

In the end, Peter takes Elizabeth to a nightclub where, although he *himself* will not be able to approach available women, he will at least be able to assist Kyle in meeting them:

Behind Kyle, a very attractive girl smiles at me. Yes! Oh, wait. Damnit, Elizabeth's here. . . . "Hey, Kyle," I whisper to him. "That girl behind you just smiled at you. Go talk to her." Perhaps Kyle will have some luck with her. He turns around, takes her by the hand, and begins dancing with her. She looks over at me and smiles again, and I smile back. I don't think Elizabeth noticed. I would have rather been in Kyle's position, but I was happy for him, and I was dancing with Elizabeth, so I was satisfied for the moment.

By the end of the night, as they chat in a taxi on the way back to campus, Peter learns that he was instrumental in securing Kyle's triumph in an additional way:

Once safely in the cab, Kyle says, "Well, that was intense." I nod. "So what ever happened with you and that girl?" I ask. "I hooked up with her. Apparently she's a senior." I ask if she knew he was a freshman. "Oh yeah. She asked how old you were, though. I said you were a junior. I had to make one of us look older."

Peter's eagerness to serve as a wingman illustrates his complicity in sustaining the ideals of hegemonic masculinity, which therefore allows him to benefit from his resultant acceptance as a member of his male friendship network and its attendant status. In doing so, he gives up the *potential* sexual rewards of the girl hunt in order to assure his more *definitive* (albeit perhaps less prestigious) gains in trustworthiness among his peers.

THE GIRL HUNT IN THE COMPANY OF MEN

The male peer group serves a number of important functions in the context of the girl hunt. Together the group members collectively engineer widespread faith in the myth of the pickup; participate in a series of collective rituals of confidence building for the supposed benefit of all members; bolster each individual member's performance of

masculinity while in the presence of women; and in a practical sense, provide the support personnel (in the form of wingmen and other shills or confederates) deemed necessary among young men in order to safely approach women in public in the first place. In addition, the peer group provides a readily available audience that can provide emotional comfort to all group members, as well as bear witness to any individual successes that might occur. As illustrated by the preceding examples, young men covet the validation and erotic prestige they receive from their accomplices upon prevailing in the girl hunt. According to Zack, a twenty-year-old sophomore, "Probably around 2:15 a.m., we split up into cabs, with the guys in one and the girls in another. . . . In the cab, all the guys want to talk about is me hooking up on the dance floor. It turns out that they saw the whole thing. I am not embarrassed; in fact, I am proud of myself."

As an audience, the group can collectively validate the experience of any of its members and can also internalize an individual's good fortune as a shared victory. (This suggests an additional benefit of working as a collective: if the success of any single member can confer status upon all other members, then traveling in a large group increases the odds that at least *someone* in the group will hook up, provided the group doesn't *impede* one's chances by introducing competition to the setting or otherwise prove distracting to the proceedings.) In a certain sense, a successful sexual interaction must be recognized by one's peers in order to gain status as an in-group "social fact," and so the group can transform a private moment into a celebrated public event—thereby making it "count" in a social sense for the male participant and his cohorts.

Of course, turning a public encounter with a stranger into an immediately consummated sexual episode occurs less frequently than most people imagine, especially when compared to the overwhelming degree of time, money, effort, and emotion young men invest in such enterprises. But if we focus on the *primary* goal of the girl hunt—the performance of masculinity—then it becomes clear that its collective nature allows peer group members to successfully enact traditional gender roles even when they ultimately fail at the sexual pursuit itself.

Again, the performance of masculinity does not necessarily require *mastery* at picking up women, just so long as one participates in the ritual endeavor enthusiastically in the company of men.

For instance, Sam, a twenty-two-year-old black senior, observes how a group of friends take pleasure in an accomplice's public rejection at the hands of an unimpressed woman:

> By this time it was around 1:30 a.m., and the party was almost over. . . . I saw a lot of the guys had their cell phones out while they were talking to the women. I figured the guys were trying to get phone numbers from the girls. So as I walked past one of the guys, I heard him ask a girl for her number. But she just laughed and walked away. That was real funny especially since his friends saw what happened and proceeded to laugh as well.

Over time young men discover that women will usually resist their sexual advances by employing humor, moral outrage, outright rejection, or physical retaliation.[42] But in a way, one man's botched attempt at an ill-conceived pickup can bolster the self-confidence of the rest of his all-male peer group as much as a victorious one. According to Brian, the aforementioned nineteen-year-old sophomore:

> We had been in the club for a little more than half an hour, when the four of us were standing at the perimeter of the main crowd in the dancing room. It was then when Marvin finished his second Corona and by his body gestures, he let it be known that he was drunk enough and was pumped up to start dancing. He started dancing behind a girl who was dancing in a circle with a few other girls. Then the girl turned around and said, "Excuse me!" Henry and I saw what happened. We laughed so hard and made so much fun of him for the rest of the night. I do not think any of us has ever been turned away so directly and harshly as that time.

In this instance, Marvin's abruptly concluded encounter with an unwilling female participant turns into a humorous episode for the

rest of his peer group, leaving his masculinity bruised yet intact. Indeed, even in his gracelessness, Marvin displays an enthusiastic heterosexuality as emphasized by his drunken attempts to court an unsuspecting target before a complicit audience of his male peers. And as witnesses to his awkward sexual advance, Brian and Henry take pleasure in the incident, as it not only raises their relative standing within the group in comparison to Marvin, but can also serve as a narrative focus for future "signifying" episodes (or ceremonial exchanges of insults) and other repeated rituals of solidarity characteristic of joking relationships among male adolescents.[43] Meanwhile, they can excuse their collective failure to attract a woman without ever actually challenging the basis of the girl hunt itself: the thrill of the pursuit, and the performance of heterosexual manhood.

In the end, young men may enjoy this performance of manhood—the hunt itself—even more than the potential romantic or sexual profits to be gained by its artful execution. In his reflections upon a missed opportunity to procure the phone number of a law student, Christopher, the aforementioned twenty-two-year-old senior, admits as much: "There's something about the chase that I really like. Maybe I subconsciously neglected to get her number. I am tempted to think that I like the idea of being on the lookout for her more than the idea of calling her to go out for coffee." While Christopher's excuse may certainly function as a compensatory face-saving strategy employed in the aftermath of another lonely night, it might also indicate a possible acceptance of the limits of the girl hunt in spite of its potential opportunities for male bonding and the public display of young heterosexual masculinity.[44] Like other sporting rituals surrounding urban nightlife, the girl hunt is as motivated by fear as by aggression—indeed, in most instances, losing the game of "bar" is far less attractive than simply breaking even.

THE GIRL HUNT AS A HUSTLE

A consistent thread in sociology concerns how structures of inequality are constituted and reproduced through recurrent patterns of

ordinary social interaction. According to sociologist Randall Collins, the very foundations of the macrosocial world and its institutions can be reduced to the agglomeration of everyday face-to-face encounters conducted among humans over time; as he argues, "Strictly speaking, there is no such thing as a 'state,' an 'economy,' a 'culture,' a 'social class.' There are only collections of individual people acting in particular kinds of microsituations." In an essay on the same subject, sociologist Michael Schwalbe and his coauthors emphasize how the repetition of everyday processes such as identity work, boundary maintenance, and emotion management all contribute to the reproduction of inequality through their frequent deployment in varied social contexts.[45]

Taken in this way, the girl hunt serves as shorthand for a composite of multiple types of collectively initiated interaction rituals capable of reproducing social inequality on the basis of gender. Group-based efforts at mobilizing masculinity and girl hunting in the context of nightclub interaction operate as mechanisms that fabricate gender myths while transforming women into targets of the collective male gaze and objects of sexual desire. By treating the girl hunt as a hustle by employing creative strategies of deception—including the use of wingmen and other confederates—would-be suitors cooperatively create nocturnal selves that suggest male competence and personal integrity through strategies of impression management, trickery, and guile. Of course, these everyday processes do not merely occur in a vacuum, but within a social setting in which the regularity of sexist banter and asymmetric courtship rituals encourage the replication of such behaviors, along with continually renewed ideologies of masculine aggression and feminine sexuality—the very foundations of the myth of the pickup.[46]

But at the same time, it is equally noteworthy that the hustle of the girl hunt also promotes social inequality and subordinate behavior *among men*. Among participants in the girl hunt, the most dominant men enjoy a disproportionate degree of social prestige relative to their competitors, as is the case in other sexual contests. Competitive sex talk among adolescent peers in the hours leading up to the girl hunt

creates an unrealistic set of sexual expectations for impressionable young men, particularly those who already suffer from anxiety over their body image and sexual development. Meanwhile, the repetition of collective rituals of masculine identification successfully condition young men to suppress empathy for females targeted by the girl hunt, just as the training regimes of military and police units serve to diminish feelings of inhibition and fear among cadets. As illustrated earlier in the chapter, male peers often rely on the social script associated with girl hunting to goad one another into performing masculinity by behaving in ways that run counter to their actual feelings and desires. In the end, the interaction rituals associated with the girl hunt reproduce structures of inequality *within* as well as *across* the socially constructed gender divide between women and men.[47]

6

HUSTLING
THE HUSTLERS
CHALLENGING
THE GIRL HUNT

As illustrated in the preceding chapter, young men commonly harbor illusions that the women they encounter in the city's nightclubs and bars are invariably interested in meeting and hooking up with potential sex partners. But as I point out, this expectation sharply contrasts with the underlying reality, as it is somewhat exceptional for complete strangers lacking in shared friendship ties to couple up over the course of their initial meeting. Contrary to the pornographic fantasy worlds conjured up by MTV *Spring Break*, *Girls Gone Wild*, and other pop-cultural sex romps and free-for-alls, most young women act more like their mature counterparts—self-reliant, cautious around strangers, protective of their personal space, and resistant to transparent come-ons. As five college juniors remark to one another when discussing the nightlife pickup scene during an all-female focus group:

"Well, in terms of meeting guys, I think the whole girl-guy bar interaction is a little bit hokey. I wouldn't be interested in someone who approached me that way in the first place, I don't think."

"I just think it's gross, like just disgusting."

"It's annoying."

"You wonder how many are thinking in their head, 'What is the probability that this girl is really going to go for me?' . . . What's their success rate? I doubt it's very high. . . ."

Other focus groups of undergraduate women express feeling similarly uncomfortable when approached by men in bars and nightclubs: "Most people are weird. It's sleazy."

"Yeah, you just don't know what to expect of them. It's also kind of awkward if someone is like, 'Let me buy you a drink,' because then you feel indebted to talk to them for a few minutes, and you don't want to do that—you just want to get your drink and leave."

"If you are barhopping and some random guy comes up to you, then it gets a little sketchy."

"Because you have to think, 'What is his ultimate goal?'"

These women also point out the frequency with which they are harassed day and night on city sidewalks by catcallers of all ages, typically by men more interested in performing a hyper-macho role in front of their friends than actually meeting a potential mate. In these moments men take pleasure in interacting with a member of the opposite sex despite the brevity and coercive nature of the encounter.[1] Female targets of harassment rarely lose sight of this fact: "Well, when you are walking down the street and drunk guys yell at you? That's just because they're drunk. No guy trying to pick you up would ever say things like that and scream things at you."

"Out of their cars and stuff . . ."

"They start trying to say stuff while sitting in their car, and I'm trying to walk to class. . . . As if, 'Oh yes, I am going to stop and talk to you because you decided to stop and yell from your car.'"

"I got harassed by a fourteen-year-old boy at eight in the morning walking to work last summer."

In the anonymous world of city life, the catcall, the grab of the waist, the unwanted kiss, and the insulting pickup line all represent routine encounters experienced by young women in public.[2] In downtown nightlife scenes in particular, these kinds of interactions occur frequently enough that many young women simply come to expect them. According to Lucy, a twenty-one-year-old racially mixed

senior, nightspots like Tiki Bob's Cantina, a dance club on the northern edge of Old City where female bartenders in bikini tops pour shots of liquor directly into the mouths of patrons, promote these kinds of encounters:

> The whole place seemed to be a "meat market." The main reason people went to clubs such as this was to go dancing with friends and for many, to meet new people and hook up with them. As we all walked around, we could feel eyes on us, as if the men were trying to stake out their prey, trying to figure out which girl was their next target. . . . The second guy who came up to me approached me from behind, so I couldn't really look at his face to see if he was attractive or not. He started to dance with me, and I figured that a little dancing was harmless, so I continued for a while. He had his hands around my hips and on my legs, which is a little awkward, but perfectly normal when you're a little drunk and in a club—these sorts of things are expected to happen.

Young women experience sexual harassment in public nightlife settings as a routine occurrence. While nearly two-thirds (62%) of American university students of both genders are likely to encounter some form of sexual harassment during their college careers, young women are more likely than men to be harassed outside campus grounds (43% vs. 29%), experience harassment involving physical contact (35% vs. 29%), and find themselves the target of sexual jokes, comments, gestures, or looks.[3] These confrontations are especially common in restaurants, bars, lounges, and dance clubs that invite sexual banter, flirtation, innuendo, and physical contact among patrons, and even perhaps even more so for women workers, whether they be cocktail waitresses, bartenders, table servers, or even creative professionals.[4] Given the frequency and repetitive nature of these encounters, it is not hard to imagine that the recurrence of asymmetrical face-to-face interactions such as these may also serve to reproduce larger macrostructures of gender inequality.[5]

But at the same time, women routinely resist uninvited sexual advances from strangers and other potentially threatening encounters in the city at night, and consequently challenge the inequality such encounters suggest. While these challenges are occasionally combative, in other instances women incorporate strategies of deception and guile into their interactions with aggressive men, and in doing so they out-hustle the hustlers at their own game. Moreover, confident heterosexual women often pursue their *own* sexual conquests, relying on subterfuge to select and entrap their targets with the same sly enthusiasm as their male counterparts, albeit with a much higher rate of success.

WHEN OPPOSITES DO NOT ATTRACT

Within heterosexual marketplaces such as nightclubs, attractive young women possess a certain degree of situational dominance, given their ability to withhold affection or confer sexual prestige onto eager male subjects. For this reason, they are often shown deference through rituals of courtesy.[6] But this situational power is not only fleeting but severely limited, since young women typically lack the means to prevent would-be suitors from soliciting them in the first place (although evidence does suggest that men give *extremely* beautiful women such a degree of social deference as to consider them entirely unapproachable).[7] Scenes of urban nightlife trap young female nightclub patrons in a double bind, because while they may desire to present themselves as sexually alluring (and enjoy the status and self-esteem that comes from such an achievement of impression management), most lack the ability to control just *which* men will find them attractive. In the course of their experiences in nightclubs and cocktail bars, these young women also come to discover an awful (if ironic) truth: while their goals of achieving glamour are wrapped up in their desire to embody *adult*-oriented sexual norms of fashion and style, they are ultimately valued by older men for their age-bound *youthful* appeal and nubile appearance.[8] This leads to an awkward mismatch of sexual desire, as demonstrated by the frequency with

which college-age women find themselves targeted in public by men on the make who are ten, twenty, and even thirty years their senior.

According to Brooke, a sophomore, "I remember last year at this one thing there were people that didn't go to Penn, and I remember feeling a little uncomfortable because they seemed to be older men and they were buying me drinks, and I just felt that I looked so young that it was a little sketchy to me." In her account of her trip to a South Street bar, Jessica, a twenty-year-old sophomore, makes it clear that under such conditions one's feminine attractiveness can easily be experienced as a burden:

> The bar was getting pretty crowded at this point. There was a man who was about thirty-five to forty years old who was extremely drunk and stumbling around. He walked up to me and with very slurred speech tried to strike up a conversation. I was definitely a little scared of him. He "wanted to go get drinks," so to get him to leave I told him in a very sarcastic tone to go ahead and order me a cosmopolitan, and I would come find him. I said this because I knew he would probably be too drunk to get drinks and wouldn't come back to bother me again. I was right—later on I saw him hitting on two women across the room.

When faced with repeated public confrontations over time, many women develop defensive strategies of interaction based on assessing the relative strengths and weaknesses of their adversaries, to greater or lesser degrees of efficacy. Regarding her evening at Denim, Natalie, a twenty-one-year-old Korean junior, reports:

> As I looked in my purse for cash, a sleazy, short old man asked me if I was going to buy him a drink. I smiled politely, informing him that it should be the other way around—shouldn't *he* be buying *me* a drink? He said that next time I come, he would buy me several. I gave him a fake smile and walked away. . . . As we left the club, most people began to stand and crowd outside the door on the sidewalk. . . . As we walked down the street, a rather

tall and thin man with thinning hair and glasses who looked to be in his early thirties asked us if we were heading to this other club. We said no, but he continued to walk alongside of us trying to make conversation by asking our names and if we were Philly locals. He also introduced us to his friend. I tried dropping hints without being rude that we weren't interested in talking: not making eye contact, giving short one-word answers, and just seeming uninterested. Unfortunately, he seemed oblivious and I wondered until when he would keep following us and if I would have to blatantly tell him GOOD-BYE. Finally and fortunately, he sensed our discomfort and left, wishing us a good-night.

When confronted with this type of hassling, some young women experiment with various strategies of situational diffusion while others wrestle with the ambiguity suggested by emerging adulthood and sexual independence. In certain cases, college females associate adult sexuality with competence at handling the uninvited stares of older men, and thus experience their own unease as a sign of immaturity. According to Marin, a racially mixed twenty-year-old junior from Barbados, describing her night out alone at Loie, a Parisian-style café and nightclub:

> There were a couple of older men in the booths up ahead, and I could sense them (and I saw them) looking over my way every now and then. Mixed feelings about that one; I mean, hey, I admit I like feeling attractive but . . . There was another guy sitting at the bar, younger than them, who was also obviously looking my way. It didn't take long for me to just shrug them all off. I'll just be cool, whatever, if they want to look, they can look. And hey, what the hell? Look at this situation for what it really is. *You're* the one that wanted to look attractive, right? *You're* the one that wants to be able to handle *any* situation! So, what's the point of that if you're going to get all hung up over some men just *looking* at you? *Grow up!*

The palpable anxiety and self-critique expressed in Marin's account provides one variant on how young women reflect upon unwanted attention from older men. But more often than not, these sexual advances simply repulse most other college-age women, and they hardly feel ashamed to express it. Phoebe, a twenty-one-year-old racially mixed senior dining at El Vez, another Starr restaurant, remarks, "The creepy balding guy keeps looking at me. I want to say something to him, anything, like 'Dude, I'm *way too young for you. Stop staring, Pops.*'" At Denim, Gina, a nineteen-year-old freshman, observes:

> I make my way out toward the dance floor, rejecting offers of drinks on my way. As I look around, I notice that although most of the people look familiar, mostly Penn students, there are also a great number of older-looking men. This makes me a bit uncomfortable. I see these men looking, leering, at the young girls who are shimmying on the dance floor, unaware of the eyes watching them. A little creepy.

Other young women describe how being confronted by an older man on the make requires a more proactive stance; according to one group of undergraduates, "I think I might be slightly different than some girls this way. It's like right out there, '*Hey, I am not interested! I am not going to hook up with you—go away, I'm twenty.*' '*You are too old,*' things like that. . . . Yeah, older guys creep me out, and I don't know why."

"No, I mean it makes sense that you don't really want to show any interest in someone that is, like, ten years older than you."

"And I am also conscious that I am underage, and the fact that maybe, like you guys were saying, maybe people *know* I am underage, and if an older guy is hitting on me because I look young and immature, that's creepy and really not cool. And you have to be really careful, because if they think I am underage and they are going to hit on me because of that, and therefore take advantage of me? That is really, really creepy—be very careful."

There is a sad irony in the fact that when grown men confront young women noticeably *maturing* to adulthood, they respond by *regressing* toward their own adolescent glory days. The sexual asymmetry suggested by intimate encounters that involve steep age differentials leads some groups of young women to respond with laughter to the advances of boorish men in their thirties, men whom college women consistently refer to as "middle-aged."[9] According to Olivia, a nineteen-year-old sophomore:

> As we passed one bar on Second Street between Chestnut and Walnut, a group of four or five men stood outside with drinks in their hands, and a few smoking cigarettes. They were dressed somewhat casual: mostly khakis and a T-shirt, some with jeans and button-downs. They were at least eight years older than us. "Free beer inside, ladies. Free beer, seriously." The five men (and I call them men, because they literally were at least thirty-year-old men) yelled to us as we walked by. Feeling slightly tipsy from our drinks, we stopped and asked them if they were serious. They said yes, so we figured we wouldn't lose anything if we went in. The bar was really upscale. There were dim lights, hardwood floors, and big dark maroon leather couches and chairs circling multiple fireplaces; the paintings added to the lush atmosphere. Speaking of atmospheres, as soon as we walked in, a man—a short man, probably about thirty-two or thirty-three—came up to us and said, "Ladies, I just wanted to let you know that you have positively added to the landscape of this here bar this evening. Really, you are truly gorgeous." Wow. Two of my friends decided to take a quick bathroom break before we got out of there. That man walked away, thankfully.
>
> As my two other friends and I were waiting, the man that told us there was free beer came inside. (This should be interesting.) His conversation was mostly one-sided: "Sorry that we lied about the beer thing, we just wanted you ladies to come in." "Are any of you ladies married? Because if you're not, I'm always available." "So, how educated are you ladies? Do you

know who painted that painting?" "Where are you all from and what school did you go to?" Once again, we stood there and hesitantly answered the questions. . . . Our two friends came back from the bathroom; we smiled and nodded at the weird man we were talking to and high-tailed it out of the bar. As soon as we walked outside, we practically fell over laughing. Had we been a year and a half younger, that definitely would have been a statutory situation. . . .

We made it home. . . . Still laughing about our encounter with the men on Second Street, we got to our apartment, changed into pajamas, made some popcorn, and turned on *Sex and the City*. I was glad to be home, stuffed from good food and drinks . . . and more importantly, away from unmarried, single, middle-aged, short, balding men.

If underage women regard "unmarried, single, middle-aged, short, balding men" with suspicion, nightlife encounters with married men may provide an even greater sense of apprehension. According to Kyra, a sophomore, "They could be married! I was at Pod—no, I am not kidding and I know it's so weird, but I've seen the guy here: he is a professor here and I don't know his name or anything like that. But one night I was at Pod, and I was getting drinks, and I was with my boyfriend Will, and he was friends with this girl, and she was with a group of her friends. They go to high school, okay, they are in *high school*, and this guy and his friend were buying them drinks and bought them dinner and all this stuff, and then the guy had taken off his wedding band because the girls could see there was like an indent. That's what I am talking about. That's what's really sketch, and that's why I feel weird taking drinks from someone, because you really don't know what their deal is."

THE TREATMENT OF FEMALE SERVICE WORKERS

At 11:00 p.m. on a January weeknight at Dirty Frank's, I pull up to the bar and order a cheap mug of Yuengling Lager, the local favorite. It

is an ordinary evening at the smoky corner tavern: the jukebox blares on, indiscriminately playing songs from every genre ("Sixteen Tons" by Tennessee Ernie Ford," "O.P.P." by Naughty by Nature, "Just What I Needed" by the Cars), while the surly bouncer mutters on his cell phone. A row of grizzly men line the bar discussing their ex-wives, while couples curl up in the booths. A handful of men drink alone, including one regular who reads his paperback book over an entire pitcher of beer while intermittently chatting with Christy, one of the regular bartenders. I receive my beer and keep my change in a pile on the bar, which Christy draws on when I order my second beer, and then my third.

Very quickly after I sit down, two men take the stools to my left: a white man with Chinese characters tattooed on his neck and a black gentleman in a black cap. They each order a glass of whiskey and a beer. Soon they call Christy over, and one of the men stands up and tells her, "We've ordered these drinks, and what we would like is to buy *you* a drink and invite you to hang out with us, so we can ask you some questions as to get to know you a little bit better. And we have this friend who will be coming by, and we'd like you both to get to know each other."

She gives them a suspicious look and tries to brush them off, attending to other customers. The men further strategize, as one suggests to the other, "Maybe she's married—you don't even know her name." He drunkenly replies: "I know her name . . . *Beautiful*." "Beautiful . . . Hey, beautiful . . . ," he calls to her. Overhearing them, the bartender turns and shakes her head. "Look," she says, "I'm not married. My name is Christy, and no, I'm not married, I'm not in a relationship, I'm not interested in starting a relationship—*I just work here*. I work, and that's all I do here."

The bouncer calls over, "Nice try, guys!" I turn to him, and he tells me that this happens all the time (especially to the *other* female bartender), and it never works. Shot down again, the men continue to strategize, slurring their words: "Actually, she was mostly looking at you when she said all that."

The other disagrees: "No, you're reading way too much into it." He doesn't think it is going well at all, but his friend is having none of it and gets back on the horse.

"Do you like strange men?" he mumbles to Christy.

"What?!"

"Do you like strange men?" Christy rolls her eyes, blowing them off as she moves away to chat with a group of three younger, mild-mannered men at the far side of the bar.

Nightclubs and bars often establish sexual attractiveness as a requirement for women employees in restaurants, nightclubs, and other entertainment establishments. Given the servile connotations of feminized service work, perhaps it is not surprising that men hassle female hostesses, bartenders, and servers even more than they do other women in public. For Allison, the twenty-one-year-old cocktail waitress at Tangerine, nightlife work invites a constant flood of unwelcome propositions:

They did a lot when I wore the shorter skirt. . . . "What are you doing after this?" "What time do you get off work?" "Do you want to meet us out? We are going to be around the corner." "We are new in town." "We are just here for the weekend." "We'll take you out if you show us where to go." "You won't pay for anything." A lot of stuff like, "You'll know where to go, we'll take you out," that kind of stuff. Sometimes they'll start off with, "Do you have a boyfriend?" or, "You probably have a boyfriend." Sometimes they'll say just stuff like, "You know, you are really cute." Just stuff about looks, looks-related, and then they'll go with it. And I cut people off. I'll just walk away or somehow dismiss it immediately. And then they get the idea.

Sometimes you kind of have to hit them over the head with it. Sometimes, like, professional athletes will come in, and they want you to come out with them afterward. And I go, "Well, I have a boyfriend." And they'll say, "So? So? Doesn't matter." And that's not just professional athletes. Some guys in general will do

that. They just don't care, so that doesn't even work. Then I'll say I just don't want to.

Male patrons commonly ask out female servers and bartenders. According to Jacqueline, a twenty-one-year-old former server at Continental Mid-Town, "They always ask, 'Oh, is that bartender single?' . . . Oh yeah, it happened a lot with everyone. I definitely gave my number to a few guys and then just didn't answer when they called. . . . I have never gone out with anyone who I gave my number to there, but people have called."

Madison, the former server at Alma de Cuba, agrees that enduring sexual come-ons from clusters of men is simply a routine part of the restaurant trade in Philadelphia and New York. Prior to one of her weeknight shifts in a Manhattan restaurant, we talk in a crowded Union Square coffeehouse.

"No matter what restaurant you work in, it seems like there is always that scene which tends to be men in groups," she begins. "They come after working long hours. . . . But they have money, they are on business expense accounts, and they are definitely interested in you being a hot female, as their waitress. And you know, you can just see it. You can feel that whole vibe: 'Oh, are you hot enough? Are we going to have fun with you? Are we going to be able to flirt with you?' And, 'Oh, if you don't really pass the hot test, well, what about the other waitresses?' It's just like they are a group and they are all in their suits, and they feel like they have a lot of power, I guess, because of their money."

"Does that make you feel uncomfortable?" I ask.

"Oh, definitely . . . it would drive me crazy. Those kinds of things really drive me nuts because . . . yes, I am serving you, but I still don't need to be ordered around. I mean, those tend to be the groups where you get the finger snaps or the hand wave, or you get treated a little bit more, you know, where it starts to become a class issue."

"How do you deal with those kinds of encounters, when businessmen are trying to flirt with you? You obviously care a lot about your job, and you don't want to feel like you are being servile. On the

other hand, presumably you want to get a nice tip. And so how do you negotiate that interaction?"

"Well, I am not a big flirter with my tables. I know I have worked with a lot of people who can read those situations, and they go in for the kill as far as flirting in order to get a good tip within the guidelines of whatever professional standards are set. But personally, that makes me go even more into my business voice and just do my job. If I've gotten you the drink you requested in a timely manner, that's what counts. And if you're being rude and interrupt me while I am at another table, I will definitely ignore you, because I know that my manager will back me up on that."

"Were you ever concerned that you were going to get a lower tip as a result?"

"Yeah, I was, but it wasn't worth it to me. As long as I knew that I served them in a professional manner, in a friendly manner that doesn't need to be over the top, then I felt comfortable that I did my job, and if they chose to be offended that I didn't flirt back, then that's their problem."

According to Madison, male customers will even flirt with attractive female servers while in the company of their wives and girlfriends, an encounter that requires a bit of diplomacy to competently negotiate without insulting either party.

"Something else that's always interesting—the guy and the girl who come together on a date, and the guy being friendly to you when you know that he may be flirting, but he may not be . . . (a) He may be flirting, in which case you want to always try to make eye contact with the woman to reassure her that you don't plan on flirting back—you are just as interested in serving her as serving him. Or (b), he is just being friendly, but then you fear that the girlfriend or wife might get jealous of the fact that you are being friendly back—'Oh my gosh, is the waitress trying to flirt with my husband?' . . . I almost enjoy trying to turn those situations into friendly situations, to reassure everyone that everybody appears to be having a good time and nobody is trying to flirt with anybody."

"And how do you do that?"

"Again, I think that eye contact with the girl is really important. I actually find that more often than not, when it's an uncomfortable situation, it's because actually the guy is flirting with you, but he is almost doing it to make the girl jealous on purpose so that they have this little drama between them. So it's almost fun to snub the guy when he is trying to talk with you more and more. Just avoid eye contact with him, and talk even more to *her*, asking her questions—of course, related to serving them."

Other female servers move beyond these interpersonal sexual politics to address how the job hierarchies indigenous to the male-dominated worlds of restaurants and nightclubs relegate women workers to second-class status. According to Alexandra, who waits tables at Ortlieb's, a local jazz club, "I've been in this business a long time; I've been in the service industry since I was fourteen. . . . There is a hell of a lot of gender in that relationship. I don't do very well with gender power dynamics anyway. Like, why do I have to suck up and take it from some dude? I don't really deal very well with that. But that's what I have to do when I am waiting tables, especially at Ortlieb's, because up until very recently there has been no management—it's really a survival of the fittest."

Alexandra explains:

You need to kiss the bartender's ass if you want your drinks, you need to kiss the kitchen's ass if you want to not get skinned alive for something, and then you've gotta kiss customer ass. So you are sort of running around kissing everybody's ass. If you are lucky, you end up making more money than anybody. But there have been times I have left in tears, with a stomach that feels like I got a hot poker in it because of the amount of bullshit I've had to suck up and take. In the kitchen at Ortlieb's, one of them is six foot four and has been in the military and played football, and the other one mugged a friend of mine in the park and I probably shouldn't say that he sells drugs, but he does, and listens to a lot of hypermasculine violent rap, like blasting on repeat about "bitches and ho's," and "get on your knees," and all that kind

of ugly shit. You know that's the stuff that has power over me in that situation. I am glad I only work there once a week.

The sexual politics of the nightlife service world ultimately drive many women away from the industry altogether. According to Sue, a former bar server at the Five Spot, a now-defunct hip-hop club in Old City: "In the end I had to stop waitressing, because I couldn't be nice to people anymore. It was just too exhausting. . . . Just dealing with the same lines. . . . I mean, it's shocking how many men are really physically grabby and things like that. It's disheartening and very uncomfortable and depressing. . . . In the beginning it was fun to talk to everybody, but eventually . . . they became the same people, with the same personalities.

"I mean, just the way people act when they're drinking is typical. I mean, there is a thing with guys and picking up the bartender or the waitress, like, flirting with the bartender or the waitress, things like that. . . . I kind of shut it off after a while and wouldn't engage people like that. But there is always a guy at the bar who wants to be your best friend. There is always a customer that wants to know your name and becomes increasingly familiar with you, and it's just weird because . . . you can't feel the same way, because you are still in a service position, so there is this strange thing.

"Because they are paying you, you are hoping to get big tips, you have to humor them, but you can't actually become friends with them because then you are in this weird place where you are working—and it's just a slight prostitution edge to being a cocktail waitress or a bartender sometimes," says Sue. "The guy sitting at the bar who wants to be your friend will get progressively drunker and progressively more obnoxious. . . . They just want that relationship for the night. . . . I don't know, just like, it would end. And then, you could only do that so many times. It would end, or they would become obnoxious."

In spite of the mythology about the friendly bartender who, like Georg Simmel's archetypical stranger, "often receives the most surprising revelations and confidences, at times reminiscent of a confessional, about matters which are kept carefully hidden from everybody

with whom one is close," bar servers like Sue share a decidedly different experience.[10] "You know, these relationships with these bar regulars are weird. I mean, you end up knowing all this stuff about them and then it's like, 'Oh, but they are a bar regular, they are weird, and I am a stranger—what's going on here?' It's kind of sick, and I don't know how much I want to be a part of it."

Like Sue, Alexandra also finds the blurry boundary between work and intimacy problematic. Although patrons flock to Ortlieb's Jazzhaus for its laid-back, bluesy vibe of staged authenticity, the personal costs of performing that authenticity are often too much for her to bear.[11] According to Alexandra:

> Some of the musicians, how I enhance their experience, I give out a lot of hugs, you know? Really, a lot of it is just that it's a very physical kind of place, and being a woman in that environment where it's 99 percent male musicians (minus a few piano players and some vocalists), so I get pulled into that kind of atmosphere. Sometimes, I refuse. Sometimes I have musicians who come in and want to be hugged and want some physical contact, and I am like, "No!" I've picked fights over, this one guy Felix, who is this amazing fucking drummer, showed up and he just started coming on the scene maybe a year ago, and I hugged the guy sitting next to him, so he thought *he* got a hug. I'm like, "*I am not part of your fucking beverage. I am not a function of your experience here,*" and I actually articulated it to them: "*I am not a function of this jazz club. If I get to know you and like you, and I feel comfortable hugging you, then yes, but don't expect that from me.*" I will draw those lines immediately with people.

The sexualized nature of cocktail service also complicates the relationships female staff employees have with their friends and lovers outside the nightlife setting. Just before wrapping up my interview with Allison, I ask her what her boyfriend thought of her job serving drinks at Tangerine.

"He hates it. He absolutely hates it."

"What does he hate?"

"He hates the way that people look at me, because he has visited me at work. He hates the way that people talk to me; he hates the way that I have to squat to serve people; he hates the way people order things at me. And he hates that I have to wear this skirt, when he knows that I wear pants everywhere. . . . Even this morning, he said, 'I can't wait until you get out of the business and you can do what you want to do, and you don't have to . . . ' Because I told him, 'Yeah, there are days I don't like it either, but find me a job where I will make $350 and walk away with it in one day, in ten hours. Find me that job and I will do it.'"

"So he doesn't often come to see you at work?"

"Oh god, no, he learned."

"Did something happen?"

"No, he's been, and he'll just stay by the bar; he doesn't say one word. But he came to visit, maybe three weeks ago, and he stood and he stayed with me until closing so we could take a cab back together, and he didn't say one word. He was talking to the bartenders because they all know him, and he was talking to everybody. But he didn't say a word to me about work until after. And then we were walking out, and he goes, 'I know you work at one of the nicest places, but this is one step up from a strip club, just because the way that people have been looking.' He was just convinced, and he was like, 'I am so glad you work here and not at a really seedy bar, because it would have been ten times worse. But even so, this is still bad enough.'"

THE FRUSTRATIONS OF CREATIVE NIGHTLIFE PROFESSIONALS

Given that the dominant stereotype of the cocktail waitress suggests feminine sexuality and class subordination, the routine harassment of women service personnel may not seem terribly surprising. Yet to a depressing extent, women serving in positions of relative power in the city's nightlife scenes *also* find themselves the frequent target of unwanted sexual attention and sex discrimination. For example, at

age twenty-five Juliana runs an agency responsible for booking bands at a number of popular rock clubs in the city. On a deafeningly loud Tuesday night at one of the clubs her firm represents, she explains to me the challenges of working in the male-dominated world of independent (or "indie") rock music.

"I could write a book about this. You have to work ten times as hard being a woman. It's very interesting, because 99.9 percent of all the bands are male and, you know, at the beginning of their night they are really respectful. And then they get a few drinks in them, and then it's flirtation, it's different. And I am not there for that. *This is a business relationship.* In order to book your band, I demand the same respect as any male, and I do encounter it, where it is not necessarily anything that is *said,* but it is more the mannerism. Like, '*You are a woman—you don't know.*'"

Given the socially progressive history of indie rock, the male chauvinism of local and touring musicians represents something of an irony. Nominally, the moniker "indie rock" refers to bands that produce and distribute their recordings independent of the four most powerful music labels. (As of this writing, these newly consolidated companies include Sony BMG, Warner Music Group, Universal Music, and EMI Group PLC.) As a genre, indie rock captures a wide sonic terrain from hard-core punk to alternative country to feminist-oriented folk music. But since the popular appropriation of indie rock in the early 1990s (due in large part to the success of Seattle-based Nirvana's multiplatinum album *Nevermind*) and its corporate repackaging as "alternative" rock, a set of musical and stylistic tendencies have come to define indie rock. These trends include the increased popularity of all-female and gender-mixed bands, vocal arrangements that deemphasize the overindulgent masculine vocals that came to define heavy metal and early punk, and often song lyrics that support a left-of-center political orientation and/or radical sexual politics. Therefore, it is somewhat surprising that female professionals working in a so-called "progressive" art world suffer some of the same difficulties as women laboring in more normatively sexist nightlife scenes.[12]

"Well, a lot of the bands that we book don't fit into that stereotypical rock show mentality," admits Juliana. "But you still get it, and you know, sometimes being a woman, you can also use it to your advantage. A smile goes a long way. . . . But you realize when you are getting into this that the music is male-dominated. And like anything else in life, it just makes you work harder. You can't say, 'Oh well, it's male-dominated, I am not going to get anywhere.' You don't give up—you just work harder, and in the long run if you are good at what you are doing, it shows, and I never let it affect me.

"I know it's there. I know there is a glass ceiling; I know that men joke around in a different way than they would if I was a male promoter. But you brush it off—it doesn't matter—because you are here to do a job. You're not here to make friends; you're not here to make somebody think they are attractive. The one thing that's interesting being a woman is that you do feel that appearance matters."

"How is that?" I ask.

"I hate even saying it because it's something I always took pride in not believing or not caring about, but you know, sometimes you just realize appearance does matter. . . . As a woman, it's really sad that I should even care that I think about my appearance doing my job, and I do. . . . Maybe you are not acknowledged as much; maybe you are taken more as a joke. You've just gotta prove yourself."

"As an indie rock person, or as a woman?"

"As a woman booking indie rock bands. Like you have to prove even more that you know what you're doing, and that you are confident. *Never let 'em see you sweat*—that's my biggest motto. Never ever let them think that you don't know what you are doing, even if you don't. Always play it cool. That also has worked for me."

"You've actually gotten hit on while on the job?" I ask.

"Yeah, and that's the biggest bummer. You know, one of the most awesome things about my job is meeting all the men, and the bands in general, that you always looked up to as a kid and you always loved. . . . You could feel it in every bone in your body that you understood what they were saying. And sometimes you meet them, and you are so disappointed; they don't treat you the way they should.

This one time—I won't say the band, but I really loved this one punk rock band growing up. I saw them, I really felt like, 'Man, this is the best band, they really just get life.' And I did a show for the lead's new band, and I was so excited I couldn't wait. And he ended up hitting on me the whole night. You know, 'Hey, what are you doing later?' 'Hey, where's the party?' And I was so upset. It wasn't a compliment; it was more like, 'Oh man, you took it there.' I guess some women would look at it as a compliment, which it is, in a certain way. But for me, it wasn't.

"But I also definitely don't want to play into this, 'Poor me, I'm a woman . . .' you know? I don't consider myself such a feminist, but it's not, 'Poor me . . .' It's good for me. You know, I work quite hard, and in the long run I am better for it."

In spite of her positive attitude, Juliana's predicament is a familiar one for women involved in booking and promotions in the male-dominated rock world. In addition to their roles as talented DJs and rock journalists, Melinda and Sandy have successfully booked hundreds of rock shows at a number of local venues together during the last several years, and they, too, have faced challenges that besiege professional women in Philadelphia's live music industry. According to Sandy, the all-male management teams at some venues simply treat them as if they were service employees, rather than creative professionals: "They were uncomfortable with the fact that we were women in positions of authority, because all of the women that worked there were either bartenders or waitresses."

Melinda agrees: "Regardless of who owned the place, there was always this problem of the owner resenting us because we were females in a position of power, which was really kind of bizarre to think about. That was probably the only time where I really thought about gender, and it's the one place where I have issues with it. They didn't like the fact that we told them certain things, like, 'You need to do this,' or, 'You need to do that.' And in my case, I felt like I have a lot more of it because my father has owned a restaurant for over thirty years. So in addition to booking shows and telling them how things need to be run, I saw where their business was failing and said, 'Well,

you *need to do this*,' or 'You *need to do that*,' and they just didn't like that. You know it was all really difficult."

Melinda and Sandy recently quit promoting rock shows for a local venue, and I asked them if these particular difficulties contributed to their decision. According to Melinda, "I think one of the reasons that we had issues with the owners was that [for them] women are not considered equals in the workplace—or equals, period—and they had issues with that," she explained. "So that was always a problem there. So it was always an uphill battle, and eventually we decided that we could keep on running our heads into the same wall over and over again, and all that was really going to happen was that we were going to give ourselves brain damage . . . and that's why we left."

DEFENSIVE DANCING

What sorts of individual and collective strategies do young women deploy in order to successfully resist harassment, particularly by men on the girl hunt? It may make sense to organize available tactics into four analytically distinct categories—strategies of *combat, engagement, avoidance,* and *deceit.* Each strategy can be alternatively grouped according to whether they are confrontational or evasive, and whether they require forthrightness or deception, and can be summarized as shown in the following table:

	FORTHRIGHT	DECEPTIVE
CONFRONTATIONAL	Combat	Engagement
EVASIVE	Avoidance	Deceit

Some tactics represent explicitly *deceitful* yet evasive, nonconfrontational options such as creating an alter ego to introduce to nosy strangers, along with a fictitious stage name or alias. According to one focus group of undergraduate women, "Yeah, I tend to give out fake names. I don't know why; I am just not comfortable if I am not interested to give my right name. Not like they are going to track me

down by it, but I am just always just like 'Hmmm . . .' and it'll just come out of my mouth before I even think, just some random fake name."

"Oh, I've done that before, too."

"Because they ask your name so quickly, before you even have time to think."

"I've done this, like, once, and used 'Maria.' I am not creative at all."

"I would use my best friend's name. . . ."

Students also cited commercials for Las Vegas nightlife featuring the slogan, "*What happens here, stays here*," in which casino-hopping tourists adopt the names of classic television characters (e.g., *Gilligan's Island*'s Ginger and Mary Ann) when introducing themselves to strangers.[13]

Another common strategy relies on the exploitation of the inflated value men place on a woman's phone number. As discussed in the last chapter, young men typically consider the procurement of a targeted woman's number as a symbol of a successful pickup and sometimes compete with one another according to who can collect the most digits over the course of an evening. Yet among *women* the cost of offering one's number is actually quite low, considering that in a digital age of cell phones, voice mail, and caller ID, screening one's incoming calls has never been easier. If threatened by an unwanted interaction, some women will politely give out their phone number without intending on ever making contact with the recipient, and then abruptly end the encounter. Some women go a step further by giving out a counterfeit phone number, while a few will give out a very *specific* fake number: (215) 618-1505. The number connects the unwitting caller to Philadelphia's local Rejection Hotline, and a prerecorded message alerts them that they have been bamboozled by the object of their affection:

Hello, this is *not* the person you were trying to call. . . . The person who gave you this Rejection Hotline number did not want you to have their real number. We know this sucks, but don't

be too devastated. So, why were you given the Rejection Hotline number? Maybe you are just not this person's type. (Note: this could mean boring, dumb, annoying, arrogant, or just a general weirdo.) Maybe you suffer from bad breath, body odor, or a nasty combination of the two. Maybe you just give off that creepy, overbearing, psycho-stalker vibe. Maybe the idea of going out with you just seems as appealing as playing leapfrog with unicorns. Regardless of the reason, please take the hint, accept the fact that you were rejected, and then get over it. And please do your best to forget about the person who gave you this number, because trust us, they've already forgotten about you. Thanks for calling the Rejection Hotline . . . and if you are still listening, don't worry, it could be much worse—in addition to being rejected, you could have been laughed at, too.[14]

Other women take a more *combative* tack. At Plough and the Stars, Morgan, a nineteen-year-old freshman, aggressively responds to a middle-aged voyeur:

> While surveying the downstairs room for a door with the insignia for a women's restroom, I noticed an older man, probably around fifty-five, leaning arrogantly against a pillar, with long gray hair in a ponytail. I realized the restroom was around the corner from him, and the man had apparently strategically placed himself nearby, staring at each girl's butt as they walked by him. I walked by and turned around to catch him red-handed staring at my backside; in an effort to make him as uncomfortable as possible, I glared angrily at him and he sheepishly turned around. Feeling triumphant, I pushed the swing door to the lavatory.

While women like Morgan confront boorish men on their own, others initiate collective resistance in solidarity with their peers. At Coyote Ugly, a themed bar and dance club, Sarah, a twenty-one-year-old junior, relies on the support of her female companion to handle a potentially dangerous encounter:

As Leigh and I were getting ready to go back upstairs, there was a guy next to me, probably in his early thirties, dressed as a biker and completely smashed. Next thing I know, this guy bites my back (I was wearing a halter top). I turned around and before I could even say a thing, Leigh went ballistic on the guy and yelled at him to keep his mouth to himself and how gross that was.[15]

A sense of camaraderie is common within cliques of young women who collectively deploy defensive strategies against the intrusion of undesirable men on the make. According to Jess, a junior, "Personally, I'll make it clear right off the bat that I want nothing to do with them. . . . I mean, if someone comes up and dances with me, I'll just walk away—I don't feel bad doing that. And if they are talking to me, I'll summon one of my friends to come save me or something." A group of female undergraduates elaborates:

"I don't think I have gone out with the intention of meeting anybody; it's usually with friends. So if we're dancing and a guy comes up to us, none of us are really interested in that. We usually go out for the purpose of just hanging out, and so we'll just all look at the guy trying to join our group of friends . . . and then walk away or close off the circle. Something really blatantly obvious, that's like, 'You were totally unwanted here, and we are not even interested in you or anyone else of your gender.'"

"With my friends back home, we have signals worked out when we are at dance clubs . . . especially because when I go back home, you know, I haven't seen my girlfriends in a long time; we don't want anything to do with guys—it's totally about hanging out together. Yeah, we totally have little signals worked out to get guys away from us. . . ."

"My friends and I were thinking about doing that once, actually. It is pretty useful."

"Yeah, I have done it at certain clubs when I go out with friends. Like, say I am in a troupe or something with only four girls . . . and we go out and then guys come talk to us, and we're all together, like, 'Get away, get away,' you know? And if I'm in a situation where I'm

talking to this guy and I want to get away, I just look at a friend of mine and she'll pull me out."

"Oh yeah, we do that all the time. There's a total thing with girls pulling people away from dancing, especially dancing."

"And it's kind of sad, too, because when you are out in that atmosphere, you don't really care about any guy's feelings. He's just a random guy, so you're a little more likely to just be like, '*Ughhh!*' and just be mean."

Similarly, many young women who would otherwise accept drink offers from friendly strangers avoid such overtures out of fear of generating a false set of expectations. According to a group of young women comparing strategies of *avoidance*, "It's not that I don't think that they can spare five or ten dollars or whatever, but I just feel bad. They are probably a scum bucket, and they probably deserve to have their money taken, but I feel like I would be obligated to talk to them more and I wouldn't want to."

"And also if you flirt with guys who are buying you drinks, like patrons, they'll take it that you're actually flirting with them."

"Yeah, and then you're sucked in and have to deal with them there."

"And then you feel like an asshole if you are like, '*Okay, thanks for the drink, gotta go!*'"

In contrast, women relying on strategies of *engagement* take advantage of these otherwise undesirable encounters for the sense of action and risky fun they may provide (not to mention free liquor), yet simultaneously prevent these interactions from spiraling into altercations by staying close to their girlfriends, selecting their words with care, and knowing how to confidently terminate an encounter in order to (in the parlance of the confidence game) *cool out the mark*. In these instances, young women are counter–con artists who craft strategies of duplicity to turn the tables on their would-be predators.[16] Frida, a nineteen-year-old Chinese-Swedish sophomore introduced earlier in the book, observes how her underage friend Paige successfully engages in an encounter with an older man during an outing to Red Sky:

We sat down and ordered our respective drinks when a man swooped in and paid for them. We politely thanked him, and he sat down next to Paige. I quietly smiled to myself because this always happens! Paige is great at attracting thirty-five-year-old balding men. She's got some sort of vibe about her! She caught my smile and shot me a mean look, unrecognizable to men, though . . . just understood by females. They began with typical small talk about where they were from and quickly found something in common where they could start the conversation—Paige is from Miami and this man was going to Miami next week. She began to play tour guide and told him all the hot spots in the Miami club scene. He seemed very intrigued by her knowledge of what to do and where to go. In general he seemed very intrigued by her. He kept asking questions about her and wouldn't stop saying how "amazing" she was. He also used the word "awesome" quite a few times.

During this time he bought her four martinis. That's $40, plus tip. As Paige got drunker and friendlier, he asked her to dance. The kicker was that no one else was dancing downstairs, which Paige noticed also. Her reaction: "Definitely not—nobody else is dancing!" This did not seem to bother him at all, and he pushed the issue. Michael Jackson's "Billy Jean" came blasting over the speakers, and since Paige loves the song as well, she gave in. She drunkenly tripped on her shoes, and he caught her. By the happy surprise in his eyes, he seemed to really enjoy this quick, intimate moment they had. He got to feel like her knight in shining armor.

He definitely seemed to be surprised by all the attention he was able to get from Paige, but after the dance he pushed it too far by trying to kiss her. Right at the bar after just meeting her, he tried to kiss her. He bought her four $10 drinks and only had one in the meantime. After all the drinks, he tried kissing her again. He was definitely surprised by her denying him. He was really expecting her to give in to him just because he bought her all those drinks, and she truly surprised him and made him real-

ize that she was not going to be bought. She never asked him for a single drink, only accepted his many offers. He was definitely frustrated by this as evidenced by his body language: he sat back in his chair farther, looked at his watch slyly, and finished his drink without buying another one. Paige noticed this and happily wrapped up the conversation. She apologized to him for not fulfilling his expectations but also told him that his expectations were unfounded. I was very proud of her for being so straightforward with him, and although he was embarrassed and $40 lighter, he was civil and wished her a good-night. Paige finally turned back to me and squeezed my thigh, and we squealed a little, which basically represented disgust for the man who tried to buy her, excitement for how drunk she got for free, and how happy she was to be talking to me again as opposed to a man way too old for her.

After the incident with the man, Paige and I decided it was time to go before someone hit on her again. We went upstairs to find our friends because we always have to let each other know where we are and where we're going. We have to watch out for each other.

Resisting the girl hunt involves developing a set of defensive strategies, including passing out counterfeit phone numbers, signaling to female friends, refusing drink offers, staring down ogling men, enduring come-ons, and giving flat-out rejections. Meanwhile, a number of creative nightlife professionals in Philadelphia have engineered several pro-women scenes that explicitly counter the male-dominated worlds of rock clubs and cocktail lounges. According to Melinda, "I would say that fewer women are likely to go out to see a show than guys. . . . Yeah, I definitely feel that the number of women who go out to shows is probably far more less, even though I think there are a lot of women who are really interested in music." According to music anthropologist Wendy Fonarow, women consistently make up 35 percent of the audience or less at punk and indie rock shows, and it is not uncommon to see women at such events standing off to the periphery

of the viewing area, avoiding the thrashing and slam-dancing often displayed in male-dominated concert settings.[17]

To help combat this problem, in 2002 Sara Sherr, Maria Tessa Sciarrino, and MJ Fine began Sugar Town, a monthly event designed to promote women in indie rock bands as well as create a safe refuge for female music fans. At a typical autumn Sugar Town night at the Balcony, the decrepit second-floor club of Philadelphia's Trocadero Theatre in Chinatown, a blond singer-songwriter decked out in red sneakers, a blue denim skirt, and blue-and-red striped shirt sits on a stool onstage playing the electric guitar to a predominantly female crowd, followed by an edgier trio led by a female singer and guitarist. These women-led rock acts challenge familiar gender stereotypes borne out of traditionally masculine genres of popular music from 1950s blues and rock 'n' roll to 1970s punk, heavy metal, and progressive rock.[18] Sherr explains how Sugar Town—a name borrowed from the title of a 1966 Nancy Sinatra song about a perfectly heavenly place where one can "lay right down here in the grass, and pretty soon all troubles will pass"—serves as a potential haven for female artists and nightlife consumers alike:

> I've been doing Sugar Town now since 2002, and nothing has really changed in terms of the amount of female musicians in town compared to the men. It's not even fifty-fifty; it's not even close. I mean, it's nice to see a lot of female promoters out there. Pretty much all the places in town, a lot of them are run by women, and that's really encouraging to see, women taking an active role in the scene like that. But I'd still like to see more women making music. . . . You know at the surface, it's just a typical rock night. I mean for me, I like to be subtly political about things, just putting women onstage and having a space for women to express themselves. I'm about creating safe spaces, and people can do with the space what they want to. If they are just there to get drunk and see a band, that's great. If they are there because they feel comfortable with other women in the room or they want to meet like-minded people, that's good, too.

To further these feminist-oriented ends, in December 2002 Sherr and Sciarrino hosted a special Sugar Town event consisting solely of young female writers performing their work, much of which specifically critiques the gender inequality experienced by women in local scenes of art production and urban nightlife. On the stage of Doc Watson's, a Center City dive bar, local poet Samantha Barrow performs a piece entitled "Back Up Boys":

> Hey, boys, I need some back up here.
> HEY, BOYS, I NEED SOME BACK UP HERE—
> Or else I'll disappear—
> To a place where my vision is safe
> And clear.
>
> You know, I love hanging out with guys,
> But sometimes I get tired of fighting for what I need.
> What I need?
> Respect.
> What I want?
> Some back up.
>
> So if you support my volume,
> Whether or not you agree with what I say, that's cool.
> Just DON'T TELL ME I'VE GOT BALLS.
>
> Clearly not what it takes to do the work I'm doin',
> Take a good look around while you're down there chewin',
> Cherish your own, hold 'em close to your heart,
> but find a better way to praise my art.
>
> Like showing me some respect when my guard falls down
> and bringing out your heart when I come around.
> Don't try to slam me out because I bring a femme
> groove here, bustin' something out loud . . .
>
> If it's a new way of hanging that you don't under-
> stand, slip off your attitude, stretch out your hand, but
> don't fear my voice; don't try to silence my rage,

'Cause this patriarchal bullshit puts us both in a cage.

What I'm talking about often happens quite subtle,
you'll say something rude and I ain't got a rebuttal.
 Don't get me wrong, I can hold my own,
 But there are times egos get overblown.

And I'm not always funny—but don't treat me like an ass,
and I'm not always pretty—but fuck you, I didn't ask!
 How come I swing like a girl only when I miss?
 Think a bit about the misogynist dis.

And stop swearing "pussy" like it's something weak, when
you're givin' out shit to some pencil-necked geek;
 Should I look the other way and pretend I don't own it?
 Naw, I'll grab it, because y'all can never clone it.

On the same stage, Philadelphia writer and journalist Meredith Broussard reads a very funny piece, "The Price of Perfection," which details the literal cost of purchasing the clothes, accessories, and special services required to pull off the feminine masquerade required of women in Philadelphia's downtown nightspots—BCBG Max Azria black knee-length wide side buckle skirt ($120), Ralph Lauren patterned square head scarf ($62), Kiehl's Pineapple Papaya Facial Scrub ($25), private sessions with a personal trainer at Philadelphia's Sporting Club ($65/hour), and so forth. As she observes, "Compare the price of perfection to the most recent census figures on what the average American woman earns. . . . Even if she wanted to, the average American woman couldn't afford all the consumer objects associated with perfection—she could barely afford to have sex in the city, much less achieve the fashion and fitness ideals glamorized in the popular HBO series."[19]

HUSTLING THE HUSTLERS

Confident heterosexual women often pursue their own sexual conquests in the city's nightclubs, martini bars, and cocktail lounges, employing the art of the hustle with as much slyness and moxie as

their male counterparts, albeit with more finesse and generally a much higher rate of success. In order to better understand exactly how women attempt to pick up men in urban nightspots, I invited four women in their mid- to late twenties to the lounge at Tangerine for cocktails on a sweltering night in late August. (I set up this meeting with my wife's permission, of course, although I did have to endure some marital ribbing at my expense.) After some initial icebreaking, we settle into an eye-opening and frank conversation about how women on the make perform the art of the hustle in the city at night.

Brielle begins. "You'll definitely see that we all differ. I guess my strategy is that generally when I go out I don't really find that many men attractive." Everyone laughs. "Well, it's true!"

"And you have a height requirement," Alexis observes, given that Brielle is five foot eight and close to six feet tall when wearing high heels.

"That's true. So I have a height requirement." Brielle continues, "The first thing I like to do when I first get there is scope the whole place out very quickly. I like to do it standing."

Dana laughs, "I like how she's going point by point. . . ."

"I'll just take a quick look around and the first thing I look for is a tall guy," Brielle continues. "Usually you'll get a pack of tall guys together. Then it's just a matter of trying to make eye contact as many times as you can. If I'm not already standing near them at this point, I try to move in so I'll be near all of them. If the eye contact thing really isn't working—depending on how desperate I am or how drunk I am—if he looks like a cool guy and he's standing in a group, I'll just go up and say 'hello.'"

This puzzles me. "How do you know if he's a cool guy if you've only seen him from across the room?" But the group has no shortage of answers.

"I think it's something about how he is with his friends—if he's having a good time."

"His body language."

"Yeah, if he's smiling. . . ."

"Someone who looks like he's just there to have a good time, not to impress."

"Or necessarily to pick up girls. Guys who look like they are sharking aren't particularly attractive."

I'm lost. "Guys who look like they are *what*?"

"*Sharking*. Like, trying to pick up girls. . . . It means like circling round and round."

"They're out for the weak," Alexis adds. "They're looking for girls who are vulnerable."

Brielle continues. "Sometimes I go up and say hello, break the ice. You weave your way up to the bar. What you do is you move right next to him, or you wink at him or ask the time—just break the ice. It's pretty easy. And then he can completely blow you off, but mostly they don't."

"Do you wait until they're isolated from their group?" I ask.

"If they're isolated, you can move right into them; you can get really close."

"As opposed to if they were in a circle?" I surmise.

Brielle nods. "Yeah, I would never do that. No, no. If they were in a group of friends, I would never go up to a group of men like that. If they're broken up, then hopefully by that time the whole eye contact thing lets them know that I'm interested."

"Is this the sort of thing where you'll be out with a group and then you'll break off from your own group to approach the person?"

"Sometimes I say I'm going to go use the bathroom."

Alexis nods. "But you know what they're doing, and you're like, '*Oh, Brielle, I think it's time you went to get another drink.*'"

"Yeah. We've all done our own thing before—I don't know. If you have another person there, then it's kind of like . . ."

Celeste interjects, "Well, it's usually good. I mean, having someone with you is usually an 'in,' and it gives you an escape route if the conversation isn't going particularly well."

But Brielle disagrees. "No, I don't think I would approach somebody with another girlfriend with me, because I would feel like a silly teenage girl—you know, like girls running to the bathroom together. I have sometimes talked to people at the bar, but I might make it so

that I can pass by them. . . . Maybe I would go to the bathroom, just so I could walk past them and smile. And I might just pass a comment their way, or I might walk past them a couple of times, and then say something. But I would *never* take a friend with me to go and start a conversation with a guy."

"Guys always talk about going out with a wingman," I offer.

"Um, yeah. We don't *need* a wing-woman," Alexis points out.

Dana laughs. "Brielle and I were out last week, and we had an experience with a guy and *his* wingman."

"Oh my god, yeah," Brielle groans.

Celeste nods. "It's like he's wearing a tag, right? He has his little wings and it's so obvious."

"Wait, so what happened?" I ask.

Dana recollects from her evening out with Brielle at World Cafe Live in West Philadelphia. "Two guys—actually, it happened the wrong way around, didn't it? One of the guys was short, and the other was tall. And the shorter guy came up and first started talking to me, and then sort of turned away and introduced himself to Brielle, which gave the guy *behind* him a chance to come in and say hello to me. And before we knew it, the two of us were celebrating with these two guys, one on either side."

"They had a technique—divide and conquer," notes Celeste.

"It felt like a technique—I was incredibly petrified, the whole night. Before this guy had *even asked my name*, he had his hands on my shoulder. I put my hands up and told him to back off, because I felt really overpowered by him. I asked Brielle if I could switch places. And similarly, your guy was touching you."

Brielle remembers. "And he was shorter than me, and it pissed me off, big time. Short guy! And in the end, what did I do to get out of it? I didn't *ask* if I could switch places, I *actually moved him*. I just moved this guy, so I could sit next to my friend."

"I think that emphasizes why I would never go for the wingman tactic," says Dana. "I would never go talk to a guy with a friend in tow. It feels like an assault, in a way. It just feels very contrived, [like you have a] one-track mind."

While the group disapproves of the wingman approach, they clearly enjoy each other's company during their nocturnal pursuits. Alexis describes how the gang went about recently evaluating a man in public. "We couldn't see his height; he had been sitting down the whole night. I'm like, *'He looks cute from the back, but he hasn't really turned around, so like, should I even bother? He might be short and ugly from the front!'* But we had a whole strategy planned. Walk by the table—nothing as aggressive as the other women do. The other women put their arm around him like that. We would never."

"So do you look to your friends for advice or as a confidence booster?"

"I think they've definitely boosted my confidence up," says Brielle. "When we were out, there was that gorgeous guy, that younger guy. And you guys were being very encouraging all that night. *'Just go talk to him, Brielle, just go do it.'* You're very good about that."

We then turn to Alexis for her account of the hustle of urban nightlife. "Well, like I was telling her the other night, my strategy starts even before. You know, we plan: What part of town are we going to hit? What am I going to wear? What kind of mood am I in? Do I want to attract people tonight, or do I want to blend in? Do I want to dance? Shoes? Again, height—do I want to look tall or do I want to look like myself? And then finally, getting into the bar and then pretending to look for a friend—*'Where could she be?'*—just so I can scope out the room. That'll be even before meeting up with my person. . . . Even before the drink, I'm walking in—I'm like, *'Well, I've never been here before,'* scope out the bar, *'and this is where the lounge is and that's the dance floor,'* and then I'll be putting it out there, *'Oh, here I am.'* But it's also pretty early in the evening, so it's not super-packed or crowded, and I'm like, *'Maybe I'll be seeing you later when you're a lot tipsier.'*"

I could be wrong, but this sure sounds like "sharking" to me.

"Does it make it easier when it's less crowded, just because it's easier to see?" I ask.

"Easier to maneuver, to see, to walk around without like bumping into everybody or getting into someone's face."

"And you can talk to people," adds Celeste.

"Yeah, and you can still hear," says Alexis. "Hearing what they're saying, like, 'What?? Yeah, okay!' If I want to make it an evening of flirting, then it'll be a less noisy bar, but if I want it to be an evening of girls and dancing, then it'll be a loud, crowded, sticky, sweaty kind of bar."

"When you're going out and you're interested in meeting a guy, will you go out with only other women or in a mixed-gender group?" I wonder.

Brielle answers, "If I choose to go out on the prowl, my ideal is me and another girl."

"Just you and another girl?"

"Absolutely. Two girls are approachable; three girls are very approachable. Four girls, five girls?"

"It's a cheerleading squad," observes Celeste.

"If there are five girls, there are usually some sharkers."

"It's like a pool of women, and someone's gotta fight," explains Alexis. "You gotta hit all of them at once—you, you. You gotta take home one of them."

"So maybe if you do go out with a group—because presumably you don't plan all your nights accordingly—so you might go out with a group of seven women, and then you two will split off?" I ask.

Brielle explains, "We would go out, a group of approximately seven girls. It would get incredibly crowded as the night went on, and me and this other friend of mine, we would visibly get bored with the girl conversation, so we would start flirting. We would call it *doing the rounds*. We would go in all six directions."

"You and a girlfriend?" I ask.

"Me and another girlfriend. We would scout for a guy we found attractive. And if we had a few drinks, one of us might start talking to him, and the other one would keep doing circles. And then you could go and join her in the conversation, rescue her if she didn't want to be in that situation, or verify it—see if it's going well. So, you do the rounds in several directions, and meet up and check in as if you just bumped into each other. And you can do it near the guys as well—make it very

clear that you're next to them. It also worked doubly well when it was in a drinking establishment where there were a lot of people we knew and a lot of guys we went to school with or people that we know and acquaintances and such over the years. So you could quite easily do the rounds and talk to several guys without it necessarily being a sexual thing. In the back of your head, you're still doing the rounds, looking for the guy that you fancy. It would be harder somewhere like here [at Tangerine], because there's not enough people to make it look inconspicuous. There's nobody you know, so you'd have to be really brave and really upfront."

I ask, "Now what happens when a guy approaches *you*, and he's someone that you fancy? Do you simply act like yourself, or is there a certain script that you feel like you have to follow?"

Alexis admits, "Even if he's great and he's someone like *'Ooo, I hope he talks to me,'* and then he finally approaches me, I'll probably act aloof. . . ."

"So you'll act aloof even if you are excited that he's come over?"

"Yeah."

"Really?" asks Brielle.

"Yeah, I'll try and hide it, and I'll think in my mind, *'Wow, I'm really keeping it mellow.'*"

Of course, not all women operate as strategically as Alexis and Brielle. Celeste characterizes her motives while out very differently. "I'm very verbal. I can walk in anywhere and be like, *'Well, they're all pretty damn good looking, but I don't really want to talk to any of them.'* So what I'm attracted to is something that's very . . . well, I call it a *spicy dexterity of wit,* which I can never get at a loud bar. I've *never* walked into a bar and said, *'I'm going to scope this crowd and find someone I really want to go out with.'* I mean, they might be really attractive, but I've never ended up dating someone who was completely attractive—I go for the brains. And that's something that in the nicest bar it's really hard to gauge.

"I've seen this once; it was one of the funniest things. A whole group of men come in—this was years ago—and they were all walking by a group of women, and everyone just stopped and started

laughing. Because it's such a cliché—we're all checking them out; they're all checking us out."

Dana notes, "It's interesting how men have to do it in a pack, whereas if we do it, we do it more subtly."

Still, as Alexis observes, "You could spend your whole life in Old City; I doubt you're going to meet someone here." Yet to these women, the city's nightlife is clearly appealing as a sexual *aesthetic*, if not a marketplace.

Dana admits, "I'm not necessarily looking to pick somebody up, but I really enjoy the thrill of the eye candy."

Everyone else agrees, "Yes!!"

"I love getting dressed up. I love going and looking around."

"And flirting with people. I guess, in that sense, what I'm looking for is a lot different than if I met someone I wanted to have a relationship with."

"Is that because you're only looking for someone to have a conversation with in a bar that can heighten the experience of being in the bar?" I ask.

"We all want to go out and feel attractive, but it's not necessarily a sexual venture," answers Celeste, and her friends agree. "Yes!!"

"You can go out and feel fulfilled by knowing you can turn men's heads," Dana adds.

Alexis agrees. "I'm going to walk away from that guy wanting me so much and I didn't have to do anything. I get to go home and sleep in my bed and not have to be uncomfortable. *Ha-ha, ha-ha! Talk to the hair!*"

7

WHERE THE
ACTION IS

STORYTELLING
AND THE
IMAGINATION
OF RISK

We look forward to evenings out because they represent open possibilities for building a favorable biographical narrative of our everyday lives. Whether as sexual escapades recollected to our locker-room buddies, anniversary dinners fondly remembered among couples, or the celebrity sightings we share with everyone else, storytelling provides us with a means of constructing an attractive nocturnal self after the fact. It is a vehicle for crafting personal identities, expressing desire, and imagining the world not necessarily as it is, but as we would like it to be. Among young people, adventures in urban nightlife represent optimal narrative possibilities advantageous for what Bijay, a twenty-two-year-old Pakistani senior at Penn, describes as "having crazy stories to tell the next day," whether of psychotic cabdrivers, good-humored embarrassment on the dance floor, or a bachelorette party gone awry. City nights represent events brimming with heightened sentiments, games of chance, passionate romances, and encounters among anonymous strangers.

Of course, the dirty little secret of urban nightlife is that typically nights out are fairly straightforward, unremarkable affairs during which very little out of the ordinary ever happens. On most evenings

out on the town, we patronize a familiar set of restaurants, clubs, and nightspots; we accompany the same friends and lovers; we take the same routes and wear the same clothes. The homogenization of themed downtowns and their branded attractions only deepens the monotony of nightlife in the city.

Given that episodes of urban nightlife are thought to represent rich narrative opportunities for storytelling and identity construction, the predictability of downtown entertainment scenes creates a dilemma for young consumers attempting to craft satisfying nocturnal selves out of the mundane experience of everyday life. As I have suggested, young people transitioning from adolescence to adulthood often respond to this challenge by approaching urban nightlife as a set of sporting rituals. In doing so, these emerging adults purposefully invite risk through a highly ritualized and peer-approved set of pursuits presumed to connote what Erving Goffman describes as *action*—activities of consequence undertaken for little other reason than their own sake, in which "the individual releases himself to the passing moment, wagering his future estate on what transpires precariously in the seconds to come." In search of action, some rely on ritual encounters among participants ensnared in relationships featuring a high degree of ambiguity or uncertainty, such as first dates. Others choose entertainment venues renowned for their authenticity or exoticism, like Afro-Cuban jazz clubs or Malaysian restaurants. Interactions with colorful characters in dingy downtown neighborhood taverns make for robust tales of the city. Gambling casinos and strip clubs offer opportunities for risk, particularly among the young and uninitiated. Of course, drunkenness (particularly among underage students) often provides a way to experience risk while generating stories for future bragging sessions, just so long as one can remember them. Drinking also occasionally leads to fighting, another form of uncertain danger and, perhaps unsurprisingly, a celebrated source of nocturnal narratives among men. Meanwhile, less violent activities such as joyriding, petty vandalism, shoplifting, public urination, and otherwise disturbing the peace constitute what sociologist Jack Katz refers to as "sneaky thrills" perpetrated as a means of experiencing the euphoria of risk.[1]

These kinds of nocturnal sporting rituals serve to provide revelers—and male revelers in particular—with an arsenal of dramatic stories to impress their friends during competitive bouts of public boasting and braggadocio. But what is often forgotten during the retellings of such tales is the extent to which thrill-seekers often attribute an exaggerated amount of risk to social situations that are relatively safe and commonplace, and incorporate this illusory sense of danger or strangeness into narrative accounts of their nightlife experiences in highly scripted ways.

By taking a skeptical step back, I propose that in many instances the experience of risk has to be *invented* by the participants, framed as an adventure, and played *as if* something were at stake. While people are perfectly capable of ignoring much of the danger that surrounds them in their everyday lives, a great deal of the risk they *do* experience is largely of their own imagination, as illustrated by the exaggerated fears many Americans harbor toward a host of boogeymen, including homeless people, undocumented immigrants, gay couples, and, perhaps most of all, black inner-city neighborhoods and their residents. As I illustrate in my book *Blue Chicago*, tourists incorporate a fear of crime into what becomes a heightened heart-pumping experience visiting blues and jazz bars located in black urban areas, in spite of the fact that these music spots are more likely to be frequented by hard-working musicians and churchgoing members of the black middle class than gun-toting drug dealers, gangbangers, and other ghetto caricatures. In this and other ways, the sense of adventure one experiences in the city at night often requires a degree of *self*-deception, particularly given the persistence of threatening stereotypes that affluent urban dwellers unthinkingly attach to certain categories of strangers, including ethnic and racial minorities, working-class men and women, and gays, lesbians, and transsexuals. In search of the personal pleasure and social status signified by ownership over an entertaining story, participants sometimes become victim to their *own* hustles when they invest in the illusions of urban danger and difference in the nocturnal city.[2]

THE PLEASURES OF STORYTELLING

As emerging adults, college students desire memorable and unpredictable nights for their narrative potential. Yet according to Caroline, a twenty-one-year-old mixed-race senior, the spontaneity required for such an identity-building occasion cannot be entrusted to the fates; it must be engineered, plotted—a literally calculated risk.

> We sit around the kitchen bullshitting, talking about what we want to do tonight, and we all decide that we are getting old and predictable. Smokey Joe's, the Blarney Stone, Brownies—we never do anything new. Tonight would be a change, though. We decide to do something different and spontaneous and so NOT like us. We are going to a strip club. Partly to see what it is like, but mostly *just to say that we went*. Hell, if nothing else, it would make for a funny story [emphasis added].

Caroline and her friends engage in what one could call *deliberate spontaneity* in order to produce an urban episode noteworthy enough to be incorporated into their repository of lively narratives. In other words, the assertion "just to say that we went" not only operates as an idiomatic utterance but communicates a literal desire as well, particularly given that in the context of city nightlife, experience connotes worldly accomplishment and nocturnal status among adolescents and young adults. The "funny story" that remains the morning after provides evidence of that accomplishment. A discussion among undergraduate men reveals how they define a "successful" night as specifically one that can generate laughable stories to be shared at sunrise:

"I think just having a funny story to tell the next day, like something stupid your friend did, or if one of your friends hooked up with someone—just making fun of them, if you know who he hooked up with, or something along those lines."

Andrew, my research assistant, asks, "Someone who doesn't go to Penn, you mean?"

"No, if it's, like, a random person."

"Does that happen very often?"

"No, no, no . . ."

"That's what makes it so great when it does happen."

"Extra bonus if they are funny-looking."

"Definitely—if you can laugh about something for months afterward, then it was a good night."

These juniors and seniors specify the ingredients often thought necessary for developing noteworthy stories out of the detritus of the nightlife experience: the chance emergence of an infrequently occurring event, and a heavy dose of sexual humor tinged with meanness. The desire to generate stories out of one's nocturnal adventures goes a long way toward explaining why college students and their post-adolescent counterparts frequently binge drink to excess with such gusto despite its obvious health risks, as drunkenness adds to the unpredictability of what would otherwise be an exercise in routine behavior—the same parties, the same nightclubs, the same friends. In this manner, overdrinking represents its own kind of deliberate spontaneity, a carefully planned (if sloppily executed) strategy for losing a maximum degree of self-control, as expressed by Bijay:

> Well, I am a binge drinker personally. I do not drink every day, nor do I drink with dinner especially. I am a binge drinker: I tend to drink as much as I possibly can without throwing up. I don't pass out, usually—my puking point is before I pass out or black out, so I remember everything. So I tend to drink as much as possible. . . . Lots of shots—Long Island iced teas, and shots. I don't drink that much beer most of the time. Certain times I have had two or three bottles of champagne in a sitting. . . . But then I do get sick. Tequila makes me sick, so I would never do that, but . . . I can take about ten drinks in two hours and survive the night. After ten drinks, I am really drunk.

From Bijay's perspective, public drunken provocations generate social episodes worthy of remembrance and recollection:

My most successful night . . . has not actually involved hitting on women. . . . It was at this [South Street] bar called Dark Horse: I was with two of my best friends and a girl. We got really, really drunk and we were hitting on all these women and we had no interest in them—they were forty-year-old women. And we were just trying to see if they would take the bait and be nice to us. But we weren't interested in them, it was just the fact that *they* were interested—that's how we defined our success.

Bijay's depiction of his flirtations with forty-something female patrons in public (which he strangely describes as having "not actually involved hitting on women" before contradicting himself) reveals the ambiguity and imagined sense of unreality he and others attach to May-December courtship rituals between younger men and older women. In these situations young people draw on the idiosyncratic nature of intergenerational encounters to heighten their evening's narrative possibilities as well as their own display of sexual power.

Meanwhile, the anonymity of downtown bars like Dark Horse increases the randomness of targeted drunken interactions among strangers, particularly those marked by social difference, whether on the basis of class, ethnicity, or age. In these instances patrons indulge in elements of the art of the hustle, including the fabrication of one's identity, for the simple pleasures of pulling off a successful hoax and having the story to prove it. As Bijay recalls of an evening out at an Irish pub, "My friend was faking an Irish accent; I was talking to the other woman in a thick Indian accent. I was telling her that I was the heir to a manufacturing fortune or something. . . . We were just making stuff up right there; there wasn't any game plan. We got hammered and decided we needed to do that."

THE TAXI DRIVER AS A NARRATIVE SYMBOL

In 2004, 42,636 motorists and nonmotorists were killed in traffic crashes. Of those tragic fatalities, nearly 40 percent (16,694) involved alcohol; among fatal crashes occurring between the late hours of

midnight and 3:00 a.m., *76 percent* involved alcohol. Thanks to a wave of moral panic over the last several decades, nearly every schoolchild in America is familiar with the hazards associated with drunk driving, and most Americans have seen any one of a number of public service announcements warning of these harms.[3]

It is therefore interesting that among hundreds of narrative accounts written by young people participating in the nightlife of the city, very few referred to the dangers of drunk driving at night, even among those who were knowingly driven home by friends who had been drinking. Yet while this is somewhat surprising in and of itself, it is especially astonishing in light of this fact: a significant number of these same respondents who ignored the risks of drunk driving in their accounts found the fear they experienced *while riding in a Philadelphia taxicab* noteworthy enough to include in their narratives. In other words, students readily disregarded the very real risks associated with drunk driving, but simultaneously fantasized that their cabdrivers—licensed professionals and presumably among the most sober drivers on the road in the midnight hours of Saturday night— were uniformly accident-prone derelicts who almost got them killed on their way home.

Logically this makes little sense—cabdrivers don't necessarily get into more accidents than *drunk* drivers.[4] As in the rest of the country, Philadelphia's late-night drinkers rely on taxicabs as a preventative strategy for avoiding the perils of drunk driving.[5] And yet the stories of my respondents seem to parallel the experiences of urban dwellers in other cities who regularly feel threatened by riding in taxis in the city (day or night). They share their tales with friends and even sympathetic strangers, as illustrated by sampling the "taxi horror stories" culled from *Chicago Sun-Times* reader responses published in a November 2006 issue. As one passenger, "Dan," reports of a memorable ride, "Worst cabdriver in the city. . . . Almost got into three accidents during 10-minute ride." According to "Ray":

My girlfriend and I were downtown Christmas shopping [when] we got into a cab to take us from one end of [Michigan Avenue]

to the other. Our driver swerved in and out of car and pedestrian traffic. [We] held onto each other, our shopping bags and our seats to keep from being tossed from door to door with each swerve! We missed pedestrians by mere inches.[6]

What can explain the narrative possibilities of the seemingly mundane taxicab ride? For affluent city residents and tourists, the taxi ride provides a unique moment during the course of the evening, given that such scenarios envelope passengers in a relationship of trust and monetary exchange with someone who is likely of a lower-class status, minority race and/or ethnicity, and foreign nationality. As sociologist Peter Bearman suggests of doormen, client relationships with taxi drivers feature both interpersonal closeness and social distance, and this is important for two reasons.[7] During cab rides in American cities, passengers experience simultaneous and contradictory sensations associated with class power and physical vulnerability. They might pay for the momentary pleasure of being chauffeured around the city by a blue-collar laborer, but this luxury requires that they entrust their persons and property to a stranger—one who by virtue of his stigmatized occupational status is also likely to be unfairly identified with any one of a number of exaggerated racial and ethnic stereotypes associated with urban danger. These stereotypes are particularly likely to be applied to Nigerians, Iranians, Afghanis, Haitians, and other immigrant groups overrepresented among cabdrivers in Philadelphia.[8]

Consequently, passengers warily examine their driver's every move. *Is he on his cell phone? Is it hands-free? Why are we taking this street during rush hour? Why are we going so fast? And now why are we moving so slow?* Taxi drivers are skilled professionals with expert knowledge of local street names, complex driving routes, and traffic patterns.[9] They are almost always linked via radio to a dispatcher (and through them a fleet of fellow cabdrivers) who regularly communicate tips regarding recent accidents and alternative routes. Unlike most automobile drivers, cabbies stake their very livelihoods on their ability to avoid car crashes, yet passengers rarely give their drivers the benefit of the

doubt during fretful instances. Like Goffman's asylum inmates, taxi drivers are always on display, enabling their customers to question every right-hand turn and missed green light.[10]

By identifying common driving norms as "mistakes" incorrectly attributed to driver incompetence or indifference, passengers not only experience the mundane as dangerously transgressive, but also rely on such experiences to concoct larger narratives about the nocturnal city. Affluent urban dwellers in search of compelling stories draw on their encounters with cabdrivers because their perceived lower status and ethnic difference allows them to be easily caricatured as lead characters in melodramatic narratives about the real and imagined dangers of the metropolis at night. Errol, a twenty-one-year-old senior, weaves together such a narrative in his retelling of a Thursday night drive to the movies—a tale in which he emphasizes his cabdriver's difficulties with English, consumption of expressive ethnic culture, and, of course, his driving:

> We leave Annabelle's apartment and get a cab right away on the corner of Forty-second and Walnut streets. It takes awhile to get the driver to understand "Ritz Theatre at the Bourse," not the "Ritz-Carlton Hotel." He drives unnervingly fast, lots of gas and lots of brake, which begins to make me sick. I never like the spinning or jerky rides at amusement parks, and this seems like a cheap version of one. We continue to whip our way around from University City to Old City. The cabbie has ethnic music of some type playing on the CD player; I cannot tell the language and I don't want to be rude and ask.

While barhoppers and nightclubbers associate the taxicab ride with urban danger, the irony is that cabdrivers themselves face more workplace dangers than almost any other occupational group in the nation. According to the National Institute for Occupational Safety and Health, during the 1980s taxicabs and taxi dispatch offices led all other workplaces in on-the-job homicides, while cabdrivers and chauffeurs top the list of riskiest occupations with an on-the-job

murder rate of 15.1 deaths per 100,000. (To place this in perspective, the murder rate among *police officers* in the United States during this time period was only 9.3 per 100,000.) Along with cashiers, taxicab drivers are overrepresented among robbery-related slayings.[11]

Passengers typically ignore these occupational hazards when characterizing their *own* anxieties while driving in taxis, and in doing so regularly exaggerate threats to their safety when emphasizing the racial and ethnic identities of their drivers. Jane, a twenty-one-year-old senior, describes a "terrifyingly speedy ride downtown" while highlighting her trip home as one during which her driver took to "singing quite loudly along to the gospel radio station." In his narrative account of a taxicab ride to a local restaurant, Derek, a twenty-year-old sophomore (who admits he has little experience riding in cabs), embellishes what he describes as an insurmountable language barrier between himself and his driver:

We hopped into the cab that was in front of the line, because I figured that they went in some kind of order like that. I do not ride in taxis very often because of the obscene amount of money they charge. I opened the door for Annie, and I followed her into the cab. The cabdriver was obviously of Asian decent, and he could not speak English very well. When I told him to take us to 600 Catherine Street, I was skeptical as to whether he understood what I said. I definitely could not understand a word that was coming out of his mouth.

The ride was smooth until about Seventeenth Street, but then we got caught in some extremely slow traffic. Sweat rolled down my face as I saw the meter click up, and up, and we were not moving. I really wanted to tell him to take a detour, but I was sure that he would not understand what I was saying. I was convinced that he only knew how to translate the names of the streets. I would have gotten out and walked, but I knew that we would never make it in time for our reservation if I had. Besides, how could I make a beautiful girl walk the remaining ten blocks all dressed up and in shoes that I am sure cannot be too comfortable to put on, let

alone walk in! The traffic started moving and slowed down again. Finally, the driver took a detour and I gave a sigh of relief. We got to our reservation with ten minutes to spare.

Young people also rely on the social distance implied by the client-driver relationship as an opportunity to breach norms of decorum commonly held in check. Aggressive face-to-face encounters with cabdrivers not only provide a source of amusement and perhaps relief for some passengers, but additionally serve as moments of transgression from the mundane and are thus easily translated into expressive narratives. According to Bryant, a twenty-one-year-old junior:

> At 11:30 p.m. we ran outside to catch a taxi. I saw my friend Jack on the street, trying to hail a cab, so I grabbed Kerri and jumped in a cab with Jack. Kerri immediately asked the driver for a cigarette; he said he didn't smoke. She asked again, and again, and again before Jack had to look her in the face and explain very clearly that he didn't have any cigarettes. Kerri proceeded to ask the driver if he thought cigarettes were unhealthy. He explained in somewhat of a monotone how smoking causes lung cancer, emphysema, and heart disease. Then, as almost if it were the next logical question, Kerri asked if cocaine is bad for you. The driver turned around and gave me a look as if to ask if I also acknowledged how inappropriate her question was. I gave him a nod, and he shrugged his shoulders and got back to driving the cab. Kerri then started giggling, proceeded to shout that she loves snorting coke despite the fact that she knows it's a bad habit. Jack leaned behind Kerri's back and started muttering how insane she is. I was shocked to hear her talk about her drug habits so freely, especially in front of a stranger.

If Bryant expresses embarrassment at Kerri's treatment of their driver, his fellow student Chuck, a nineteen-year-old sophomore, shares little of his sympathy or graciousness when accompanied by his drugged classmates:

On this Friday night, four of my friends and I hail a cab in order to meet a large group at Devon Seafood Grill in Rittenhouse Square for a birthday dinner. . . . I hop into the backseat of the cab and tell the driver to put the pedal to the metal and get us to 225 South Eighteenth Street. To whet our appetites, a couple of my friends and I had rolled a joint just prior to leaving and proceeded to smoke it while sipping Yuenglings [a brand of beer brewed in Pennsylvania], thus causing us to act a bit "strange" in the cab. My friend Dan, being a little tipsy, feigns a slapping motion toward the back of the driver's head. The driver, of course, sees him and shoots him a dirty look that would shut most people up for the rest of the ride. That's not the case for this group. . . . We keep talking and laughing about the types of things that inebriated people talk and laugh about. I would imagine that the cabdriver isn't especially pleased with us, but that doesn't stop him from driving at fifteen miles per hour for nearly the whole trip, causing the normally five-minute trip to take twice that long. It doesn't really matter to us, though. We're buzzed and feeling good, so we don't mind spending a few extra minutes in the back of the taxicab.

Finally we roll up to Devon. . . . We shove each other out of the cab, giving the driver twelve dollars and telling him to keep the change. *"Slow and lazy asshole, learn to drive. You're lucky we're even tipping you a dollar,"* I thought.

SLUMMING AND THE EXPERIENCE OF SOCIAL DIFFERENCE

Social distance has always served as an integral feature of the urban nightlife experience for the affluent classes. During the 1920s sporting rituals such as "slumming" among middle- and upper-class whites characterized the racially integrated social worlds of Harlem and Chicago's black entertainment zones, a tradition that continues today in the latter's most popular blues clubs.[12] In Philadelphia affluent men and women seek out the deviant thrills symbolized by the city's working-class corner taverns and dive bars. Among young people,

this heightened sense of social distance rooted in class reaches its apogee in sexualized environments such as downscale drag shows, gay bars, and strip clubs. Mallory, a self-described "straight but not narrow" twenty-one-year-old senior, prepares to attend the Thursday drag show at Bob & Barbara's Lounge, a racially integrated dive bar, in typical slumming fashion: "I thought it sounded hilarious. [My friend] Tina described Bob & Barbara's Lounge as not only featuring drag queens, but bad, ghetto-fabulous drag queens." Although she insists that "I am completely accepting of just about everything, and have friends of all sexual persuasions," her enjoyment with the evening nevertheless relies on her emphasized sense of class difference between herself and the urban drag world:

> I assumed that a drag show would have a more alternative crowd, so to fit in somewhat I drew out of my closet one of what I call my three "punk" shirts. (I'm basically an Abercrombie or Express girl, clothes-wise.) . . . Thus it took me about forty-five minutes to get dressed in my jeans, tank top, glittery slippers, and to put on makeup with a heavier hand than I usually do. I felt somewhat transformed from my privileged Penn self, to someone "cool" going to a bar not frequented often by my fellow classmates.

Affluent young people rely on the social distance experienced during adventures in slumming to infuse their nocturnal storytelling with giddy excitement and a hint of snobbery. On her excursion to the Cave, an all-male revue located along Philadelphia's riverfront strip of nightclubs, Vanessa, a nineteen-year-old freshman, eagerly anticipates what she and her friend Stacie hope will be a memorable evening of guilty pleasure:

> We hailed a cab, got in, and laughed and giggled as we mentioned the address to the cabdriver. Despite all our incipient embarrassment that we so vocally expressed to each other about the night that was to follow, *we loved to tell people where we were going when*

people asked. It was fun, daring, brave and admittedly "cool" in our eyes. The drive there was an uneventful jumble of gossip and exclamations at the hysteria of the night. . . . We told each other we would not tell anyone who asked that we went to the University of Pennsylvania. In our minds, with that stated we would even more certainly stick out like sore thumbs [emphasis added].

When Vanessa and Stacie arrive at the Cave, they are immediately struck by the club's sexual theme, as underscored by Vanessa in her recounting of the experience: "We swung the curtain open, and the sight was nothing I had ever seen before. To the immediate left was a glass container full of sex toys and games galore. Ranging from furry handcuffs to penis lollipops to *Playgirl* magazines, the glass container was full of erotic gifts and bachelorette surprises." As we follow Vanessa's narrative, we discover how her reaction to the largely working-class clientele colors her experience of the sexually explicit atmosphere:

Stacie and I had now entered a new domain, a new environment and a new subculture of girls and women so different and so unlike any other people we had encountered before that we felt as if a new, more courageous task was on our hands. I felt like I was on the *Jerry Springer Show*, and being a master viewer of the show, I felt as if I had some firsthand experience with these types of people. Girls were practically naked, wearing shirts exposing their stomachs and skirts only half-covering their underwear. One particular girl with long, blond curly hair and a cosmetically "perfect" face was wearing the shortest white skirt I had ever seen and a pink halter top with her breasts pushed together for cleavage purposes. As I excused myself past her, she noted to her friend, "I wasn't going to even wear underwear tonight!" With a giggle, her friend, wearing a similar style of clothing, shrugged the comment off. I, on the other hand, was more than thankful she had made that last-minute decision.

By evoking the widely maligned *Jerry Springer Show*, Vanessa characterizes the Cave as a distinctly working-class environment to be enjoyed as trash culture, as an eye-rolling joke.[13] Her account of the performance itself and the audience reaction accentuates the boundaries she maintains between herself and her fellow patrons:

> The first man was dressed in a naval officer suit and dark sunglasses. As he approached the front of the stage, he saluted the audience as new music droned from the background speakers and two large American flags were hoisted on pegs jutting from the back wall. Nothing could have been cheesier than the playing of the national anthem. The increasing screams and applause almost deadened the music. A young girl, who seemed only about fifteen years old, screamed toward the stage, "I love a man in uniform!"
>
> It then hit me. For Stacie and I, this form of entertainment was somewhat of a joke. We had come here to have fun and treated it almost as an experiment, knowing full well that this would probably be a once-in-a-lifetime experience. For many of these other women, however, I could tell that these men and this strip club offered them so much more than what it offered Stacie and me. For them, it was so much more real and so much more rewarding. As Tommy G., the naval officer, ripped off his uniform, tore off his white tank top, and exposed his blond, frosted, spiked hair, the women screamed and marveled, almost receiving actual pleasure from his antics. So many women were staring at him, not removing their eyes from his gaze.

Vanessa's enjoyment of the striptease is predicated on her tacit refusal to identify with the other female audience members. She describes one such woman, Jackie, as a working-class caricature, "an older woman about forty years old with long, straggly dirty-blond hair, large, bottle-rimmed glasses, and crooked teeth with a large gap between her two front ones. She was wearing unattractive black leather pants and an oversize and extremely colorful tie-dye shirt."

Vanessa's account highlights the social distance she experiences in relation to Jackie and the pleasure the Penn freshman derives from observing her outrageous behavior:

> The announcer instructed her to keep her hands latched to the back of the chair; however, I could tell from her drunken stumbling onto the stage and her incoherent mumbles when she plopped onto the seat that Jackie was not going to follow directions so easily. . . . She chose a man named Matt as her dancer who was dressed as a cowboy in a straw hat, a button-down flannel shirt, and brown leather boots. Matt started the dance from behind, told Jackie to sit totally still, and jumped right over the chair onto her lap. Jackie was ecstatic and with Matt only left wearing a purple thong, she clasped her two hands onto each one of his butt cheeks and began to spank him. She was out of control screaming, "*Ride me, cowboy! Ride me!*" As Matt flung her hands off him and the announcer warned Jackie again to keep her hands attached to the back of the chair, she subsequently started biting him on his back and legs. . . . In a flash, a large security guard with a walkie-talkie in hand shoved Jackie off the seat and forcefully escorted her off the stage and out the door. Stacie and I were hysterically laughing. This was to be our exit as well. Why not end the night on a high note?

Why not, indeed, especially when such a "high note" can serve as the exclamation point for Vanessa's retelling of her adventure in slumming? Yet interestingly enough, by the end of her account, she admits that *she herself* participated in the sexualized rituals of the Cave—but explains her behavior away as a purely ironic gesture, illustrative of the very essence of slumming as a performance of social distance:

> One large woman who had huge and overwhelming breasts placed the dollar bill between her "babies" (as she referred to them) and gleefully watched as Tommy G. opened his mouth to grab the money from between her breasts. I pushed myself

toward the front to get a piece of the action. "When in Rome, do as the Romans do." If I was at a strip club already, I might as well fully participate in the event. As he turned around and knelt forward to expose his naked butt, I placed the bill under the thong strap.

Of course, in the context of urban nightlife, slumming only works as a social practice if the carousing of so-called "Romans" is read as straightforward, earnest audience participation, rather than tacitly acknowledged as the "irony" so often enjoyed by more affluent tourists and cultural consumers.

RISKY PLAY

Although popular narratives surrounding male nude revues, gentlemen's clubs, and gambling casinos often portray them as dens of iniquity, consumers can easily exaggerate the risks attributed to such storied nightspots. Unlike novice patrons, exotic dancers and croupiers experience their workplaces as mundane occupational settings, while nightclubs employ professional security teams to curtail aggressive behavior.[14] Although all urban areas feature a degree of risk, Philadelphia's centrally located entertainment zones like Old City tend to be relatively affluent, pedestrian-friendly, and well-policed, and thus present significantly fewer dangers compared to more remote neighborhoods in the city.

Still, urban legends, televised moral panics, and other predictably salacious tales of debauchery tend to overemphasize the hazards inherent in consuming entertainment in the nocturnal city. For example, many men regularly employ the gentlemen's club as a metaphor for risky behavior in which they themselves rarely indulge. While young men in particular commonly incorporate familiar narratives regarding the risqué nature of erotic environments into their competitive banter and boasting among their peers, they do not necessarily patronize strip clubs with any regularity as much as they rely on them as a representation of the upper limits of risk consump-

tion and sexual adventure. According to Garrett, a twenty-year-old sophomore:

> Whenever we're stuck on a Friday night with only the traditional fraternity parties to attend, we always kid around saying that next weekend we're going to be brave and venture to a strip club. Even now, I can see the smile radiating across Bob's face as he claps his hands together and exclaims, "Oohh, yeah, let's go get us some strippers tonight!" Of course, we've never actually acted upon the idea, but rather laugh the mere suggestion off.

Eventually Garrett and his friends do decide to patronize Signatures, a downtown gentlemen's club, and their confident bravado—"Oohh, yeah, let's go get us some strippers tonight!"—gives way to genuine confusion about their upcoming adventure. "As we finally left our apartment, we all agreed to hit the ATM before catching a cab. After all, we would need plenty of one-dollar bills to attract the ladies in the club. As I punched my familiar four-digit PIN into the worn buttons of the machine, Jay mused, 'If the girls are naked, where are we supposed to put the money?' 'Good point,' I responded. 'I guess they'll find a way.'" In the context of the club, confusion turns to bashfulness:

> As I walked into the main interior of Signatures, I didn't exactly know what to expect. In some respects, I was nervous and just wanted to fit in with the rest of the crowd. Finding three chairs along one of the back walls, we settled in. By the way we were sitting (very stiff, backs upright, looking uncomfortable), I think that anyone would notice that we were newbies to the scene. . . . In the middle of the room, a bar surrounded a stage, with a pole in the middle. Patrons who sat at the bar generally desired a more private experience with the dancers, while people at the surrounding tables generally appeared more detached. We chose the more impersonal experience by sitting at one of the tables; after all, we didn't want to cause too much attention.

As adolescents negotiating the rocky transition to adulthood, Garrett and his friends lack familiarity with the real-life world of gentlemen's clubs and the sexual aggressiveness of the professional strippers they employ, which explains their heightened sensitivity to the potential dangers of their surroundings. Young women also draw on the imagination of risk when exploring sexually charged nightlife scenes. Cameron, a nineteen-year-old sophomore, begins her tale of her Thursday night adventure to the Cave, the aforementioned all-male revue, by forging a nocturnal self that punctuates the pleasures of risky play:

> It's 6:00 p.m. and Tessa and I are getting ready to go out. She was already in the clothes she planned on wearing: a shiny blue tank top with black pants. I, on the other hand, was NOT going to go to a club in a baggy gray Penn shirt. On went the panty hose, the black skirt, tight pink-and-white shirt, and four-and-a-quarter-inch black heels. . . . I had to stop at the ATM. I had the ten-dollar cover charge with me but needed money for the cab. "And whatever else!" whispered the devil on my shoulder. "No, this girl is CHASTE! Stop giving her ideas!" said the gentle angel on the other shoulder.

Cameron presents her adventure as an internal dialogue between a guardian angel and a naughty devil that assists her in creating a narrative that defines the evening in terms of risky play:

> This will be just like a regular club, right? Right? We finally entered the actual Cave. It was somewhat dimly lit and had those lights that swing around and are all different colors. . . . The walls and ceiling were made to look like rocks, as if we were inside a cave. Tribal masks decorated the walls, along with little fake torches. . . . The angel on my shoulder started to flip out. "You had thirteen years of Catholic schooling! You're a member of Penn's Catholic club! Little Miss Conservative, what the hell do you think you're doing?!" Meanwhile, the devil hummed to

herself and filed her nails, biding her time. . . . At about 8:30 p.m., they showed a brief movie clip of "The Men of the Cave" TV spots, live performances, et cetera. I leaned over to Tessa and whispered, "My god, just watching that makes me salivate! Where are they?!"

Cameron's experience of the strip club is marked by its ambiguity as the hypothetical thrills of risky adventure and wild abandon are tempered by the show's campy theatrics and staged ribaldry:

Eventually, the show began. . . . Most of the sets had the same basic format: The boy and his theme—GI Joe, pilot, fireman, Latin lover—were introduced, and the boy would do a sexy little dance as he removed his clothing down to a tiny little bikini-like thing. It was all very melodramatic. . . . During the dance, I found myself either laughing hysterically (come on . . . male strippers? There is nothing in that statement that doesn't imply hilarity), modestly glancing away as they did some gyrating motions, cheering at the first sign of a lifted shirt, or staring in awe at their acrobatic prowess. These boys are flexible!

As the night progresses, Cameron's outrage over the club's commodified sexual environment grows stronger: "The girls would get a little touchy-feely—that's only to be expected—but the boys did too!"

They weren't content to just take the money and walk. They'd then give the girl her own little private dance, with her as a participant. I was absolutely shocked when I saw a guy lift a girl's leg up in the air (devil giggled expectantly, angel screamed in horror), "SMACK!" as the boy spanked her. . . . My angel won out. No way would I be waving any money at these boys; they could get their tips elsewhere.

Yet the playfulness of sexualized yet relatively safe, female-dominated settings such as the Cave invites young women to project a flexible

nocturnal self when negotiating the thrilling if ultimately staged terrain of the city's nightlife. Minutes after rejecting the advances of "The Men of the Cave," Cameron "noticed the girl immediately next to me getting a dance from one of them, and I thought to myself, 'Stop being a tight-ass. You're young. When else will you be in the arms of a guy like this?'"

Before I knew what I was doing, I got the guy's attention and was putting my little bill in his little . . . whatever you'd call what they were wearing. "No, no, no," he said, taking the bill from my hand and placing it in my mouth. I think I had time to look at Tessa bewilderedly before he bent me over backward and kissed me, removing the bill from my mouth. The angel lay draped over my shoulder, X's over her eyes and a pitchfork through her heart. . . . I'm fairly friendly with boys, but only to the point where I'll chummily throw an arm over his shoulder or possibly kiss him on the cheek for a greeting if we're really close. I don't know what it was about this night, but here I was, smooching a boy whose name I didn't even know. This girl in my body DEFINITELY was not the girl I usually am! I'm still a little shocked at myself. I'm still trying to figure it out. At the time, however, I was remembering the last smooch I had before that, in October when I broke up with my last boyfriend. HA! NO COMPARISON! I resolved at that point to marry a stripper. Or stay single forever and just enjoy them. After he walked away, I needed to sit down. . . . Frankly, I wish I could have seen my own expression. . . . For the rest of the night, whenever he walked by or happened to glance in my direction, he would wink or reach out a hand and stroke my cheek. I could have died of happiness.

I walked away from that place with the best self-image I've had in a long time. I felt like the most powerful, hot, sexy woman on the planet. This may be an incredibly fucked-up way of looking at things, but I think all girls, especially single ones like me, should be able to have an experience like this. Just when you worry you'll never attract a boy again, for one night here are the best-looking

ones in America, wanting to be your friend. I'm recommending this to all my girlfriends that I see, and this summer when my high school friends are home again, we're definitely having a girls' night out. I felt nothing but wonderful walking out of this and will most certainly be going back again.

GAY NIGHTLIFE AND THE IMAGINATION OF DANGER

While adventures in slumming among the affluent are common in working-class settings and hypersexualized environments, straight men and women frequently approach gay bars in a similar fashion. While heterosexual women periodically seek out gay male environments as "safe" spaces free from unwelcome sexual advances from ogling men, straight males often feel threatened in gay bars and night-clubs, fearful of being wrongly identified as homosexual.[15] They typically experience this largely imagined threat in highly exaggerated ways and consequently organize their narrative accounts of visits to gay bars and nightclubs as if depicting an epic odyssey, a cross between Joseph Conrad's *Heart of Darkness* and the former NBC television sitcom *Will & Grace*.

These accounts share several narrative elements. They begin by expressing an *assumption of danger* upon entering Philadelphia's gay-friendly entertainment zone, a cluster of blocks surrounding Thirteenth and Locust streets affectionately designated as the city's "Gayborhood."[16] According to Alec, a straight twenty-one-year-old junior on his way to 12th Air Command, a Gayborhood nightspot, "As we were walking to the bar, I realized that we were in a section of downtown that is predominately homosexual. As I realized this, I assumed that the people at this particular bar were going to be gay and was a little bit nervous about the whole situation, as I have never been to this type of bar." Regarding his visit to Woody's, another gay bar, Stewart, a straight twenty-one-year-old senior, remarks, "I am not gay, so I was a little nervous about it at first. I grew up in a small town in Ohio where there are not a lot of big nightclubs, and there are fewer gay nightclubs. I did not know what to expect when

we got there." They often pair this assumption of danger with a self-congratulatory nod, as if one's liberal avowal of social tolerance in *theory* should compensate for their feelings of trepidation in *practice*. According to Evan, a straight twenty-four-year-old senior, "I would like to think that I am a pretty open-minded person, but the thought of going to a gay lounge/bar without my girlfriend didn't sound very appealing to me. . . . I relented. I would go, without the safety net of my girlfriend."

These stories inevitably introduce a specifically drawn character: a trusted gay friend or relative intended to provide social entrée into the unknown gay world, just as Virgil leads Dante on a tour of the various gates of Hell. Again, as Alec explains, "Richard is an openly gay friend who goes out downtown almost every weekend, so I figured he would know some interesting places we could go." According to Pedro, a straight twenty-year-old Mexican sophomore, "Joe is thirty and a Mexican gay graduate student here at Penn. He is someone I have known since high school and completely trust. I had called him earlier, pleading with him to go with me and, like any good friend, he agreed."

Upon arrival at one of Philadelphia's downtown Gayborhood bars such as Woody's, many young straight men fear that gay strangers will suspect them of being homosexual themselves, and therefore sexually available for the plucking. (Straight young men tend to overestimate their sexual desirability among gay men, a reflection of dominant stereotypes regarding the boundless sexual appetites of homosexual males.) As Evan remarks of his experience at Bump, another Gayborhood nightclub, "It would be difficult not to notice some of the guys who looked at me. They weren't staring, but they weren't quick glances either. Now I know how women feel when they say that they are made to feel like pieces of meat." As he navigates his way around the bar, Evan continues to fear that men might be checking him out. "I tried to be as discreet as possible because, you know, I didn't want them to get the wrong idea."[17] In these instances, straight men rely on their trusted gay friends or female companions for protection against unwanted attention from strangers. Again, according to Stewart:

As we walked up to the club, I noticed a bunch of rainbow flags hanging from the building, and I immediately got nervous about what someone standing outside the bar might assume about me as I walked up to the door. "Brady [his gay companion], whatever you do, don't leave me standing by myself in here," I said as we walked in. He laughed and assured me I would be fine, but I was still nervous that some guy might see me standing there by myself and come over and start talking to me, thinking I was there because I was gay and wanted to meet other gay men. When we walked in the door, there were guys everywhere: young guys, old guys, and everything in between.

In the context of the gay bar, Pedro fears abandonment in the crucial moments when he is separated from his gay friend Joe:

After finishing my beer, I had to go to the bathroom again. I told Joe to go with me, but he told me not to be such a girl and go by myself. As I walked to the bathroom, I observed a couple of men holding hands, and as I hurried into the restroom, I saw two men kissing. I tried to pee as soon as possible and went back to my seat. When I sat back down, Joe told me that he needed to go to the bathroom. I jokingly called him a jerk for not going with me as he stood up and left. While all alone, I overheard the bartender telling one of the men at the bar, "What can I do for you, baby?" I looked at the bartender; he was an older man with a mustache and all. After serving the man his beer, the bartender looked at me and started walking toward me. I started thinking if he would call me "baby" as well. As I was thinking, he asked me if I wanted anything else to drink. I told him, "No thanks," and he walked away. As I sat there alone, waiting for Joe to come back, I really did not want to make any eye contact. I sat there staring at the television, counting the seconds that Joe was gone.

However, as much as these young straight men take comfort in the companionship of their gay guides, they simultaneously struggle to

differentiate themselves from them in their outward public behavior, lest strangers falsely identify them as gay. This leads to quite a bit of worrying over extremely subtle cultural signals, such as what kind of alcoholic beverage to order. According to Stewart:

> Brady and his friend got Tequila sunrises and I got a beer. In a straight bar I probably would have tried one of the mixed drinks, but at this place I opted to stick with a drink that wouldn't be confused as a "gay" drink. I know that what I drink does not define me as straight or gay, but for some reason, I was self-conscious about portraying myself as something that would possibly give someone the wrong idea. (I know that is a very ignorant thing to think, but anywhere you go there are "fruity" drinks that only girls drink, and men drink beer or whiskey.)

Pedro experiences a similar sense of discomfort while on the dance floor with his friend Joe:

> When Joe finally got back, he told me that I needed to go dance with him. At first I thought he was joking around. . . . I listened to the song they were playing, and I told him, "Please don't make me dance to the 'Milkshake' song [a sexually suggestive 2003 recording by female R&B artist Kelis]." He laughed and got me by the hand and pulled me on the dance floor. As we were dancing, I wondered if I was dancing differently. I tried to emulate Joe so that people would not think I was an outsider. When I felt comfortable enough to look up, I started looking around. I realized that I was on the dance floor with nothing but men. To make matters worse, there were two men without shirts dancing around me. I began to panic. I did not know what to do. Joe got close and he told me to relax, that they would not try anything.

Finally, the denouement common to these accounts reflects the narrator's newfound understanding of gay-oriented scenes of urban nightlife and a reinterpretation of such scenes as strikingly simi-

lar to mainstream culture and thus safe for consumption. Whereas Evan had been self-conscious of being targeted as gay upon entering Bump, toward the end of his journey he admits that "as the night wore on, it wasn't so bad. Glances and looks were just that, glances and looks." After an evening of distress at Woody's, Pedro observes that "after two songs I loosened up a little more and just started dancing. For once, I cared very little about not dancing like the shirtless men dancing around me. I was actually having a good time." Reflecting on the evening, Stewart reaches a similar conclusion: "All in all, it was a fun night and definitely a learning experience. We did basically the same kinds of things straight people do when they go out. We drank a few drinks, some people danced, and we just hung out with friends." In many ways, discoveries like those illustrated here by Evan, Pedro, and Stewart represent among the best examples of how exploring the nightlife of the city can bring young people closer to a level of maturity and cultural awareness commensurate with the post-adolescent life.

8

SMOKE AND
MIRRORS

On an unseasonably mild January night, my friend Jacques and I take the elevated train from Philadelphia's 30th Street Station to the opening of Zee Bar, the newest in local nightclub swank. Situated just off the city's redeveloped riverfront corridor, Zee Bar sits in its strip-mall hideaway next to Delilah's, Philly's premier gentlemen's club. At first we can barely see the club at all until we catch a glimpse of the long queue, a mile-long crowd of would-be revelers who, like us, have been tricked into believing that their e-mailed "guest passes" would promise the rarefied taste of exclusivity. After stumbling upon a gang of acquaintances with the foresight to arrive earlier than us, we duck into their place in line only steps from the nightclub's waves of gate-keepers—the publicity assistants with their clipboards full of guest lists, doormen flashlighting IDs, bouncers running patrons through metal detectors, and coat checkers collecting winter parkas, brief-cases, and all else lacking in glamour and frivolity.

After working our way through this gauntlet of suspicious eyes, we enter the cavernous club, a palace of Brazilian redwood and wal-nut, exposed brick and slate. A series of tiny lounges (referred to by management as "conversation pits") adorned with plush couches

surround the packed dance floor, a gathering of nobodies and every-bodies—lawyers, professional football players, local news anchors, has-been reality TV stars from *Survivor* and Donald Trump's *The Apprentice*.[1] We work our way past negligee-clad hostesses and tat-tooed acrobats to the open bar, where complimentary cocktails await any customer possessing the fortitude to claw their way through the dense crowd of drinkers and patiently summon the attention of the club's handful of overworked bartenders.

Our group eventually sinks into its own set of couches at the opposite end of the club, where giggling cocktail waitresses serve us gin and tonics until 11:00 p.m., the witching hour when the cash bar begins. A young woman spots Jacques smoking his favorite brand of expensive European cigarettes, and when she asks him for one, he smiles and pulls out one of the cheap Camels he keeps planted in the pack. My eyes slowly wander to yet another set of rooms aglow with sultry lighting and beautiful people, and I brush past the less attractive crowd of wannabes blocking my path to what promises to be the nightclub's most luxurious frontier—only to walk into a wall of reflecting mirrors, as the nobodies stare back at me through the glass and smoke.

THE NIGHTLIFE OF THE CITY

Late twentieth-century American films portray Philadelphia as a city of bruisers and broken dreams, a perfectly dreary setting in which to frame the rough streets of the working poor (*Rocky*), the tragedy of AIDS (*Philadelphia*), the curse of urban ghosts (*The Sixth Sense*), and the postapocalyptic metropolis (*12 Monkeys*). But in the wake of the city's 1990s renaissance, much has changed as developers convert aban-doned textile factories into luxury condominiums, entertainment moguls reinvent decaying neighborhood spaces as sleek nightclubs and steakhouses, and the city's downtown emerges as a 24/7 nonstop consumer playground for the affluent classes. As I noted in the intro-duction, much of this development has been driven by the strength of the city's postindustrial economy, in which growth in higher

education, professional services, and symbolic production fills the Center City corridor with abundant numbers of potential cultural consumers with disposable incomes. They include business travelers, conventioneers, leisure tourists, artists, and highly mobile frequent-flying professionals who canvass the city's restaurants, dance clubs, movie theaters, music venues, cigar bars, and entertainment attractions in mobilized teams and urban tribes. Their clusters of companionship serve as a kind of social bulletproofing designed to protect them from unwanted encounters with strangers in the anonymous city.

Of these entertainment consumers, the most ubiquitous are Philadelphia's 100,000-plus undergraduate and postbaccalaureate students enrolled in the area's universities, art colleges, music conservatories, and graduate schools of law, business, and medicine. These late-adolescent and twenty-something students represent a growing cohort of young Americans who have postponed the traditional accomplishments of adulthood—degree completion, stable employment, marriage, and parenthood—for what demographers and psychologists have hailed (or decried, depending on the source) as a prolonged transition to adulthood. As the preceding chapters presented here illustrate, this recent shift in *human* development serendipitously converges with the postindustrial city's *urban* development to create an adolescent playground in which young people experiment with strategies of role-playing, impression management, and sexual interaction in public. In the company of their friends and classmates, college students explore elaborate codes of fashion, appearance, and personal grooming; engage in rituals of confidence building; employ tactics of deception intended to trick nightlife gatekeepers and unwitting bystanders; strategically avoid risky confrontations with overbearing competitors; playfully flirt with desirable members of the opposite gender; and cautiously defend themselves against unwanted advances, aggressive come-ons, and other forms of sexual harassment. For these young thrill-seekers, the consumption of urban nightlife requires engaging in sporting rituals designed to take advantage of the anonymity of urban life while defending themselves from the occasional dangers that accompany

public interactions with strangers. For better or worse, in today's age of elongated adolescence, these moments make up the experience of emerging adulthood, a developmental stage that for some may seemingly last through one's thirties and beyond.

Given the anonymity of the contemporary metropolis and the expectations shared by affluent young people eager to experience the promise of the city's entertainment landscape and its tantalizing fantasy of opulence and promiscuity, cultural producers draw on strategies of deception and guile in their development of local nightspots from themed restaurants to designer cocktail lounges. Through a series of elaborate set pieces, staged performances, and unconventional tactics of creative marketing, teams of cultural entrepreneurs, service workers, and public relations consultants collectively generate the city's nightlife as a series of hustles intended to entrap unwitting audiences, both young people and their more "sophisticated" elder counterparts.

Within this environment, nightclubs literally employ smoke and mirrors along with elaborate lighting schemes in order to cloak their interiors in an aura of mystification as well as conceal health code violations and cheap construction materials. Table servers, bartenders, hostesses, cocktail waitresses, sommeliers, and exotic dancers draw on studiously rehearsed scripts when interacting with customers. Publicists fabricate anniversaries, celebrations, and other pseudo-events in order to artificially boost the exposure and popularity of otherwise fledging restaurants and nightspots, while female "reality marketers" serve their clients by posing as ordinary patrons with the single-minded purpose of engineering an exciting atmosphere electrified by the staged allure of sexual abandon and nocturnal pleasure.

SOMETHING FOR NOTHING

Given that scenes of urban nightlife rely on these meticulously deployed strategies of stagecraft and theatrical excess, skeptical readers may wonder how any of it—the simulated exclusivity suggested by an elaborate PR campaign, the phony giggles of a coquettish cocktail

waitress, the restaurant interior constructed out of Styrofoam, the prearranged sightings of NFL athletes and other celebrities for hire, the engineering of synthetic fun—ever actually fools anyone. We approach now-antiquated confidence games with the same incredulity. In the nineteenth century, a swindler named Reed Waddell peddled lead bricks painted gold to unwitting New Yorkers for thousands of dollars, while during the 1920s Victor "the Count" Lustig made hundreds of thousands of dollars selling suckers a "money box," a simple box with a crank and a false bottom that he convinced marks could replicate an infinite supply of $20 bills.[2] Today these scams seem so bafflingly ridiculous, but we fall for our own versions of the short con often enough: the casino bet that always favors the house; the stripper whose whispered secrets and make-believe turn-ons generate untold tips; the fake phone number.

Why does the art of the hustle continue to succeed, particularly among society's most affluent and highly educated members? According to David W. Maurer's *The Big Con*, confidence artists typically victimize those who are most easily persuaded to follow their own *inner* hustler, willing to employ dishonest means for a quick buck:

> The first thing a mark needs is money. But he must also have what grifters term "larceny in his veins"—in other words, he must want something for nothing, or be willing to participate in an unscrupulous deal. If a man with money has this trait, he is all that any con man could wish. He is a mark. "Larceny," or thieves' blood, runs not only in the veins of professional thieves; it would appear that humanity at large has just a dash of it—and sometimes more. And the con man has learned that he can exploit this human trait to his own ends; if he builds it up carefully and expertly, it flares from simple latent dishonesty to an all-consuming lust which drives the victim to secure funds for speculation by any means at his command.[3]

Do consumers of urban nightlife similarly possess this "larceny" in their veins? In many ways they do. The restaurant diner and bar

drinker desire the savings and status implied by a complimentary beverage or little "extra" offered by a self-interested server, and so they repay him or her for the favor in tips exceeding the price of the free item. Of course, usually the "something for nothing" they seek is purely symbolic, like the prestige suggested by a hot table in a popular restaurant. The male patron on the make dizzies with excitement over the sexual innuendo thrown his way by an attractive barmaid or flirtatious customer, and he gives away his whole wallet by closing time. Nightclubbing fans expend great effort to increase their nocturnal capital, or status gained by their savvy knowledge of the city's nightlife, by hunting down and experiencing the most fashionably groovy cocktail lounges and hipster dives.[4] In the context of selling urban nightlife, the hustler seeks out victims who think they can purchase this status at a downtown cocktail lounge for a $10 cover charge, or buy their way into the glamorous life for the simple cost of admission—only to be sold a shoddy reproduction of the real thing, a glittery gold brick made of lead.

THE HUSTLE OF URBAN NIGHTLIFE

In 2006 the *Spectator*, Columbia University's student newspaper, reported on a New York City team of confidence artists who profit by grifting unsuspecting college students. According to the article:

> A swindling pair of "homeless-looking" people is calling the streets of Morningside Heights home, playing on their victims' fear and pity to make a quick buck. Their modus operandi is simple. Walking into unsuspecting passersby, the couple—a young man and woman—drop a plastic bag containing a glass bottle. The bottle shatters. The man angrily demands to be repaid for the contents, while the woman insults the stunned fall guy. If the "bottle job" is successful, the couple runs off with the cash. . . .
> It is not the first time Morningside residents have had to deal with angry street charlatans. In 2003, *The Spectator* reported on a notorious "You Broke My Glasses" con who angrily demanded

money after bumping into people around campus and dropping his eyeglasses.[5]

If college students make for easy marks among *actual* thieves and career con men, it is easy to blame their gullibility on their naïveté among strangers, until one observes just how savvy young people can be at perpetrating hustles of their own making. A likely majority of underage students at Penn make common use of counterfeit ID cards to gain access to off-campus bars and downtown nightclubs, while others simply lie their way into such establishments. (One evening while I was shadowing and interviewing servers, hostesses, and cooks in the dining room and kitchen of Barclay Prime, a group of Penn college students from my Sociology of Media and Popular Culture class attempted just this, by claiming to the manager to be graduate researchers under my instruction at the university.) As illustrated in chapters 4 and 5, young men on the make engage in girl hunting and other rituals of camaraderie that involve a number of hustles: employing wingmen as shills willing to perform the dirty work necessary to engineer intimacy between a leading man and his female target; posturing as investment bankers and professional athletes in order to impress older women; the clandestine use of hair- and skin-care products employed to produce a devil-may-care look. For their part, young women similarly deploy strategies of deception and guile while negotiating the nightlife of the city: applying heavy doses of facial cosmetics and wearing stilettos in order to masquerade as women of drinking age; flirting with desperate men (both customers and bartenders) in the hopes of procuring a steady supply of free cocktails; passing off phony aliases and bogus phone numbers as legitimate.

Yet one cannot help but conclude that these young people become victims of their own success. As pointed out by feminist writer and *Nation* columnist Katha Pollitt, contemporary women often characterize their conformity to highly sexist norms of fashion as empowering, as evidence of their hard-won autonomy, while ignoring how the personal pleasures gained from dressing in bone-crushing Jimmy

Choo metallic snake slingbacks are simultaneously the product of unforgiving social pressures and the sexual desires of men.[6] Meanwhile, in the long run the over-the-top rituals surrounding the girl hunt—the competitive sex talk, the idolatry bestowed on successful paramours, the reliance on fictional male characters from popular film and rap recordings as models of realistic sexual behavior, the punishing alcohol abuse suggested by the Power Hour and the Century Club—seem more effective as instruments designed to promote a sense of *inferiority* among young men, rather than invincibility.

Moreover, while young consumers may succeed as amateur hustlers as they endeavor to sneak into nightlife venues and negotiate their risky social terrains, their unbridled enthusiasm for doing so ultimately reveals their susceptibility to the most entrenched fabricated myths regarding the manufactured glamour of the city's downtown entertainment zones. I am reminded of Indrajit, a nineteen-year-old Indian freshman from Gladstone, New Jersey, whose comparison of Alma de Cuba to the fictitious universe presented as contemporary Manhattan in *Sex and the City* discloses a wide-eyed sense of excitement common to many college-aged suburbanites new to the seductive world of urban nightlife. As she recalls in a remarkable display of sincerity lacking in the cynicism often associated with American adolescence:

I pushed open the heavy door and was at once overwhelmed by the scene. I really didn't think such places existed outside of Carrie Bradshaw's world in a glamorous New York, and even then, on a TV sitcom. The exhilarating beat of Spanish music, similar to the Gipsy Kings, boomed out of powerful surround-sound speakers and below the elevated bar area was a seating area sprinkled with white couches and coffee tables. Large black fans whirled overhead, and the mahogany and dark wood decor really gave the place an exotic feel. Alma de Cuba was packed. I half-expected to turn around and see the four females of the often-quoted show seated behind me. [My friend] Steven went off to the bathroom and told me to order him whatever I was

having. I took a breath, told myself to be confident, that I didn't look like I belonged in middle school on this evening, and edged into the crowd surrounding the bar. . . . That half hour at Alma de Cuba was the closest to the epitome of a real night out on the town that I'd ever experienced. Everyone looked so young, beautiful, carefree, and fun; it was right out of a movie. I'm glad I savored the experience because it will be a very long time before I'm back. The whole scene was "fabulous," as my hero, Carrie Bradshaw, would say.

SEX AND THE NIGHTLIFE OF THE CITY

In the end, the coming-of-age story I have presented in these pages is one of class, gender, and sexuality, and how affluent young urban dwellers employ the nocturnal landscape of the city as a backdrop for their performances of sexual attractiveness and desire. Debonair nightclub swingers and sassy martini tipplers accomplish convincing performances of upper-class style and overstated masculinity, femininity, and metrosexuality by employing suitably chic designer brands—Christian Dior, Seven, Dolce & Gabbana, Diesel, James Perse, Manolo Blahnik, Burberry, Prada—as sexual battle armor doused with overpriced perfumes and cologne. Men and women alike deploy strategies of impression management in deeply patterned rituals of heterosexual courtship, but just as enthusiastically perform for themselves in collective moments of homosocial interaction enjoyed while applying lipstick in a public restroom, dancing to a festive pregaming sing-along, or taking what would otherwise be a lonely taxicab ride home.

In nightlife settings young men and women both attempt to "do" gender and sexual status as a public performance, and throughout the course of their evening they illustrate how such roles are continuously accomplished on a moment-to-moment basis with varying degrees of skill and sophistication. More than a costume, the accomplishment of a gendered nocturnal identity demands adherence to a disciplined display of one's body in motion, an arduous presentation

of self in which a woman must avoid chewing gum or tripping over her impossibly tall stiletto heels while continually moving through a succession of Goffmanian front stages, while men face a similarly laborious task of performing physical toughness and masculine confidence when confronted by an aggressively drunk patron. In doing so, young men and women not only experiment with a set of fashion styles, but also studied nonverbal gestures, improvised modes of talk, norms of attentiveness and civility, and the barely observed but ever-present facial cues that make up an individual's personality and social self.

Of course, this never-ending process of social-skill acquisition is hardly limited to the efforts of adolescents and young adults, but describes how men and women of all ages struggle to maintain competence in the art of impression management throughout the life course. In fact, perhaps this explains why so many depictions of urban nightlife in popular culture—*Saturday Night Fever, Sex and the City, Swingers*—emphasize adult social behavior at its clumsiest as well as its most glamorous. In *Sex and the City*, Carrie Bradshaw may enjoy limitless cosmopolitans and taxis, the most expensive designer shoes and dresses, and the gorgeous blond hair of actress Sarah Jessica Parker, but her popularity as a postfeminist representation of the urban woman ultimately stems from her dating foibles and failures, the very qualities that make her so vulnerable, so human. Like the most gullible of swindled marks, Bradshaw is forever optimistic that she will eventually win at the high-risk game of urban nightlife. In the final analysis, perhaps it is for this reason that her millions of fans cheer her on as she continually returns with her girlfriends to the city's nightclubs, cocktail bars, and happy hours, all in the hopes that she will someday beat the hustle, that the glittery bricks she so foolishly covets will one day turn out to be gold after all.

ACKNOWLEDGEMENTS

For this project I received generous funding from the University of Pennsylvania Research Foundation, the Alice Paul Center for Research on Women, Gender, and Sexuality, and the Penn Institute for Urban Research. I received permission and valuable guidance from the Institutional Review Board of the Penn Office of Regulatory Affairs.

All my thanks in the world go out to the many ethnographic informants whose contributions made this volume possible, with special gratitude to the hundreds of Penn students whose written accounts of their own experiences on the town shaped many of the book's central arguments and conclusions. A number of graduate students were responsible for assisting in the collection of these accounts: Faye Allard, Ian Born, Rachelle Brunn, Giovanna Citti, Jan Jaeger, Colette Joyce, Taryn Kudler, Cathy Mayer, Abigail Platten, Georges Reiners, Jessica Rubin, Lindsay Rutherford, Elizabeth Vaquera, and Yuping Zhang. Under my supervision, Ian Born, Lauren Fernandez, and Andrew Rosenthal conducted focus groups of their peers at Penn, while Becca Aronson conducted supplementary fieldwork and interviews. Suzanne Stein and Sarah Vaghari were responsible for transcribing all recorded interviews and focus groups. Peter Fleming helped me with troubleshooting during my early stages of data coding. Faye Allard, Garth Bond, Jacques Bromberg, Julie Janus, Bethany Klein, Julie Park,

Guy Raviv, and Jason Schnittker accompanied me on various fieldwork excursions, offering their insights along the way.

My colleagues in the Department of Sociology at the University of Pennsylvania provided immeasurable guidance and support throughout the duration of this project by discussing research strategies over lunch and/or coffee, reading manuscript drafts, commenting on presentations, and offering their reflections on Philadelphia and its rich urban milieu: Eli Anderson, Chuck Bosk, Randall Collins, Irma Elo, Frank Furstenberg, Robin Leidner, Janice Madden, and Susan Watkins. I offer special thanks to Randall Collins and Robin Leidner for their guidance and support; both also read over the entire manuscript.

Over the past few years, I have been given the opportunity to present this work and related projects at invited talks at Penn and around the country at CUNY Graduate Center, Franklin and Marshall, Harvard, Louisiana State, NYU, Northwestern, Princeton, Saint Joseph's, Stanford, Temple, the University of Chicago, Vanderbilt, and the MacArthur Foundation Research Network on Transitions to Adulthood, and the project has greatly benefited from the many comments and suggestions offered on those occasions. I also thank the audiences and co-presenters at the panels on which I have presented pieces of this project at annual meetings of the American Sociological Association and the Social Science History Association. All of these occasions have provided me with the opportunity to exchange ideas with an expanded network of colleagues, and I thank them for their valuable insights regarding this project: Elizabeth Armstrong, Howard Becker, Katie Bogle, Laura Carpenter, Richardson Dilworth, Mitchell Duneier, Neil Gross, Jerome Hodos, Sarah Igo, Philip Kasinitz, Maria Kefalas, Eric Klinenberg, Jennifer Lena, Richard Peterson, Michael Rosenfeld, Bryant Simon, and Caitlin Zaloom.

I thank my editors at the University of Chicago Press for their patience and thoughtfulness during this latest endeavor. As usual, Doug Mitchell offered his encouragement and support throughout the entire research and writing process, Tim McGovern provided much-needed editorial assistance, and Erin DeWitt expertly edited the finished manuscript. I also thank two anonymous readers for their helpful suggestions for revision.

Finally, I reserve my deepest thanks and gratitude to my wife, Meredith Broussard. Meredith and I were introduced (at a bar, of course) by a mutual friend during my first year living in Philadelphia and have been inseparable ever since. She showers me with encouragement, kindness, love, and patience; and as a talented writer herself, she is always generous in offering a trusting editorial hand. I have dedicated this book to her and our beautiful son, Nathaniel.

APPENDIX:
RESEARCH METHODS

Since arriving in Philadelphia in September 2001, I spent five years investigating the production and consumption of urban nightlife in downtown Philadelphia by relying on a variety of ethnographic and other qualitative research methods, as outlined below.

A. PARTICIPANT OBSERVATION. Between September 2001 and September 2005, I conducted ethnographic fieldwork in several of Philadelphia's nightlife districts, including Old City, Rittenhouse Square, South Street, Fitler Square, Chinatown, Fairmount, Italian Market, Northern Liberties, University City, and the city's "Gayborhood." Over the course of my research, I paid visits to over 175 downtown restaurants, cafés, taverns, nightclubs, cocktail lounges, rock and jazz venues, private social clubs, hotel bars, and late-night eateries, during which time I conducted countless conversations and informal interviews with local patrons in addition to bartenders, restaurant servers, musicians, promoters, DJs, and entertainment journalists. For the four-year duration of my fieldwork, I resided in Center City's bustling Rittenhouse Square district, which greatly eased my immersion in the field.

B. FORMAL INTERVIEWS. Over the course of the project, my research assistants (RAs) and I conducted, recorded, and transcribed twenty-four interviews with

local nightlife industry personnel. I conducted and recorded twenty-one of these interviews, while Becca Aronson, an undergraduate research assistant (RA), conducted the remaining three interviews with restaurant service personnel. All interviews were transcribed by Suzanne Stein, an undergraduate RA, and Sarah Vaghari, a graduate student. These recorded interview subjects are listed as follows, along with their occupation or affiliation. Pseudonyms are given in quotation marks, while (*) denotes an interview conducted by an RA:

1. "Blake," restaurant manager (Barclay Prime)
2. "Joshua," restaurant server (Barclay Prime)
3. "Mark," restaurant server (Barclay Prime)
4. "Rick," contributor, *Where* magazine, Philadelphia
5. Maria Tessa Sciarrano, indie rock promoter, DJ
6. "Diana Redstone," president and CEO of "Redstone Productions," a public relations firm
7. "Ashleigh Roberts," director of public relations for "Redstone Productions"
8. "Alexandra," bartender and server (Ortlieb's Jazzhaus, Philadelphia Fish & Co.)
9. "Danny Lake," public relations consultant
10. Maureen Tkacik, Philadelphia journalist, *New York Times*, *Philadelphia Magazine*
11. Avram Hornik, restaurateur and bar owner (Bar Noir, Drinker's Pub, Drinker's Tavern, Loie, Lucy's Hat Shop, Noche)
12. "Jason," bartender, server, and bar back (Tangerine, Delilah's, Adriatica, La Terrasse, Mansion)
13. Sam Adams, film editor, *Philadelphia City Paper*
14. Sara Sherr, indie rock promoter, DJ, music journalist
15. Jessica Pressler, Philadelphia journalist, *New York Times*, *Philadelphia Magazine*, *Philadelphia Weekly*
16. "Juliana," rock music club house manager and booking agent
17. "Katie Klein," founder, "The Katie Klein Company," a public relations and "reality marketing" firm
18. "Madison," restaurant server (Alma de Cuba)
19. "Caitlin," restaurant server (Morimoto, Barclay Prime)
20. "Allison," restaurant server and hostess (Tangerine, Pod)
21. "Misty," restaurant server (Le Bec-Fin, Susanna Foo)
*22. "Jonas," restaurant busboy (Continental Mid-Town)

*23. "Carl," restaurant busboy (Continental Mid-Town)

*24. "Jacqueline," restaurant server (Continental Mid-Town, Alma de Cuba)

C. NARRATIVE ACCOUNTS OF NIGHTLIFE PARTICIPATION. To further my understanding of how young consumers experience Philadelphia's downtown nightlife scenes, I collected and analyzed 811 firsthand narrative accounts of nightlife participation. These accounts were written by undergraduate students at the University of Pennsylvania enrolled in my course on the Sociology of Media and Popular Culture. This data collection occurred in two stages.

STAGE 1. In fulfillment of a required course assignment, during the fall 2003 and spring 2004 semester terms, respondents attended at least one nightlife entertainment venue of their own choice (e.g., restaurant, café, dance club, sports bar, cocktail lounge) located in Philadelphia's Center City district and its immediate surrounding neighborhoods for the duration of a few evening hours' time. The ecological boundaries defining the parameters of the assignment (from the Schuylkill River to the Delaware River, and from Washington Street to Girard Avenue) were selected beforehand for the purposes of ensuring a wide availability in the respondents' chosen destinations while still maintaining geographical consistency in their experiences.[1] Student respondents were also given specified two- to three-week windows for completion of the exercise (November 12–24, 2003, and March 24–April 12, 2004) to ensure temporal consistency within each semester, and were required to conduct their observations at night, broadly defined as anytime after dark. They were encouraged to select familiar sites where they would feel both comfortable and safe. (This was illustrated by the diverse range of sites selected by my respondents, which included not only nightclubs, dinner restaurants, and cocktail lounges, but also pizzerias, fast-food eateries, branded coffee shops, symphonic concerts, and a Christian fundamentalist gospel performance.) Respondents were also permitted to choose whether to conduct their outing alone or seek the accompaniment of one or more friends, relatives, boy-/girlfriends, or acquaintances of either gender. (Illustrative of the wide variety of options available to respondents, several students chose to report on events in which they were accompanied by their parents and other family members.)

Upon the conclusion of their evening, students were instructed to document their experience in detailed narrative accounts, with attention given to their early preparations for the evening; any social interactions conducted among friends, acquaintances, or strangers in public; and their personal and emotional reflections on the evening's events. After submitting their typed narrative accounts electronically to a team of teaching assistants (who in turn read them to ensure

that each adhered to proper standards of protocol), the respondents' names were removed from their submissions to protect their anonymity. Afterward these accounts were forwarded to me, at which time I assigned them individual case numbers, systematically coded them, and then analyzed them separately on the basis of gender. While all names were removed in order to assure the anonymity and confidentiality of the respondents, students were asked to supply basic demographic information along with their accounts (including gender, age, year of school, residence, racial and ethnic origin, and sexual orientation [optional]) to be used as a reference during coding and analysis, which was conducted with the help of NVivo, a qualitative data software package.

This collection yielded a sample of 526 separate narrative accounts, with respondents nearly evenly divided by gender: 51 percent ($n = 267$) male and 49 percent ($n = 259$) female undergraduate students. This sample consists of 24.5 percent ($n = 129$) freshmen, 38.5 percent ($n = 203$) sophomores, 19 percent ($n = 100$) juniors, and 18 percent ($n = 94$) seniors. Respondents ranged from 18 to 26 years of age, with a mean age of 19.8 years. The racial and ethnic makeup of the sample is as follows: 73 percent ($n = 385$) white, 13 percent ($n = 70$) Asian, 4.5 percent ($n = 23$) non-Hispanic black, 4 percent ($n = 20$) Hispanic, and 5.5 percent ($n = 28$) mixed race/other. While my data analysis did uncover very small differences in consumption patterns among my sample on the basis of race and ethnicity, I could not detect notable differences relevant to the arguments presented in the book's chapters. As for student residence prior to college, 67 percent ($n = 352$) lived in suburban areas and 28.5 percent ($n = 149$) hail from urban environments, with 4.5 percent ($n = 25$) from rural/other areas; also, 19.5 percent ($n = 102$) resided in the Commonwealth of Pennsylvania, while 6.5 percent ($n = 33$) are Philadelphia natives.[2]

Given their presumed homogeneous intellectual interests and dispositions, some might object to sampling students enrolled in discipline-based college courses in general and sociology courses in particular. However, among the declared majors participating during the 2003–04 academic year, less than 10 percent of the students are sociology majors (7.1%), while the vast majority hail from a cross section of disciplines spanning the other social sciences (32.9%), physical, biological and engineering sciences (15.6%), humanities (10.2%), business (11.5%), professional tracks in nursing and education (5.4%), and interdisciplinary programs in the arts and sciences (17.3%).

The findings presented in chapter 5 on the girl hunt derive from a separate analysis of those accounts sampled written by heterosexual male college students ($n = 243$). Again, in my original pool of 526 students, 51 percent, or 267 students, identified as male. For inclusion in the sample generated for this chap-

ter, male students either voluntarily self-identified as heterosexual, or else were coded as such from their written narrative accounts (i.e., referenced a female sex partner or generalized heterosexual desire). While it is certainly possible that those coded as heterosexual may *also* engage in homosexual or bisexual practices, this did not preclude them from inclusion in the sample, given the nature of the research question. In my original pool of 267 eligible male subjects, 4 self-identified as gay and 34 opted not to disclose their sexual orientation; of the latter, 14 were eventually coded as heterosexual, while 20 remained nondescript enough to be removed from this particular sample.[3]

An initial read-through of accounts submitted by these 243 male respondents revealed that about one-fifth of the reports clustered around a set of shared commonalities, including a pronounced goal of seeking out young women as potential sexual and/or romantic partners. Subsequent coding of these accounts highlighted their emphasis on collective behavior (including rituals involving the consumption of alcohol), a strong reliance on one's peer group, and the deployment of team-oriented strategies deemed necessary for approaching women in public. Since these reports only account for one evening's worth of behavior and experience, I lack the means to validate whether they accurately characterize the lifestyles of my individual respondents, although peer-led focus groups later conducted among a smaller sample of 30 male respondents (see below) uncovered similar findings.[4]

STAGE 2. To supplement my sample of 526 narrative accounts, during the fall 2004 semester (November 10–22) I collected an additional 285 accounts from male and female students enrolled in the same course, Sociology of Media and Popular Culture, bringing the total number of collected narrative accounts to 811. This additional pool of accounts served a number of useful purposes. The added cases enabled me to test hypotheses generated during my earlier analysis. They also provided surplus data on underrepresented respondent groups, including gay students and persons of color. Finally, in order to add to the variety of urban contexts provided by my original data on local cultural scenes, at this second stage of collection I allowed respondents to report on nightlife venues located outside of Philadelphia's downtown Center City districts. This yielded accounts of city life in a wide range of urban entertainment zones, including Boston's North End, Washington D.C.'s Adams Morgan neighborhood, and Atlantic City's casino-lined boardwalk. In addition, many respondents reported on nightlife in the West Philadelphia area surrounding the university campus, a district sporting inexpensive college bars, cafés, and ethnic restaurants; others reported on mass cultural events from NBA night basketball games to arena hip-hop concerts.

D. FOCUS GROUPS. My RAs and I conducted focus groups among 71 Penn undergraduate students (41 women, 30 men). We organized 19 focus groups on the basis of gender, and when possible, academic year. The sessions were all held in available classrooms on campus. They ran anywhere from 45 to 90 minutes and were conducted and recorded by one of three facilitators trained by me: two Penn undergraduates, Lauren Fernandez and Andrew Rosenthal, and Ian Born, a graduate student. (Ms. Fernandez led all of the focus groups with female participants, with the male RAs conducting the remainder.) Ten female-dominated focus groups were held between November 8, 2004, and November 26, 2005, and the remaining nine male focus groups were conducted from April 11, 2005, to January 28, 2006.

Nearly all group discussants were former students enrolled in a previous semester of my Sociology of Media and Popular Culture course. Exceptions include one session consisting solely of undergraduate sorority sisters and two sessions with fraternity brothers. These latter sessions were created to develop perspectives on Greek life on campus and its impact on the experience of nightlife for Penn students.[5] (In each case, the focus group facilitator was a member of the fraternity or sorority to be interviewed and actively recruited participants from their own chapter.) All students participated in the sessions on a voluntary basis, signed consent forms granting their permission to be recorded, and were paid ten dollars for their time. All focus-group recordings were transcribed by Suzanne Stein, an undergraduate RA.

This project was approved by the Institutional Review Board, Office of Regulatory Affairs at the University of Pennsylvania, under three separate protocols: nos. 709101, 709102, and 709103.

NOTES

CHAPTER 1

With a few exceptions indicated in the text, the names of all places of business and their neighborhood locations have remained unaltered, as have the names of all local restaurateurs, club owners, journalists, critics, and other public figures. However, in the interests of protecting the privacy rights of my research informants, the names of all student respondents and nearly all interview subjects have been changed throughout the book; exceptions are denoted in the appendix.

1. The popularity of this Darwinian perspective in evolutionary psychology is illustrated by Robert Wright, *The Moral Animal: Evolutionary Psychology and Everyday Life* (New York: Vintage, 1995).

2. Ben Mezrich, *Bringing Down the House: The Inside Story of Six M.I.T. Students Who Took Vegas for Millions* (New York: Free Press, 2002); Neil Strauss, "He Aims, He Shoots and . . . Yes!" *New York Times*, January 25, 2004, sec. 9, p. 1; Neil Strauss, *The Game: Penetrating the Secret Society of Pickup Artists* (New York: Regan Books, 2005); Elana Berkowitz, "Are You with Him? Why Yes, Want to Date Him?" *New York Times*, October 10, 2004, sec. 9, p. 1; Frank Owen, "An In with the In Crowd," *New York Times*, January 16, 2005.

3. The anonymous quality of downtown nightlife venues has long been recognized by sociologists of urban culture; see Harvey Warren Zorbaugh, *The Gold*

Coast and the Slum: A Sociological Study of Chicago's Near North Side (Chicago: University of Chicago Press, 1929); Paul G. Cressey, *The Taxi-Dance Hall: A Sociological Study in Commercialized Recreation and City Life* (Chicago: University of Chicago Press, 1932); and David Gottlieb, "The Neighborhood Tavern and the Cocktail Lounge: A Study of Class Differences," *American Journal of Sociology* 62 (1957): 559–62.

4. Georg Simmel, "The Metropolis and Mental Life" (1903), in *On Individuality and Social Forms*, ed. Donald N. Levine (Chicago: University of Chicago Press, 1971), 331. On the experience of anonymity in the modern city, also see Robert E. Park, "The City: Suggestions for the Investigation of Human Behavior in the Urban Environment," in *The City*, ed. Robert E. Park, Ernest W. Burgess, and Roderick D. McKenzie (Chicago: University of Chicago Press, 1925); Louis Wirth, "Urbanism as a Way of Life," *American Journal of Sociology* 44 (1938): 1–24; Lyn H. Lofland, *A World of Strangers: Order and Action in Urban Public Space* (New York: Basic, 1973); and Richard Sennett, *The Fall of Public Man* (New York: Knopf, 1977).

5. Simmel, "The Metropolis and Mental Life," 336–38; emphasis added.

6. Park, "The City," 40.

7. For example, see Zorbaugh, *The Gold Coast and the Slum*, particularly his study of Towertown, Chicago's notorious bohemian enclave.

8. On the social and economic restructuring of the postindustrial city, see Saskia Sassen, *The Global City: New York, London, Tokyo* (Princeton, NJ: Princeton University Press, 1991); Sharon Zukin, *Landscapes of Power: From Detroit to Disney World* (Berkeley: University of California Press, 1991); Sharon Zukin, *The Cultures of Cities* (Cambridge, MA: Blackwell, 1995); John Hannigan, *Fantasy City: Pleasure and Profit in the Postmodern Metropolis* (London: Routledge, 1998); Rebecca R. Sohmer and Robert E. Lang, "Downtown Rebound," Fannie Mae Foundation and Brookings Institution Center on Urban and Metropolitan Policy Census Note (May 2001); Richard Florida, *The Rise of the Creative Class* (New York: Basic, 2002); and Eugenie L. Birch, "Who Lives Downtown," The Brooking Institution, Living Cities Census Series (November 2005).

9. In addition, anonymity within contemporary cities may be further increasing as social networks continue to develop outside the context of physical urban space as a result of new telecommunications technologies such as e-mail and inexpensive long-distance telephone service; see Barry Wellman, "The Community Question: The Intimate Networks of East New Yorkers," *American Journal of Sociology* 84 (1979): 1201–31. Also, according to Robert D. Putnam, *Bowling Alone: The Collapse and Revival of American Community* (New York: Simon and Schuster,

2000), in recent decades Americans have experienced a decline in civic engagement, interpersonal cohesion, and social capital among friends and neighbors within multiple spheres of public life, including realms of entertainment and leisure. Of course, one could also argue that new media technologies from mobile phones to the Internet simultaneously *facilitate* the arrangement of face-to-face encounters in public among friends and acquaintances, as well as introduce strangers to one another who may eventually reconnect in the built urban environment; for instance, Internet dating services likely work to *reduce* the level of anonymity within cities and their downtown entertainment zones.

10. Birch, "Who Lives Downtown," 6, 13, 14; Joseph A. Slobodzian, "Center City Renaissance," *Philadelphia Inquirer*, December 27, 2005, A1; Center City District and Central Philadelphia Development Corporation, *State of Center City* (2006). On Edward G. Rendell's accomplishments as mayor of Philadelphia during the 1990s, see Buzz Bissinger, *A Prayer for the City* (New York: Random House, 1997).

11. John Mariani, "Is This a Great Restaurant Town or What?" *Philadelphia Magazine*, January 2002, 76; "Philly's Trendy Music Scene," CNN.com, April 7, 2005; Center City District, *State of Center City* (2006).

12. Center City District, *State of Center City* (2006), 24.

13. Sasha Issenberg, "Raising Philadelphia," *Philadelphia Magazine*, September 2003, 51; Center City District, *State of Center City* (2006); annual figures are from 2004. Also, in 2004 the city attracted over a quarter of a million visitors who attended a convention or trade show at the Pennsylvania Convention Center, and 427,000 international travelers, making the city a top-ten U.S. destination from western Europe.

14. John D. R. Platt, *The City Tavern*, Historic Resource Study, Independence National Historic Park, Philadelphia, 1973; Joseph Mitchell, "The Old House at Home," in *Up in the Old Hotel* (1940) (New York: Vintage, 1993); also see Ray Oldenburg, *The Great Good Place* (New York: Paragon, 1989). Although these establishments have been lionized for their welcoming atmosphere, it should be noted that this camaraderie was almost never extended to female patrons. On the growth of "urban tribes" among young people, see Ethan Watters, *Urban Tribes: A Generation Redefines Friendship, Family, and Commitment* (New York: Bloomsbury, 2003).

15. John Shiffman, "Pioneering Restaurateur Gets Jail for Tax Evasion," *Philadelphia Inquirer*, January 21, 2006, A01. In contemporary ethnographies of black urban neighborhoods, "hustling" refers more specifically to unreported and potentially illegal work performed among street dwellers laboring in the informal underground economies common to the inner city; see Loic Wacquant,

"Inside the Zone: The Social Art of the Hustler in the Black American Ghetto," *Theory, Culture & Society* 15 (1998): 1–36; Mary Pattillo-McCoy, *Black Picket Fences: Privilege and Peril among the Black Middle Class* (Chicago: University of Chicago Press, 1999), 60; Sudhir Alladi Venkatesh, *American Project: The Rise and Fall of a Modern Ghetto* (Cambridge, MA: Harvard University Press, 2000), 83–99; Sudhir Alladi Venkatesh, "'Doin' the Hustle': Constructing the Ethnographer in the American Ghetto," *Ethnography* 3 (2002): 91–111; Loic Wacquant, *Body and Soul: Notebooks of an Apprentice Boxer* (Oxford: Oxford University Press, 2004), 46; Sudhir Alladi Venkatesh, *Off the Books: The Underground Economy of the Urban Poor* (Cambridge, MA: Harvard University Press, 2006), 166–213.

16. Larry Platt, "The Reincarnation of Stephen Starr," *Philadelphia Magazine*, September 2000, 83.

17. http://www.starr-restaurant.com/. Of Starr's fifteen Philadelphia restaurants, twelve are still in business as of this writing.

18. On the mass media and other local boosters as active participants in urban growth machine politics, see John R. Logan and Harvey L. Molotch, *Urban Fortunes: The Political Economy of Place* (Berkeley: University of California Press, 1987).

19. David W. Maurer, *The Big Con: The Story of the Confidence Man* (1940) (New York: Anchor, 1999), 296. For this reason it is hardly surprising that, according to Edwin H. Sutherland, ed., *The Professional Thief* (Chicago: University of Chicago Press, 1937), 23, professional female thieves are often recruited from the ranks of restaurant servers, hotel employees, and sex workers. On deep acting, emotion work, and feminized labor in the service industries, see Arlie Russell Hochschild, *The Managed Heart: Commercialization of Human Feeling* (Berkeley: University of California Press, 1983).

20. Howard S. Becker, *Art Worlds* (Berkeley: University of California Press, 1982); Peter Bearman, *Doormen* (Chicago: University of Chicago Press, 2005).

21. Maurer, *The Big Con*, 47.

22. Gary Alan Fine, *Kitchens: The Culture of Restaurant Work* (Berkeley: University of California Press, 1996); on backstage kitchen work, also see Anthony Bourdain, *Kitchen Confidential: Adventures in the Culinary Underbelly* (New York: Ecco Press, 2000).

23. Personal communication with Kate Andrews, December 9, 2005. On the fictitious backgrounds that exotic dancers appropriate in their interactions with customers in order to generate "counterfeit intimacy," see Lisa Pasko, "Naked Power: The Practice of Stripping as a Confidence Game," *Sexualities* 5 (2002): 49–66.

24. Sutherland, *The Professional Thief*, 58n17.

25. Maurer, *The Big Con*, 33; Sutherland, *The Professional Thief*, 58n17.

26. Ben McGrath, "The Oops Con," *New Yorker*, May 15, 2006, 33–34, reports on a confidence game run in New York that has victimized a number of Columbia University students.

27. Erving Goffman, *The Presentation of Self in Everyday Life* (Garden City, NY: Anchor Books, 1959), 49.

28. This behavior is also displayed in Chicago blues and jazz clubs, which tourists often evaluate on the basis of their African American clientele; see David Grazian, *Blue Chicago: The Search for Authenticity in Urban Blues Clubs* (Chicago: University of Chicago Press, 2003).

29. As David Hummon argues in *Commonplaces: Community Ideology and Identity in American Culture* (Albany: State University of New York Press, 1990), urban dwellers frequently draw unfair distinctions between city and suburban residents; and Herbert J. Gans, "Urbanism and Suburbanism as Ways of Life: A Reevaluation of Definitions," in *Metropolis: Center and Symbol of Our Times*, ed. Philip Kasinitz (New York: New York University Press, 1995), observes that urban sociologists often make similarly defenseless claims.

30. "Table 11: Employed persons by detailed occupation, sex, race, and Hispanic or Latino ethnicity," *U.S. Bureau of Labor Statistics* (2004). Although women have long worked in bars as waitresses and barmaids, the role of the bartender has traditionally been considered masculine work: for instance, in 1940 women held only 2.5 percent of U.S. bartending jobs. In the late nineteenth and early twentieth century, many state governments outlawed hiring female workers in establishments where liquor was sold, out of fear of corrupting their virtuous morals. Arcane social conventions dictated that even professionalized women were incompetent at mixing spirits, physically unable to control drunken male patrons, and possessed temperaments ill-suited for bar work. After Prohibition, male-dominated unions prevented women from entering the profession out of fear they would compete for jobs at lower pay scales. Women were eventually able to take bartending jobs in greater numbers during the 1970s, due to the invalidation of exclusionary hiring laws through Title VII of the 1964 Civil Rights Act, the decline of bartending unions, and a loosening of social conventions regarding women and alcohol. Meanwhile, the feminization of the bartending profession was accelerated as men rapidly left the profession because of an earnings decline in real wages during the 1970s due to tendencies to hire less skilled nonunion labor and a move from wages to tips as the primary basis of bartender pay in the 1960s. See Linda A. Detman, "Women Behind Bars: The Feminization

of Bartending," in *Job Queues, Gender Queues: Explaining Women's Inroads into Male Occupations*, ed. Barbara F. Reskin and Patricia A. Roos (Philadelphia: Temple University Press, 1990); on the marginalization of women in public drinking establishments and private men's clubs since the 1880s, see E. Digby Baltzell, *Philadelphia Gentlemen: The Making of a National Upper Class* (1958) (New Brunswick, NJ: Transaction, 2002); Kathy Peiss, *Cheap Amusements: Working Women and Leisure in Turn-of-the-Century New York* (Philadelphia: Temple University Press, 1986); and Roy Rosenzweig, "The Rise of the Saloon," in *Rethinking Popular Culture: Contemporary Perspectives in Cultural Studies*, ed. Chandra Mukerji and Michael Schudson (Berkeley: University of California Press, 1991).

31. Andrew J. Cherlin, *Marriage, Divorce, Remarriage*, revised and enlarged ed. (Cambridge, MA: Harvard University Press, 1992); Catherine A. Fitch and Steven Ruggles, "Historical Trends in Marriage Formation: The United States 1850–1990," in *The Ties That Bind: Perspectives on Marriage and Cohabitation*, ed. Linda J. Waite et al. (New York: Aldine de Gruyter, 2000); Frank Furstenberg, "The Sociology of Adolescence and Youth in the 1990s: A Critical Commentary," *Journal of Marriage and the Family* 62 (2000): 896–910; Joshua R. Goldstein and Catherine T. Kenney, "Marriage Delayed or Marriage Forgone? New Cohort Forecasts of First Marriage for U.S. Women," *American Sociological Review* 66 (2001): 506–19. Significantly, two exceptions to the postponement of institutional markers of adulthood in recent years are reported increases in cohabitation among young people and earlier experiences of first sexual intercourse, two activities suggestive of lifestyle experimentation as well as age-based status; see Edward O. Laumann, John H. Gagnon, Robert T. Michael, and Stuart Michaels, *The Social Organization of Sexuality: Sexual Practices in the United States* (Chicago: University of Chicago Press, 1994), 324; and R. Kelly Raley, "Recent Trends and Differentials in Marriage and Cohabitation: The United States," in *The Ties That Bind*, ed. Waite et al.

32. Jeffrey Jensen Arnett, "Are College Students Adults? Their Conceptions of the Transition to Adulthood," *Journal of Adult Development* 1 (1994): 213–24; Jeffrey Jensen Arnett, "Emerging Adulthood: A Theory of Development from the Late Teens through the Twenties," *American Psychologist* 55 (2000): 469–80; Jeffrey Jensen Arnett and Susan Taber, "Adolescence Terminable and Interminable: When Does Adolescence End?" *Journal of Youth and Adolescence* 23 (1994): 517–37.

33. Frances Kobrin Goldscheider and Julie DaVanzo, "Semiautonomy and Leaving Home in Early Adulthood." *Social Forces* 65 (1986): 187–201; Michael J. Rosenfeld and Byung-Soo Kim, "The Independence of Young Adults and the Rise of Interracial and Same-Sex Unions," *American Sociological Review* 70 (2005): 541–62.

34. Stuart Hall and Tony Jefferson, eds., *Resistance Through Rituals: Youth Subcultures in Post-War Britain* (London: Routledge, 1975); Angela McRobbie and Jenny Garber, "Girls and Subcultures," in *Resistance Through Rituals*, ed. Hall and Jefferson; Paul E. Willis, *Profane Culture* (London: Routledge, 1978); Dick Hebdige, *Subculture: The Meaning of Style* (London: Routledge, 1979); Sarah Thornton, *Club Cultures: Music, Media and Subcultural Capital* (Hanover, NH: Wesleyan University Press, 1996); Paul Hodkinson, "Translocal Connections in the Goth Scene," in *Music Scenes: Local, Trans-Local, and Virtual*, ed. Andy Bennett and Richard A. Peterson (Nashville, TN: Vanderbilt University Press, 2004).

35. On the concept of the nocturnal self, see Grazian, *Blue Chicago*; also see Ben Malbon, *Clubbing: Dancing, Ecstasy and Vitality* (New York: Routledge, 1999); Wayne H. Brekhus, *Peacocks, Chameleons, Centaurs: Gay Suburbia and the Grammar of Social Identity* (Chicago: University of Chicago Press, 2003); and Richard Lloyd, *Neo-Bohemia: Art and Commerce in the Postindustrial City* (New York: Routledge, 2005); on the sidewalk life of the city, see William H. Whyte, *City: Rediscovering the Center* (New York: Doubleday, 1988); Elijah Anderson, *Streetwise: Race, Class, and Change in an Urban Community* (Chicago: University of Chicago Press, 1990); Elijah Anderson, *Code of the Street: Decency, Violence, and the Moral Life of the Inner City* (New York: Norton, 1999); and Mitchell Duneier, *Sidewalk* (New York: Farrar, Straus and Giroux, 1999).

36. Exceptional studies addressing this question include Malbon, *Clubbing*; and James Farrer, *Opening Up: Youth Sex Culture and Market Reform in Shanghai* (Chicago: University of Chicago Press, 2002).

37. http://www.newschannel5.tv/News/Other/5092/-Girls-Gone-Wild--producer-sentenced.

38. Venkatesh, "'Doin' the Hustle'"; David Grazian, "The Production of Popular Music as a Confidence Game: The Case of the Chicago Blues," *Qualitative Sociology* 27 (2004): 142.

39. David O. Sears, "College Sophomores in the Laboratory: Influences of a Narrow Data Base on Social Psychology's View of Human Nature," *Journal of Personality and Social Psychology* 51 (1986): 515–30.

CHAPTER 2

1. On the Nigerian e-mail scam, see Mitchell Zuckoff, "The Perfect Mark," *New Yorker*, May 15, 2006, 36–42. There is a rich scholarly and popular literature on the confidence game; see Herman Melville, *The Confidence-Man: His Masquerade*

(New York: Dix, Edwards, and Co., 1857); J. Frank Norfleet, *Norfleet: The Amazing Experiences of an Intrepid Texas Rancher with an International Swindling Ring*, rev. ed. (Sugar Land, TX: Imperial, 1927); Herbert Asbury, *Sucker's Progress: An Informal History of Gambling in America from the Colonies to Canfield* (New York: Dodd, Mead, and Co., 1938); David W. Maurer, *The Big Con: The Story of the Confidence Man* (1940) (New York: Anchor, 1999); Alexander Klein, ed., *Grand Deception: The World's Most Spectacular and Successful Hoaxes, Impostures, Ruses and Frauds* (Philadelphia: Lippincott, 1955); Johannes Dietrich Bergmann, "The Original Confidence Man," *American Quarterly* 21 (1969): 560–77; Susan Kuhlmann, *Knave, Fool, and Genius: The Confidence Man as He Appears in Nineteenth-Century American Fiction* (Chapel Hill: University of North Carolina Press, 1973); Jay Robert Nash, *Hustlers and Con Men: An Anecdotal History of the Confidence Man and His Games* (New York: M. Evans and Co., 1976); John G. Blair, *The Confidence Man in Modern Fiction: A Rogue's Gallery with Six Portraits* (New York: Barnes and Noble Books, 1979); Gary Lindberg, *The Confidence Man in American Literature* (New York: Oxford University Press, 1982); Richard Rayner, *Drake's Fortune: The Fabulous True Story of the World's Greatest Confidence Artist* (New York: Doubleday, 2002); Mitchell Zuckoff, *Ponzi's Scheme: The True Story of a Financial Legend* (New York: Random House, 2005); and Timothy J. Gilfoyle, *A Pickpocket's Tale: The Underworld of Nineteenth-Century New York* (New York: Norton, 2006); also see David Mamet, *House of Games* (New York: Grove, 1987), and *The Spanish Prisoner* (New York: Vintage, 1999).

2. Chicago school ethnographic accounts of various confidence games include Harvey Warren Zorbaugh, *The Gold Coast and the Slum: A Sociological Study of Chicago's Near North Side* (Chicago: University of Chicago Press, 1929); and Paul G. Cressey, *The Taxi-Dance Hall: A Sociological Study in Commercialized Recreation and City Life* (Chicago: University of Chicago Press, 1932). Later sociological work on the confidence game includes Edwin H. Sutherland, ed., *The Professional Thief* (Chicago: University of Chicago Press, 1937); Edwin M. Schur, "Sociological Analysis of Confidence Swindling," *Journal of Criminal Law, Criminology, and Political Science* 48 (1957): 296–304; and Ned Polsky, *Hustlers, Beats, and Others* (Garden City, NY: Anchor, 1967), all influenced by the Chicago tradition.

3. Erving Goffman, "On Cooling the Mark Out: Some Aspects of Adaptation to Failure," *Psychiatry* 15 (1952): 451–63; Erving Goffman, *The Presentation of Self in Everyday Life* (Garden City, NY: Anchor Books, 1959); W. I. Thomas and Dorothy Swaine Thomas, *The Child in America: Behavior Problems and Programs* (New York: Knopf, 1928); Polsky, *Hustlers, Beats, and Others*, 53n8. In addition to the work of Goffman and Polsky, other social research that explicitly relies on the metaphor

of the confidence game includes Abraham S. Blumberg, "The Practice of Law as a Confidence Game: Organizational Cooptation of a Profession," *Law & Society Review* 1 (1967): 15–40; Gerald D. Suttles, *The Man-Made City: The Land-Use Confidence Game in Chicago* (Chicago: University of Chicago Press, 1990); Richard A. Leo, "Miranda's Revenge: Police Interrogation as a Confidence Game," *Law & Society Review* 30 (1996): 259–88; Lisa Pasko, "Naked Power: The Practice of Stripping as a Confidence Game," *Sexualities* 5 (2002): 49–66; and David Grazian, "The Production of Popular Music as a Confidence Game: The Case of the Chicago Blues," *Qualitative Sociology* 27 (2004): 137–58. Other studies that employ the metaphor of the hustle in a more or less implicit manner include Everett C. Hughes, *Men and Their Work* (London: Free Press of Glencoe, 1958); Daniel J. Boorstein, *The Image: A Guide to Pseudo-Events in America* (New York: Vintage, 1961); Arlie Russell Hochschild, *The Managed Heart: Commercialization of Human Feeling* (Berkeley: University of California Press, 1983); Eric Klinenberg, *Heat Wave: A Social Autopsy of Disaster in Chicago* (Chicago: University of Chicago Press, 2002), 165–84; Jeffrey J. Sallaz, "The House Rules: Autonomy and Interests among Service Workers in the Contemporary Casino Industry," *Work and Occupations* 24 (2002): 394–427; and Peter Bearman, *Doormen* (Chicago: University of Chicago Press, 2005).

4. Goffman, *The Presentation of Self in Everyday Life.*

5. Maurer, *The Big Con.*

6. Jim Quinn, "The Making of Morimoto," *Philadelphia Magazine,* January 2002, 142; David Grazian, "I'd Rather Be in Philadelphia," *Contexts* 4 (2005): 71.

7. Larry Platt, "The Reincarnation of Stephen Starr," *Philadelphia Magazine,* September 2000, 82, 83.

8. For more on Dynamic Imagineering's role in designing Cuba Libre, see "A Little Havana, Right Here in Old Philadelphia," *Philadelphia Business Journal,* November 10, 2000.

9. In addition to its theme parks, the Disney Corporation family includes ABC, ESPN, Disney Channel, Touchstone Pictures, Miramax Films, and New York's New Amsterdam Theatre. On the impact of the Disney Corporation on the entertainment landscapes of world-class cities, see Sharon Zukin, *Landscapes of Power: From Detroit to Disney World* (Berkeley: University of California Press, 1991); Sharon Zukin, *The Cultures of Cities* (Cambridge, MA: Blackwell, 1995); Michael Sorkin, ed., *Variations on a Theme Park: The New American City and the End of Public Space* (New York: Hill and Wang, 1992); John Hannigan, *Fantasy City: Pleasure and Profit in the Postmodern Metropolis* (London: Routledge, 1998); Douglas Frantz and Catherine Collins, *Celebration USA: Living in Disney's Brave New Town* (New York:

Henry Holt, 1999); Naomi Klein, *No Logo: Taking Aim at the Brand Bullies* (New York: Picador, 1999); and David Grazian, *Blue Chicago: The Search for Authenticity in Urban Blues Clubs* (Chicago: University of Chicago Press, 2003).

10. Craig LaBan, "Both Steak and Setting Are Prime," *Philadelphia Inquirer*, February 13, 2005.

11. Blake also credits Mahdavi's European taste and upbringing for the unisex design of Barclay Prime's restroom.

12. Quoted in Becca Aronson, field notes, University of Pennsylvania, January 2005.

13. Coco Henson Scales, "The Hostess Diaries: My Year at a Hot Spot," *New York Times*, July 11, 2004, sec. 9, p. 6.

14. It is perhaps unfair that I have singled out Alma de Cuba, Bleu Martini, Pod, and Continental, since literally hundreds of restaurants in Philadelphia have received similar health code violations in recent years; for instance, see http://www.phila.gov/health/units/ehs/Restaurant_Inspectio.html; also see Michael Klein, Tom Avril, and Alletta Emeno, "City Makes Restaurant Inspections Data Public," *Philadelphia Inquirer*, May 20, 2006.

15. Note how easily Blake shifts among theatrical ("stage," "play") and cinematic ("screenplay," "photographers") metaphors. On the contemporary use of film discourse to describe everyday experiences, see Neal Gabler, *Life the Movie: How Entertainment Conquered Reality* (New York: Vintage, 2000).

16. Pennsylvania has some of the most stringent liquor laws in the country, and as a result restaurants often pay retail instead of discount prices for wine. Thus, bottles of wine tend to be even more expensive in Philadelphia restaurants than in other U.S. cities. On the impact of Pennsylvania's liquor laws on Philadelphia's nightlife economy, see Angela Valdez, "A Pour Solution," *Philadelphia Weekly*, October 6, 2004, 20; Kristen Henri, "Consuming Crisis," *Philadelphia Weekly*, December 22, 2005; and Bob Finkelstein, "Licenses and Rejections," *Philadelphia City Paper*, January 12, 2006, 9.

17. Leo, "Miranda's Revenge," 273.

18. Sutherland, *The Professional Thief*, 43.

19. Pasko, "Naked Power," 58. Similarly, Malcolm Gladwell, *Blink: The Power of Thinking without Thinking* (New York: Little, Brown, 2005), explains how experts in fields as diverse as psychology and automobile sales rely on "thin slicing," or the art of discovering patterns based on very narrow slices of experience, when evaluating human encounters and social situations.

20. On the dynamics of pricing and profit-making in restaurants, see Gary Alan Fine, *Kitchens: The Culture of Restaurant Work* (Berkeley: University of California Press, 1996).

21. Leo, "Miranda's Revenge," 265.

22. John Nielsen, "Even Those Who Serve Must Audition for the Part," *New York Times*, March 2, 1988, C1; also see Zukin, *Landscapes of Power*; Zukin, *The Cultures of Cities*; and Richard Lloyd, *Neo-Bohemia: Art and Commerce in the Postindustrial City* (New York: Routledge, 2005).

23. Of course, some motion picture actors (John Wayne, Woody Allen) have historically performed screen roles that echo their publicity-enhanced celebrity images, if not their actualized selves; see Joshua Gamson, *Claims to Fame: Celebrity in Contemporary America* (Berkeley: University of California Press, 1994).

24. Lloyd, *Neo-Bohemia*; on the concept of nocturnal capital, see Grazian, *Blue Chicago*, 67–68.

25. It should be noted that rebelliousness in hair, cosmetics, and other affectations of bohemian style can easily fall victim to its own norms of conformity; see Keith White, "Burn Down the House of Commons in Your Brand New Shoes," in *Commodify Your Dissent: Salvos from "The Baffler,"* ed. Thomas Frank and Matt Weiland (New York: Norton, 1997); and Luc Sante, "Be Different! (Like Everyone Else!)," *New York Times Magazine*, October 17, 1999.

26. Robin Leidner, *Fast Food, Fast Talk: Service Work and the Routinization of Everyday Life* (Berkeley: University of California Press, 1993).

27. Anne Allison, *Nightwork: Sexuality, Pleasure, and Corporate Masculinity in a Tokyo Hostess Club* (Chicago: University of Chicago Press, 1994); Grazian, *Blue Chicago*; Lloyd, *Neo-Bohemia*.

28. On the use of "flair" and other assorted uniform accessories worn by employees at chain restaurants (and routinely mocked in popular culture as well as within the industry itself), see "A Side of Décor: T.G.I. Friday's and Ruby Tuesday Cooked Up New Looks for Mass Consumption," *Washington Post*, December 8, 2005, C1.

29. Negotiating large crowds while serving drinks onto sunken tabletops represents a considerable physical challenge faced by all female cocktail waitresses required to wear tight, constraining attire. In her exposé on working at New York's Playboy Club, Gloria Steinem remarks on the painful difficulties of performing the "Bunny dip," "a back-leaning way of placing drinks on low tables without falling out of the costumes." See Gloria Steinem, "I Was a Playboy Bunny," in *Outrageous Acts and Everyday Rebellions* (New York: Plume, 1983), 46.

30. Servers point out that not all "people enjoy being recognized" while dining out, such as gentlemen who escort multiple dates to the same restaurant on different nights of the week. According to Misty, "I should let you lead as to whether or not I recognize you. Because this guy that comes in three times a week might tell the girl that he's with that this is his first time, and he doesn't want you going, 'Hey, Mr. Smith, are you going to have the fish like you always do?' You know what I'm saying? There's a lot riding on whether or not these people are going to come back, and you can sort of see—like I've had guys like slip me a kickback because I acted like I never saw them before." Rachel Sherman, *Class Acts: Service and Inequality in Luxury Hotels* (Berkeley: University of California Press, 2007), 28–29, similarly observes that hotel guests often prefer anonymity over the performance of familiarity.

31. On the deployment of "secret shoppers," see Sara Steindorf, "Shoppers Spy on Those Who Serve," *Christian Science Monitor*, May 28, 2002. On Jeremy Bentham's panoptic prison, see Michel Foucault, *Discipline and Punish: The Birth of the Prison*, trans. Alan Sheridan (New York: Vintage, 1979).

32. On the emotion work required of female service workers in domains of commercialized leisure, see James P. Spradley and Brenda J. Mann, *The Cocktail Waitress: Woman's Work in a Man's World* (New York: John Wiley, 1975); Steinem, "I Was a Playboy Bunny"; and Hochschild, *The Managed Heart*. On the social uses of emotion work more generally, also see Leidner, *Fast Food, Fast Talk*; and Laura Grindstaff, *The Money Shot: Trash, Class, and the Making of TV Talk Shows* (Chicago: University of Chicago Press, 2002).

33. Hochschild, *The Managed Heart*.

34. The contrived look of Philadelphia's taverns and corner dives parallels the staged authenticity of Chicago blues and jazz bars; see Grazian, *Blue Chicago*.

35. Denny Lee, "Remember, You Didn't Read about It Here," *New York Times*, July 31, 2005.

36. Maureen Tkacik, "Lord of the Barflies," *Philadelphia Magazine*, April 2005, 92.

CHAPTER 3

1. Robert H. Frank and Philip C. Cook, *The Winner-Take-All Society: Why the Few at the Top Get So Much More Than the Rest of Us* (New York: Penguin, 1995), 27.

2. Thomas Frank, *The Conquest of Cool: Business Culture, Counterculture, and the Rise of Hip Consumerism* (Chicago: University of Chicago Press, 1997).

3. Al Ries and Laura Ries, *The Fall of Advertising and the Rise of PR* (New York: Harper Business, 2002), 90, 99.

4. Walter Lippman, *Public Opinion* (New York: Harcourt, Brace, and Co., 1922), 194.

5. Edward L. Bernays, *Crystallizing Public Opinion*, (New York: Liveright, 1923), 195, 197.

6. Daniel J. Boorstin, *The Image: A Guide to Pseudo-Events in America* (New York: Vintage, 1961).

7. Naomi Klein, *No Logo: Taking Aim at the Brand Bullies* (New York: Picador, 1999); "Global Brands," *Business Week*, August 2005.

8. U.S. Census Bureau, *Census 2000*.

9. http://www.centercityphila.org/goingout/cc_nightlife.aspx; accessed December 27, 2006.

10. http://www.gophila.com/C/Things_to_Do/211/Itineraries_and_Tours/428/Itineraries/429/I/Real_Young,_Real_Fun,_Real_Philly_Itinerary/9.html; accessed December 27, 2006.

11. To quote the *USA Today* article: "'I felt it was appropriate to accustom our customers to the euro, and to accommodate our international customers,' says co-owner Barry Gutin. 'Our regular clientele often travels abroad and might bring back euros . . . so why not spend them here?'" Jerry Shriver, "Euro Money Is Good Here," *USA Today*, February 1, 2002.

12. Michael Klein, "$100 Cheesesteak May Lose Foie Gras After Some Beefs," *Philadelphia Inquirer*, October 31, 2004, B2.

13. Michael Klein, "A Phila. Redo Is on a Roll," *Philadelphia Inquirer*, October 12, 2004, A1.

14. The atomizer has a retail value of $750, and the port wine is priced at $2,500 a bottle. In addition to placing the *Inquirer* article, Lake was also able to secure coverage in *U.S. News & World Report* and *South Jersey Life Style* magazine. See Michael Klein, "A Casino Dessert to Break the Bank," *Philadelphia Inquirer*, April 24, 2005, B1, B3; Carl Harrington, "Just Desserts," *U.S. News & World Report*, June 6, 2005; and Adrienne Sorisi, "Indulgences," *South Jersey Life Style*, Fall 2005, 9.

15. David Bernstein, "Hey, Bartender, Can You Break $1,000?" *New York Times*, December 18, 2005.

16. Paul M. Hirsch, "Processing Fads and Fashions: An Organization-Set Analysis of Cultural Industry Systems," *American Journal of Sociology* 77 (1972): 639–59.

17. See Dana Pennett O'Neil, "Could Operation Benefit McNabb?" *Philadelphia Daily News*, October 19, 2005, 74; and Jere Longman, *If Football's a Religion,*

Why Don't We Have a Prayer?: Philadelphia, Its Faithful, and the Eternal Quest for Sports Salvation (New York: HarperCollins, 2005).

18. On the mass media as an active participant in urban growth machine politics, see John R. Logan and Harvey L. Molotch, *Urban Fortunes: The Political Economy of Place* (Berkeley: University of California Press, 1987).

19. James Zeleniak, "Philadelphia After Dark," *Where*, May 2005, 14.

20. Marc Kravitz, "Craig LaBan, Local Man of Mystery," *Philadelphia City Paper*, August 1–7, 2002.

21. Barry Glassner, *The Gospel of Food: Everything You Think You Know about Food Is Wrong* (New York: Ecco, 2007).

22. Kravitz, "Craig LaBan."

23. Robert K. Merton, "The Self-Fulfilling Prophecy," in *On Social Structure and Science*, ed. and trans. Piotr Sztompka (Chicago: University of Chicago Press, 1996), 185. The observation that pseudo-events operate as self-fulfilling prophecies belongs to Boorstin, *The Image*, 12.

24. Boorstin, *The Image*, 10.

25. Malcolm Gladwell, *The Tipping Point: How Little Things Can Make a Big Difference* (Boston: Back Bay, 2002); Rachel Donadio, "The Gladwell Effect," *New York Times*, February 5, 2006.

26. Mark S. Granovetter, "The Strength of Weak Ties," *American Journal of Sociology* 78 (1973): 1360–80; Mark S. Granovetter, *Getting a Job: A Study of Contacts and Careers* (Cambridge, MA: Harvard University Press, 1974); Gladwell, *The Tipping Point*; Ronald S. Burt, "Structural Holes and Good Ideas," *American Journal of Sociology* 110 (2004): 349–99. On the popularity of word-of-mouth promotion and other nontraditional tactics used in the marketing industry, see Julie Bosman, "Advertising Is Obsolete. Everyone Says So," *New York Times*, January 23, 2006.

27. Pelaccio quoted in Florence Fabricant, "With 420 New Seats to Fill, Restaurateur Banks on Buzz," *New York Times*, January 25, 2006.

28. In addition to her *Philadelphia Weekly* gossip column "Pressler's Miscellany," Pressler may be locally best known for a *New York Times* article she penned on how Philadelphia has slowly become New York City's "sixth borough"; see Jessica Pressler, "Philadelphia Story: The Next Borough," *New York Times*, August 14, 2005: Sunday "Styles," 1.

29. Jessica Pressler, "Girl Power," *Philadelphia Magazine*, June 2005, 106.

30. Pressler's reasoning has been echoed by experts in the marketing industry as well. According to Jamie Tedford, senior vice president for marketing and media innovation at Boston's Arnold Worldwide, "The search for the cool kids,

the kind of cool hunting that we all used to be a part of—it's just not that cool anymore"; as quoted in Bosman, "Advertising Is Obsolete." While the publicity-generating open-bar party may be losing its potency as a marketing tool, there is also evidence that the gift-bag industry may be diminishing in its effectiveness as well; see Hilary de Vries, "Bag It," *New York Times*, January 14, 2006.

31. Fabricant, "With 420 New Seats to Fill."

32. As David Hummon argues in *Commonplaces: Community Ideology and Identity in American Culture* (Albany: State University of New York Press, 1990), urban dwellers frequently levy unjustified attacks against suburbanites. As Jason, the bartender introduced in the last chapter, points out, suburbanites do not necessarily represent a specific set of *identities*, but *orientations* toward the nightlife of the city.

> People who don't live in a city are looking for the big night out. It's like, if you've got to travel for forty-five minutes to get somewhere, it better be worth the forty-five-minute drive, whereas if you live in a city you are usually not looking for the big destination. . . . You live around the corner and you are going out grabbing a drink somewhere. It's much more low-key. That's the big difference. . . . It's the tourist mentality. It's like, if you go to Jamaica, you are going to go and do the tourist thing, because you don't know. You are not going to go explore the city for real; you are going to go to the destinations. . . . I think just the expectation is different.

33. David W. Maurer, *The Big Con: The Story of the Confidence Man* (1940) (New York: Anchor, 1999), 47.

34. James P. Spradley and Brenda J. Mann, *The Cocktail Waitress: Woman's Work in a Man's World* (New York: John Wiley, 1975); Gloria Steinem, "I Was a Playboy Bunny," in *Outrageous Acts and Everyday Rebellions* (New York: Plume, 1983); David Grazian, *Blue Chicago: The Search for Authenticity in Urban Blues Clubs* (Chicago: University of Chicago Press, 2003), 104. On emotional labor, see Arlie Russell Hochschild, *The Managed Heart: Commercialization of Human Feeling* (Berkeley: University of California Press, 1983); and Robin Leidner, *Fast Food, Fast Talk: Service Work and the Routinization of Everyday Life* (Berkeley: University of California Press, 1993).

35. On the commerce of urban strip clubs, see Elizabeth Bernstein, "The Meaning of the Purchase: Desire, Demand and the Commerce of Sex," *Ethnography* 2 (2001): 389–420.

36. According to sociologist Richard Lloyd, *Neo-Bohemia: Art and Commerce in the Postindustrial City* (New York: Routledge, 2005), urban bartenders and servers

enjoy a personal familiarity with the larger network of nightlife service workers in the city. On the concept of "nocturnal capital," see Grazian, Blue Chicago, 21.

37. Danielle Perlman, "'Popular' Students Hired to Promote Local Bar," Daily Pennsylvanian, October 11, 2005, 5.

38. Pressler, "Girl Power," 106.

CHAPTER 4

1. Simone de Beauvoir, The Second Sex, ed. and trans. H. M. Parshley (1952) (New York: Vintage, 1989), 532; Erving Goffman, The Presentation of Self in Everyday Life (Garden City, NY: Anchor Books, 1959), 57–58; Candace West and Don H. Zimmerman, "Doing Gender," Gender & Society 1 (1987): 125–51.

2. While excerpts taken from my student-written accounts have been mildly edited for spelling, punctuation, and (in extreme cases only) grammar to ensure readability, I have otherwise attempted to present them as unadulterated as possible. All students' names have been changed to protect their identity.

3. On the androgynous quality of much of contemporary women's fashion, see Fred Davis, Fashion, Culture, and Identity (Chicago: University of Chicago Press, 1992).

4. Premium designer jeans have spiked up dramatically in popularity and price since the late 1990s; see Guy Trebay, "Who Pays $600 for Jeans?" New York Times, April 21, 2005.

5. Gloria Steinem, "I Was a Playboy Bunny," in Outrageous Acts and Everyday Rebellions (New York: Plume, 1983), 37, 68.

6. Housewife Marge Simpson wore a pair of Blahnik's mules in a 1991 episode of The Simpsons.

7. Erving Goffman, "Symbols of Class Status," British Journal of Sociology 2 (1951): 294–304; Pierre Bourdieu, Distinction: A Social Critique of the Judgment of Taste, trans. Richard Nice (Cambridge, MA: Harvard University Press, 1984); Candace West and Sarah Fenstermaker, "Doing Difference," Gender & Society 9 (1995): 8–37.

8. Patricia Highsmith, The Talented Mr. Ripley (1955) (New York: Everyman's Library, 1999). Of course, the reverse is also true insofar as affluent youth sometimes attempt to present themselves in working-class attire and demeanor as a means of performing authenticity, subcultural style, or proletarian chic; see Ned Polsky, Hustlers, Beats, and Others (Garden City, NY: Anchor, 1969); Dick Hebdige, Subculture: The Meaning of Style (London: Routledge, 1979); and David Grazian,

Blue Chicago: The Search for Authenticity in Urban Blues Clubs (Chicago: University of Chicago Press, 2003).

9. As black scholars argue, straightened hair and other European hair textures and styles conform to dominant conventions of high-status feminine beauty, which may explain why hair straightening represents such a popular strategy among young women (both black *and* white) in their nightlife preparations. On the racial politics surrounding women's hair, see Kathy Russel, Midge Wilson, and Ronald Hall, *The Color Complex: The Politics of Skin Color among African Americans* (New York: Anchor, 1993), 81–93; Kobena Mercer, "Black Hair/Style Politics," in *The Subcultures Reader*, ed. Ken Gelder and Sarah Thornton (London: Routledge, 1997), 420–35; Patricia Hill Collins, *Black Feminist Thought: Knowledge, Consciousness, and the Politics of Empowerment*, 2nd ed. (New York: Routledge, 2000), 89; and Ayana D. Byrd and Lori L. Tharps, *Hair Story: Untangling the Roots of Black Hair in America* (New York: St. Martin's Press, 2001).

10. Lauren Weisberger, *The Devil Wears Prada* (New York: Broadway Books, 2003); Plum Sykes, *Bergdorf Blondes* (New York: Hyperion, 2004). On the iconic representations of contemporary feminine fashion displayed in television programs such as *Sex and the City* and *Ally McBeal*, see Maureen Dowd, *Are Men Necessary?: When Sexes Collide* (New York: Putnam, 2005).

11. Gary Alan Fine, "Adolescence as Cultural Toolkit: High School Debate and the Repertoires of Childhood and Adulthood," *Sociological Quarterly* 45 (2004): 1–20.

12. According to the American Society of Plastic Surgeons, American doctors performed 10.2 million cosmetic plastic surgery procedures in 2005; breast augmentation and nose reshaping surgeries were included among the top five procedures performed, along with liposuction, tummy tuck, and eyelid surgery.

13. Despite university policy and the laws of Pennsylvania, many of my undergraduates under the age of twenty-one used fake IDs to gain access to bars and nightclubs in the city, and consequently drank alcohol illegally while conducting the nightlife participation required by the assignment for my course (see appendix). While I rely on their reports in the book, please note that I did not condone such behavior, and in subsequent semesters underage students have been explicitly advised by me not to consume alcohol for purposes of the assignment, while students twenty-one and older have been advised not to drink to excess.

14. Laura Grindstaff, *The Money Shot: Trash, Class, and the Making of TV Talk Shows* (Chicago: University of Chicago Press, 2002), explores how these class-based stereotypes are reproduced through popular culture.

15. Perhaps unsurprisingly, these represent high-end grooming products; according to 2006 figures, most varieties of Creed men's cologne cost $90 an ounce.

16. On the uniform among undergraduate students at elite American colleges, see Paul Fussell, "Uniformity in American Higher Learning," in *Uniforms: Why We Are What We Wear* (Boston: Houghton Mifflin, 2002), 136–39.

17. Of course, this so-called "feminized" behavior has long been associated with masculinity for centuries, and only in the modern period have women (and gay men) taken over this role in Western culture.

18. In the misogynist world of professional baseball, a "slump-buster" refers to an undesirable woman with whom a ball player superstitiously has sex in order to break a batting slump or losing streak; see Jose Canseco, *Juiced: Wild Times, Rampant 'Roids, Smash Hits, and How Baseball Got Big* (New York: Regan Books, 2005), 95–96.

19. Alexa Hackbarth, "Vanity, Thy Name Is Metrosexual: D.C.'s Dating Scene Gets a Lot Prettier," *Washington Post*, November 17, 2003, C10. The term is problematic insofar as it solidifies a monolithic and essentialist vision of what both homosexual *and* heterosexual men ought to be like, yet correctly emphasizes the contemporary blurring of fashion boundaries between affluent gay and straight men; see David Colman, "Gay or Straight? Hard to Tell," *New York Times*, June 19, 2005.

20. "Hooking up" is an ambiguous term referring to a range of possible sexual encounters (including kissing, genital stimulation, oral sex, and vaginal or anal intercourse) that take place on a casual basis among participants who may (or may not necessarily) be involved in a traditional romantic relationship. On the sexual rituals surrounding "hooking up" among college students, see Kathleen A. Bogle, *From Dating to Hooking Up: The Emergence of a New Sexual Script* (Ph. D. diss., University of Delaware, 2004); Paula England and Reuben J. Thomas, "The Decline of the Date and the Rise of the College Hook Up," in *Families in Transition*, 14th ed., ed. Arlene S. Skolnick and Jerome H. Skolnick (Boston: Allyn and Bacon, 2006). In his ethnographic work on inner-city neighborhoods, Elijah Anderson, in "Sex Codes and Family Life among Poor Inner-City Youths," *Annals of the American Academy of Political and Social Science* 501 (1989): 59–78; *Streetwise: Race, Class, and Change in an Urban Community* (Chicago: University of Chicago Press, 1990); and *Code of the Street: Decency, Violence, and the Moral Life of the Inner City* (New York: Norton, 1999), documents how sex codes among youth evolve in a context of peer pressure in which young black males "run their game" by women

in the pursuit of in-group status, a finding that can be generalized to explain the sexual behavior of other youth populations as well.

21. Some gay men associate their elaborate preparations with femininity (and thus stigmatized) as well. According to Landon, a twenty-two-year-old senior, "Gay preparation can be as bad as a sorority girl sometimes. Yeesh."

22. Marcella Bombardieri, "Colleges Crack Down on Preparty Drinking: Schools Target Underage Binging," *Boston Globe*, April 9, 2006.

23. In his preparations for the pregame, Edward expresses his anxieties over making an illegal alcohol purchase as a twenty-year-old:

> The first thing we did was go to Campus Pizza to buy some beer. Granted, neither of us are twenty-one. On our walk over, we played "odds-evens" (each person puts out either one or two fingers: if the total is what you called, odds or evens, you lose) to see who would have to risk their fake ID to buy the beer. I lost, so I had to buy the beer. The clerk sold me the beer, but told me he would never sell to me again with the ID I used. He said this partially because it was not me on the ID, and partially because it had expired.

24. The pregaming ritual mimics similar activities associated with adult-oriented socializing, including professional football game tailgate parties and pre-theater cocktail parties.

25. During the 2000–01 academic year, the University of Pennsylvania's drinking rate—as measured by the proportion of students who reported imbibing at least four (for women) or five (for men) alcoholic drinks on a single occasion at least once in the two weeks prior to the study—was 49 percent, and pregaming rituals such as the Power Hour are inevitably a likely contributor. See "Data Review—Undergraduate Alcohol and Other Drug Use at Penn," Office of Health Education, University of Pennsylvania; http://www.vpul.upenn.edu/alcohol.

26. In these kinds of status-challenging moments, affluent young men sometimes resort to unlawful sidewalk behaviors such as urinating in public. As Edward confesses:

> First we had to find a place to pee. We obviously were not welcome in the club to use their bathroom. There was even a security standing guard in the parking lot. Jordan showed me a brilliant maneuver (or at least I thought so). Stand by a bush with a cell phone by your ear as you go. This makes you completely incognito to any security because they think you're just making a call.

The propensity for this type of unapologetic antisocial behavior among adolescent men and young adults likely contributes to the current moral outrage and spirited public scorn against underage binge drinking in the United States. Still, the fact that affluent young men regularly urinate in public while intoxicated, while homeless men face police harassment and the possibility of arrest for committing the same misdemeanor, speaks to society's double standard concerning the treatment of the poor versus their well-off counterparts in the city at night. On the similar propensities for homeless black men and wealthier whites to urinate in public (while facing radically different consequences for such behavior), see Mitchell Duneier, *Sidewalk* (New York: Farrar, Straus and Giroux, 1999), 186.

27. Richard A. Leo, "Miranda's Revenge: Police Interrogation as a Confidence Game," *Law & Society Review* 30 (1996): 271.

28. For these and other relevant data on student drinking, see Office of Health Education, University of Pennsylvania; http://www.vpul.upenn.edu/alcohol.

29. Also see Kristen Henri, "Penn in the Neck," *Philadelphia Weekly*, May 10, 2006, 55.

30. According to linguistics professor Deborah Tannen, *You Just Don't Understand: Women and Men in Conversation* (New York: William Morrow, 1990), 24–25, social norms of communication among men dictate that even everyday interactions ought to be understood as contests of one-upmanship, as "negotiations in which people try to achieve and maintain the upper hand if they can."

31. In his essay "Where the Action Is," Erving Goffman, *Interaction Ritual: Essays on Face-to-Face Interaction* (New York: Pantheon, 1967), examines a range of risk-taking activities, including gambling, stickups, and surfing.

32. Kathryn Graham, Linda La Rocque, Rhoda Yetman, T. James Ross, and Enrico Guistra, "Aggression and Barroom Environments," *Journal of Studies on Alcohol* 41 (1980): 277–92; Kathryn Graham and Ross Homel, "Creating Safer Bars," in *Alcohol: Minimising the Harm*, ed. Martin Plant, Eric Single and Tim Stockwell (London: Free Association Books, 1997); Brian M. Quigley, Kenneth E. Leonard, and Lorraine Collins, "Characteristics of Violent Bars and Bar Patrons," *Journal of Studies on Alcohol* 64 (2003): 765–72. Rather than assume that the presence of bouncers serves as a *cause* of violent barroom behavior, it could very easily be the case that venues known for violent activity simply tend to hire more bouncers due to security concerns.

33. Randall Collins, *Violent Interaction: A Microsociological Theory* (Princeton, NJ: Princeton University Press, 2007); Graham et al., "Aggression and Barroom Environments."

34. Kathryn Graham and Samantha Wells, "Aggression among Young Adults in the Social Context of the Bar," *Addiction Research and Theory* 9 (2001): 204.

35. Jack Katz, *Seductions of Crime: Moral and Sensual Attractions in Doing Evil* (New York, Basic Books, 1988); Anderson, *Code of the Street*; Curtis Jackson-Jacobs, "Taking a Beating: The Narrative Gratifications of Fighting as an Underdog," in *Cultural Criminology Unleashed*, ed. K. J. Hayward, Jeff Ferell, Wayne Morrison, and Mike Presdee (London: Glasshouse Press, 2004).

36. Graham and Wells, "Aggression among Young Adults," 201.

37. Guenter Hitsch, Ali Hortacsu, and Dan Ariely, "What Makes You Click? An Empirical Analysis of Online Dating," unpublished ms., University of California, Santa Cruz, 2004, 9, 10; Jennifer Egan, "Love in the Time of No Time," *New York Times Magazine*, November 23, 2003.

38. Erving Goffman, "The Arrangement Between the Sexes," *Theory and Society* 4 (1977): 301–31. As suggested by my use of non-gender-specific language here, I extend Goffman's discussion of instigated courtship rituals to apply to both men *and* women of heterosexual *and* homosexual persuasions, whereas Goffman's somewhat dated article emphasizes public interactions initiated by straight men.

CHAPTER 5

1. Unlike normative occupational settings where formal guidelines and official workplace norms (at least theoretically) censure sexually suggestive talk and behavior, restaurants, bars, and other nightlife establishments frequently hire both female and male employees on the basis of their sensual allure and tolerate amorous relations among staff; see James P. Spradley and Brenda J. Mann, *The Cocktail Waitress: Woman's Work in a Man's World* (New York: John Wiley, 1975); Gloria Steinem, "I Was a Playboy Bunny," in *Outrageous Acts and Everyday Rebellions* (New York: Plume, 1983); Anne Allison, *Nightwork: Sexuality, Pleasure, and Corporate Masculinity in a Tokyo Hostess Club* (Chicago: University of Chicago Press, 1994); Patti A. Giuffre and Christine L. Williams, "Boundary Lines: Labeling Sexual Harassment in Restaurants," *Gender & Society* 8 (1994): 378–401; and Richard Lloyd, *Neo-Bohemia: Art and Commerce in the Postindustrial City* (New York: Routledge, 2005). On urban nightclubs as "direct sexual marketplaces," see Edward O. Laumann, Stephen Ellingson, Jenna Mahay, Anthony Paik, and Yoosik Youm, eds., *The Sexual Organization of the City* (Chicago: University of Chicago Press, 2004).

2. Studies of sex partnering and mate selection in cities include Laumann et al., *The Sexual Organization of the City.*

3. Erving Goffman, *The Presentation of Self in Everyday Life* (Garden City, NY: Anchor Books, 1959); Erving Goffman, "The Arrangement Between the Sexes," *Theory and Society* 4 (1977): 301–31; Candace West and Don H. Zimmerman, "Doing Gender," *Gender & Society* 1 (1987): 125–51.

4. Marc Mishkind, Judith Rodin, Lisa R. Silberstein, and Ruth H. Striegel-Moore, "The Embodiment of Masculinity," *American Behavioral Scientist* 29 (1986): 545–62; Mike Donaldson, "What Is Hegemonic Masculinity?" *Theory and Society* 22 (1993): 643–57; Sharon R. Bird, "Welcome to the Men's Club: Homosociality and the Maintenance of Hegemonic Masculinity," *Gender & Society* 10 (1996): 120–32; Michael A. Messner, *Taking the Field: Women, Men, and Sports* (Minneapolis: University of Minnesota Press, 2002).

5. Wendy Chapkis, *Beauty Secrets: Women and the Politics of Appearance* (Boston: South End, 1986); R. W. Connell, *Gender and Power: Society, the Person, and Sexual Politics* (Stanford, CA: Stanford University Press, 1987); R. W. Connell, "A Very Straight Gay: Masculinity, Homosexual Experience, and the Dynamics of Gender," *American Sociological Review* 57 (1992): 735–51; R. W. Connell, "The Big Picture: Masculinities in Recent World History," *Theory and Society* 22 (1993): 597–623; R. W. Connell, *Masculinities* (Berkeley: University of California Press, 1995); Donaldson, "What Is Hegemonic Masculinity?"; Jocelyn A. Hollander, "Resisting Vulnerability: The Social Reconstruction of Gender in Interaction," *Social Problems* 49 (2002): 474–96; R. W. Connell and James W. Messerschmidt, "Hegemonic Masculinity: Rethinking the Concept," *Gender & Society* 19 (2005): 829–59.

6. West and Zimmerman, "Doing Gender"; Connell, *Masculinities*, 79.

7. Mishkind et al., "The Embodiment of Masculinity"; Jeffrey Jensen Arnett, "Are College Students Adults? Their Conceptions of the Transition to Adulthood," *Journal of Adult Development* 1 (1994): 213–24; Jeffrey Jensen Arnett, "Young People's Conceptions of the Transition to Adulthood," *Youth and Society* 29 (1997): 3–23; Jeffrey Jensen Arnett, "Emerging Adulthood: A Theory of Development from the Late Teens through the Twenties," *American Psychologist* 55 (2000): 469–80.

8. Robert T. Michael, John H. Gagnon, Edward O. Laumann, and Gina Kolata, *Sex in America: A Definitive Survey* (New York: Warner Books, 1995), 72; Laumann et al., *The Sexual Organization of the City.*

9. Messner, *Taking the Field*, draws on sports metaphors in this manner.

10. Edward O. Laumann, John H. Gagnon, Robert T. Michael, and Stuart Michaels, *The Social Organization of Sexuality: Sexual Practices in the United States*

(Chicago: University of Chicago Press, 1994), 239n12. Of course, as the authors themselves point out, the gender discrepancy here may reflect reporting biases, with men overreporting and women underreporting their sexual behavior. For a critique of the National Health and Social Life Survey and the reliability of sex research more generally, see Richard C. Lewontin, "Sex, Lies, and Social Science," *New York Review of Books*, April 20, 1995.

11. Laumann et al., *The Social Organization of Sexuality*, 163–65. This finding conforms to similar empirical results derived from psychology experiments that found that men share an exponentially greater proclivity for seeking out and consenting to sexual relations with unknown partners than women; see David M. Buss and David P. Schmitt, "Sexual Strategies Theory: An Evolutionary Perspective on Human Mating," *Psychological Review* 100 (1993): 227.

12. Paula England and Reuben J. Thomas, "The Decline of the Date and the Rise of the College Hook Up," in *Families in Transition*, 14th ed., ed. Arlene S. Skolnick and Jerome H. Skolnick (Boston: Allyn and Bacon, 2006).

13. Jenna Mahay and Edward O. Laumann, "Neighborhoods as Sex Markets," in *The Sexual Organization of the City*, ed. Laumann et al., 74. According to the Chicago Health and Social Life Survey, the exception to this statistic is the Mexican community area called Westside, in which 23 percent of women (but only 19 percent of men) reported having met their most recent partner at a bar, dance club, or nightclub; see Mahay and Laumann, "Neighborhoods as Sex Markets," 81.

14. David A. Snow, Cherylon Robinson, and Patricia L. McCall, "'Cooling Out' Men in Singles Bars and Nightclubs: Observations on the Interpersonal Survival Strategies of Women in Public Places," *Journal of Contemporary Ethnography* 19 (1991): 423–49; Mitchell Duneier and Harvey Molotch, "Talking City Trouble: Interactional Vandalism, Social Inequality, and the 'Urban Interaction Problem,'" *American Journal of Sociology* 104 (1999): 1263–95; Hollander, "Resisting Vulnerability"; Greta Foff Paules, *Dishing It Out: Power and Resistance among Waitresses in a New Jersey Restaurant* (Philadelphia: Temple University Press, 1991).

15. Tom Wolfe, *I Am Charlotte Simmons* (New York: Farrar, Straus and Giroux, 2004); Tucker Max, *I Hope They Serve Beer in Hell* (New York: Citadel, 2006); see Kathleen A. Bogle, *From Dating to Hooking Up: The Emergence of a New Sexual Script* (Ph.D. diss., University of Delaware, 2004); and Alex Williams, "Casual Relationships, Yes. Casual Sex, Not Really," *New York Times*, April 3, 2005, sec. 9, pp. 1, 12.

16. Connell and Messerschmidt, "Hegemonic Masculinity," 851. The inflated peer status ascribed to erotically successful men also explains the recent runaway success of how-to dating books among male readers, e.g., Neil Strauss, *The*

Game: *Penetrating the Secret Society of Pickup Artists* (New York, Regan Books, 2005). On erotic prestige and dating desirability as hierarchically ordered social status rankings, see Willard Waller, "The Rating and Dating Complex," *American Sociological Review* 2 (1937): 727–34; and Hans L. Zetterberg, "The Secret Ranking," *Journal of Marriage and the Family* 28 (1966): 134–42.

17. William H. Whyte, *City: Rediscovering the Center* (New York: Doubleday, 1988); Snow, Robinson, and McCall, "'Cooling Out' Men in Singles Bars and Nightclubs"; Duneier and Molotch, "Talking City Trouble."

18. Similar types of homosocial behavior among young males are examined in Barrie Thorne and Zella Luria, "Sexuality and Gender in Children's Daily Worlds," *Social Problems* 33 (1986): 176–90; Patricia Yancey Martin and Robert A. Hummer, "Fraternities and Rape on Campus," *Gender & Society* 3 (1989): 457–73; Peggy Reeves Sanday, *Fraternity Gang Rape: Sex, Brotherhood, and Privilege on Campus* (New York: New York University Press, 1990); and Kenneth Polk, "Masculinity, Honor and Confrontational Homicide," in *Just Boys Doing Business?: Men, Masculinities and Crime*, ed. Tim Newburn and Elizabeth A. Stanko (London: Routledge, 1994).

19. On the "mobilization" of masculinity among male peers engaged in homosocial interaction, see Patricia Yancey Martin, "'Mobilizing Masculinities': Women's Experiences of Men at Work," *Organization* 8 (2001): 587–618.

20. Randall Collins, *Interaction Ritual Chains* (Princeton, NJ: Princeton University Press, 2004).

21. Respondents in my research exhibited a variety of socially recognizable masculine roles in their accounts, including the "doting boyfriend," "dutiful son," and "perfect gentleman." In the interests of exploring the girl hunt as *one among many types* of social orientation toward the city at night, the examples presented here represent only the accounts of those heterosexual young men whose narratives clustered around a set of shared commonalities relevant to the girl hunt as outlined above. These accounts represent about one-fifth of those submitted by my heterosexual male respondents.

22. Connell, *Masculinities*.

23. Connell and Messerschmidt, "Hegemonic Masculinity," 850.

24. Henning Bech, "Citysex: Representing Lust in Public," *Theory, Culture & Society* 15 (1998): 215–41.

25. Michael S. Kimmel and Rebecca F. Plante, "The Gender of Desire: The Sexual Fantasies of Women and Men," in *The Gender of Desire: Essays on Male Sexuality*, ed. Michael S. Kimmel (Albany, NY: SUNY Press, 2005).

26. On the anonymity and unconventionality of urban life, see Georg Simmel, "The Metropolis and Mental Life" (1903), in *On Individuality and Social Forms*, ed. Donald N. Levine (Chicago: University of Chicago Press, 1971); Louis Wirth, "Urbanism as a Way of Life," *American Journal of Sociology* 44 (1938): 1–24; Lyn H. Lofland, *A World of Strangers: Order and Action in Urban Public Space* (New York: Basic, 1974); and Claude Fischer, "Toward a Subcultural Theory of Urbanism," *American Journal of Sociology* 80 (1975): 1319–41; on the relationship between the social organization of the city and sexuality, see Bech, "Citysex"; Paul Chatterton and Robert Hollands, *Urban Nightscapes: Youth Cultures, Pleasure Spaces and Corporate Power* (London: Routledge, 2003); and Laumann et al., *The Sexual Organization of the City*.

27. Bird, "Welcome to the Men's Club"; Erving Goffman, *Stigma: Notes on the Management of Spoiled Identity* (New York: Simon & Schuster, 1963). In his ethnographic fieldwork on urban neighborhoods, Elijah Anderson examines how sex codes among youth evolve in a context of peer pressure in which young black males "run their game" by women as a means of pursuing in-group status, a finding that can be generalized to explain the sexual behavior of other populations, including affluent college students. See his "Sex Codes and Family Life among Poor Inner-City Youths," *Annals of the American Academy of Political and Social Science* 501 (1989): 59–78; *Streetwise: Race, Class, and Change in an Urban Community* (Chicago: University of Chicago Press, 1990); and *Code of the Street: Decency, Violence, and the Moral Life of the Inner City* (New York: Norton, 1999).

28. For a content analysis of contemporary rap lyrics, see Kembrew McLeod, "Authenticity within Hip-Hop and Other Cultures Threatened with Assimilation," *Journal of Communication* 49 (1999): 134–50.

29. Peter Lyman, "The Fraternal Bond as a Joking Relationship: A Case Study of the Role of Sexist Jokes in Male Group Bonding," in *Changing Men: New Directions in Research on Men and Masculinity*, ed. Michael S. Kimmel (Newbury Park, CA: Sage, 1987); Bird, "Welcome to the Men's Club."

30. See Messner, *Taking the Field*. In this context, the male ritual of jumping in unison to loud music bears a close resemblance to the "circle dance" initiated by fraternity brothers immediately prior to an alleged incident of gang rape, as described in Sanday, *Fraternity Gang Rape*.

31. Martin and Hummer, "Fraternities and Rape on Campus"; Sanday, *Fraternity Gang Rape*; A. Ayres Boswell and Joan Z. Spade, "Fraternities and Collegiate Rape Culture: Why Are Some Fraternities More Dangerous Places for Women?" *Gender & Society* 10 (1996): 133–47.

32. Gary Alan Fine, "Popular Culture and Social Interaction: Production, Consumption and Usage," *Journal of Popular Culture* 11 (1977): 453–56; Nina Eliasoph and Paul Lichterman, "Culture in Interaction," *American Journal of Sociology* 108 (2003):735–94; Ann Swidler, *Talk of Love: How Culture Matters* (Chicago: University of Chicago Press, 2001).

33. Ann Swidler, "Culture in Action: Symbols and Strategies," *American Sociological Review* 51 (1986): 273–86; Swidler, *Talk of Love*; Connell and Messerschmidt, "Hegemonic Masculinity."

34. Sanday, *Fraternity Gang Rape*.

35. Thorne and Luria, "Sexuality and Gender in Children's Daily Worlds," 181.

36. Connell, *Masculinities*; Demetrakis Z. Demetriou, "Connell's Concept of Hegemonic Masculinity: A Critique," *Theory and Society* 30 (2001): 337–61.

37. On the role of the shill in the classic confidence game, see David W. Maurer, *The Big Con: The Story of the Confidence Man* (New York: Anchor, 1940); Goffman, *The Presentation of Self in Everyday Life*; and David Grazian, "The Production of Popular Music as a Confidence Game: The Case of the Chicago Blues," *Qualitative Sociology* 27 (2004): 137–58.

38. In this instance, Michael politely disengages from the interaction without challenging the ideological basis of the girl hunt itself. Rather, his passive performance amounts to what Connell, *Masculinities*, refers to as "complicit masculinity" insofar as he is able to sustain his friend's interaction and thus benefit from the "patriarchal dividend" (acceptance within a male homosocial group and the status associated with such membership) gained from the promotion of the ideals of hegemonic masculinity as represented by the girl hunt; also see Demetriou, "Connell's Concept of Hegemonic Masculinity."

39. Nocturnal tales concerning the wingman appear in Gabe Fischbarg, *The Guide to Picking Up Girls* (New York: Plume, 2002); "Maxim's Wingman Training Manual," *Maxim*, May 2003; Strauss, *The Game*; Frank Kelly Rich, *The Modern Drunkard: A Handbook for Drinking in the 21st Century* (New York: Riverhead, 2005); and Tucker Max, *I Hope They Serve Beer in Hell* (New York: Citadel, 2006). On the rise of "fratire" in popular literary culture, see Warren St. John, "Dude, Here's My Book," *New York Times*, April 16, 2006.

40. Fischbarg, *The Guide to Picking Up Girls*, 36.

41. Mishkind et al., "The Embodiment of Masculinity"; Martin and Hummer, "Fraternities and Rape on Campus."

42. Snow, Robinson, and McCall, "'Cooling Out' Men in Singles Bars and Nightclubs"; Hollander, "Resisting Vulnerability."

43. Lyman, "The Fraternal Bond as a Joking Relationship," 155.

44. Bernard Berk, "Face-Saving at the Singles Dance," *Social Problems* 24 (1977): 530–44.

45. Randall Collins, "On the Microfoundations of Macrosociology," *American Journal of Sociology* 86 (1981): 987–88; Michael Schwalbe, Sandra Goodwin, Daphne Holden, Douglas Schrock, Shealy Thompson, and Michele Wolkomir, "Generic Processes in the Reproduction of Inequality: An Interactionist Analysis," *Social Forces* 79 (2000): 419–52.

46. Schwalbe et al., "Generic Processes in the Reproduction of Inequality," 424.

47. Waller, "The Rating and Dating Complex"; Zetterberg, "The Secret Ranking"; Robert Wright, *The Moral Animal: Evolutionary Psychology and Everyday Life* (New York: Vintage, 1995); Mishkind et al., "The Embodiment of Masculinity"; Schwalbe et al., "Generic Processes in the Reproduction of Inequality," 437.

CHAPTER 6

1. According to Catherine Hill and Elena Silva, *Drawing the Line: Sexual Harassment on Campus* (American Association of University Women Educational Foundation, 2005), on American college campuses, *less than one-fifth* of students who admitted to sexually harassing another student reported desiring a date with the target. A similar point is also made by William H. Whyte, *City: Rediscovering the Center* (New York: Doubleday, 1988), in his discussion of male catcallers in Midtown Manhattan.

2. For ethnographic exemplars of these types of public interactions, see Whyte, *City*; Elijah Anderson, *Streetwise: Race, Class, and Change in an Urban Community* (Chicago: University of Chicago Press, 1990); Mitchell Duneier, *Sidewalk* (New York: Farrar, Straus and Giroux, 1999); and Mitchell Duneier and Harvey Molotch, "Talking City Trouble: Interactional Vandalism, Social Inequality, and the 'Urban Interaction Problem,'" *American Journal of Sociology* 104 (1999): 1263–95.

3. Data cited in Hill and Silva, *Drawing the Line*. The study defined sexual harassment broadly as "*unwanted* and *unwelcome* sexual behavior which interferes with your life . . . and *not* behaviors that you like or want (for example *wanted* kissing, touching or flirting)" (6).

4. James P. Spradley and Brenda J. Mann, *The Cocktail Waitress: Woman's Work in a Man's World* (New York: John Wiley, 1975); Gloria Steinem, "I Was a Playboy Bunny," in *Outrageous Acts and Everyday Rebellions* (New York: Plume, 1983);

Arlie Russell Hochschild, *The Managed Heart: Commercialization of Human Feeling* (Berkeley: University of California Press, 1983); Patti A. Giuffre and Christine L. Williams, "Boundary Lines: Labeling Sexual Harassment in Restaurants," *Gender & Society* 8 (1994): 378–401.

5. Randall Collins, "On the Microfoundations of Macrosociology," *American Journal of Sociology* 86 (1981): 984–1014; Cecilia L. Ridgeway, "Interaction and the Conservation of Gender Inequality: Considering Employment," *American Sociological Review* 62 (1997): 218–35; Michael Schwalbe, Sandra Goodwin, Daphne Holden, Douglas Schrock, Shealy Thompson, and Michele Wolkomir, "Generic Processes in the Reproduction of Inequality: An Interactionist Analysis," *Social Forces* 79 (2000): 419–52.

6. Randall Collins, "Situational Stratification: A Micro-Macro Theory of Inequality," *Sociological Theory* 18 (2000): 39; Randall Collins, *Interaction Ritual Chains* (Princeton, NJ: Princeton University Press, 2004), 293.

7. James M. Dabbs Jr. and Neil A. Stokes III, "Beauty Is Power: The Use of Space on the Sidewalk," *Sociometry* 38 (1975): 555; Whyte, *City*, 22–23.

8. I thank Robin Leidner for bringing this observation to my attention.

9. As suggested by their frequent misuse of the term "middle age," young women likely misread the actual ages of the men with whom they encounter, just as those same men invariably mistake underage women for their older (albeit not *too* much older) counterparts.

10. Georg Simmel, "The Stranger," in *On Individuality and Social Forms* (1903), ed. Donald N. Levine (Chicago: University of Chicago Press, 1971), 145.

11. I discuss the staged authenticity of urban blues and jazz clubs at length in David Grazian, *Blue Chicago: The Search for Authenticity in Urban Blues Clubs* (Chicago: University of Chicago Press, 2003).

12. Joanne Gottlieb and Gayle Wald, "Smells Like Teen Spirit: Riot Grrrls, Revolution and Women in Independent Rock," in *Microphone Fiends: Youth Music and Youth Culture*, ed. Andrew Ross and Tricia Rose (New York: Routledge, 1994); Simon Reynolds and Joy Press, *The Sex Revolts: Gender, Rebellion, and Rock 'n' Roll* (Cambridge, MA: Harvard University Press, 1995); Thomas Frank, "Alternative to What?" in *Commodify Your Dissent: Salvos from "The Baffler,"* ed. Thomas Frank and Matt Weiland (New York: Norton, 1997); Mary Ann Clawson, "When Women Play the Bass: Instrument Specialization and Gender Interpretation in Alternative Rock Music," *Gender & Society* 13 (1999): 193–210; Michael Azerrad, *Our Band Could Be Your Life: Scenes from the American Indie Underground, 1981–1991* (Boston: Little, Brown, 2001).

13. See Michael McCarthy, "Vegas Goes Back to Naughty Roots," USA Today, April 11, 2005.

14. In addition to Philadelphia, the Rejection Hotline operates in seventy American cities, including nightlife havens such as New York City, Miami, Los Angeles, Austin, San Francisco, Nashville, and Boston. Each city requires its own specific number in order to reflect local area codes and exchanges.

15. As far as my research/teaching staff and I could tell, the student did not sustain any injuries or illnesses as a result of the assault; since the incident, the Philadelphia branch of Coyote Ugly has gone out of business.

16. Similarly, Ron Rosenbaum, "How to Trick an Online Scammer into Carving a Computer Out of Wood," Atlantic Monthly, June 2007, 78–84, exposes a secret world of "scam-baiters" who target online con artists with hustles of their own. On cooling out the mark, see David W. Maurer, The Big Con: The Story of the Confidence Man (1940; repr., New York: Anchor, 1999), 289; Erving Goffman, "On Cooling the Mark Out: Some Aspects of Adaptation to Failure," Psychiatry 15 (1952): 451–63; David A. Snow, Cherylon Robinson, and Patricia L. McCall, "'Cooling Out' Men in Singles Bars and Nightclubs: Observations on the Interpersonal Survival Strategies of Women in Public Places," Journal of Contemporary Ethnography 19 (1991): 423–49.

17. On the gendered behavior of women at indie rock venues, see Wendy Fonarow, "The Spatial Organization of the Indie Music Gig," in The Subcultures Reader, ed. Ken Gelder and Sarah Thornton (London: Routledge, 1997), 360–69.

18. Gottlieb and Wald, "Smells Like Teen Spirit"; Reynolds and Press, The Sex Revolts; Mavis Bayton, Frock Rock: Women Performing Popular Music (Oxford: Oxford University Press, 1998); Clawson, "When Women Play the Bass."

19. In the interests of full disclosure, I should point out that although we were not romantically involved when I recorded these field notes on December 5, 2002, Meredith Broussard and I began dating about a month later and eventually married in September 2004. (See acknowledgments.)

CHAPTER 7

1. Erving Goffman, Interaction Ritual: Essays on Face-to-Face Interaction (New York: Pantheon, 1967), 185; Jack Katz, Seductions of Crime: Moral and Sensual Attractions in Doing Evil (New York: Basic, 1988).

2. On the irrational fears whites harbor toward black inner-city neighborhoods and their residents, see Elijah Anderson, Streetwise: Race, Class, and Change

in an *Urban Community* (Chicago: University of Chicago Press, 1990); Barry Glassner, *The Culture of Fear: Why Americans Are Afraid of the Wrong Things* (New York: Basic Books, 1999); and David Grazian, *Blue Chicago: The Search for Authenticity in Urban Blues Clubs* (Chicago: University of Chicago Press, 2003).

3. Statistics on traffic accidents come from the National Center for Statistics and Analysis of the National Highway Traffic Safety Administration. On the social construction of drunk driving as a moral panic and national public problem, see Joseph Gusfield, *The Culture of Public Problems: Drinking-Driving and the Symbolic Order* (Chicago: University of Chicago Press, 1981); and James B. Jacobs, *Drunk Driving: An American Dilemma* (Chicago: University of Chicago Press, 1989).

4. At the very least, findings on this score are ambiguous. According to Gar Joseph, "Hell on the Streets with Crummy Cabs: Rocky Rides and Clueless Drivers Are among the Woes Customers Face," *Philadelphia Daily News*, October 21, 1998, 5, accident data involving taxicabs in Philadelphia are difficult to ascertain, given that the city's police department lumps them together with all vehicles when compiling local accident statistics. Meanwhile, according to L. Stuart Ditzen, "Hail a Taxi in Phila. at Your Own Risk," *Philadelphia Inquirer*, October 19, 2003, A01: "Industry experts say that cabs in Philadelphia are involved in an average of 1.5 accidents per year." Given their extensive time on the road, perhaps it should not be surprising that cabdrivers get into more accidents than all other drivers in the aggregate. However, according to a study of Quebec cabdrivers, although taxicab drivers actually do get into more vehicular accidents than other drivers, these accidents tend to be minor, rarely resulting in serious injury or death; see Urs Maag, Charles Vanasse, Georges Dionne, and Claire Laberge-Nadeau, "Taxi Drivers' Accidents: How Binocular Vision Problems Are Related to Their Rate and Severity in Terms of the Number of Victims," *Accident Analysis and Prevention* 29 (1997): 217–24.

5. Desiree F. Hicks, "WTAF Gives Free Ride to Holiday Celebrators," *Philadelphia Inquirer*, July 5, 1984, B01; "Drunk Drivers Offered Cab Fare by Blue Cross," *Philadelphia Inquirer*, December 14, 1984, B19.

6. "I Am Not Afraid to Die," *Chicago Sun-Times*, November 20, 2006, 8.

7. Peter Bearman, *Doormen* (Chicago: University of Chicago Press, 2005).

8. According to Tom Belden, "New Brand of Taxi Driver," *Philadelphia Inquirer*, May 10, 1993, C01, foreign-born immigrants make up approximately three-quarters of the city's estimated 2,500 cabdrivers. On taxi driving as an immigrant niche in Philadelphia, see Murray Dubin, "In Fare Game, World-Class Players:

Cab Driving Here Becoming Domain of Foreign-Born," *Philadelphia Inquirer*, June 12, 1987, B01; and Lini S. Kadaba, "They Find Niche, and Fuel Economy," *Philadelphia Inquirer*, November 22, 1998, B01.

9. Patrick Peruch, Marie-Dominique Giraudo, and Tommy Garling, "Distance Cognition by Taxi Drivers and the General Public," *Journal of Environmental Psychology* 9 (1989): 233–39; Eleanor A. Maguire, Richard S. J. Frackowiak, and Christopher D. Frith, "Recalling Routes around London: Activation of the Right Hippocampus in Taxi Drivers," *Journal of Neuroscience* 17 (1997): 7103–10; Virpi Kalakoski and Pertti Saariluoma, "Taxi Drivers' Exceptional Memory of Street Names," *Memory and Cognition* 29 (2001): 634–38.

10. Erving Goffman, *Asylums: Essays on the Social Situation of Mental Patients and Other Inmates* (New York: Anchor, 1961).

11. Joan Kirchner, "Dangerous World for Cabdrivers," *Philadelphia Inquirer*, October 26, 1993, C11; Dana DiFilippo, "Cabbies Cope with Crime: Jamie Aponte Was Third Cab Driver to Be Killed in City in Last Six Weeks," *Philadelphia Daily News*, December 18, 2000, 3; Kathryn E. Moracco, Carol W. Runyan, Dana P. Loomis, Susanne H. Wolf, David Napp, and John D. Butts, "Killed on the Clock: A Population-Based Study of Workplace Homicide, 1977–1991," *American Journal of Industrial Medicine* 37 (2000): 629–36; Heather Hamill and Diego Gambetta, "Who Do Taxi Drivers Trust?" *Contexts* 5 (2006): 29–33.

12. Walter C. Reckless, *Vice in Chicago* (Chicago: University of Chicago Press, 1933); Milton "Mezz" Mezzrow and Bernard Wolfe, *Really the Blues* (New York: Random House,1946); William Howland Kenney, *Chicago Jazz: A Cultural History, 1904–1930* (New York: Oxford University Press, 1993); George Chauncey, *Gay New York: Gender, Urban Culture, and the Making of the Gay Male World, 1890–1940* (New York: Basic Books, 1994); Grazian, *Blue Chicago*.

13. On the representation of working-class stereotypes on *Jerry Springer* and other television talk shows, see Laura Grindstaff, *The Money Shot: Trash, Class, and the Making of TV Talk Shows* (Chicago: University of Chicago Press, 2002).

14. On the occupational features of stripping, see Lisa Pasko, "Naked Power: The Practice of Stripping as a Confidence Game," *Sexualities* 5 (2002): 49–66; on croupiers and other casino service workers, see Jeffrey J. Sallaz, "The House Rules: Autonomy and Interests among Service Workers in the Contemporary Casino Industry," *Work and Occupations* 29 (2002): 394–427.

15. As Dawne Moon, "Insult and Inclusion: The Term *Fag Hag* and Gay Male 'Community,'" *Social Forces* 74 (1995): 487–510, observes, gay men often denigrate straight women who frequent male-dominated gay entertainment venues

as "fag hags," a position articulated (and then abruptly modified) by Byron, a twenty-two-year-old senior who self-identifies as gay:

> There's always the increasing spattering of straight girls that have been show-ing up to the gay bars and clubs lately. And it's getting a little annoying if I might say so myself. I KNOW *Queer Eye for the Straight Guy* and *Will & Grace* have made gay culture a bit of a spectacle and even something hip and novel, but come on. I understand it's nice to dance with a bunch of really hot guys and not having to worry about getting hit on all the time, but I really don't want to dance with you either. So lay off. And go home. Or at LEAST get out of my way.
>
> OK, enough ranting. I only mean some of that. There's also the breed of girl who gets brought along as the emotional support for the guy she's found sandwiched around. Especially for the newly out, or otherwise timid, gay guy out there to test the waters. That's not usually something ANYONE wants to experience alone. So it's understandable. And you can always spot them from a mile away.

16. Damon C. Williams, "New Signs Make It Official: We Have a 'Gaybor-hood,'" *Philadelphia Daily News*, April 19, 2007, 22.

17. It should be noted that young gay men often share a similar experience, as explained by Parker, a nineteen-year-old freshman who self-identifies as gay:

> One of the first things I felt when we went in was that I was getting checked out by many of the guys. I guess it is something I am used to since I go to gay clubs all the time, but it always seems to be a bit nerve-racking to know that you are being objectified by the guys around you. The crowd seemed pretty young, mostly college students, which is good because I was worried that there would be a few older men trying to pick up younger guys.

CHAPTER 8

1. For a more specific list of celebrity guests, see Michael Klein, "Inqlings," *Philadelphia Inquirer*, January 15, 2006.

2. Jay Robert Nash, *Hustlers and Con Men: An Anecdotal History of the Confidence Man and His Games* (New York: M. Evans and Co., 1976), 37, 118–19.

3. David W. Maurer, *The Big Con: The Story of the Confidence Man* (1940) (New York: Anchor, 1999), 116–17. In a discussion on relations of trust, James S. Cole-

man, *The Foundations of Social Theory* (Cambridge, MA: Harvard University Press, 1990), 104–6, similarly argues that the victims of confidence games frequently decide to participate in such deals after rationally calculating the amount of the potential payoff they would stand to gain from the hustler's offer, relative to the potential loss.

4. David Grazian, *Blue Chicago: The Search for Authenticity in Urban Blues Clubs* (Chicago: University of Chicago Press, 2003), 67–68.

5. Eleazar David Melendez, "Clever Couple Swindling Pedestrians," *Columbia Spectator*, April 26, 2006.

6. Katha Pollitt, "Sex and the Stepford Wife," *Nation*, July 5, 2004.

APPENDIX

1. Center City's official downtown neighborhood districts are bounded to the north and south by Vine and South streets, respectively, and therefore demarcate a smaller geographic area than that designated by the boundaries selected for the assignment. I purposely chose a wider region in order to incorporate a number of developing entertainment zones that flourish at the margins of Center City, including Northern Liberties, Fairmount, Queen Village, and the Italian Market.

2. According to Sara Sklaroff, *U.S. News and World Report 2005 Edition, America's Best Colleges* (Holiber, 2004), 247, recent available statistics estimate the gender makeup of the undergraduate student body at the University of Pennsylvania at 50 percent male and 50 percent female; the proportion of minority students is characterized as 17 percent Asian, 6 percent black, and 5 percent Hispanic; and 19 percent of Penn's students hail from within the state.

3. The lack of data on the experiences of homosexual students is a clear limitation of this chapter. On the varied performances of contemporary gay men in the context of urban nightlife, see Wayne H. Brekhus, *Peacocks, Chameleons, Centaurs: Gay Suburbia and the Grammar of Social Identity* (Chicago: University of Chicago Press, 2003).

4. The sample of 243 heterosexual male students consists of 21.4 percent ($n = 52$) freshmen, 36.6 percent ($n = 89$) sophomores, 21.8 percent ($n = 53$) juniors, and 20.2 percent ($n = 49$) seniors. Respondents ranged from 18 to 24 years of age, with a mean age of 19.9 years. The racial and ethnic makeup of the sample is as follows: 78.2 percent ($n = 190$) white, 11.5 percent ($n = 28$) Asian, 4.5 percent ($n = 11$) non-Hispanic black, 2.9 percent ($n = 7$) Hispanic, and 2.9

percent (n = 7) mixed race/other. Nearly 40 percent of the Asian students in this sample are of Indian descent. Again, while my data analysis did uncover very small differences in consumption patterns among my sample on the basis of race and ethnicity, I could not detect notable differences relevant to the arguments presented in this chapter. As for student residence prior to college, nearly three-quarters (70.0%) of the sample lived in suburban areas, while about one-quarter hail from urban environments (26.3%), with the small remainder from rural areas (3.7%). Students residing in Philadelphia prior to attending Penn comprise 8.2 percent of the entire sample, while 22.2 percent hail from within the Commonwealth of Pennsylvania.

5. Alexandra Robbins, *Pledged: The Secret Life of Sororities* (New York: Hyperion, 2004) provides rich data on the impact of Greek life on contemporary college campuses.

INDEX

Aaron (student), on girl hunt, 140–41

Abigail (student), on sporting rituals, 95–96, 100–101

adulthood, transition to, 22–25, 226–27

advertising, supplanted by public relations, 63–67

Aimee (student), on sporting rituals, 131

Alec (student), storytelling and, 219, 220

Alexandra (server): on girl hunt and treatment of service workers, 174–75, 176; on staging, 55–56, 57

Alexis, on girl hunt, 191–97

Allan (student), on sporting rituals, 117–20

Allison (server and hostess), 19; on customer demands, 1–2; on girl hunt and treatment of service workers, 171–72, 176–77; on sporting rituals, 118, 120; on staging, 39, 48–49, 54, 57–58

Alma de Cuba, 68; public relations and, 77; staging and, 35, 37, 47–48, 49, 50, 52, 94

Andrews, Kate, 17, 19

Andrew (student), on sporting rituals, 127–28

anonymity, of urban life, 5–13, 244n9; changes in organization of city life, 6–10; changes in Philadelphia's nightlife, 10–13, 245n13; competition and, 5–6; sporting rituals and, 20–22, 94–95

Arnett, Jeffrey Jensen, 23

Art Worlds (Becker), 16

athletes, posing as, 128

audience segregation, 19

Avenue B, 14

avoidance, as strategy for handling girl hunt, 181, 185

"Back Up Boys" (Barrow), 189
Barclay Prime: public relations and, 66, 69–70; staging and, 33–34, 35, 37–41, 43, 47, 50, 94; treatment of college students, 115
bar fighting, 120–25
Barrow, Samantha, 189
bartending jobs, women in, 21–22, 247n30
Bearman, Peter, 16, 205
Beauvoir, Simone de, 95
Becker, Howard S., 16
Bernays, Edward L., 64–65
Bianca (associate manager), staging and, 41–42
Big Con: The Story of the Confidence Man, The (Maurer), 15, 18, 31, 228
"big store" design, 31–37
Bijay (student), storytelling and, 198, 202–3
Bill (student), on sporting rituals, 103
Blake (restaurant manager): on public relations, 69–70; on staging, 34, 37–41, 44, 53
Bleu, 14
Bleu Martini, 3–4, 11; staging and, 37
Blue Chicago (Grazian), 23–24, 200
Bob & Barbara's Lounge, 60, 210
Boorstin, Daniel, 65, 80
bottle service, 68–69
Bradley (student), on sporting rituals, 106
brand marketing, public relations and, 66–71

Brian (student): on girl hunt, 141, 157; on sporting rituals, 128–29
Brielle, on girl hunt, 191–96
Brooke (student), on girl hunt, 165
Broussard, Meredith, 190, 271n19
Brulee dessert, for $1,000, 70, 255n14
Bryant (student), storytelling and, 208
Buddakan, 11, 14
Burt, Ronald S., 82–83
Byron (student), on gay nightlife, 273–74n15

Café Habana, 68
Caitlin (server), on staging, 46, 51–52
Cameron (student), storytelling and, 216–19
Carol (student), on sporting rituals, 102
Caroline (student), storytelling and, 201–2
Cave, 210–14, 216–19
celebrities, pseudo-events and, 77–85
Celeste, on girl hunt, 192–93, 195–97
cheesesteak, for $100, 66, 69–70
Chelsea, 71
Chicago Sun-Times, 204–5
Christopher (student), on girl hunt, 149–50, 158
Christy (bartender), on girl hunt and treatment of service workers, 170–71
Chuck (student), storytelling and, 208–9
City Tavern, 13, 245n14
cocktails, novelty, 70–71
"Cohiba," 68
Colin, staging and, 41–42

collective activity, girl hunt as: shared experience and, 149–52; wingmen and, 152–55, 268n38

collective rituals, of confidence building, 143–49; dress code, 144–45; films, 147–49; pregaming, 146–47; rap music, 143–44

college students: Friday bar-hopping experiences of, 2–5; as marks, 18–19; of Philadelphia, 12, 25–27, 226; service employees' opinions of, 115–16

Collins, Randall, 121–22, 159

combat, as strategy for handling girl hunt, 181, 182–85

Comcast Corporation, 71–72

Commonplaces: Community Ideology and Identity in American Culture (Hummon), 257n32

competitiveness, of urban nightlife, 5–6

confidence, girl hunt and rituals to build, 143–49; dress code, 144–45; films, 147–49; pregaming, 146–47; rap music, 143–44

confidence games, 29–30

Connell, R. W., 140, 268n38

Continental Mid-Town: "reviewed," 73–74; staging and, 34, 35, 39, 50, 56–57, 94

Continental Restaurant and Martini Bar, 11; staging and, 14, 36, 37

Cook, Philip C., 63

Cory (student), on sporting rituals, 97

cosmetics: men and, 107–8; women and, 98, 259n9

cosmetic surgery, 101, 259n12

counterfeit IDs/underage drinking, 21, 102, 114–15, 261n23

Coyote Ugly, 86

Crystallizing Public Opinion (Bernays), 64–65

Cuba Libre Restaurant and Rum Bar, 11, 68; staging and, 32–33

Cynthia (student), on sporting rituals, 96

Daily Pennsylvanian, 90

Dana (student), on girl hunt, 191, 193, 197

Darren (student), on girl hunt, 149–50

Deborah (student), on sporting rituals, 98–99

deceit, as strategy for handling girl hunt, 181–83

Denim, 67

Derek (student), storytelling and, 207–8

dessert, for $1,000, 70, 255n14

Dipak (student), on girl hunt, 142

Dirty Frank's, 60, 61

Disney Corporation, 33

dive bars, 59–62, 209–10

Doc Watson's, 60

door policies, women and staging, 3–4, 58–59

Drawing the Line: Sexual Harassment on Campus (Hill and Silva), 269n1, 269n3

dress code, for student clubbers: confidence and girl hunt, 144–45; for men, 103–9, 116, 260n17; for women, 95–101

dress code, for support personnel, 47–49, 56, 253n29
Drew (student), on sporting rituals, 116
drinking rituals, 109–12
drunkenness, storytelling and, 202–3

Edward (student), on sporting rituals, 105–6, 110, 112–13, 261n23
Egan, Jennifer, 126
emotional labor, 54–59, 86
engagement, as strategy for handling girl hunt, 181, 185–87
England, Paula, 137
Errol (student), storytelling and, 206
euros, used at 32 Degrees, 66, 69, 255n11
Evan (student): on sporting rituals, 103–4; storytelling and, 220
Eve (student), on sporting rituals, 99–100
exotic dancers, 17, 42

"fag hags," 273–74n15
Fall of Advertising and the Rise of PR, The (Ries and Ries), 64
Felicia (student), on sporting rituals, 102–3
fictitious names, giving out, 181–82
fighting, at bars and clubs, 120–25
films, girl hunt and, 147–49
Fine, Gary Alan, 17
Fine, MJ, 188
Fishmarket, 14
Fonarow, Wendy, 187
Francis, Steve, 24
Frank, Robert H., 63
Frank (student), on girl hunt, 143

Frida (student): on girl hunt, 185–87; on sporting rituals, 100

Garrett (student), storytelling and, 215
gay men: dressing for heterosexual girl hunt and, 144–45; preparation for clubbing, 106–8
gay nightlife: storytelling and imagination of danger, 219–23, 273n15, 274n17; storytelling and slumming, 209–10
Gina (student), on girl hunt, 167
girl hunt, men's view, 134–60; as collective activity, 149–55; collective rituals of confidence building, 143–49; masculinity and, 135–40, 156–57; peer group support for, 155–58; social inequality and, 158–60. See also pickups
girl hunt, women's view, 161–97; hustle and, 190–97; older men and, 164–69; strategies for handling, 181–90; treatment of female music professionals, 177–81; treatment of female service workers, 169–77
"Girl Power" (Pressler), 83
Girls Gone Wild videos, 24
Gladwell, Malcolm, 82
Glassner, Barry, 75
Goffman, Erving: "action," 199; "audience segregation," 19; impression management, 30, 31, 37, 95
Gospel of Food, The (Glassner), 75
Grace Tavern, 61
Granovetter, Mark S., 82
Gregory (student), on girl hunt, 144

Guide to Picking Up Girls (Fischbarg), 153
Gutin, Barry, 255n11

hair straightening, 99, 259n9
harassment, of women, 161–64, 269n1, 269n3
Harry (student), on sporting rituals, 109–10
health code violations, 37, 252n14
high-heeled shoes, as club accessory, 97–98
Hill, Catherine, 269n1, 269n3
Hochschild, Arlie Russell, 55
hooking up. See sexual encounters
Hornik, Avram, 61, 125
Hummon, David, 257n32
humor, in peer group support for girl hunt, 157–58
hustle, art of urban, 13–20, 245n15; girl hunt and men, 158–60; girl hunt and women, 190–97; hotspot owners and, 13–15; marks for, 17–20; public relations and, 15; success of, 227–32; support personnel and, 15–17

Image, The (Boorstin), 65, 80
impersonations, for pickups, 126–28
independent (indie) rock music, 178–80, 187–89
Indrajit (student), on nightlife, 231–32
inequality. See social inequality
insiders. See support personnel
interior design, staging and, 31–37
Internet dating, 126

Iron Chef (television program), 32
Issenberg, Sasha, 12

Jacqueline (server), on girl hunt and treatment of service workers, 172
Jake (student), on sporting rituals, 109
Jane (student), storytelling and, 207
Jason (bartender and server): on sporting rituals, 117, 125–26, 133; on staging, 35–36, 44, 45–46, 54; on suburbanites, 257n32; on University of Pennsylvania students, 115–16
Jay (student), on sporting rituals, 108
Jess (student), on girl hunt, 184–85
Jessica (student), on girl hunt, 165
J.J. (student): on girl hunt, 138; on sporting rituals, 123–24
Joey (student): on girl hunt, 146–47; on sporting rituals, 113–14, 129–30, 133
John (student), on sporting rituals, 108–9
Jonas (busboy), on staging, 39
Joshua (server), 43; on Craig LaBan, 74–75
Juliana (booking agent), on treatment of music professionals, 178–80
Julian (student), on sporting rituals, 124

Karl (student), on sporting rituals, 121
Katie Klein Company, 86–91
Katz, Jack, 199
Kevin (student), on girl hunt, 147–48
Kitchens (Fine), 17
Klein, Katie, 86–91

Kristen (student), on sporting rituals, 101
Kyra (student), on girl hunt, 169

LaBan, Craig: on staging, 34; venue preparations for visit by, 74–77
La Esquina, 60
Lake, Danny (public relations consultant): on public relations, 65–66, 67, 70, 78, 81–82, 85; on staging, 32–33, 58–59
Lauren (student), on sporting rituals, 97–98
Lawrence (student), on girl hunt, 150–51
Leidner, Robin, 47
Leo, Richard A., 43–44, 113
lighting schemes, for staging, 35–37
Lippman, Walter, 64
Lucy (student), on girl hunt, 162–63
Lustig, Victor "the Count," 228

Mackenzie (student), 2–5
Madison (server): on girl hunt and treatment of service workers, 172–74; on staging, 35, 44–45, 47–48, 50
Mahdavi, India, 33
male-bonding rituals, prior to girl hunt, 143–49, 267n30
Mallory (student), storytelling and, 210
Mandy (student), on sporting rituals, 103
Marbar, 90
Marin (student), on girl hunt, 166–67
marks, for urban hustlers, 17–20
married men, girl hunt and, 169

Martin, Patricia Yancey, 139
masculinity: girl hunt strategy's success and, 137–38; performance of, as goal of girl hunt, 135–36, 138–40, 156–57; signifiers of, 136
masquerade, sporting ritual and: of men, 103–9, 116, 260n17; of women, 95–103, 259n9
Maurer, David W., 15, 18, 31, 228
McSorley's Old Ale House, 13, 245n14
media. See public relations
Melinda (booking agent): on treatment of music professionals, 180–81, 185–87; on women at music shows, 187
men: anxiety and behavior in clubs, 116–20, 262n30; bar fighting and, 120–25; entry to clubs and, 112–16; pickups and, 125–30, 133; preparations for clubbing, 103–9, 116, 260n17; public urination of, 261n26. See also girl hunt; masculinity
Merton, Robert K., 80
"Metropolis and Mental Life" (Simmel), 7–8
metrosexuality, 103–9; defined, 106, 260n19
Mia (student), 2–5
Michael (student), on girl hunt, 151–53
Miles (student): on girl hunt, 144–45; on sporting rituals, 107–8
Misty (server), on staging, 46, 61
Mixto, 68
Molly (server), on staging, 56
Morgan (student), on girl hunt, 183
Morimoto, Masaharu, 31–32

Morimoto, staging at,
31–32, 33, 50–52
music professionals, treatment of, 177–81

names, giving out fictitious, 181–82
Nancy (student), on sporting rituals, 123
Natalie (student), on girl hunt, 165–66
Nicholas (student), on girl hunt, 154
Nicole (student), 2–5
Nielsen, John, 44
nightlife professionals, treatment of, 177–81
nocturnal self, 24

Old City, 11–12
older men, girl hunt and, 164–69
Olivia (student), on girl hunt, 168–69
online dating, 126
Ortlieb's Jazzhaus, 57

Paradigm, 34–35
Park, Robert, 8–9
Parker (student), on gay nightlife, 274n17
PartyBuddys, 6
Pasko, Lisa, 42
Pedro (student), storytelling and, 220, 221–22
Pelaccio, Zak, 83
Peter (student), on girl hunt, 154–55
Peyton (server), staging and, 42, 43
Philadelphia, PA: business travelers and, 12–13, 245n13; changes in Center City life, 10–13, 225–26,

245n13; college students of, 12, 25–27, 226; demographics of, 10, 12; liquor laws and, 252n16; media and journalistic outlets in, 72; on The Real World, 25
Philadelphia City Paper, 75
Philadelphia Fish & Co., 55
Philadelphia Inquirer, 74. See also LaBan, Craig
Phoebe (student), on girl hunt, 167
pickups: men and, 125–30, 133; men and myth of, 140–42; women and, 130–33. See also girl hunt
Pod, staging at, 32, 37
Pollitt, Katha, 230
Polsky, Ned, 30
pregaming, 22, 109–12, 146–47
Presentation of Self in Everyday Life, The (Goffman), 19, 30, 31
Pressler, Jessica, 256n28; on public relations, 83–84, 91
"Price of Perfection, The" (Broussard), 190
Professional Thief, The (Sutherland), 17–18, 42
public relations, 15, 63–92; advertising supplanted by, 63–67; brand marketing and, 66–71; celebrities and pseudo-events and, 77–85; press reviews and, 71–77; reality marketing and, 66, 86–92

rap music, girl hunt and, 143–44
Rashid, Karim, 32
reality marketing, 66, 86–92
Real World, The (television program), 24–25
Red Sky Lounge, 100; "reviewed," 73

Redstone, Diana, on public relations, 77–78, 79, 80, 85
Redstone Productions, 77, 79, 91
Rejection Hotline, 182–83, 271n14
Rendell, Edward G., 10
Reserve, 71
restrooms, staging of, 34–35, 61
reviewers: free publications and, 72–74; treatment of serious, 74–77
Rick (magazine contributor), on public relations, 72–73
Ridgway, Nicole, 26
Ries, Al, 64
Ries, Laura, 64
risk, imagination of. See storytelling
Roberts, Ashleigh: on public relations, 78–79
Robert (server), staging and, 42
Robert (student), on girl hunt, 154
Rouge, 14
Running of the Bulls: Inside the Cutthroat Race from Wharton to Wall Street, The (Ridgway), 26
Ryan (student), on sporting rituals, 103

Saint Jack's, 3
Sam (student), on girl hunt, 157
Sammy (student), on sporting rituals, 104–5
Sanday, Peggy Reeves, 149
Sandy (booking agent), on treatment of music professionals, 180–81
Sarah (student), on girl hunt, 183–84
Scales, Coco Henson, 37
Schwalbe, Michael, 159
Sciarrino, Maria Tessa, 188–89

"scripted improvisation," 43–53; customer interactions and, 43–47, 49–53, 254n30; dress code and, 47–49, 253n29
Sears, David O., 25
Second Sex, The (Beauvoir), 95
secret shoppers, staging and, 51–52
service workers. See support personnel
Sex and the City (television program), 233
sex talk, male competitive, 142
sexual asymmetry, girl hunt and, 164–69
sexual encounters: "hooking up," 106, 260n20; statistics about, 137, 265n13
sexual harassment, of women, 161–64, 269n1, 269n3
Shannon (student), on sporting rituals, 131
sharking, 192
Sharon (student), on sporting rituals, 102
Sherr, Sara, 188–89
Sid (student), on sporting rituals, 122
Signatures, 215
Silva, Elena, 269n1, 269n3
Simmel, Georg, 7–8, 175–76
slumming, 209–14
"slump-buster," 106, 260n18
social class, masquerade and, 99
social inequality: girl hunt and, 158–60; storytelling and slumming, 209–14; storytelling and taxi drivers, 205, 207–9
Spectator, 229–30
sporting rituals, in urban nightlife, 20–22, 93–133; competition and

winning bar, 112–25; men and masquerade, 103–9, 116, 260n17; pickups and, 125–33, 140–2; pregaming and, 22, 109–12, 146–47; women and masquerade, 95–103, 259n9. *See also* storytelling

staging, 29–62; "big store" design and, 31–37; dive bars and, 59–62; "scripted improvisation" and, 43–53, 253n29, 254n30; theater and, 37–43; women employees and clientele and, 54–59

Standard Tap Room, 61

Starr, Stephen, 14, 69, 84–85

Starr Restaurant Organization (SRO), 14–15; staging and, 31–32, 48–52, 54

Stein, Neil, 14

Steinem, Gloria, 97, 253n29

Stewart (student), storytelling and, 219–23

storytelling, 198–223; gay nightlife and, 219–23, 273n15, 274n17; pleasures of, 201–3; risky play and, 214–19; slumming and, 209–14; taxi drivers and, 203–9

strip clubs, storytelling and: risky play, 214–19; slumming, 210–14

Striped Bass, 14

suburbanites, public relations and, 85, 257n32

Sue (server), on girl hunt and treatment of service workers, 175–76

Sugar Town, 188–89

support personnel: hustle and, 15–17; staging and, 37–59; treatment of female, 54–59, 169–77

Sutherland, Edwin H., 17–18, 42

Swingers (film), 147–49, 150

Tangerine, 1–2, 11, 14; sporting rituals at, 117–20; staging and, 35–36, 39, 45–46, 48–49, 54

Tannen, Deborah, 262n30

taxi drivers, as narrative symbols, 4–5, 203–9, 272n4

Teatro Euro Bar, 71

Tedford, Jamie, 256n30

telephone etiquette: public relations and, 77; staging and, 52–53

telephone numbers, giving false, 182–83, 271n14

theater. *See* staging

32 Degrees: public relations and, 66, 68–69, 255n11; staging and, 54–55

Thomas, Dorothy Swaine, 30

Thomas, Reuben J., 137

Thomas, W. I., 30

Thomas (student), on sporting rituals, 111–12

Tierra Colombiana, 68

Tiki Bob's Cantina, 116, 163

Tipping Point, The (Gladwell), 82

Tkacik, Maureen: on dive bars, 59, 60–62

Tom Drinker's Tavern, 61–62

Tommy (server), on staging, 54–55

Tracy (student), on sporting rituals, 131–33

Two-Foot Rule, 50

Tyler (student), on sporting rituals, 104

underage drinking/counterfeit IDs, 21, 102, 114–15, 261n23

uniforms. *See* dress code
University of Chicago, 29
University of Pennsylvania,
 25–27, 114–15, 261n25
unsanitary conditions, 37, 252n14
urban nightlife: anonymity of, 5–13;
 sexualized atmosphere of, 21–22;
 smoke and mirrors of, 224–33;
 sporting rituals in, 20–22; transi-
 tion to adulthood and, 22–25,
 226–7. *See also* hustle, art of urban
urination, public, 261n26
USA Today, 69, 255n11

Vanessa (student): on sporting ritu-
 als, 130; storytelling and, 210–14
Violent Interaction (Collins), 121–22
vocabulary, staging and, 50–51

Waddell, Reed, 228
West, Candace, 136
Where magazine, 72–74

wine knowledge, staging
 and, 37–41, 252n16
wingmen, 152–55, 268n38; wom-
 en's reactions to, 193–94
Wingwomen.com, 6
"winning bar," 112–25; bar fights and
 violence, 120–25; entry tactics,
 112–16; male anxiety and com-
 petitiveness, 116–20, 262n30
women: anxiety at clubs, 100–103;
 emotional labor and, 86; pick-
 ups and, 130–33; preparations
 for clubbing, 95–103; reality
 marketing and, 86–91; stag-
 ing and, 3–6, 54–59; as support
 personnel, 21–22, 54–59, 169–77,
 247n30. *See also* girl hunt
World Fusion, 12

Zack (student), on girl hunt, 156
Zee Bar, 224–25
Zimmerman, Don H., 136